THE GREAT SPECTACLE

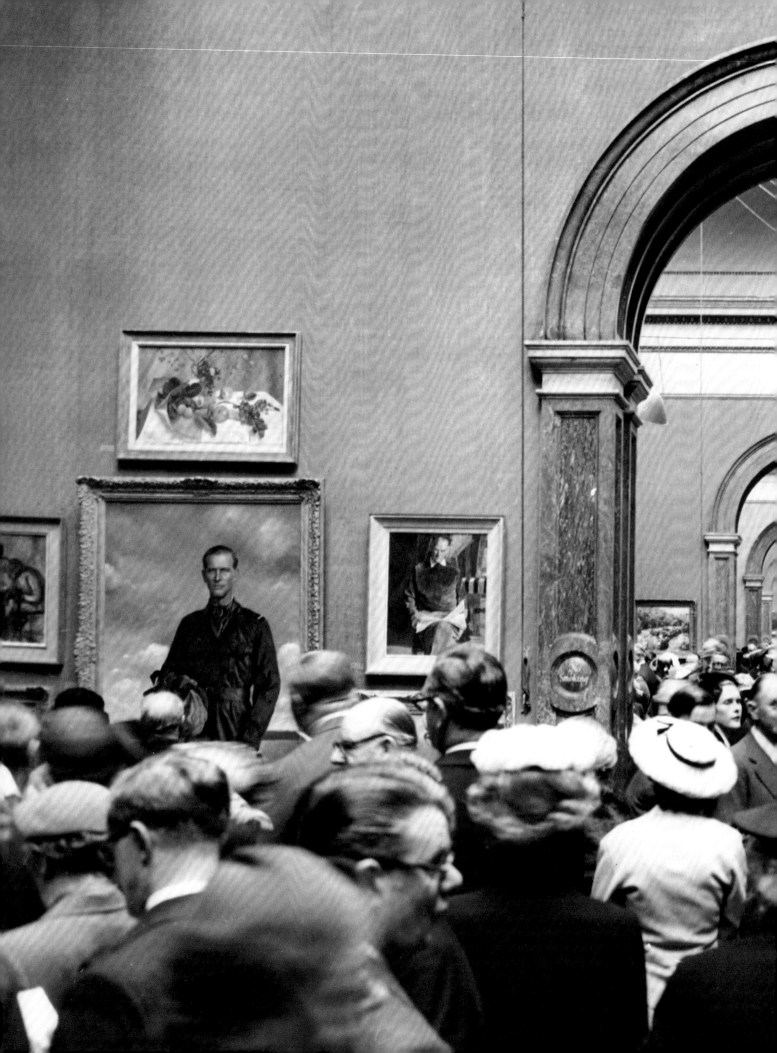

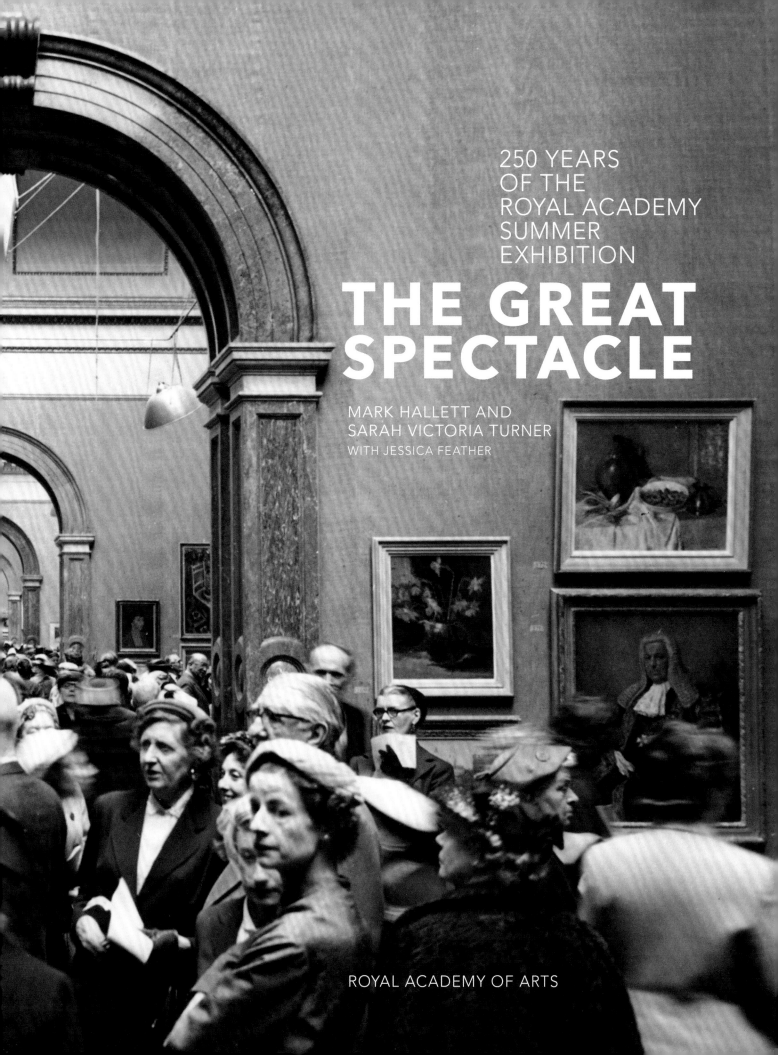

250 YEARS
OF THE
ROYAL ACADEMY
SUMMER
EXHIBITION

THE GREAT SPECTACLE

MARK HALLETT AND
SARAH VICTORIA TURNER
WITH JESSICA FEATHER

ROYAL ACADEMY OF ARTS

First published on the occasion of the exhibition
'The Great Spectacle:
250 Years of the Summer Exhibition'

Royal Academy of Arts, London
12 June – 19 August 2018

Supported by Cate Olson and Nash Robbins
Supported by Peter Williams

Department for Digital, Culture Media & Sport

This exhibition has been made possible as a result of the Government Indemnity Scheme. The Royal Academy of Arts would like to thank HM Government for providing indemnity and the Department for Digital, Culture, Media and Sport and Arts Council England for arranging the indemnity.

ARTISTIC DIRECTOR
Tim Marlow

EXHIBITION CURATORS
Paul Mellon Centre for Studies in British Art
Mark Hallett
Sarah Victoria Turner
assisted by Jessica Feather

Royal Academy of Arts
Per Rumberg
assisted by Anna Testar

EXHIBITION ORGANISATION
Elana Woodgate
assisted by Jessica Reid

PHOTOGRAPHIC AND
COPYRIGHT CO-ORDINATION
Caroline Arno

EXHIBITION CATALOGUE
Royal Academy Publications
Production Co-ordinator: Florence Dassonville
Production Manager: Carola Krueger
Editorial Director: Peter Sawbridge
Publisher: Nick Tite

Project Editor: Kate Bell
assisted by Rosie Hore
Design: Kathrin Jacobsen
Picture Researcher: Sara Ayad
Colour Origination: Gomer Press
Printed in Wales

British Library Cataloguing-in-Publication Data
A catalogue record for this book is available from the British Library

ISBN 978-1-910350-70-6

Distributed outside the United States and Canada by ACC Art Books Ltd, Sandy Lane, Old Martlesham, Woodbridge, Suffolk IP12 4SD

Distributed in the United States and Canada by ARTBOOK | D.A.P., 155 Sixth Avenue, New York NY 10013

EDITORIAL NOTES
Dimensions of all works of art are given in centimetres, height before width before depth. The exhibited date is given only where it differs from the year a work was made.

ILLUSTRATIONS

Cover
El Anatsui Hon RA, *TSIATSIA – searching for connection*, 2013. Aluminium (bottletops, printing plates, roofing sheets) and copper wire, 15.6 x 25 m. Courtesy of the artist and October Gallery

Pages 2–3
Fig. 1 **Private view of the 1956 Summer Exhibition**

Pages 6–7
Fig. 2 **Visitors in the Wohl Central Hall, Summer Exhibition, 2015**

Pages 168–69
Fig. 110 **Installation view of the Large Weston Room, Summer Exhibition, 2016**

PRESIDENT'S FOREWORD 9
ACKNOWLEDGEMENTS 10

INTRODUCTION 12
MARK HALLETT AND SARAH VICTORIA TURNER

 WELCOME TO THE EXHIBITION 26
 JESSICA FEATHER

1 A GEORGIAN PARADE 28
MARK HALLETT

 AGOSTINO CARLINI AND THE ROYAL IMAGE 42
 MARK HALLETT

2 THE RISE OF GENRE PAINTING 44
MARK HALLETT

 TWO EARLY CATALOGUES 58
 MARK HALLETT

3 THE TRIUMPH OF LANDSCAPE 60
MARK HALLETT

 TURNER AND THE EXHIBITION WATERCOLOUR:
 RISE OF THE RIVER STOUR AT STOURHEAD 76
 JESSICA FEATHER

4 THE PRE-RAPHAELITES ARRIVE 78
SARAH VICTORIA TURNER

 PRE-RAPHAELITE SCULPTURE AND BEYOND 90
 SARAH VICTORIA TURNER

5 VICTORIAN ACCLAIM 92
SARAH VICTORIA TURNER

 WHISTLER'S ETCHINGS 110
 JESSICA FEATHER

6 DEALING WITH THE MODERN 112
SARAH VICTORIA TURNER

 THE EXHIBITION POSTER 126
 SARAH VICTORIA TURNER

7 POST-WAR VISIONS AND NEW GENERATIONS 128
SARAH VICTORIA TURNER

 THE SELECTION COMMITTEE 144
 MARK HALLETT

8 NEW SENSATIONS 146
MARK HALLETT

 THE EXHIBITION ON CAMERA 166
 SARAH VICTORIA TURNER

9 EXHIBITING ARCHITECTURE 170
JESSICA FEATHER

 THE ARCHITECTURAL MODEL 186
 JESSICA FEATHER

ENDNOTES 189
BIBLIOGRAPHY 194
LENDERS TO THE EXHIBITION 197
PHOTOGRAPHIC ACKNOWLEDGEMENTS 198
INDEX 199

PRESIDENT'S FOREWORD

Originally known simply as the Royal Academy's 'Annual Exhibition', the Summer Exhibition is the world's longest running annual display of contemporary art. Ever since 1769, and at a succession of locations – Pall Mall (1769–79), Somerset House (1780–1836), Trafalgar Square (1837–68) and eventually Piccadilly (since 1869) – the Academy's exhibition rooms have been crowded for some two months each year with hundreds of paintings, sculptures, drawings and prints produced by many of Britain's leading artists. Over the last 250 years, this great spectacle – dominated by its famously crowded and collage-like arrangement of pictures – has captured the interest of millions of visitors.

As well as expressing the Academy's own ambitions and achievements, these annual displays have played a central role within London's art world. In the eighteenth and nineteenth centuries, they provided the main forum within which Britain's artists could exhibit and compete with their rivals for popular and critical acclaim. Today, even as they continue to feature the works of many distinguished painters and sculptors, they are just as famous for providing hitherto unknown, sometimes amateur practitioners with the opportunity of seeing their creations hanging alongside the works of their more celebrated peers. These exhibitions thus offer a unique prism through which to view the history of the Royal Academy itself, and of modern British painting and sculpture more generally.

'The Great Spectacle' was made possible by support from Cate Olson and Nash Robbins, and Peter Williams. The exhibition was curated by Mark Hallett and Sarah Victoria Turner, respectively Director of Studies and Deputy Director for Research at the Paul Mellon Centre for Studies in British Art, assisted by Jessica Feather, Allen Fellow at the Paul Mellon Centre. They worked in collaboration with Per Rumberg, Curator at the Royal Academy, supported by Tim Marlow, Artistic Director at the Royal Academy. It would not have been possible without the help and dedication of Anna Testar, Elana Woodgate and Jessica Reid as well as the exhibition designer, Ian Gardner. Last, but not least, I thank the authors, the book's designer, Kathrin Jacobsen, and RA Publications for creating this handsome catalogue.

Christopher Le Brun PRA
President, Royal Academy of Arts

Fig. 3 **Jim Lambie, 'Zobop' staircase installation for the 2015 Summer Exhibition**

ACKNOWLEDGEMENTS

This book, and the exhibition which it accompanies, have been collaborative projects from the start. We would like to begin by thanking Charles Saumarez Smith, Tim Marlow and Christopher Le Brun of the Royal Academy for inviting us to curate 'The Great Spectacle' exhibition, and thereby welcoming us into the rich array of activities marking the Academy's 250th anniversary in 2018. We would also like to thank those other colleagues at the Royal Academy who have made this project so enjoyable and stimulating: in particular, our co-curators, Per Rumberg and Anna Testar, who have shaped this project in innumerable ways and whose support, advice and friendship has been hugely appreciated throughout the whole process. We also wish to thank Andrea Tarsia, Head of Exhibitions, for his calm supervision of the whole project, together with Elana Woodgate, Jessica Reid and Caroline Arno, all of whom have played important roles in keeping the project on the road. Thanks, too, to the exhibition's designer, Ian Gardner. The research and writing of this book would not have been possible without the expertise of the staff of the Academy's Archive and Library. We would particularly like to thank Mark Pomeroy and Adam Waterton for offering their unrivalled knowledge and advice during the preparation of both book and exhibition. The Academy's Collections team have also been unstintingly helpful, and we would like to thank Annette Wickham, Morgan Freely, Helen Valentine and Maurice Davies, among others, for all their help. This book would not exist without the excellent team at RA Publications, with whom we have very much enjoyed working, together with project editor, Kate Bell, designer, Kathrin Jacobsen, and picture researcher, Sara Ayad.

We have written this book with the support and assistance of our wonderful colleagues at the Paul Mellon Centre for Studies in British Art. We would like to thank Harriet Fisher for early research assistance; Maisoon Rehani for picture research; the Research Collections staff, in particular Emma Floyd and Natasha Held, for helping us chase up many references; and Bryony Botwright-Rance and Stephen O'Toole, for all their administrative support. Emily Lees has offered extremely useful advice, and Martin Postle has been a great source of information on the early Academy. Our colleagues Baillie Card, Maisoon Rehani and Tom Scutt have worked with us in developing *The Royal Academy Summer Exhibition: A Chronicle, 1769–2018* (www.chronicle250.com), which is being published in tandem with this book. Sean Ketteringham gathered together press reviews to help us carry out our research, as did Thomas Powell, whom we also thank for his ongoing research assistance on both this book and on the Chronicle project.

A number of colleagues offered advice and feedback on the texts; we would like to thank the following in particular: David Solkin, Elizabeth Prettejohn and Edith Devaney.

In preparing her contributions to the book, Jessica Feather would like to thank the staff of the Royal Academy library, archive and collections; as well as Neil Bingham, Helen Dorey, Tom Fotheringham and his team at Stanton Williams architects, Kate Goodwin, Anna Gruetzner Robins, Frances Sands, Nicholas Savage and M. J. Wells.

The collaborative ethos from which we have benefited at the Royal Academy and at the Paul Mellon Centre has extended deep into this book's own development and structure. Although we have divided up our writing tasks, we have continually shared our thoughts with each other, and offered constructive feedback on each other's successive drafts; we trust that the benefits of having worked together so closely are felt across this book's pages. Finally, we would like to thank our families for their unstinting support while we have worked on this project.

Fig. 4 **Leonard Rosoman** RA, **detail of poster for the 1971 Summer Exhibition**

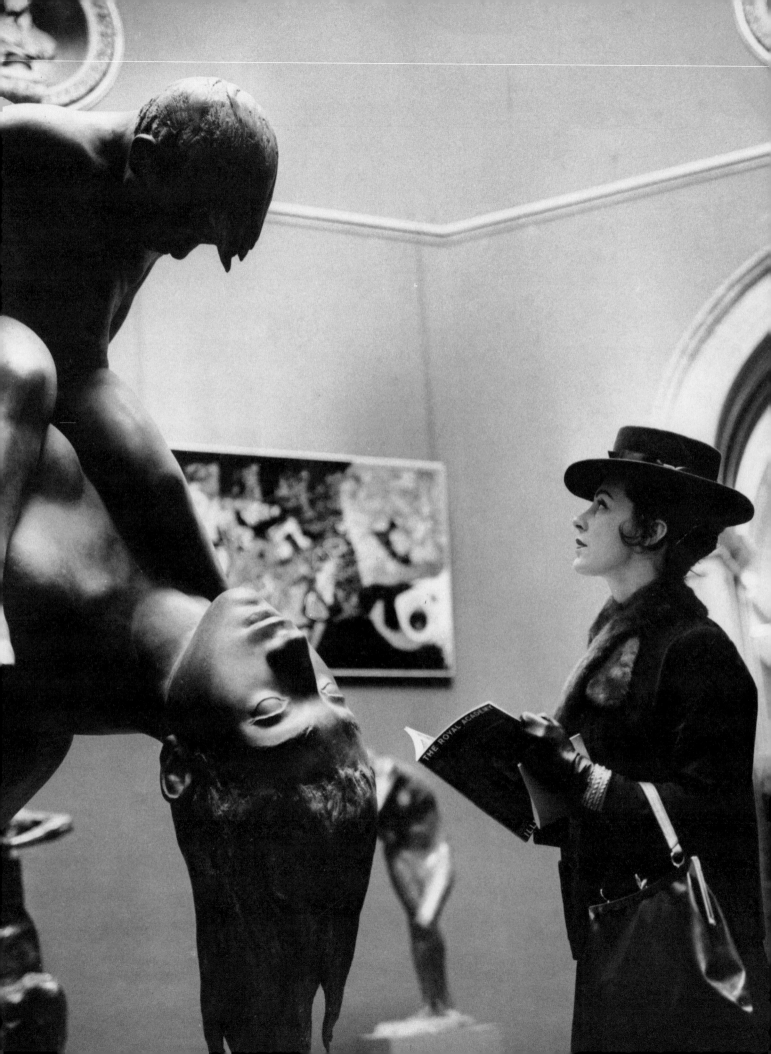

INTRODUCTION

MARK HALLETT AND
SARAH VICTORIA TURNER

On Thursday 27 April 1769, the *London Chronicle* reported that the previous day had seen the opening, 'for the first time', of 'the exhibition of the Royal Academy in Pall Mall, to a very crowded and brilliant route of persons of the first fashion'.[1] The *Chronicle*'s report conveys something of the sense of excitement and promise generated by the Academy's first ever Summer Exhibition, which ran for four and a half weeks in the fashionable London street of Pall Mall. Though very modest in scale when compared to later displays, showcasing only 136 works by 56 artists, it already boasted many of the country's leading painters, sculptors and architects among its participants, including the Academy's first President, Sir Joshua Reynolds, and such celebrated artists as Thomas Gainsborough, Benjamin West and Angelica Kauffman. Then, as now, the works of these already famous painters jostled with pictures produced by numerous less-well-known artists and by amateur practitioners, on walls crowded with canvases from floor to ceiling. As the *Chronicle*'s reviewer indicated, this first iteration of the exhibition's famously dense display was enjoyed by large crowds of visitors: by the end of its relatively short run, the exhibition had been seen by more than 14,000 people.[2]

This inaugural display was one of the first fruits of a significant artistic event that had taken place late in the previous year. The Royal Academy of Arts had been founded in December 1768, following discussions between George III and a group of leading artists who had recently seceded from what had previously been the main professional body for such practitioners, the Society of Artists.[3] These secessionists, who were led by the architect William Chambers, sought and won the King's support for the creation of a new, more formal organisation that would serve to promote a national school of British art. It was envisaged that this institution, like the venerable Royal Academy of Painting and Sculpture in France, would be both a teaching body and an organisation hosting regular exhibitions showcasing the work of leading contemporary artists.[4] The importance of exhibitions to this project was made clear in the new Academy's Instrument of Foundation, issued in December 1768. This outlined the rules by which the institution – made up of 40 artist-Academicians – was to operate, and declared that there was to be 'an Annual Exhibition of Paintings, Sculptures and Designs, which shall be open to all Artists of distinguished merit'.[5]

This was the moment that the Academy's Annual Exhibition was born. Ever since the display in Pall Mall that took place just a few months later, and over an astonishingly unbroken run of nearly 250 years, the Royal Academy has hosted an annual display of contemporary art that has remained strikingly loyal to the words of the Instrument of Foundation's declaration. During its extended and sometimes turbulent history, the exhibition – which became widely known as the 'Summer Exhibition' in the nineteenth century – has grown dramatically in scale and been transformed in a multitude of ways.[6] Yet throughout the entirety of its existence, the exhibition has retained many of the features that were in evidence in 1769. Thus, in each of the different venues it has occupied ever since it opened in Pall Mall, it has presented a rich mixture

Fig. 5 **A visitor to the 1963 Summer Exhibition examines Maurice Lambert RA's original model for the casting of** *Basildon Fountain (Mother and Child)*

of contemporary art, by many of the leading British-based artists of the day, to a large audience. The annual display has also been a place of fashionable parade and self-promotion, which people have visited not only to look at and talk about works of art, but also to look at and talk about each other. It has long been an event that has attracted the attention – from the fawning to the savage – of the press, and has always been a crucial means through which the Royal Academy has defined and supported itself. It continues to be an important source of income and helps to provide free education at the Academy's Schools. Above all, the display has constituted a great urban spectacle, in which art, entertainment, commerce, education and self-promotion have mingled together in a riot of colour and conversation. This book tells the story of this remarkable cultural phenomenon over its long life, and in doing so places the Summer Exhibition at the heart of the history of modern British art.

PLACES

The Summer Exhibition has, like the Royal Academy itself, moved across central London during its lifetime: in fact, it has taken place at four different locations, each of which tells a different story about the display, and each of which has shaped its character and history. The 'Great Room' at Pall Mall (fig. 6) was the first and shortest-lived of the four. Having previously served as a print warehouse and an auctioneer's premises, it was rented and speedily adapted to the Academy's purposes in the early months of 1769 and was to remain the place in which the institution hosted its exhibitions for the next ten years.[7]

In its character as a rented and somewhat improvised space, located in a busy but fashionable area of London, the Pall Mall 'Great Room' bore many similarities to the kinds of environment in which, over the previous decade, Britain's first public exhibitions of contemporary art had taken place.[8] Such displays were still, in 1769, a very novel kind of cultural event in Britain. The nation's first ever

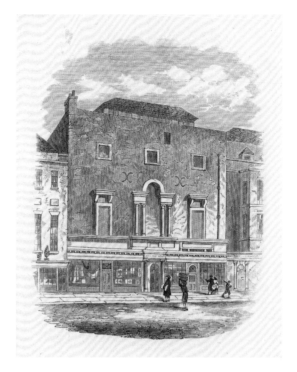

exhibition of contemporary art, organised by a loose collective of painters and sculptors, had taken place less than a decade beforehand, in the spring of 1760, and in another borrowed 'Great Room', this time off the Strand. Thereafter, the Society of Artists, which was formed in the aftermath of the 1760 display, held its own exhibitions on an annual basis at an auctioneer's 'Great Room' in Charing Cross, a pattern that it was to maintain throughout the 1760s. The works of many of the new Royal Academy's members had featured in these earlier exhibitions, which had already introduced the metropolitan public to a rich mixture of modern art: the 1768 exhibition of the Society of Artists, for instance, featured 320 works, among them such pictures as Benjamin West's ambitious history painting *Agrippina Lands at Brundisium, with the Ashes of Germanicus*, and two full-length portraits of officers by Thomas Gainsborough.[9]

The Royal Academy displays at Pall Mall, which built on the example of these earlier exhibitions, and which continued to compete with the rival shows organised by the Society of Artists during the 1770s, enjoyed considerable success. By 1779, the number of works exhibited in its rented Great Room had risen to more than 400, and its attendance

Fig. 6 **Attributed to Edmund Evans,** *View of the Old Royal Academy in Pall Mall*, 1862. Wood engraving, 14.3 x 11.3 cm. Royal Academy of Arts, London

figures had almost doubled when compared to those of 1769. However, it was only in 1780, with the Academy's move to permanent, purpose-built premises at Somerset House on the Strand, that the exhibition found a home which began to live up to the ambitions expressed on the occasion of its inaugural display, and that competed in scale and grandeur with the spectacular biennial 'Salon' exhibitions organised by the French Academy of Painting and Sculpture, which took place in the *Salon carré* of the Louvre.[10] The Academy's new premises, which are today occupied by the Courtauld Gallery, had been designed by its Treasurer, the architect William Chambers, and incorporated an elegant suite of teaching and meeting rooms that could be adapted to house hundreds of works of art during the annual exhibition. More significantly, it featured, on its top floor, a spectacular 'Great Room'. Three times larger than its Pall Mall predecessor, this space truly lived up to its name. Between 1780 and 1836, the annual exhibition was to centre upon this capacious, evenly lit room, even as the display's ever-growing scale saw it spreading inexorably outwards across the Academy's new building. Pietro Antonio Martini's engraving after Johann Heinrich Ramberg's drawing of the 1787 exhibition (fig. 7), though subtly amplifying the Great Room's scale and visual drama, brilliantly conveys the character and structure of the shows that took place there, and powerfully confirms the extent to which the exhibition at Somerset House was becoming a visual jamboree of the most varied kind. Thus, this exhibition of 1787, which was visited by nearly 50,000 people, consisted of more than 650 works, produced by more than 300 artists.

This pictorial variety is made just as apparent in an early nineteenth-century print of the Great Room produced after drawings by Thomas Rowlandson and Augustus Pugin (fig. 8), where the walls are once again crowded with a diverse parade of pictures. Just as significantly, however, both this print and its predecessor suggest the forms of pictorial balance and harmony that also

characterised the display as a whole and helped calm its visual impact. This was in part thanks to the effects of the moulding, or 'line', which partially structured the arrangement of pictures in the Great Room at Somerset House, and which ran around the room at a height of eight feet. Larger, more highly ranked works were typically placed above this 'line', and placed on a wooden frame that allowed them to be tilted forward for better visibility, while smaller exhibits, many of which were painted in ways that invited close-up forms of viewing, were hung beneath this line. Furthermore, the exhibited works were arranged with symmetry in mind: in Rowlandson's and Pugin's image, paintings elegantly echo and interact with each other across the walls, in ways that chime with the patterns of looking and talking that can be seen rippling across the pictured crowd of exhibition-goers itself.[11]

Though this print grants the Great Room an elegant spaciousness, it soon became clear that the premises at Somerset House would not in future be large enough to sustain all the Academy's different activities, including its ever-expanding exhibition. By 1830, for example, more than 1,250 works were included, attracting more than 70,000 visitors. Two years later, the architect and Academician William Wilkins was asked by the government to design a building on the north side of Trafalgar Square that would provide more space for the Academy and its exhibitions, and that it would share with the recently formed National Gallery. This was duly built, and the Academy moved into its half of the building – on the eastern side – in 1837. That year's summer display was the first to be held in the new premises, which featured a series of five spacious exhibition rooms on the building's principal floor, all of which were bathed in natural light thanks to their glass roofs. At this first exhibition, as was to be the case for all those that took place during the Academy's three decades of residence at Trafalgar Square, these rooms were devoted to paintings and drawings, while sculpture – to the consternation of many of

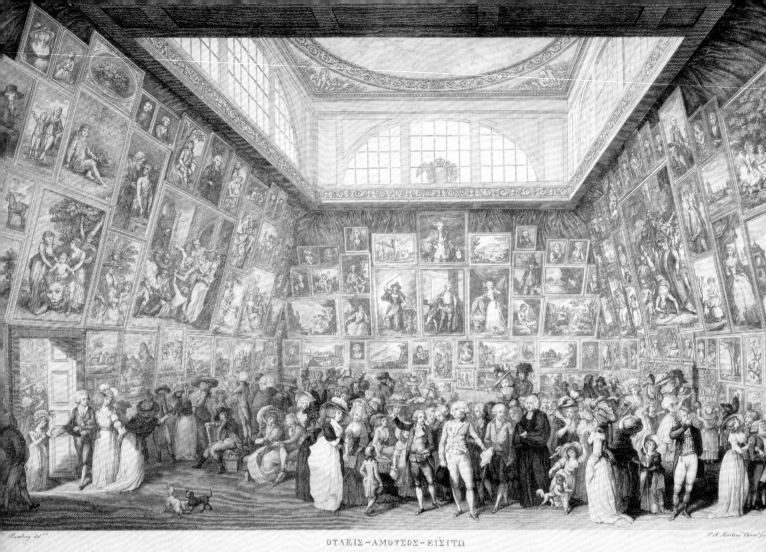

OΥΛΕΙΣ – ΑΜΟΥΣΟΣ – ΕΙΣΙΤΩ

THE EXHIBITION OF THE ROYAL ACADEMY, 1787.

its practitioners – was instead tucked away in a cramped and gloomy room on the ground floor.[12]

The Yale Center for British Art in New Haven owns a rare pen, ink and watercolour drawing of the display at Trafalgar Square (cat. 1). It is accompanied by a contemporary, handwritten text that suggests the drawing depicts the Academy's East Room during the 1858 Annual Exhibition. This text cautions the reader to get to the display before breakfast if he or she should want to miss the crowds; tellingly, the image itself shows the room packed not only with pictures, but also with people: we are confronted with a bobbing array of black top-hats and a bright patchwork of silk and crinoline, as men and women flow into the room through the distant doorway (surmounted by the words 'East Room'), and pool out to the gallery's edges. Significantly,

1858 saw a then-record number of 139,906 visitors to the display, many of whom, no doubt, felt impelled to come and see that year's huge pictorial hit – William Powell Frith's *The Derby Day* (see fig. 62) which hung, indeed, in the East Room depicted in this view. Perhaps, then, it was *Derby Day*'s presence that explains the scrum of people shown here, and the drawing's inscription; for, as Frith himself wrote in his diary on the day the exhibition opened: 'never was such a crowd seen around a picture. The secretary obliged to get a policeman to keep people off. He is to be there from eight in the morning.'[13] You really did need to get there before breakfast.

In 1868 the Royal Academy celebrated its centenary. The decades leading up to this milestone had been ones of change and expansion for the institution. For one thing, it was under increasing

Fig. 7 Pietro Antonio Martini (after Johann Heinrich Ramberg), *The Exhibition of the Royal Academy, 1787*, 1787. Engraving, 32 x 49.1 cm. Royal Academy of Arts, London, 06/5356

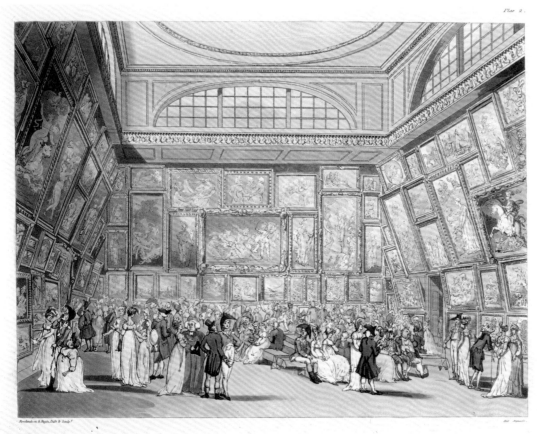

EXHIBITION ROOM, SOMERSET HOUSE.

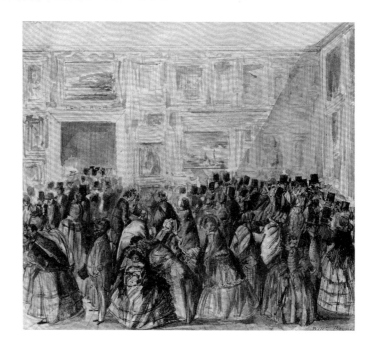

Fig. 8 John Hill (after Thomas Rowlandson and Augustus Pugin), *Exhibition Room, Somerset House*, 1808. Aquatint and etching on paper, 19.4 x 25.9 cm. Royal Academy of Arts, London, 03/6170

Cat. 1 William Payne, *Private View of the Royal Academy*, 1858. Watercolour with pen and black ink over graphite on paper, 9.5 x 10.5 cm. Yale Center for British Art, Paul Mellon Collection, B1986.29.155

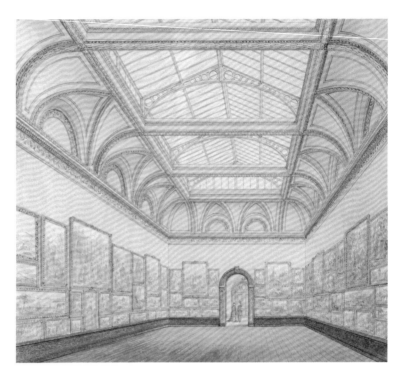

scrutiny from the state. In 1855 the House of Commons requested details of attendance at the exhibition and profits from the catalogues.[14] Further attention came in 1863, when a Royal Commission was appointed to inquire into the 'present position of the Royal Academy in relation to the Fine Arts'.[15] The Commission also investigated the Royal Academy's occupation of a part of the National Gallery in Trafalgar Square. Although predominantly favourable towards the Academy and praising of its 'great service to the country', the Report recommended several improvements, including the election of more architects and sculptors, and of Honorary Foreign Members. However, as is noted by the Academy's first historian, Sidney Hutchison, 'certain recommendations were adopted in 1866 but no great change was made'. Crucially, 'the Academy retained its independence'.[16] In 1868 the category of Honorary Foreign Member was indeed instituted and six 'distinguished Foreign Artists not resident in the United Kingdom' were elected in 1869, including the leading French painter Jean-Léon Gérôme.

The annual reports, which were instigated in 1860, clearly demonstrate that the Academy was profit-making, and confirm that, as had long been the case, it derived its income largely from its annual exhibitions. These ever-expanding events required adequate space to accommodate both the exhibited works of art and the audiences who came to see them; the Academy also needed space for its Schools and administrative offices. There were numerous discussions about an expansion and relocation out of Trafalgar Square, and after delicate negotiations under the presidencies of Charles Eastlake (who died in 1865) and Francis Grant, the government agreed in 1866 to grant the Academy a 999-year lease on Burlington House, just set back from Piccadilly – the location it still occupies today. The building was offered for a nominal rent of £1 per annum, on the proviso that the Academy would construct at its own cost the buildings needed

for the Schools and for the growing exhibitions on the northern site of Burlington Gardens, in accordance with a set of plans developed by the architect and RA, Sydney Smirke.[17] This building project was expensive, amounting to over £100,000, a considerable proportion of which was raised from a bequest of £40,000 from the sculptor John Gibson. Constructed at remarkable speed, the new Academy buildings were ready in just over a year; a first meeting was held in them on 24 November 1868. They included the grand suite of galleries that were specifically designed to host the burgeoning Summer Exhibition and are still in use for that purpose today. These rooms set a standard for large temporary exhibition galleries that was to be emulated around the world. In a beautiful presentation drawing (cat. 2), produced as part of his plans, Smirke populates the largest of these galleries – known as Gallery III – with an imaginary, ghost-like array of pictures. They seem to hover expectantly around the empty exhibition space, awaiting, perhaps, the entry of the two figures pictured standing and talking in the distant doorway.

In 1883 William Powell Frith exhibited a painting (cat. 3) that showed this same room, Gallery III, newly packed with people. His work

Cat. 2 Sydney Smirke RA, *Design for Gallery III, Burlington House, Piccadilly, c. 1866-67.* Watercolour and gouache with pen and black ink over graphite on paper, 29 x 32.5 cm. Royal Academy of Arts, London, 05/2123

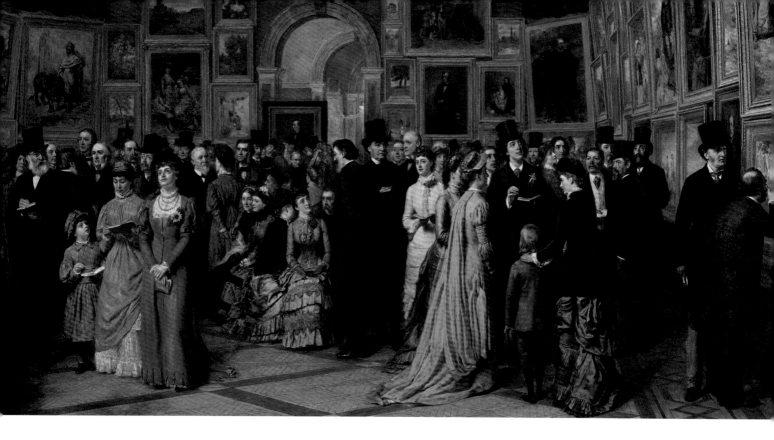

offers a celebrity-filled image of the private view that took place before the public opening of the 1881 Summer Exhibition – a gathering that features Oscar Wilde, William Gladstone, Anthony Trollope, Ellen Terry and the Academy's President Frederic Leighton, among others. As will immediately be apparent, Frith's work maintains many of the pictorial features found in far earlier views of the display; at the same time, it suggests the sweep and confidence of the exhibition during the Victorian period. This is signified most powerfully, perhaps, by the imagery of the receding archways at the picture's centre, which suggests that this is a show that stretches endlessly on, picture after picture, gallery after gallery, year after year. And, indeed, this was to prove an accurate foretaste of the exhibition's future at Burlington House. This site has provided an enduring and highly successful home for the Summer Exhibition – one, indeed, that has witnessed millions of people flooding through those same archways in the many decades since Frith exhibited his picture. These visitors can be seen in 1956 (fig. 1), the first year in which photographers were allowed in to record the private view; and they can be seen in a photograph of the 2015 exhibition (see fig. 99), walking through a repainted

Gallery III that, even though it had been temporarily transformed by a glowing coat of magenta paint, still carried the traces of Smirke's original vision in its ceiling. Burlington House has ended up providing a space for the Academy's display that, even as it continually changes, always remains at least partly the same. Something similar, of course, can be said for the Summer Exhibition itself.

PEOPLE

The history of the exhibition is as much about its people – artists, critics, patrons and visitors – as its places. Most importantly of all, of course, the Academy's annual display has been organised by and for artists, and throughout this book, we will focus in particular on the ways in which painters, sculptors, architects, printmakers and the producers of exhibited drawings have contributed to the Summer Exhibition and shaped its development. We will look at the dynamics of artistic rivalry, emulation and self-advertisement as they played themselves out in this arena; we will explore the politics and personnel of the famous Selection and Hanging Committees, which, composed of select groups of Academicians, respectively choose the works that are to go into each year's show, and decide upon

Cat. 3 **William Powell Frith** RA, *A Private View at the Royal Academy, 1881*, 1883. Oil on canvas, 102.9 x 195.6 cm.
A Pope Family Trust, courtesy Martin Beisly

their arrangement across the galleries and walls; and we will trace such topics as the emergence of women artists at the Academy's exhibition, and the role of international artists in helping to energise recent displays. Indeed, we will look afresh at the careers and practice of artists of all kinds – insiders and outsiders, rebels and rejects, the famous and the obscure – as we tell our story. Artists are at the centre not only of the Academy's own history, but also of our own account of its Summer Exhibition.

However, it is also crucial to recognise the importance of the exhibition's other participants to its remarkable history. One such figure is the critic. Interestingly, in Britain at least, the position of the art critic was one that was largely created by the phenomenon of the early exhibitions themselves. Newspaper proprietors and editors in the later decades of the eighteenth century, having published the occasional short notice on the first displays, and seeing the interest they generated among their readers, began to publish more regular reviews.[18] Following the Academy's move from Pall Mall to Somerset House, this kind of journalistic commentary grew ever more expansive and varied; and from the early nineteenth century onwards, when great critics like William Hazlitt and Robert Hunt were in their heyday, newspapers and journals frequently offered extraordinarily extensive and attentive reviews of the exhibitions and of the more prominent works on display.

The pictures on show also came to the attention of pamphlet commentaries authored by individual critics. Especially celebrated examples of such publications were the annual *Academy Notes* written by John Ruskin in the 1850s, which offered pithy, sophisticated and sometimes scathing discussions of the works on show at Trafalgar Square.[19] By this point, the judgement of leading critics like Ruskin carried substantial weight in the art world, and often earned such writers enormous opprobrium on the part of the practitioners they attacked. In some ways, this has remained the

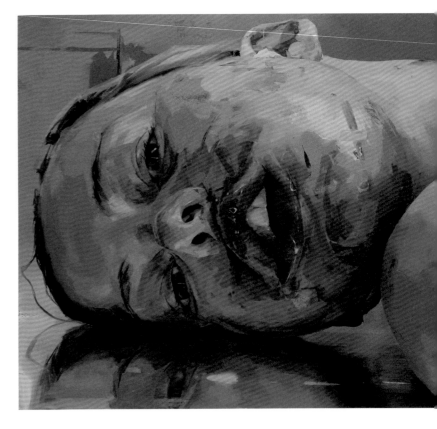

case ever since, though the art criticism attracted by the Summer Exhibition has – as has always been true – varied enormously in quality, and has sometimes, in recent decades, descended into little more than lazy journalistic puffery or hatchet-work. On occasion, however, the Summer Exhibition has continued to attract writing that, even though it is not always complimentary, is marked by a sharply honed critical sensibility. Thus, in 2004, Richard Dorment, writing in the *Daily Telegraph*, offered a sensitive and extended response to that year's distinctive hang, organised by David Hockney and Allen Jones, and selected for special praise works such as Jenny Saville's 'astonishing, mesmerising' *Reverse* (fig. 9) and John Hoyland's *Golden Traveller* (fig. 10).[20] Though the days of the multi-paragraphed analysis of a single exhibited painting may be over, a good critic will still be able to sift through the thousands of works on show, and spot those that reveal genuine artistic distinction.

Another important figure at the Royal Academy's display is that of the buyer – or, rather, the potential buyer. The Summer Exhibition,

Fig. 9 **Jenny Saville RA**, *Reverse*, 2002-03.
Oil on canvas, 213.4 x 243.8 cm. Private collection

even though it has often promoted itself as an enlightened and emulative forum of fine art, has also always been a commercial enterprise and a marketplace. Visitors have paid an entrance charge since the first Pall Mall exhibition, and the works on display are either for sale, or else, having already been bought, serve instead as forms of artistic advertisement designed to prompt future sales. Consequently, major collectors – or, in more recent eras, the representatives of major collections – have often been an important presence in the ranks of the exhibition's visitors.[21] Meanwhile, and more importantly, the exhibition has always attracted far more modest kinds of buyer: that is, the great swathe of affluent but not exceptionally wealthy art lovers who have flocked to the show from its beginnings and who, as the display has expanded to encompass increasingly affordable works of art – prints, in particular – have often bought them from its walls. As is noted later in this history, the Summer Exhibition is the birthplace of the famous red dot signifying a sale. Today, these little visual punctuation marks continue to wind their way around the exhibitions, making up a thin red thread that is continually extended not only by the occasional spectacular acquisition, but also by the hundreds of smaller-scale purchases that take place on a daily basis, and which now play an essential role in keeping both the Academy and its exhibiting artists in business. In 1977, in response to desperate financial circumstances, the sale of pictures at the Summer Exhibition was first used to generate extra income for the Academy. A commission of 15% on sales was levied by the Academy, bringing

Fig. 10 John Hoyland RA, *Golden Traveller*, 2004. Acrylic on canvas, 254 x 236.2 cm. John Hoyland Studios LLP

in revenue of £29,481.06.[22] Two years later this was raised to 20%. It remains a vitally important funding stream for an institution that, though often seen as a public body, is entirely self-financing.

Famously, however, people do not come to the Summer Exhibition only to buy, or to think about buying, works of art. The event, right from its beginnings, has been an opportunity for self-display and self-fashioning, and for the careful calibration of class identity.[23] It is an arena in which people – and their behaviour, dress and conversation – have been as much on view as the portraits that surround them. Indeed, for much of its existence, and in particular through the late Victorian and Edwardian periods, the Summer Exhibition was one of the last events of the London season, that programme of lavish entertainments in which Britain's upper classes gathered together in the capital and flaunted their privilege and sophistication, not only to each other but also to those who observed them. The preview party continues to be billed as 'the highlight of London's social calendar' and invites celebrities and art collectors to be 'the first to view and buy works at the world famous Summer Exhibition'.[24] At the same time, however, the exhibition has always been a place in which a far larger, 'middling' and then middle-class audience has asserted its cultural literacy and social standing; so much so that in the second half of the twentieth century the exhibition was often seen as little more than a reactionary bastion of middle-class, middle-aged and middle-brow taste. More recently, in turn, there has been a further shift in its character, as the Academy and its exhibitions have made a concerted attempt to cultivate a younger, more diverse and more cosmopolitan audience, and to compete with the burgeoning international art fairs that rival or surpass the Summer Exhibition in size and scope.

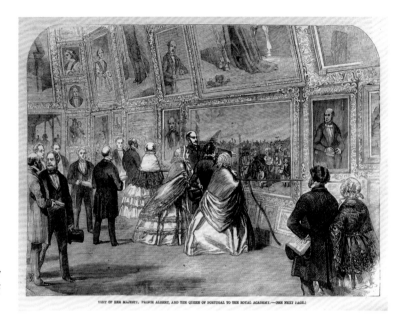

VISIT OF HER MAJESTY, PRINCE ALBERT, AND THE QUEEN OF PORTUGAL TO THE ROYAL ACADEMY.—(SEE NEXT PAGE.)

The story of the Summer Exhibition's audience, and the role it has played in the character of the show itself, is thus a complicated and continually shifting one; however, in every period, it has offered a spectacle that has been as intriguing and often as entertaining as the display on the Academy's walls. This is confirmed, as we have already begun to see, by the many images of the exhibition that have been produced over its history, which have typically concentrated as much on its visitors as its contents. Some, like those that populated the Illustrated London News throughout its long nineteenth- and twentieth-century history, offer an image of the exhibition audience as a thoroughly genteel body, respectfully and thoughtfully appreciating the art on view, and sometimes even including members of the royal family (fig. 11). Others, like John Ward's design for the 1972 Summer Exhibition poster (fig. 12), suggest a gathering that, though still very decorous, has a dash of youthful bohemianism and fashionable style.

Many other works, however, have poked fun at the exhibition's visitors, implying that the forms of gentility they often adopt are little more than paper-thin. In the Georgian period, Thomas Rowlandson, when operating in an unequivocally

Fig. 11 *Queen Victoria at the Royal Academy, London, 1858*, from the *Illustrated London News*, 22 May 1858, p. 501. Engraving

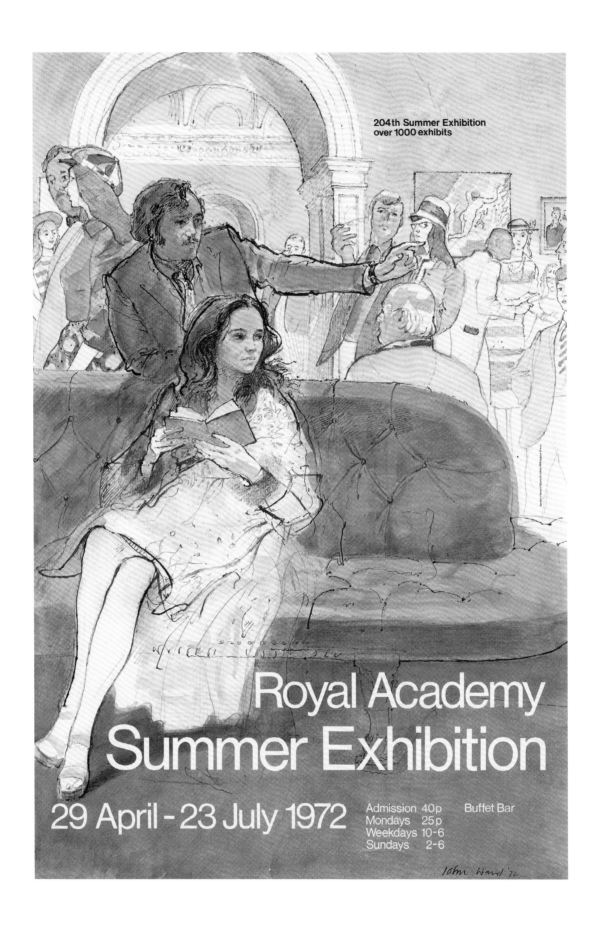

Fig. 12 **John Ward RA, poster for the 1972 Summer Exhibition**

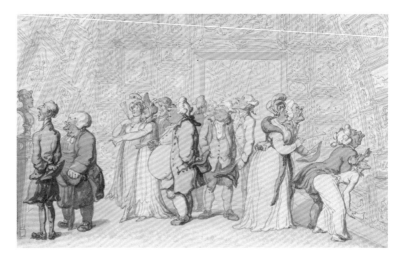

satirical mode, launched some especially adroit and inventive forms of visual attack at those who attended the summer display. In *The Exhibition Stare-Case* (cat. 4), which took as its setting the famously steep staircase that led to the Great Room at Somerset House, he brilliantly suggests that the decorous forms of behaviour and connoisseurship associated with the display stood only a slip away from scenes of chaos and the surge of predatory, masculine lasciviousness.[25] In a later image (cat. 5), he wryly lampoons a clutch of visitors as they inspect the works on display, transforming them into a comic miscellany that includes a grotesquely corpulent gentleman, a red-faced cleric, stooping connoisseurs, an overdressed matron and two beautiful young women, the latter of whom smile, pink-cheeked, as they look at a wall of paintings adorned with a female nude. In 1958 Ronald Searle (fig. 13) cheekily updated the same kind of critique as he highlighted the snobbery, envy and ennui of some of the exhibition's visitors, and inserted the duplicated figure of a painted nude into the crowd itself.[26] Even in the modern period, it is clear, the pictorial tradition to which Rowlandson made his early and brilliant contributions has remained alive and well.

THE GREAT SPECTACLE

Though its setting and visitors have always contributed to the visual spectacle on offer at the Summer Exhibition, at the heart of this spectacle – from 1769 to today – has been the pictorial display itself, and the dense, collage-like arrangement of artworks that gives it such vivacity and depth. Nowadays, we are used to encountering very different, far sparser kinds of hang when we walk into an exhibition: ones which are supposed to give pictures and sculptures room to breathe and to allow them to be appreciated in isolation from one another. The Summer Exhibition has operated to an almost entirely contrary logic, in which works of art, even as they ask to be appreciated in their own right, are placed in intimate physical proximity and visual dialogue. Like the crowds of people who have, year after year, gathered in front of these works, the objects on show at the Summer Exhibition interact, breathe each other's air, infringe on each other's space, and make up a kind of ephemeral, interlinked community.

It is this distinctive form of display, together with all the storylines that have swirled around it, that have helped give the Summer Exhibition its

Cat. 4 Thomas Rowlandson, *The Exhibition 'Stare-Case',* *Somerset House, c.* 1800. Watercolour with pen and black ink on paper, 44.5 x 29.7 cm. Yale Center for British Art, Paul Mellon Collection, B1981.25.2893

Cat. 5 Thomas Rowlandson, *Viewing at the Royal Academy,* *c.* 1815. Watercolour with pen and grey and brown ink over graphite on paper, 14.6 x 24.1 cm. Yale Center for British Art, Paul Mellon Collection, B2001.2.1161

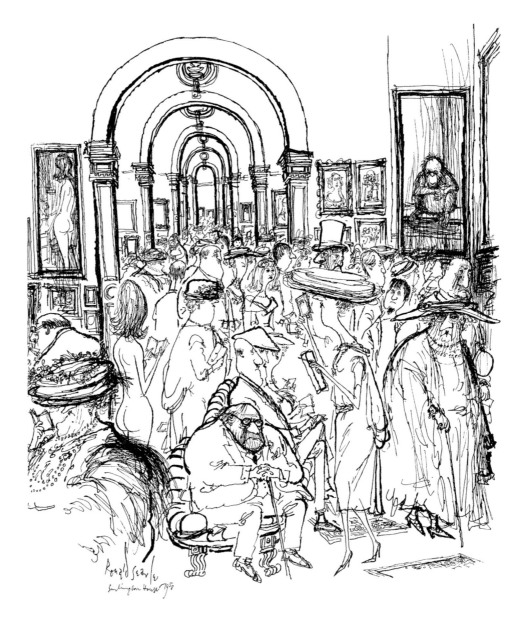

unique character, and that encourage us to delve deeper into its rich, unfolding, ongoing history. In this book, and in the exhibition it accompanies, we do this in part by continuing to look closely at the fascinating contextual materials that have often been generated by the annual display itself: engraved views, pieces of newspaper criticism, catalogues and supplements, photographs, council minutes, tickets and satires. At the same time, we concentrate in some detail on examples of the remarkable works of art that have been shown in the displays at Pall Mall, Somerset House, Trafalgar Square and Burlington House, and on the individuals who have produced them, who range from Joseph Wright of Derby to Zaha Hadid, from Mary Moser to Michael

Craig-Martin and from the first President, Sir Joshua Reynolds, to the current President, Christopher Le Brun. Doing so allows us to recover the ways in which the works of leading artists – largely British, but not exclusively so – have contributed to, and been shaped by, the Academy's annual display. Finally, we give a sense of variety to our narrative by interspersing chapters that cover the different periods of the exhibition's history with shorter textual and pictorial sections that deal with more specific items of interest. Mixing our approaches in this kind of way will, we hope, generate a lively account that is not only engaging, but also fully in keeping with the famously heterogeneous character of the Summer Exhibition itself.

Fig. 13 *Private View: Ronald Searle at the Academy*, illustration in *Punch*, 7 May 1958, p. 613. Engraving after an ink sketch, 24 x 19.5 cm. PUNCH Magazine Cartoon Archive

WELCOME TO THE EXHIBITION

JESSICA FEATHER

At the 1792 exhibition at Somerset House, John Russell's beaming portrait of one of the Academy's porters (cat. 6) greeted visitors as they walked their way up from the vestibule and entered one of the rooms on the first floor, the Antique Academy, where it hung at a slant, adjacent to the door frame.[1] Russell's portrait probably depicts John Withers, who was then the senior porter.[2] Ever since the Academy's foundation, porters had played a vital role in the annual exhibition. Their jobs included the taking in of works from artists and their organisation in the weeks prior to the opening and much behind-the-scenes running of messages. But, as Russell's portrait suggests, the porter had a more public-facing role, too: he was often the first person whom visitors would have encountered as they arrived to see the exhibition.

In Russell's picture, Withers is situated in the vestibule at Somerset House, with its grand staircase just visible in the background. Rather differently to Thomas Rowlandson's image of the same scene (cat. 4), it is Withers and not the crowds on the 'stare-case' who is the dominant feature in the picture. As he holds up a blue exhibition ticket and a catalogue (it was the porter's responsibility to sell both), his kindly face both announces the exhibition and acts as its gate-keeper.

As Britain's most prominent pastellist and a regular exhibitor at the Academy, John Russell was someone with whose works late eighteenth-century exhibition-goers would have been very familiar. Such works were generally commissions from wealthy, middle-class sitters. This portrait of Withers is thus unusual among Russell's œuvre, although it is not totally without precedent at the Academy in being a depiction of the porter, one of the salaried members of staff. Significantly, however, Withers is depicted not as a worker, but in the dress of a polite eighteenth-century gentleman: without the work's title, he could almost be mistaken for one of the visiting public. Russell's motivations in choosing such a subject might reflect the friendly relationship he had developed with Withers, who, like most of the porters, probably served as a life model in the Schools: Russell's inclusion of the cast of the famous Belvedere Torso from the Life Academy might be a reference to this. The Academy's porters often developed convivial relationships with the Royal Academicians, and the quirky addition of what appears to be a wine glass sitting on top of the Torso might be another kind of pictorial in-joke. The artist's fondness for the sitter is intimated by the fact that the work was still in Russell's possession on his death.

The fact that the portrait was displayed in the Antique Academy, alongside a mix of works in a variety of media, including watercolours and oils, placed it in a part of the exhibition that enjoyed far less prestige than the Great Room at the top of the Somerset House staircase. Although this might reflect the relative modesty of the portrait's subject, and the sense that pastel was not such a grand medium as oil, the picture's location within the display was in many ways a highly appropriate one: hanging in the doorway of one of the first galleries that visitors would enter, Withers offered them a warm welcome in painted form, just as he would have done often in reality.

Cat. 6 John Russell RA, *A Porter of the Royal Academy*, 1792. Pastel on paper, 77 x 64 cm. The Samuel Courtauld Trust, Courtauld Art Gallery, London, D.2001.XX.3

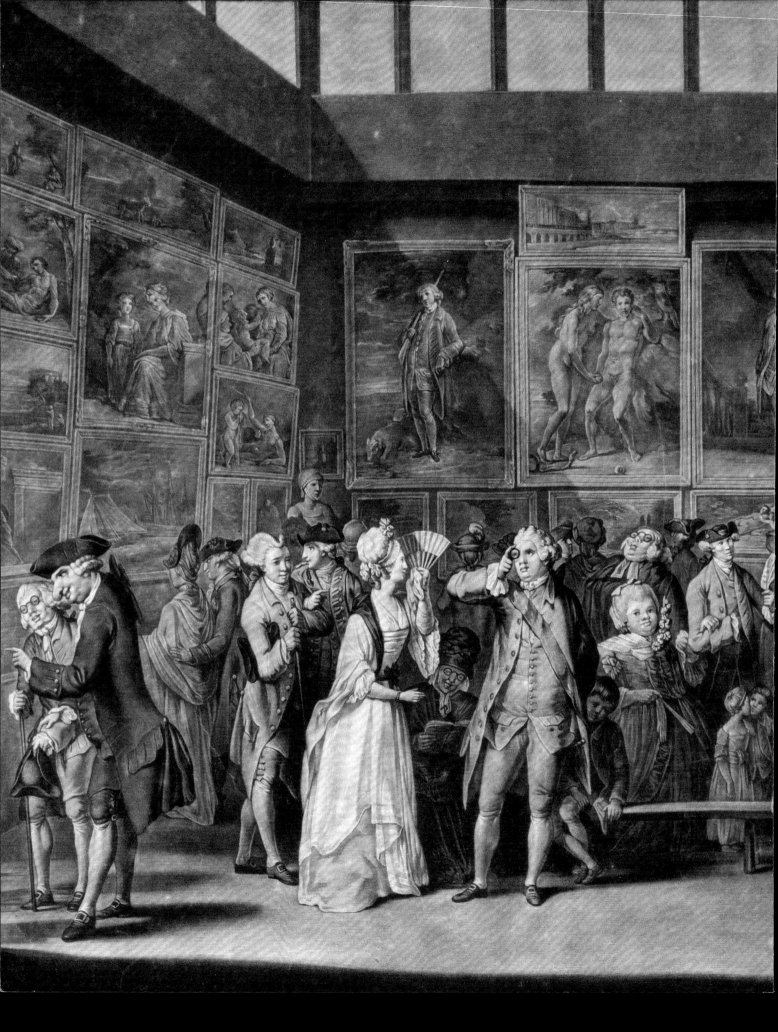

A GEORGIAN PARADE

MARK HALLETT

Our earliest image of the Summer Exhibition is a mezzotint produced by the artists Richard Earlom and Charles Brandoin (cat. 7).[1] The print depicts the third of the Academy's displays, that of 1771, and gives us the chance to take a closer look at the ways in which the exhibition was being pictured in the first phase of its history. Here, the rented Great Room in Pall Mall is revealed as full of people and paintings. On the ground, the kinds of connoisseurs later lampooned by Rowlandson are shown peering at pictures from close-up. Other visitors look from further back, with catalogues in hand; some take in the view from behind monocles, spectacles and fans. Bodies overlap, intermingle and contrast: a plump, voluminously robed clergyman is juxtaposed with a stout, overdressed matron; couples stroll with encircled arms; and on the bench at the centre of the room, an old woman, quietly reading in the midst of the hubbub, sits next to a boy whose head and shoulders slump with boredom. Around this gently satirised miscellany of exhibition visitors, the walls are packed with a parade of canvases. On the far wall, a painting of the Temptation of Adam by the artist James Barry is hemmed in by two full-length portraits and, from above, by an architectural landscape.[2] To the left and right, painted figures twist and turn within the grids of framed canvases that, hanging cheek by jowl, cover every available inch of the available wall space. The imagery of trees, buildings and vistas is scattered across this dense array of pictures; just under the ceiling, to the right, a tier of portraits looks down at the spectators below.

Though humorous in tone, Earlom's and Brandoin's print vividly conveys the sheer hustle and

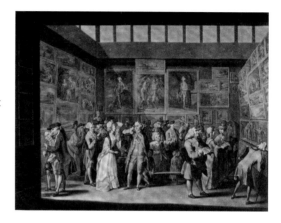

bustle of even the earliest Summer Exhibitions, and the mixture of people that they attracted. It also confirms that a collage-like hang was a distinctive feature of the display from its very beginnings, and suggests the sheer profusion of pictures – 250 in 1771 – that were already being submitted to the Academy's annual show. Right from the start, then, the Georgian Summer Exhibition was an animated, crowded occasion, busy with visitors and images. It was also, as can now be explored, a highly contested event, in which the many different types of artists and works on show were continually jostling for attention and respect.

HISTORY PAINTING: ANGELICA KAUFFMAN AND BENJAMIN WEST

For the Royal Academy itself, one of the main aims of the exhibition was to showcase the fact that its members were fully capable of producing the most elevated forms of art: in particular, history paintings

Left: Detail of cat. 7
Above: Cat. 7 **Richard Earlom (after Michel Vincent 'Charles' Brandoin),**
The Exhibition at the Royal Academy in Pall Mall in 1771, 1772.
Mezzotint, 47.2 x 56.6 cm. Royal Academy of Arts, London, 03/4350

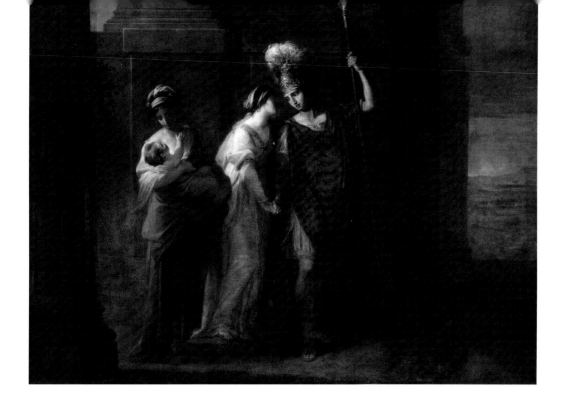

that depicted tragic, heroic and affecting narratives taken from the Bible, mythology or the historical record. One of the few artists who consistently succeeded in fulfilling this aim was Angelica Kauffman, a Swiss-born painter who had settled in England in the mid-1760s, and who became a founder-member of the Academy.[3] An example of Kauffman's work – *The Return of Telemachus* (Chrysler Museum, Norfolk, Virginia), which pictures a scene from Homer's classical epic *The Odyssey* – can be spotted hanging on the lower right of Earlom's and Brandoin's print, just above the beribboned tail-wig of a crouching connoisseur. This painting succeeded a series of related subjects exhibited by the artist at the previous two Academy displays. Indeed, Kauffman had sent a pair of Homeric history paintings to the inaugural exhibition in 1769, including a striking image of *Hector Taking Leave of Andromache* (cat. 8), which depicted a famous episode from the author's other great epic, *The Iliad*. In this earlier picture, Kauffman explores her trademark interests in masculine heroism and feminine fortitude, and in the conflicts between public duty and private life. She depicts the moment in Homer's tale when the doomed Trojan hero, Hector, heading for battle, bids a reluctant, lingering but ultimately steadfast farewell to his wife Andromache and their child, Astyanax. Such paintings fused the weighty

storylines of heroic sacrifice with more intimate and domestic narratives of farewell and – in the case of *The Return of Telemachus* – of joyful reunion.

Similar interests characterised the early Academy submissions of the American painter Benjamin West, who was later to become the institution's second president. He, too, exhibited a series of Homeric canvases in this period, including, in 1771, another depiction of *Hector Taking Leave of Andromache*. This painting can also be seen in the print depicting that year's display, hanging on the upper-right wall. For the same exhibition, however, West also submitted a picture that translated the pictorial language of history painting into a new, far more contemporary idiom. In his *The Death of General Wolfe* (fig. 14), which escaped Earlom's and Brandoin's gaze, the artist depicted the heroic end of the great military commander James Wolfe, who, in 1759, had famously died on the battlefield of Quebec at the moment of the British Army's victory against the French. In this daring canvas, which builds on an earlier depiction of Wolfe's death by West's fellow-Academician Edward Penny, a modern general takes the place typically reserved in history painting for great martial heroes such as Hector or, in the genre's religious guises, for the figures of martyred saints or the deposed Christ.[4] A familiar, much-celebrated turning point in the

Cat. 8 Angelica Kauffman RA, *Hector Taking Leave of Andromache*, 1768 (exh. 1769). Oil on canvas, 134.6 x 177.8 cm. National Trust Collections (Saltram, The Morley Collection, accepted in lieu of tax by HM Treasury, and transferred to The National Trust in 1957), NT 872177

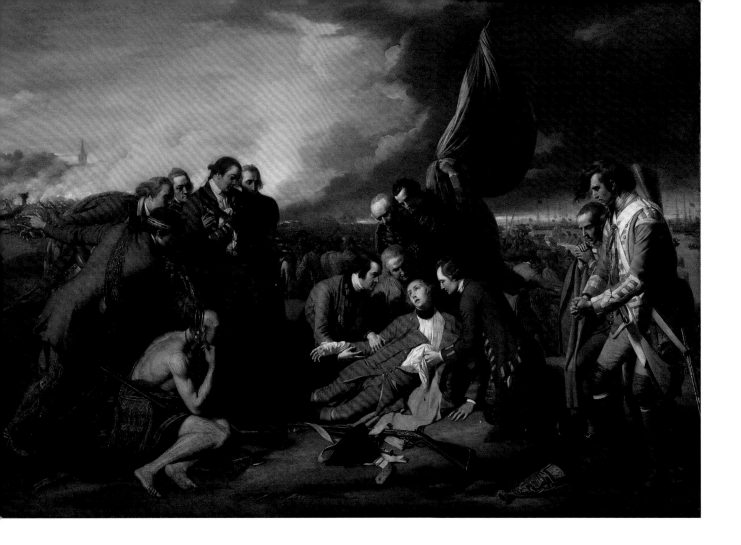

recent Seven Years' War replaces the more distant narratives of antique, biblical or national history; and the modern uniforms of the British armed forces stand in for classical armour and ancient robes. With this work, a new kind of picture – the contemporary history painting – entered the story of the Royal Academy exhibition, of a type that would find itself being continually renewed and revised in the decades and centuries to come.

PORTRAITURE: THE EXAMPLE OF REYNOLDS

Though history paintings of various types were to remain a staple of the Academy's displays, the summer exhibitions of the Georgian era were dominated by another category of picture altogether: the portrait. Thanks in part to the absence of any large-scale patronage for the visual arts on the part of the State or the Church, and to the widespread preference of the art-buying elite for buying continental rather than locally produced

examples of historical and landscape painting, the privately commissioned portrait – a requisite for most families of status – ended up becoming by far the most popular kind of picture on the British art market. Consequently, the most lucrative and sustainable career available to a native painter in the eighteenth century tended to be that of a portraitist; and of the many artists who made this their primary professional activity in this period, and who exhibited examples of such work at the Annual Exhibition, the most famous was Sir Joshua Reynolds, the Academy's first President.[5]

In the two decades before the institution of the Academy, Reynolds had established himself not only as a portraitist of distinction, but also – as his election to the presidency confirmed – one of the leading artists of his time. His portraits were seen as innovative and animated works of art that carried something of the pictorial weight and richness of the Old Masters while illuminating the

Fig. 14 Benjamin West PRA, *The Death of General Wolfe*, 1770. Oil on canvas, 152.6 x 214.5 cm. National Gallery of Canada, Ottawa. Gift of the 2nd Duke of Westminster to the Canadian War Memorials, 1918; Transfer from the Canadian War Memorials, 1921, 8007

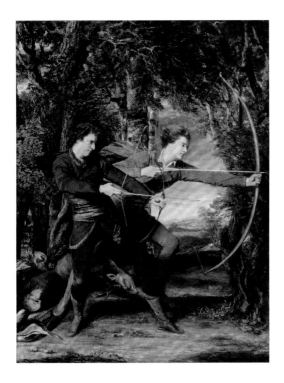

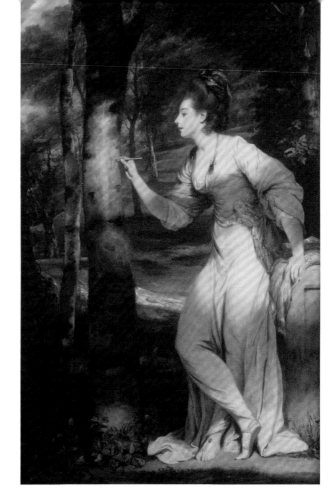

inner character of their modern subjects: in the words of a poetic admirer, writing at the time of the first Summer Exhibition, 'you catch the passions … and from the Face inform us of the Soul'.[6] Just as crucially, Reynolds became extremely adept at submitting exhibition portraits that he knew would catch the public's eye for reasons other than their pictorial sophistication and psychological acuity, including their drama and beauty. Thus, in 1770, he exhibited a flamboyant full-length double portrait, now known as *The Archers* (fig. 15), of the close friends Lord Sydney and Colonel Acland, which pictured the two men racing through a forest, bows in hand, as if involved in a breathless and bloody Renaissance hunt; a trail of dead animals lies in their wake. Though almost absurd to our eyes, and perplexing even to those of some contemporaries, Reynolds knew that dashing, heroic portraits such as this would jump out from the exhibition walls.

His main strategy for gaining attention in the exhibition space in the 1770s, however, was through the display of a series of stunning full-length female

portraits, in which he placed his beautiful and genteel subjects in sun-dappled pastoral settings, and depicted them as graceful combinations of metropolitan fashionability and classical refinement. These included works such as his portrait of Mrs Joanna Lloyd (cat. 9), which he exhibited in 1776 alongside a similarly alluring portrait of the famous Georgiana, Duchess of Devonshire. Hung near each other, the two works offered visitors to the exhibition an elegantly twinned imagery of elite femininity. The newly married Mrs Lloyd – reversing the young lovers' storylines of Shakespeare's *As You Like It* – is pictured in the quiet, introspective activity of carving her husband's name on a tree. The Duchess of Devonshire, meanwhile, looks directly out at the viewer, with an expression that caught the imagination of numerous critics. One especially rhapsodic observer, writing after the exhibition had closed, lauded the painter's 'magic art' for its brilliance in capturing the Duchess's 'fascinating eye' and 'killing grace'; only Reynolds, it is suggested, could 'trace the whole enchantment of her face'.[7]

Fig. 15 **Sir Joshua Reynolds** PRA, *Colonel Acland and Lord Sydney: The Archers*, 1769. Oil on canvas, 236 x 180 cm. Tate, T12033

Cat. 9 **Sir Joshua Reynolds** PRA, *Joanna Leigh, Mrs Richard Bennett Lloyd, Inscribing a Tree*, 1775–76 (exh. 1776). Oil on canvas, 239.5 x 147.8 cm. Waddesdon (Rothschild Family), on loan since 1995

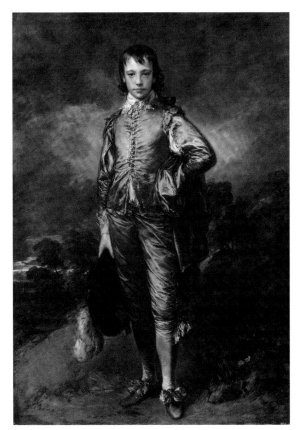

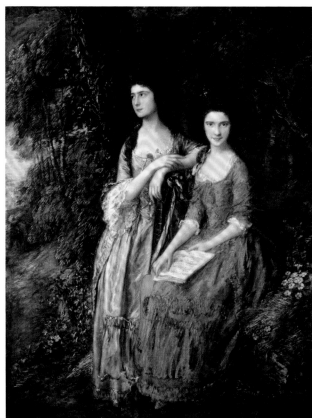

THE RIVAL: THOMAS GAINSBOROUGH

The highly public character and distinctive hanging arrangements of the summer exhibitions lent themselves to keen artistic rivalry. All the leading painters of the Georgian period recognised that the Academy's annual show offered them a prime opportunity to promote their work to a wide audience, and to distinguish it from that of their peers. They would thus prepare for the display throughout the previous winter, all the while keeping a close eye on what was going on in their fellow-practitioners' studios. The anxieties and competitiveness this process generated were further accentuated by the fact that, at the exhibition itself, each artist's works hung directly next to those of his or her contemporaries.

The hang encouraged visitors – and, in particular, trouble-making critics – to compare individual exhibition works with their close neighbours on the walls, and to judge their relative merits. In the 1770s and 1780s this kind of scrutiny bore down especially intensively on the portraits

produced by Reynolds and Thomas Gainsborough, a painter who was widely regarded as the President's equal in talent. Famously, however, the two artists were very different in their approaches to painting. Gainsborough eschewed the pictorially learned character of many of Reynolds's portraits in favour of likenesses that expressed a more direct and unmediated engagement with the sitter. In addition, his portraits flaunted his dazzling painterly dexterity, which remains fully in evidence when looking at his works today: his brush strokes have the delicacy and complexity of a spider's web seen in early-morning sunshine.

In the first years of the Summer Exhibition, the artist captivated viewers with such works as *The Blue Boy* (fig. 16), exhibited in 1770. With its bold visual address – structured around the boy's direct, close-up look out at the viewer – and its powerful colour contrasts, this is a picture that seems to have been designed for maximum impact in the exhibition room, and to compete with such pictures as Reynolds's *Archers*. Two years later, Gainsborough

Fig. 16 **Thomas Gainsborough** RA, *The Blue Boy*, 1770.
Oil on canvas, 179.4 x 123.8 cm. Huntington Library and Art Gallery,
California, 21.1

Cat. 10 **Thomas Gainsborough** RA, *Elizabeth and Mary Linley*,
c. 1772, reworked 1785 (exh. 1772). Oil on canvas, 199 x 153.5 cm.
By Permission of Dulwich Picture Gallery, London, DPG320

followed this picture up with a similarly spectacular double portrait of the Linley sisters, Elizabeth and Mary (cat. 10). These two young women were already celebrated in the artist's then-residence of Bath for their professional musical performances; they became newly touched by controversy in the spring of 1772, following the elopement of Elizabeth with the famous playwright Richard Brinsley Sheridan. If the gossip surrounding this affair helped to generate extra interest in Gainsborough's portrait at the exhibition that year, the qualities of the picture itself guaranteed it a great deal of attention. In the person of Mary, who looks out the viewer with a winning smile, Gainsborough duplicates the direct visual appeal he had exploited in *The Blue Boy*; meanwhile, his depiction of Elizabeth, her face turned gently to one side, offered viewers the opportunity to linger upon a more reflective model of feminine beauty and accomplishment, of the type that his rival, Reynolds, was later to explore in paintings such as that of Mrs Lloyd.[8]

In Gainsborough's picture of the Linley sisters, spectators were also offered a bravura demonstration of landscape painting: the wooded glade in which the two musicians appear is brought thrillingly to life by the sparkling hatch-work of Gainsborough's brush. Whereas Reynolds felt obliged, as President, to begin exhibiting history paintings alongside the portraits that were his forte, Gainsborough instead consistently combined his portrait submissions with landscape paintings. In doing so, he contributed to a pictorial genre that was a familiar if as yet unheralded part of the Georgian Summer Exhibition's offerings. While artists such as his fellow founder-member Richard Wilson regularly displayed Italianate views dotted with classical architecture, Gainsborough's exhibition landscapes were appreciated instead as drawing upon a wider variety of pictorial templates, including those offered by Dutch and

Flemish art, which he proceeded to transform into something entirely new. This was thanks, partly, to the sheer drama of his handling: thus, one critic, commenting on the painting now known as *The Watering Place* (fig. 17), which Gainsborough sent to the 1777 exhibition, becomes lost for words when trying to describe what he calls its 'pencilling': 'But what may I say of the pencilling? I really do not know; it is so new, so original, that I cannot find words to convey any idea of it.'[9]

Over time, and over successive displays, Gainsborough's landscapes, such as *Rocky Landscape*, submitted in 1783 (cat. 11), came to constitute their own distinctive, familiar and, in the phrase of one reviewer of this work, 'romantic' world.[10] This was an isolated, wood-covered realm of mountains, crags and precipices, populated by wandering peasants, lonely shepherd boys and grazing animals, and traversed by rough, winding paths. Yet it was also appreciated as an arena that was calm, empty of conflict, free of all traces of modern life, and enticingly available for both artist and viewer to project themselves into imaginatively. A critic, writing of this painting, described it as having been produced by Gainsborough 'con amore', with love: he goes on to note that 'the landscape appears to him a Labour of Love, on which his Imagination and Pencil never tire, and never leave, but to resume with augmented

Fig. 17 Thomas Gainsborough RA, *The Watering Place*, before 1777. Oil on canvas, 147.3 x 180.3 cm. The National Gallery, London. Presented by Charles Long MP, later Lord Farnborough, 1827, NG 109

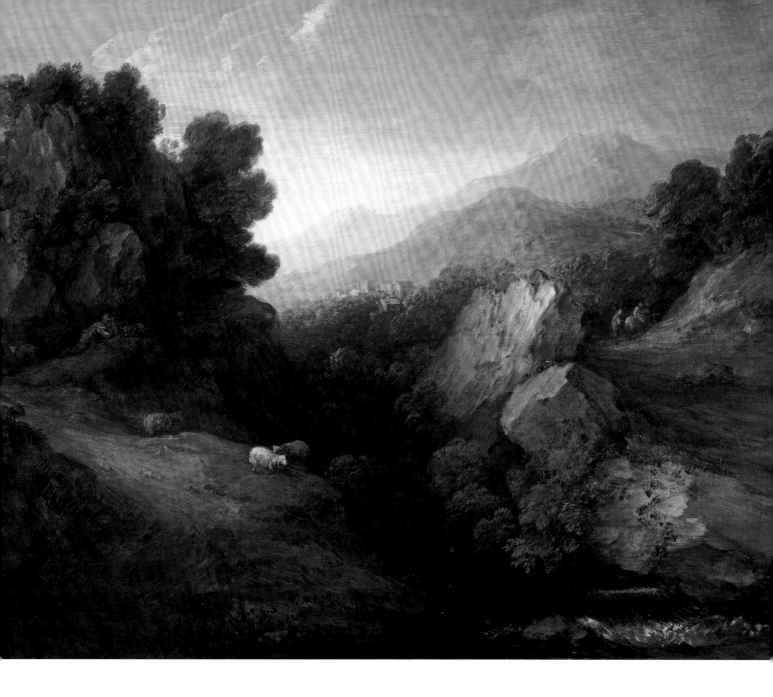

Rapture'.[11] For visitors too, we can suggest, such pictures would themselves have come to seem like visual watering holes within the exhibition's heated and cacophonous environment.

VARIETY

1783 proved to be the final year in which Gainsborough was to submit works to the Academy show. Demanding of others and quick to take offence, his relationship with the institution and its exhibitions had long been troubled and erratic. Angry about the placement of his pictures in the

displays, he had already absented himself from the exhibitions between 1773 and 1777; in 1784, he once again fell out with the Academy regarding the hang of his works, and thereafter exhibited his paintings in his private residence.[12] Despite his absence, the Annual Exhibition continued to thrive. It did so partly because of the enduring commitment to the show of many of the first generation of Academicians, and the diversity of works they submitted. Mary Moser, one of only two female founder-members (no further women, scandalously, were to be elected Royal Academicians until the

Cat. 11 Thomas Gainsborough RA, *Rocky Landscape, c.* 1783.
Oil on canvas, 119.4 x 147.3 cm. National Galleries of Scotland,
Edinburgh. Purchased with the aid of a Treasury Grant, 1962, NG 2253

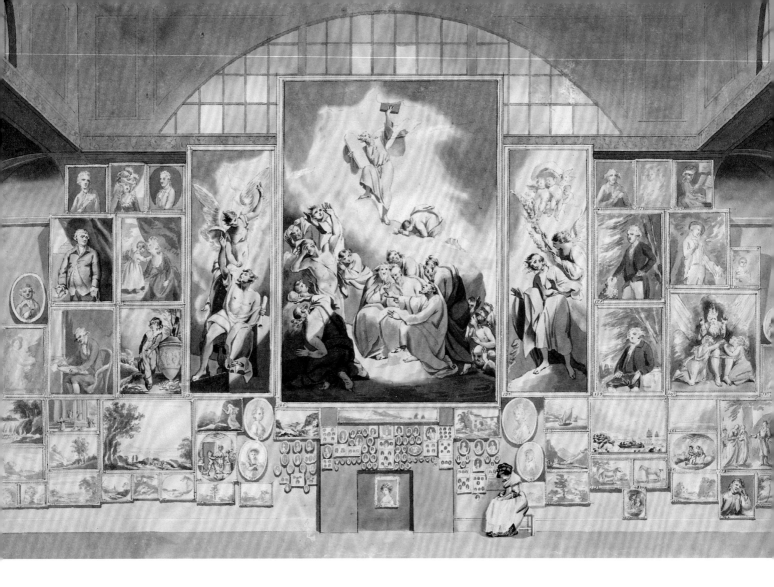

twentieth century), and who is remembered today as a specialist flower painter, is a good example. She sent in paintings of this type (cat. 13) to the display on a regular basis; but she also submitted portraits and modestly scaled historical works, such as a now-lost *Medora and Angelica*, which depicts a scene from Ariosto's Renaissance poem *Orlando Furioso*, and which she exhibited in 1784. Her output succinctly expresses the range of works found at the exhibitions, from flower paintings that occupied a relatively low status in traditional hierarchies of the arts, but that provided exquisite punctuation points within the broader Academy hang, to more learned, historical canvases that fulfilled the institution's loftier ideals, and that continued to give its annual showcase a certain intellectual legitimacy.[13]

Though Moser's *Medora and Angelica* has disappeared from view, it can be seen hanging close to the ground, under an oval portrait by Reynolds of the actress Frances Abington, in one of three (see also cat. 12) detailed pen-and-wash drawings of the 1784 exhibition produced by the talented young draughtsman Edward Francis Burney (fig. 18). Looking more carefully at this same image, which depicts the west wall of the Academy's Great Room at its new premises in Somerset House, usefully confirms that the variety of Moser's own practice was typical of the display as a whole. The wall is dominated by a dizzying array of portraits, is dotted with numerous classicised and picturesque landscapes, and has at its centre a grandiloquent contemporary history painting, this time depicting a dramatic naval escape; but it also contains a wide range of other kinds of picture. Thus, just a few feet away from Moser's canvas, we find George Garrard's depiction of dray-horses being loaded

Cat. 12 Edward Francis Burney, *East Wall of the Great Room, Somerset House*, 1784. Watercolour with pen and grey ink on paper, 34.3 x 49 cm. The British Museum, London, 1904, 0101.3

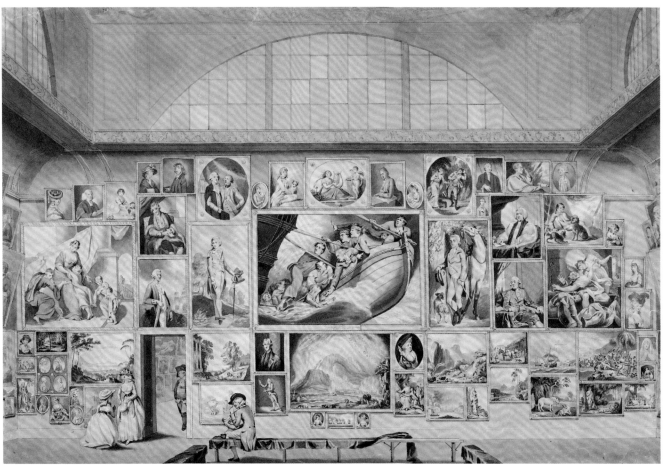

Cat. 13 Mary Moser RA, *Summer, c.* 1780. Oil on canvas,
63.5 x 53.3 cm. Royal Academy of Arts, London, 03/491

Fig. 18 Edward Francis Burney, *West Wall of the Great Room,
Somerset House*, 1784. Watercolour with pen and grey ink on paper,
33.5 x 49.2 cm. The British Museum, London, 1904, 0101.1

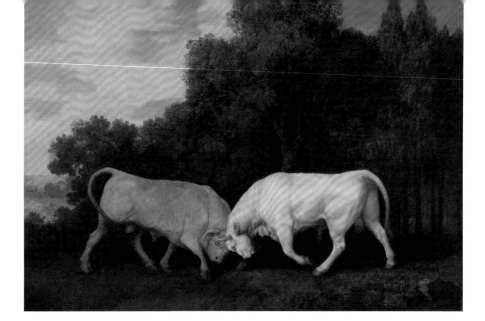

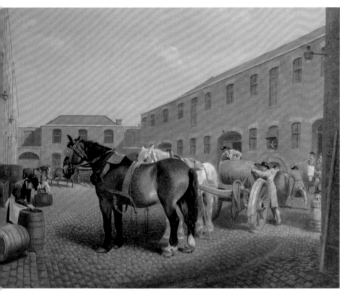

royal counterpart was George Stubbs, who began displaying works at Pall Mall from 1775, and who was elected an Associate Academician in 1780. In works such as his *Bulls Fighting* (cat. 14), which he exhibited alongside its counterpart *Horses Fighting* at the 1787 exhibition, he took the theoretically lowly genre of animal painting produced by artists such as Garrard to remarkable levels of artistic sophistication.[14] That works such as these were deserving of extended scrutiny and appreciation was not only recognised by contemporary critics, but also by the Academy's Committee of Arrangement (now more widely known as the Hanging Committee), which organised the placement of paintings for each year's exhibition. Tellingly, in the 1787 display, the paintings of the warring bulls and horses were granted a very prominent position, hung at eye-level at the centre of the Great Room's north wall, directly beneath the most eye-catching of all the pictures on show that year: a flamboyant Reynolds portrait of the Prince of Wales. Unlike Garrard's lowly dray-horses, Stubbs's animals were not to be easily missed.

WRIGHT OF DERBY AND EXHIBITION CULTURE
Another important defector from the Society of Artists was Joseph Wright of Derby, who first exhibited with the Academy in 1778. Even more sensitive and quick to take offence than

up with beer barrels at Whitbread's Brewery in London (fig. 19). Such works, though enjoying only a marginal position on the Academy's walls, and requiring the visitor to crouch down to see them properly, helped keep the exhibition fresh.

Garrard had enrolled as a student at the Royal Academy Schools in 1778, and was thus part of a new generation of former students replenishing the institution's annual exhibitions from within. An influx of other talent, this time from outside the Academy, was generated by the defection of leading artists from rival exhibiting organisations, most notably an increasingly forlorn Society of Artists. One of the most brilliant of the artists who left the Society's ranks to exhibit with its more successful

Fig. 19 George Garrard ARA, *Loading the Drays at Whitbread Brewery, Chiswell Street, London*, 1783. Oil on canvas, 72.4 x 91.7 cm. Private collection

Cat. 14 George Stubbs ARA, *Bulls Fighting*, 1786 (exh. 1787). Oil on panel, 61.6 x 82.6 cm. Yale Center for British Art, Paul Mellon Collection, B1977.14.93

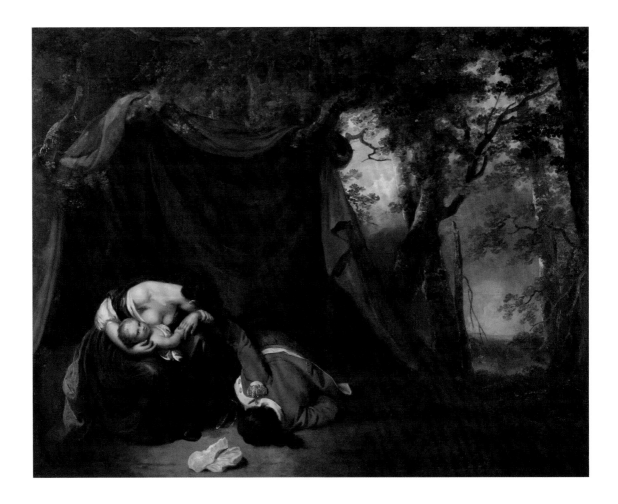

Gainsborough, and haunted by an enduring tendency to depression, Wright's relationship with the royal institution was also a troubled one. Having failed to secure election as an Academician in the spring of 1783, he withdrew from its exhibitions for five years, before a temporary reconciliation that saw him returning to the display between 1788 and 1790 with a remarkable array of works. These included powerful pictures of sentiment, designed to generate an overpowering experience of deep emotion in the viewer, in part through their mixture of tragedy and beauty.[15]

One such painting was *The Dead Soldier* (cat. 15), exhibited to acclaim in 1789. This illustrated a scene described in a modern poem by John Langhorne entitled *The Country Justice*, which, alluding to the battlefields of the mid-century Seven Years' War, imagines the figure of a weeping widow mourning over her dead soldier-husband, while cradling her infant child to her breast.[16]

Wright translates this literary source into a strikingly inventive contemporary history painting, in which we are denied a glimpse of the faces of either the slain soldier or his widow, but instead confront that of their child, who looks out at us while unknowingly playing with the fingers of his dead father. Borrowing from a long-standing artistic convention of showing a mourning widow with face concealed, Wright asks us to do the work of imagining the stricken woman's tear-stained face and desperate grief. In stripping the soldier, too, of an individualised portrait, and omitting the trappings of rank, he renders his fallen subject an anonymous everyman – no famous general or dashing young hero, but an ordinary soldier, arbitrarily cut down in battle. The painting becomes about the pity of war, not its glory. As such, it subverted many of the assumptions of works such as Kauffman's *Hector Taking Leave of Andromache* and West's *Death of General Wolfe*, even as it followed in their footsteps.

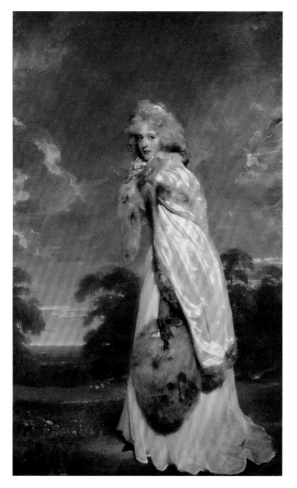

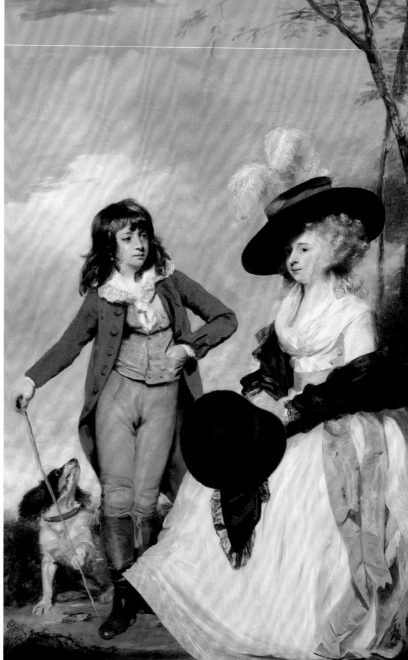

Wright's critical engagement with the iconography of these earlier exhibition paintings is symptomatic of his testy relationship with the Academy and the types of art it promoted. An earlier exhibition of his works, which the artist had held in 1785 during his self-imposed exile from the royal institution, suggests the wider challenges being faced by the Academy and its annual displays in this period. Such one-man shows, which had also been mounted by Gainsborough and another leading Academician, John Singleton Copley, offered a radically alternative form of public exhibition to the Somerset House display.[17] Even more pointedly, 1789 saw the launch of John Boydell's Shakespeare Gallery, which was heavily promoted in the press as a venue that offered metropolitan art lovers the chance to escape the crush of portraits at the Royal Academy, and to gaze instead at high-minded but entertaining depictions of scenes from the great playwright's works.[18] Though the Shakespeare Gallery's offerings were dominated by paintings produced by Academicians themselves, Boydell's enterprise was perceived by many as one that had successfully appropriated the Summer Exhibition's agenda of showcasing the best of contemporary British art. Faced with such challenges, the Academy – and its flagship event – needed to fight back.

Fig. 20 **Sir Thomas Lawrence** PRA, *Elizabeth Farren, Later Countess of Derby*, 1790. Oil on canvas, 238.8 x 146.1 cm. The Metropolitan Museum of Art, New York. Bequest of Edward S. Harkness, 1940, 50.135.5

Cat. 16 **Sir Joshua Reynolds** PRA, *Maria Marow Gideon and Her Brother, William*, 1786–87 (exh. 1788). Oil on canvas, 240 x 148 cm. The Henry Barber Trust, The Barber Institute of Fine Arts, University of Birmingham, 2013.1

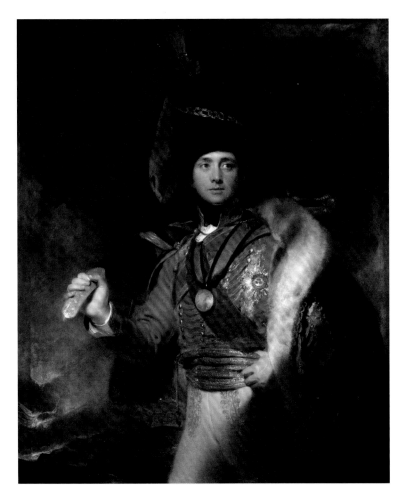

THOMAS LAWRENCE AND MODERN PORTRAITURE

One of the ways it was able to do so, paradoxically, was through the renewal of its central attraction: portraiture. As visitors to the 1789 exhibition moved on from looking at – and even crying in front of – Wright's *Dead Soldier*, and perused the rest of that year's offerings, they would have had the chance to enjoy no fewer than thirteen works by a bright new star of in the British art firmament, the twenty-year-old Thomas Lawrence.[19] A former child prodigy who excelled in producing portraits marked by an exquisite economy of handling and a painterly nonchalance that belied hours of attentive labour, Lawrence was already being widely touted as Reynolds's natural successor, and as someone who 'bids fair, in a very short time, to be one of the best portrait painters of the age'.[20] Lawrence's true breakthrough, however, occurred

the following year, when he exhibited a brilliant, shimmering portrait of the actress Elizabeth Farren (fig. 20), in which she seems almost to float across the landscape, dressed in a fluttering, fashionable, near-weightless combination of muslin, silk and fur.

The painting follows on from Reynolds's recent exhibition works, such as his double portrait of Maria and William Gideon (cat. 16), which revelled, like Lawrence's portrait of Farren, in the materials and colours of modern fashion, and in a bold pictorial rhetoric of flattened planes and sharpened silhouettes. At the same time, Lawrence's portrait felt like something novel to his contemporaries, who compared it flatteringly to the President's own offerings in 1790. To them, the painting seemed unmoored to tradition, even as it gestured to the past; the harbinger of change, even as it paid its pictorial respects. And it is striking that Reynolds himself – who, suffering from failing eyesight, exhibited for the last time that year – also considered Lawrence to be his true successor.[21]

Along with those other men and women who had helped found the royal institution, and who saw their numbers being thinned by death and retirement, the veteran President would have realised that it was now time for a new generation of painters and sculptors, including Lawrence, to take the Academy and its exhibitions into fresh artistic territory. Lawrence himself was to fulfil such hopes: over the next four decades, he continued to submit spectacular and innovative works to the Academy on a regular basis, including such flamboyant male portraits as his picture of Charles William Vane-Stewart (cat. 17), which was exhibited in 1813.[22] Other young artists, too, were to rise to the challenge. These included portraitists, history painters, landscapists and sculptors; but they also included artists who revitalised the summer displays through pursuing a very different kind of practice altogether: that of genre painting.

Cat. 17 Sir Thomas Lawrence PRA, *Charles William Vane-Stewart, 3rd Marquess of Londonderry*, 1812 (exh. 1813). Oil on canvas, 143.5 x 118 cm. National Portrait Gallery, London. Purchased with help from the Art Fund and the National Heritage Memorial Fund, 1992, NPG 6171

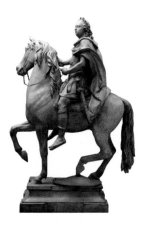

AGOSTINO CARLINI AND THE ROYAL IMAGE

MARK HALLETT

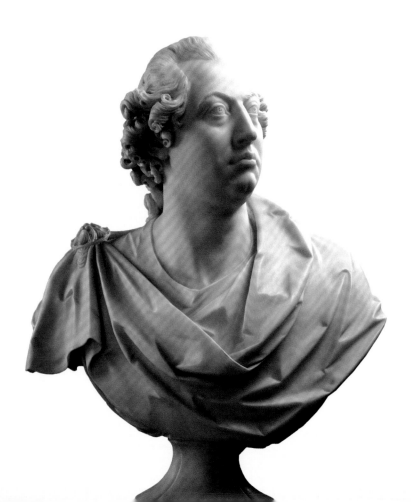

In 1781 the Italian antiquarian and scholar Giuseppe Baretti published *A Guide through the Royal Academy*, which offered the reader an extended tour of the institution's new home at Somerset House.[1] In describing the Academy's Library and its Council Room, Baretti notes two works of sculpture by a contemporary Academician, Agostino Carlini: 'an excellent Bust of his Majesty as Founder of the Royal Academy, executed by the masterly hand of Signor Carlini' (cat. 18), which stood atop a mantelpiece in the Library; and 'a small Model of His Majesty on horseback by Signor Carlini' (fig. 21), which was placed on a mantelpiece in the Council Room.[2] Both of these works continue to live in the Academy today; and, before they found themselves being described by Baretti, both had been shown at the institution's Annual Exhibition. The equestrian model was listed as work no. 9 in the catalogue for the Academy's first ever show, in 1769; and then, four years later, Carlini exhibited his 'A bust of the king, in marble' at the 1773 display.[3]

The presence of the Italian sculptor's works in the Academy's home and in its exhibitions testifies both to his artistic distinction and to the crucial importance played by the royal image in both venues. The Academy was not only an institution that George III had helped to create; it was also one that, for the first few years of its existence, depended on the Crown's financial support for its survival. And although the Academy realised that the symbolic presence of both the King and the Queen in their exhibitions,

Fig. 21 **Agostino Carlini** RA, *Model for an Equestrian Statue of King George III*, 1769. Gilded plaster with metal and string bridle, 87.6 x 38.1 x 59.7 cm. Royal Academy of Arts, London, 03/1684

Cat. 18 **Agostino Carlini** RA, *George III*, 1773. Marble, 81 x 60 x 38 cm. Royal Academy of Arts, London, 03/1685

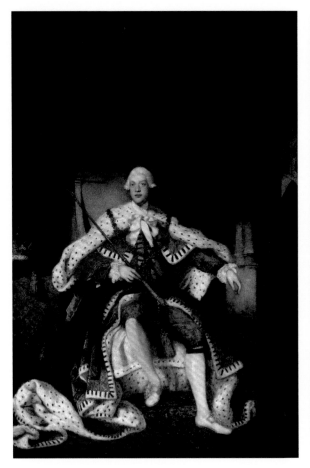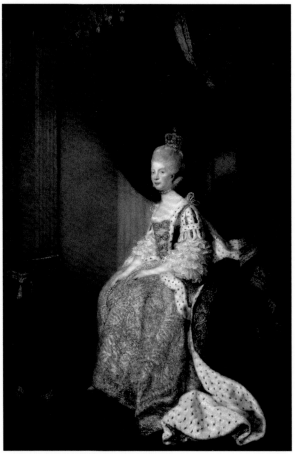

along with images of other members of the royal family, would powerfully reinforce the institution's patriotic credentials, so too the Court realised that the annual exhibitions offered a powerful means of promoting a virtuous image of the British royal family.

Unsurprisingly, given these circumstances, painted and sculpted portraits of the King and Queen regularly took pride of place at the Academy's early displays; furthermore, such ephemeral displays of the royal body operated in tandem with more fixed kinds of representation at Somerset House.[4] Visitors to the Academy's premises not only encountered the King's portrait when they paused to stop in front of Carlini's pieces; as they entered the Council Room, they were also confronted by Joshua Reynolds's permanently installed portraits of both the ruling monarch and his queen (figs 22, 23).[5]

The association between the Academy, its exhibitions and the British royal family was to prove an important and enduring one: it soon became a fact of cultural life that visitors would see at least one portrait of the nation's ruling family, and sometimes many more, as they walked through the annual exhibition. The familiarity, even the banality, of this repeated form of encounter served to maintain the monarchy's status as a reassuring and virtuous fixture of modern Britain. It also, somewhat paradoxically, reinforced the privately funded Academy's own status as one of the nation's great public institutions.

Fig. 22 **Sir Joshua Reynolds** PRA, *Portrait of King George III*, 1779. Oil on canvas, 277.4 x 185.5 cm. Royal Academy of Arts, London, 03/1303

Fig. 23 **Sir Joshua Reynolds** PRA, *Portrait of Queen Charlotte*, 1779. Oil on canvas, 278.2 x 185.7 cm. Royal Academy of Arts, London, 03/3066

THE RISE OF GENRE PAINTING

MARK HALLETT

In 1792 the Royal Academy's Professor of Architecture, Thomas Sandby, was appointed a member of the Annual Exhibition's Hanging Committee. Once the Committee's work had been done, and all the paintings in the exhibition had been hung on the walls, he took the opportunity to produce a series of highly accurate drawings of the display. In these fascinating visual records, an example of which depicts the Great Room's west wall (fig. 24), the exhibited pictures are rendered in diagrammatic form and labelled with their artists' names.[1] By looking a little more closely at this example, and consulting the catalogue for that year's show (see fig. 33), we can identify some of the canvases that were on display on the west wall in 1792. Thus, we find the centre of the wall occupied by *The Institution of the Order of the Garter* (Royal Collection), a magisterial history painting by Benjamin West, who had been elected the Academy's new President following Reynolds's death earlier that year.[2] This, in turn, was bracketed by two full-length portraits by Thomas Lawrence: on the left, a portrait of the celebrated Emma Hamilton; and, on the right, a double portrait of Mr and Mrs Julius Angerstein.[3] Hanging directly beneath West's painting, meanwhile, we find examples of works by one of the leading landscape artists of the day, Philippe Jacques de Loutherbourg.[4]

Sandby's drawing also records two pictures that are of a rather different character to all of the above, focusing as they do on the figures, environments and storylines of everyday life. These are works of a type that, today, we tend to call genre painting. One is William Redmore Bigg's *The Gypsies Detected*, which Sandby shows hanging directly above Lawrence's portrait of Hamilton, and which is now known only from a clumsily executed print that carries the title *The Plundering Vagrants* (fig. 25). The other is George Morland's *Morning, or The Benevolent Sportsman* (cat. 19), which hangs below Lawrence's portrait of the Angersteins, towards the lower right of the display. Looking at both works, and both artists, in a little more detail allows us to begin recovering the remarkable story of how, at the turn of the eighteenth and nineteenth centuries, genre painting, which had enjoyed a long-standing but largely unremarked presence at the Annual Exhibition, suddenly became hot property.

THE PIONEERS: BIGG AND MORLAND

Though he is almost entirely forgotten today, William Redmore Bigg is nevertheless a phenomenon in the history of the Summer Exhibition. Starting in 1780, he displayed works at the exhibition for no less than 47 consecutive years, rising slowly through the Academy's ranks as he did so: he became an Associate in 1787, and a full Academician only in 1813.[5] He was best known for modestly scaled genre pictures, which typically featured small gatherings of low-born figures – often children, and often members of the same family – arranged in front of a modest rural dwelling, normally a cottage or small farmhouse. These figures act out storylines that are easily accessible, sometimes dramatic, and always designed to warm the viewer's sentiments. In this instance, the children of a gypsy

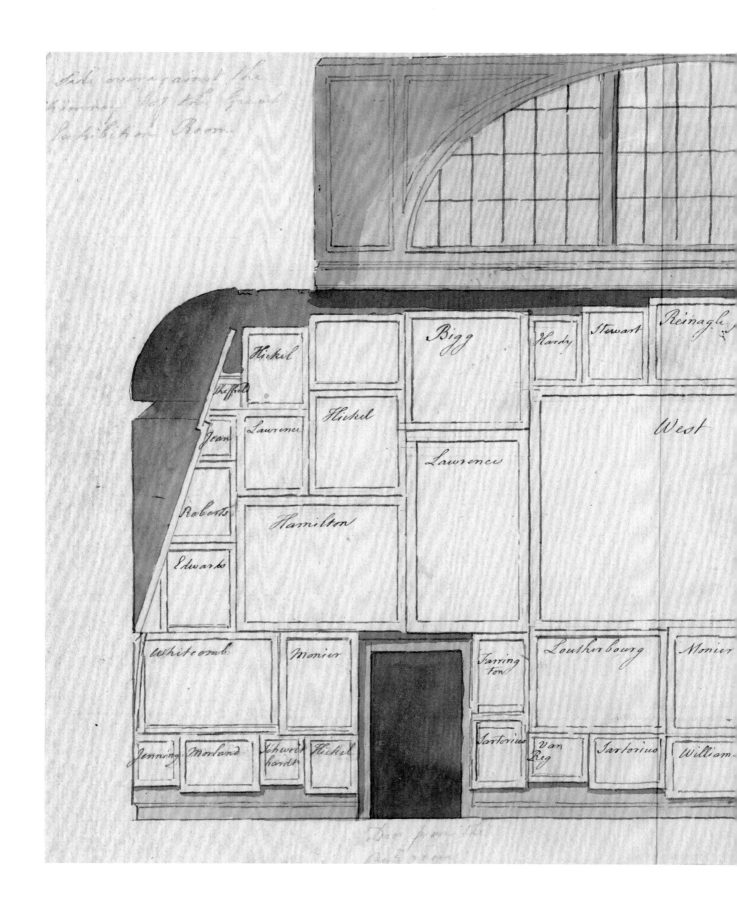

Side arranged about the
Summer by the Great
Exhibition Room.

Hickel

Sheffield

Lawrence

Jean

Hickel

Roberts

Hamilton

Edwards

Bigg

Hardy

Stewart

Reinagle

West

Lawrence

Whitcomb

Monier

Farring
ton

Loutherbourg

Monier

Jenning

Morland

Schweec
hardt

Hickel

Sartorius

Van
Reg

Sartorius

William

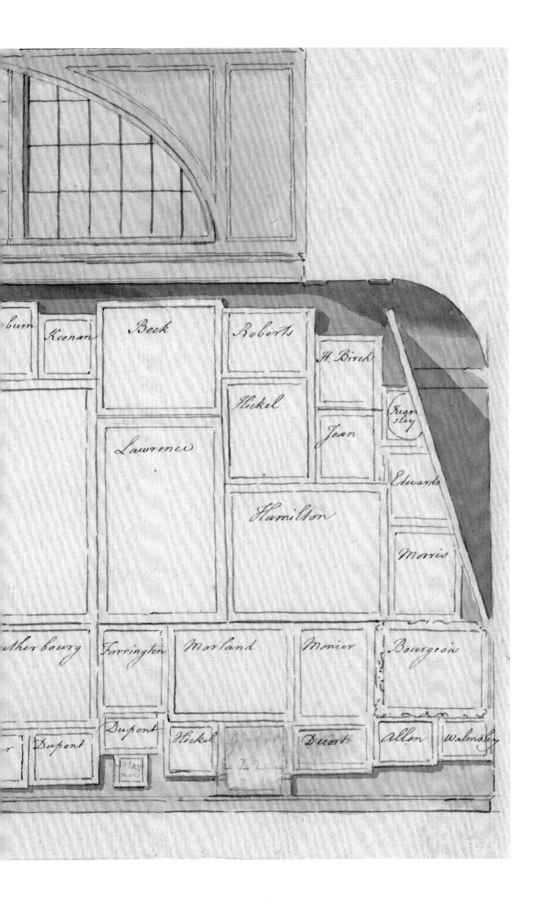

Fig. 24 **Thomas Sandby** RA, *The Royal Academy Annual Exhibition of 1792: The Great Room, West Wall,* 1792. Pen and ink with wash on paper, 22.1 x 35.3 cm. Royal Academy of Arts, London, 08/2007. **Given by Leverhulme Trust 1936**

family have been detected plundering livestock by an angry, staff-wielding farmer and his snarling dog. Though the image plays upon widespread prejudices regarding the shamelessness and thievery of the gypsy population, in this instance Bigg encourages the viewer – and his angry farmer – to feel sympathy for the poorly parented, doe-eyed and soft-skinned children who plead for mercy: in the words of the caption appended to the printed translation of the image: 'Spare, farmer! Spare the threaten'd Blow, / These suppliant imps some pity claim, / For ne'er have they been taught to know / The moral sense of guilt or shame.'[6]

To Bigg's admirers, these works displayed – in the strikingly hyperbolic words of one critic in 1792 – 'an attention to nature, and an appeal to the mind, which we have seldom seen equalled'.[7] On this occasion, the reviewer's praise was directed both at Bigg and at an artist who was then enjoying a good deal of renown: George Morland. Despite being plagued by indebtedness and alcoholism, Morland managed to submit a sequence of ambitious subject paintings featuring rural protagonists to the annual exhibitions from the late 1780s through to the year of his death in 1804. These included, in 1792, the picture recorded by Sandby, which once again directed sympathy at the figures of a gypsy family.[8] In Morland's painting, a Romany mother and father, accompanied by their young child and loyal dog – their donkey rests nearby – sit next to a flimsy tent and a forlorn collection of domestic implements and utensils. Reworking an older iconography of charity deployed by artists such as Bigg's teacher, Edward Penny, in which benevolence is dispensed from horseback, Morland pictures this family receiving the charity of a well-dressed huntsman, seemingly thanks to the intervention of their eldest son, who has stood up to talk to the rider.[9]

Though far more subtle and open to interpretation than Bigg's image – we might even detect a trace of sullen independence in the gypsies' expressions and body language – this painting, too, provided visitors to the exhibition with a heart-warming pictorial fiction. It is one in which, under the enfolding green arc of an English oak, a member of the nation's social elite demonstrates an admirable form of fellow feeling in his dealings with his less fortunate social inferiors. One critic, who entitled the picture the 'compassionate sportsman', described the painting as 'beautiful and natural'; another, writing more broadly of the artist's Academy submissions in 1792, and quoting from a dramatic prologue that contrasted English plays with 'smuggled' French imports, declares that, in Morland's works, 'you see Nature in her true colours, and his scenery, as well as his animals, "Is English, English, sirs!, from top to toe."'[10] A picture like The Benevolent Sportsman, exhibited at a time of heightened military crisis with France and in the aftermath of a series of ruinous harvests, served to provide its viewers with an uplifting, patriotic tale of English sentiment and rural fortitude, cloaked in a convincing pictorial language of the 'natural'.

Thanks to works such as those of Bigg and Morland, and to other scenes of everyday life submitted by artists such as Francis Wheatley, locally produced examples of genre painting had,

Fig. 25 **William Barnard (after William Redmore Bigg RA),** *The Plundering Vagrants,* **1802. Hand-coloured mezzotint, 47.8 x 60.2 cm. The British Museum, London, 1867, 1012.770**

by the turn of the century, become a standard part of the Annual Exhibition.[11] Nevertheless, this category of work, which enjoyed a rather lowly place in the theoretical hierarchies of painting, was rarely deemed worthy of extended scrutiny or comment. This, however, was about to change, thanks to the intervention of a young Scottish artist, who managed to transform genre painting into what contemporaries perceived as an especially exciting strand of the Somerset House display – one, indeed, that could compete in its complexity and ambition with the 'higher' categories of history painting and grand-manner portraiture that would be found hanging nearby.

Cat. 19 **George Morland, *Morning, or the Benevolent Sportsman*,**
1792. Oil on canvas, 101.6 x 137.2 cm. The Syndics of the Fitzwilliam
Museum, University of Cambridge, 1786

THE ARRIVAL OF WILKIE

In 1806 the twenty-one-year-old artist David Wilkie exhibited *The Village Politicians* (cat. 20), which instantly become the most talked-about picture of that year's exhibition.[12] This small painting attracted not only an enormous amount of critical attention, but also a swarm of viewers within the Great Room, who jostled against each other to get a better look, and to pore over its many details. The painting that attracted such scrutiny takes the viewer deep inside a Scottish public house, and into a scene that was set a decade or so earlier, in the middle of the feverish period following the outbreak of the French Revolution. The artist homes in on a central group of labouring men who, fired up by the radical views of the newspaper that lies across their table, are shown arguing about politics. Wilkie grants this gathering a complex range of expressions and gestures, from the angrily intense face and jabbing finger of the ploughman on the left, who currently holds court, to the caricature-like gawps and grimaces of the two central figures, through to the

more contemplative profile and stilled, cross-legged pose of the older man on the right, who holds the short-lived, pro-Revolutionary Edinburgh *Gazetteer* in his left hand. A secondary group of figures, all of whom are painted with an acute sensitivity to body language and facial expression, are gathered around the fireplace. Elsewhere within the image, a slack-mouthed newspaper reader sits on his own; a serving woman enters through a back door; a child protects her food from a dog; and in the lower right, another hungry hound buries its muzzle in a clay pot to lick away its remaining contents.

In some respects, this painting follows on from the kinds of pictures produced by artists such as Bigg and Morland; indeed, the latter artist had produced a work entitled *Alehouse Politicians* that was reproduced as a mezzotint only five years beforehand (fig. 26). But, as connoisseurs and every critic would have recognised, *The Village Politicians* also did something very different – more particularly, it offered an updated and uncannily faithful reworking of seventeenth-century

Cat. 20 **Sir David Wilkie** RA, *The Village Politicians*, 1806. Oil on canvas, 57 x 74.5 cm. The Earl of Mansfield, Scone Palace Collection, Perth

Netherlandish painting, in particular the art of David Teniers the Younger, whose canvases enjoyed great esteem among contemporary British collectors, and fetched high prices on the London art market. One of the numerous works by the Flemish master that helps make the connection clear is the National Gallery's *Two Men Playing Cards in the Kitchen of an Inn* (fig. 27), in which we find a host of similar pictorial elements. For the more knowing admirers of Wilkie's painting at Somerset House, it seemed as if the young Scottish artist had managed not simply to imitate the Dutch master, but to inhabit his vision, and to train it with equal force on a modern British subject: in the words of the *Morning Post*, 'Mr Wilkie may be said to have looked at nature with the same spirit and eye that Teniers would have looked at it, and he has delineated the alehouse politicians of Scotland with the same fidelity that Teniers has represented the Dutch and Flemish boors'.[13]

This brilliant form of pictorial ventriloquism, as well as impressing art-world insiders, generated an image that was packed with pictorial anecdote and accurately observed detail, of the type that non-connoisseurs, visiting the Annual Exhibition, could enjoy just as easily as their more knowledgeable contemporaries. No wonder, then, that at the 1806 exhibition, *The Village Politicians* attracted viewers like a magnet, and held onto them for so long that the picture ended up disrupting the normal flow of visitors around the Great Room. Yet the popularity of Wilkie's canvas must have owed something, too, to the fact that it allowed those same metropolitan visitors – even if they weren't collectors or connoisseurs of high art – to feel comfortably superior to the alehouse politicians depicted by the artist, and to smile at their temporary and laughably misdirected political convictions. One critic, lauding what he called an 'extraordinary production', saw the painting as a work that 'evinced an intimate knowledge of vulgar nature'.[14] As such, it was a picture that, even as it invited the viewer imaginatively to enter the interior

of a Scottish village inn, and to explore its every nook and cranny, also served to accentuate the differences between the groups of people who gathered so avidly around the canvas in Somerset House, and the gathering of figures found within the painting itself, who, in the words of *La Belle Assemblée*, demonstrated only 'the conceit which a little knowledge produces upon vulgar minds'.[15]

THE EXPANSION OF GENRE PAINTING: BIRD AND MULREADY

The celebrity of *The Village Politicians* in 1806, and Wilkie's success thereafter in exhibiting genre paintings, often of a more decorous sort, at the Academy's summer displays, encouraged a host of other painters to follow in his footsteps. One such artist was Edward Bird, whose reputation was also established by the first painting he exhibited at the Annual Exhibition, a now-lost work called *Good News*, which he submitted to the 1809 display.[16] From what we can gather from the detailed and rhapsodic reviews it received, the picture was one that adopted the basic setting and storylines established by Wilkie's *Village Politicians*, and took them in a far more explicitly positive and patriotic direction. *Good News* was once again set in a common room in a village inn, crowded with what the art critic Robert Hunt, writing in *The Examiner*, described as 'an assemblage of every age and sex'.[17] This time, however, the pictorial composition revolved around the figure of an old soldier – a veteran of the Battle of Quebec in which Wolfe had died – rejoicing in the news of a contemporary

military victory against the French, which is shown being read out to the crowd by an old cobbler. Hunt, reflecting on Bird's achievement, declared that the artist, like Wilkie, painted works that focused on the 'effusions of the heart in humble and domestic life'; as such, he goes on, 'they will delight more universally than those of a higher class, which address themselves to the cultivated and therefore partial refinements of taste'.[18] Here, then, was a form of painting that appealed to the broad bourgeois audiences that increasingly flocked to the Somerset House displays, and who helped ensure that the exhibition received more than 60,000 visitors in 1809.

Bird, like Wilkie, became famous at one fell swoop; the artist William Mulready acquired his renown rather more gradually.[19] Though Mulready had exhibited at the Academy regularly since 1804, it was not until he started submitting a trademark strand of genre painting in the century's second decade – pictures that focused on children, and on the conflicts and transitions of childhood – that his remarkable talent started being widely recognised. His *The Idle Boys* (fig. 28), which he submitted to the 1815 display, shows the punishment meted out to two young schoolboys who, rather than

Fig. 28 William Mulready RA, *The Idle Boys*, 1815. Oil on panel, 78.8 x 66.6 cm. Private collection

Detail of fig. 28

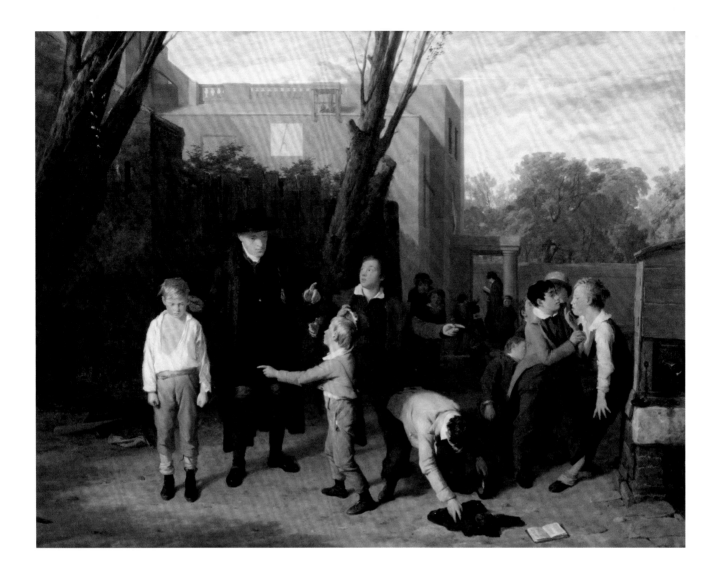

following their teacher's instructions, have been discovered doodling on their slates: one has just received a rap on the fingers, another is about to do so.[20] In the background, their classmates look on anxiously. The painting is of modest size, yet garnered plenty of attention, thanks partly to the skilful way in which it pared down the components of genre painting to their essentials. Thus, the artist's mastery of expression is conveyed through a striking economy of means: if we look at the three boys in the background, for example, we notice how powerfully their anxieties are conveyed through the depiction of their eyes – or, in the case of the boy with his back to us, a single eye. Mulready knew that the half-hidden face could be more expressive than one seen in its entirety. We notice, too, the exquisite

care with which Mulready parses out the objects that are distributed across his composition, which include the bookcase with its open door, revealing a tier of cluttered shelves that can also be enjoyed as a succession of beautifully painted still-lifes. In this painting, critics were granted the opportunity not only to appreciate what one described as Mulready's 'portraiture of incidental character … the stern resentment of a Schoolmaster, and the Schoolboy's pangs and diffused terrors'.[21] They were also invited to admire a highly wrought exercise in pictorial abbreviation and compositional rigour.

Mulready's true breakthrough occurred the following year, however, with *The Fight Interrupted* (cat. 21), which recycled many of the themes of *The Idle Boys* and was lauded by the *Repository of Arts*

Cat. 21 William Mulready RA, *The Fight Interrupted,* 1816.
Oil on panel, 72.4 x 94 cm. Victoria and Albert Museum, London.
Given by John Sheepshanks, 1857, FA.139[O]

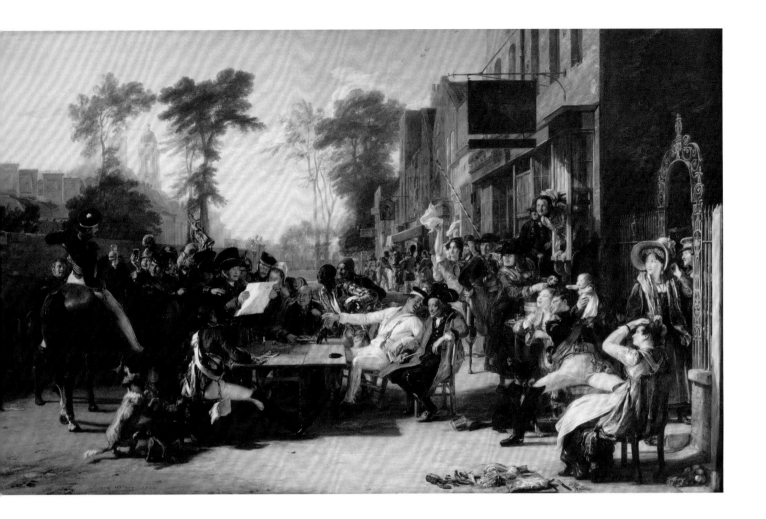

as 'the point of attraction in the great room'.[22] This painting, which features a schoolmaster who is the double – or the near-double – of the man found in *The Idle Boys* (both are portraits of the artist's father), takes him outside his school, and shows him intervening in a fight between two of his charges. *The Fight Interrupted* has rightly been seen as a work that needs to be understood in relation to contemporary debates about education, corporal punishment and social control, and that offers a meditation upon the fighting spirit that had led to the great British victory at Waterloo in 1815.[23] It is also a picture that, like *The Idle Boys*, provides a masterly exercise in the 'portraiture of incidental character': in the words of the *New Monthly Magazine*'s reviewer, 'the lively interest, the heart-burnings and the bustle, which this fight has occasioned among the other boys, is faithfully depicted, and to this the quiet dignity and subduing interposition of the aged

schoolmaster is admirably contrasted'.[24] In *The Fight Interrupted*, furthermore, Mulready showed that he could successfully operate on a larger scale than that of his earlier painting. His image is structured by a densely populated and elaborately choreographed frieze of overlapping figures which runs across the length of the canvas, and that is carefully overlaid across the near-geometrical grid of the painted backdrop. Within this overall pictorial architecture, however, Mulready once again revels in the hidden and the obscured. Remembering his painting of the previous year, we can note, in particular, the trio of boys who this time surround one of the wounded combatants and his ministering companion, to the right of the picture. We catch only a glimpse of these boys' faces. Rather, we are confronted by a succession of single, staring eyes, dotted across the canvas like the notes of a musical score, and sounding a chorus of fascination and alarm.

Cat. 22 **Sir David Wilkie** RA, *Chelsea Pensioners Reading the Waterloo Despatch*, 1822. Oil on panel, 96.8 x 158.2 cm. The Wellington Collection, Apsley House (English Heritage), WM. 1469-1948

CHALLENGING HISTORY

The ambition and sophistication of the genre paintings being submitted to the annual display at Somerset House prompted Robert Hunt of *The Examiner* to suggest, in 1815, that narrative pictures of the type painted by Wilkie and Mulready should be granted a place immediately after history painting in the critical hierarchies of art.[25] Over the next few years, both artists were to exhibit works that rendered the distinction between the two categories even more unstable, and which confidently colonised the kinds of territory that had hitherto been occupied by contemporary history painting. The prime example of such a picture was a work by Wilkie that, in the 1822 exhibition catalogue, was entitled *The Chelsea Pensioners Receiving the London Gazette Extraordinary of Thursday, June 22nd, 1815, Announcing the Battle of Waterloo!!!* (cat. 22). The exclamation marks at the end of the picture's title found an echo in the unprecedented excitement generated by the painting when it was put on display: as the *European Magazine* noted: 'Wilkie's picture is so

admired, that it is difficult to approach it; and the Academy have been compelled to put a bar before it, to prevent its admirers from touching it.'[26]

The work that caused such a sensation was commissioned by the victor of Waterloo himself, the Duke of Wellington, and seems to have served as a competitive reworking of Bird's *Good News* on Wilkie's part. It is a painting in which the host of anecdotal storylines and pictorial details expected of the artist's work are married to a grand historical narrative. The news of the victory at Waterloo is shown being read out to a mass of figures gathered in the sunshine outside a public house in Chelsea, to an audience dominated by Pensioners and serving soldiers. Those present included, as Wilkie made clear in the exhibition catalogue, veterans of a succession of wars against France. Indeed, the old soldier who holds the special issue of the *London Gazette* in his hands is described as a 'survivor of the Seven Years' War, who was at the taking of Quebec with General Wolfe'.[27] Those to whom he reads out the news include figures from across the British empire, together with numerous women and a smiling baby; as such, the gathering offers not only a living embodiment of Britain's modern military history, but an idealised microcosm of the victorious imperial state. Though there is one obvious note of anxiety in this picture – the detail of the woman who, baby in arms, scours the newspaper's list of fallen soldiers, in dread that she might find the name of her husband – this is thoroughly overwhelmed by the painting's iconography of collective joy.

Wilkie's picture, thanks to its skill in conveying the expressions, gestures and appearances of its scores of protagonists, and in integrating them into an overall composition that had both pictorial rhythm and thematic weight, was instantly lauded by critics as a work of art that outshone all its pictorial neighbours in the Great Room, including the history paintings that hung nearby, which were deemed dull and irrelevant in comparison. Yet,

Fig. 29 **Sir Thomas Lawrence** PRA, *Arthur Wellesley, 1st Duke of Wellington, c.* 1821 (exh. 1822). **Oil on canvas, 76.2 x 64.8 cm. Private collection**

55

as well as recognising the status of the *Chelsea Pensioners* as a work that stood dramatically apart from its fellow pictures in the exhibition, it is also worth returning the painting to the display in which it shone so brightly, and seeing it as part of a more complex pictorial story being told across the walls of Somerset House in 1822 – a story about Waterloo, about the role of genre painting, and about the Summer Exhibition itself.

In the Great Room that year, Wilkie's work hung near a head-and-shoulders portrait of Wellington by Thomas Lawrence (fig. 29); meanwhile, a major canvas depicting the Battle of Waterloo, executed by George Jones, hung in the adjoining Painting Room.[28] In this respect, Wilkie's work, described by one writer as a 'trophy to the Duke of Wellington', contributed to a broader commemoration of the victory and its architect at that year's Annual Exhibition – one that served to

reinforce the notion of Waterloo as an unreservedly glorious episode in British history.[29] At the same time, however, the walls of the Great Room included paintings that served to complicate such a narrative, and that gestured to the costs of a battle that had left thousands of British soldiers lying dead and wounded in the field.[30] Most pointedly of all, the display included a painting that can be appreciated as a jarring pictorial counterpoint to Wilkie's canvas: William Mulready's *The Convalescent* (fig. 30). Here, an injured veteran of the recent battle is pictured sitting with his wife and daughter on a thinly populated expanse of beach, watching his two sons play-fight nearby.[31] With one hand he holds his side, as if in pain; his other hand rests in that of his mournful wife. He is in clear need of support, both physical and emotional. A stick lies by his side, resting on a fallen tree that itself provides a symbolic echo of the fallen bodies at Waterloo. Most subtle

Fig. 30 **William Mulready** RA, *The Convalescent*, 1822. Oil on panel, 60.5 x 76.9 cm. Victoria and Albert Museum, London, 506-1882

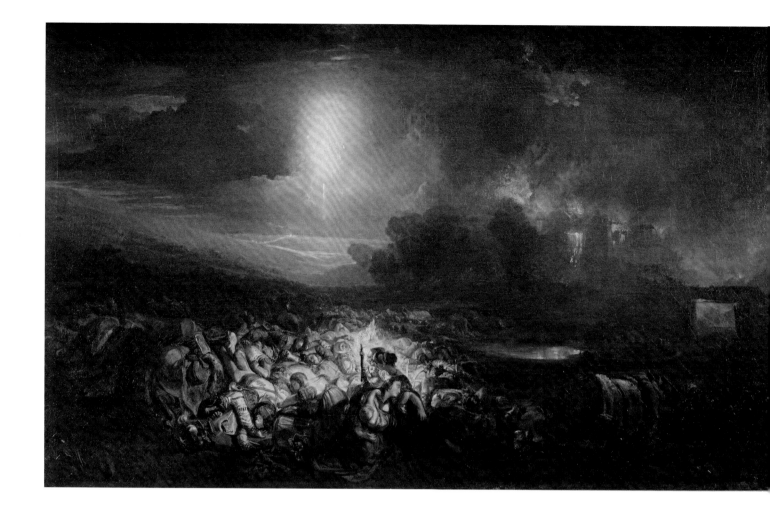

and poignant of all, however, is the expression on the convalescent's face as he gazes across at his wrestling sons. It is one in which can be read a fusion of desolation, pain and pride; and it can also be understood as revealing a man haunted by the memory of the fighting figures he had once seen in another landscape, lying beyond the sea that stretches into the distance. The melancholy poetry of this expression was eloquently distilled by the critic Robert Hunt, who, describing the smile on the soldier's 'pale face' as he looks at his boys, wrote that it was 'like faint sun-shine on dreary snow'.[32]

Here, then, was a work that showed how genre painting could explore the darker histories of the present, and, in doing so, successfully occupy the kind of pictorial ground once traversed by bleak works of contemporary history such as Joseph Wright of Derby's *The Dead Soldier* (see cat. 15). And here, too, was a painting that demonstrated the capacities and contradictions of the Annual Exhibition itself: even as it promoted the jingoistic narratives of imperial victory, the display was fully capable of housing works of art that profoundly challenged the political orthodoxies of the time. An earlier example of such a painting, and one that similarly subverted the more celebratory retellings of Wellington's victory, was Joseph Mallord William Turner's *The Field of Waterloo* (fig. 31), which had been exhibited at the Academy's summer display in 1818, and which offered a haunting vision of a battlefield piled high with the bodies of slaughtered soldiers.[33] Genre painting, it seems, was not the only branch of picture-making trespassing into the supposedly higher realms of history at the Annual Exhibition; landscape painting, too, as the next chapter explores, was also defining itself as a pictorial genre that operated at the vanguard of contemporary British art.

Fig. 31 **Joseph Mallord William Turner** RA, *The Field of Waterloo*,
1818. Oil on canvas, 147.3 x 238.8 cm. Tate, N00500

TWO EARLY CATALOGUES

MARK HALLETT

Ever since its inception, the Summer Exhibition has been accompanied by a catalogue of the works on display. In the Georgian period, these grew very rapidly from rather meagre and uncertain beginnings into a dense and increasingly helpful form of information and communication.

Two pages serve to suggest the flavour of the catalogue for the first ever Royal Academy exhibition (fig. 32), which in its entirety listed 129 works by 50 professional artists and seven works by six 'honorary' or amateur practitioners.[1] Early catalogues, rather than listing works in relation to their location within the display, listed participating artists in alphabetical order, and grouped their exhibited works together: so we see

[7]

47 A compofition of different antique buildings taken from nature, a coloured drawing.
48 The Caftle at Canterbury, with St. Mildred's Church, ditto.

JOHN GWYNN, R. A.
Little-court, Caftle-ftreet, Leicefter-Fields.

49 An architectonick drawing defigned for the alteration of an old room in Shropfhire.

FRANCIS HAYMAN, R. A.
Dean-ftreet, Soho.

Two fceaes in Don. Quixote, viz.
50 The difpute with the Barber upon Mambrino's helmet.
51 Meeting Cardenio in the Black Mountain.

NATHANIEL HONE, R. A.
St. James's-place.

52 A fmall whole length
53 A portrait of a Clergyman, three quaters.
54 A portrait of a young gentleman.
55 A candle light.
56 A piping boy.
57 A portrait in enamel.

[8]

WILLIAM JAMES,
At the Golden Head, in Bedford-ftreet, Covent garden.

The remains of fome antient Egyptian Temples, as they are now ftanding in and about Thebes, in Upper Egypt, viz.
58 * A fide view of the Great Temple of Ofiris, at Carnack, to which there were avenues of Sphynxes half a mile in length, adorned with triumphial arches; on the right hand is a Portico of a Temple at Amara.
59 * The Temple of Ofmanduas, at Luxor.
60 * The Temple of Ifis, at the Ifle Ell Hief, a little above the firft Cataract of the Nile; on the right hand is a fmall Temple called the Temple of the Hawk, becaufe Ifis was there worfhiped under that fymbol.

ANGELICA KAUFFMAN, R. A.
Golden-fquare.

61 The interview of Hector and Andromache.
62 Achilles difcovered by Ulyffes amongft the attendants of Deidamia.
63 Venus fhewing Æneas and Achates the way to Carthage.
64 Penelope taking down the bow of Ulyfes for the trial of her wooers.

that Angelica Kauffman showed four pictures in the 1769 show, including *Hector Taking Leave of Andromache* (see cat. 8). Artists' addresses were also given, so that prospective clients might visit them at their studios. Those who were Academicians are granted an 'R.A.' after their name; and works for sale are marked by an asterisk. The two pages illustrated also confirm the extreme reticence used in describing most portraits: painting no. 54, for instance, is listed simply as 'A portrait of a young gentleman'.

By the end of the century, the look and contents of the catalogue had changed quite dramatically. Thanks to the huge growth in the size of the exhibitions since 1769, the catalogues were now far fuller and longer: thus, whereas the 1769 catalogue was only 15 pages long, that for the 1792 exhibition ran to 34 pages, and listed 780 works by scores of artists.[2] Looking at the opening page of that year's catalogue (fig. 33) makes clear the difference: this page, rather than granting swathes of space to the names of the artists and their works, is packed to the brim.[3] The asterisk is still occasionally on view, and we still find the letters 'R.A.' at the end of the Royal Academicians' names, while elsewhere we find the letter 'A' for Associate, and, interestingly, an italicised 'R.A.' for those Academicians who, as the notes declare, 'are Foreign'. This was the case for J.-L. Mosier [Jean-Laurent Mosnier], whose work listed as no. 14 – 'portrait of a lady and child' – confirms that the catalogue still cloaked portraits' sitters in a veil of anonymity.

Most importantly of all, in a change that had been introduced on the occasion of the Academy's move to Somerset House in 1780, and that made

it far easier for exhibition-goers to match the works listed in the catalogue to those hanging in the display, the pictures were now, as a finger-pointing hand indicates at the top of the page, 'numbered as they are placed in the Room. The First Number over the Door.' In this instance, the pictures listed are those that were distributed to the right

of the door on the west wall of the Great Room in 1792. This wall was pictured in diagrammatic form by Thomas Sandby (see fig. 24); and, if we flick between this catalogue page and Sandby's drawing, we can identify many of the exhibited pictures, including George Morland's *Benevolent Sportsman* (cat. 19), which is no. 23 in the catalogue.[4]

A

CATALOGUE.

☞ The PICTURES are numbered as they are placed in the Room. The First Number over the Door.
The PICTURES, &c. marked (*) are to be difpofed of.
R. A. Royal Academician.
A. Affociate.
N. B. Thofe marked R. A. in Italics are Foreign.

1	Portrait of a lady of fafhion, as La Penferofa	*T. Lawrence*, A.
2	Gypfies detected	*W. R. Bigg*, A.
3	Portrait of Mr. Saloman	*W. T. Hardy*
4	Portrait of a gentleman	*T. Stewart*
5 *	Landfcape and cattle	*R. R. Reinagle*, jun.
6	Portrait of a gentleman	*H. Raeburn*
7	Portrait of a gentleman	*J. Keenan*
8	The firft ceremony, when Edward the Third, with the original knights, inftituted the moft noble order of the garter, painted for the audience chamber, in Windfor Caftle	*B. Weft*, R. A.
9	View of part of Windfor caftle	*J. Farington*, R. A.
10	Infide of a ftable	*J. N. Sartorius*
11	Rendezvous of the Brabantine patriots	*Van Regemonté*
12	A ftraw yard	*J. N. Sartorius*
13	A ftorm, and paffage boat running afhore	*P. J. De Loutherbourg*, R. A.
14	Portrait of a lady and child	*J. L. Mofnier, R. A.*
15	A view	— *Williams*
16 *	A farm yard	*C. Catton*, jun.
17	Cottage children	*W. Miller*
18	A frefh wind, the tide fetting in	*P. J. De Loutherbourg*, R. A.
19	Portrait of a gentleman	*T. Maynard*
20	A landfcape, with figures	*G. Dupont*
21 *	A fcene in the Sultan	*A. Hickel*
22	Mary, Queen of Scots, the morning before her execution	*J. Graham*
23 *	Benevolent fportfman	*J. Morland*
24	Part of Weftminfter bridge, the abbey, &c.	*J. Farington*, R. A.
25	Portraits of a gentleman and his lady	*T. Lawrence*, A.
26	View on the Rumney, near Caerfilli, Monmouthfhire	*G. Beck*
27	View of a water-mill, in Ireland	*T. S. Roberts*
28 *	The parent's hope.	*A. Hickel*
29	Portrait of Samuel Beft	*H. Burch*
30	Portrait of a gentleman.	*P. Jean*

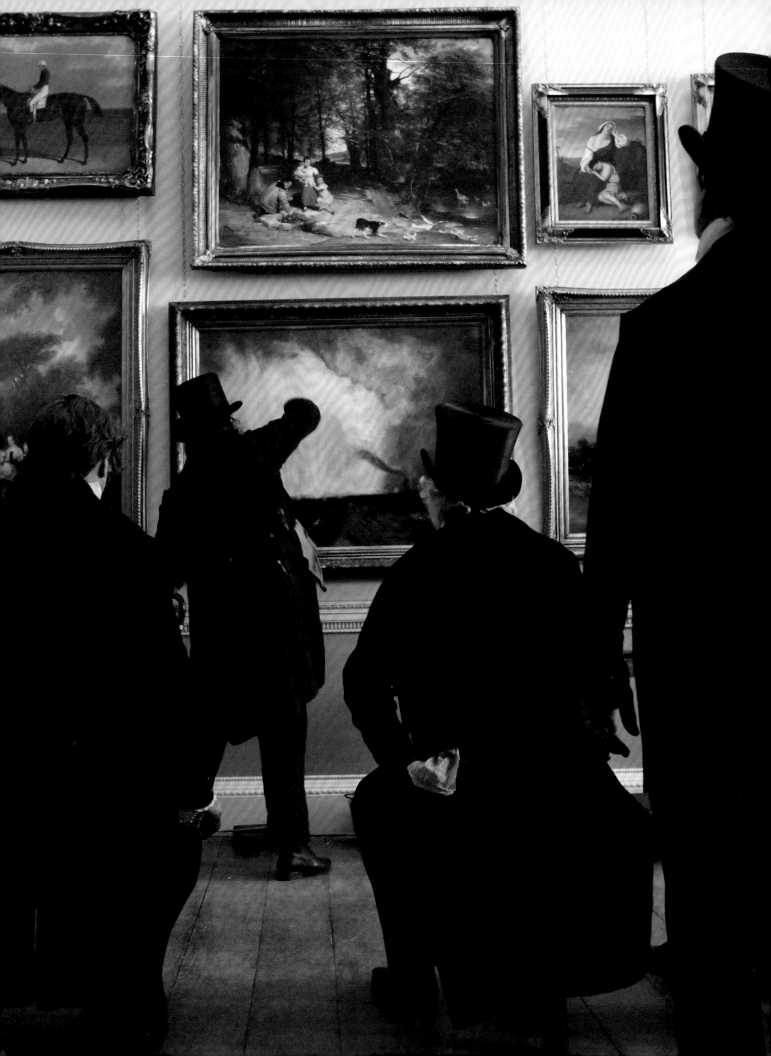

THE TRIUMPH OF LANDSCAPE

MARK HALLETT

Mike Leigh's celebrated film *Mr Turner* provides the Summer Exhibition with a starring role (fig. 34).[1] It dwells in detail on the kinds of artistic performance that took place on the 'Varnishing Days' which, from 1809 onwards, provided Academicians with the chance to make final changes to their installed paintings in the run-up to the opening of the display.[1] Leigh uses one such day to retell a story made famous by the painter and biographer Charles Robert Leslie, which was supposed to have taken place in 1832.[2] According to Leslie, J. M. W. Turner, having seen John Constable labouring away at his substantial and heavily reworked canvas of *The Opening of Waterloo Bridge* (fig. 35), looked with new eyes upon his own, more modestly sized marine painting *Helvoetsluys: The City of Utrecht, 64, Going to Sea* (fig. 36), which happened to have been hung directly alongside that of his industrious contemporary. Noting the enormous amount of red paint that Constable was expending in touching up his *Waterloo Bridge*, Turner walked decisively up to his Dutch seascape, and put a single 'round daub of red lead [pigment], somewhat bigger than a shilling, on his grey sea'. Leslie reports that Turner then 'went away without saying a word' and did not come back into the room 'for a day and a half; and then, in the last moments that were allowed for varnishing, he glazed the scarlet seal he had put on this picture, and shaped it into a buoy … the intensity of the red lead, made more vivid by the coolness of his picture, caused even the vermilion and lake of Constable to look weak. "He has been here", said Constable, "and fired a gun."'[3]

Today, due perhaps to the effects of pictorial fading, the visual impact of Turner's red buoy is rather muted; it is thus more difficult to appreciate the artist's realisation that, in the exhibition room, quick-witted extemporisation could trump labour, and less could mean more. Nevertheless, Leslie's story remains significant, in part because it highlights the role of artistic rivalry in pushing landscape painting to new heights of achievement in this period. The genre had, of course, been a staple ingredient of the Pall Mall and Somerset House shows since 1769, and had, as we have seen, played an important role in the submissions of leading artists such as Gainsborough. The turn of the century, however, saw this kind of work being assigned a new ambition and importance not only within the Academy display, but within British art more generally. There seem to have been a number of reasons for this, including the rise of new patterns of taste, shaped by the picturesque and associationist writings of Archibald Alison, Uvedale Price and Richard Payne Knight, and by a fresh influx of famous Old Master landscape paintings onto the London art market in the 1790s.[4] Important, too, was the new patriotic resonance that could be granted to images of the British landscape during the long period of war with France, which lasted, with only a brief interruption, from 1793 to 1815. Another crucial stimulant to the genre's success, however, was the fact that Turner and Constable were part of a remarkable generation of landscape artists, all born within just a few years of each other, and all of whom were spurred on by each other's practice. Turner shared his birth year, 1775, with the brilliant watercolour painter Thomas Girtin; Constable was born in 1776; and another leading contemporary landscape painter, Augustus Wall

Fig. 34 **Still from Mike Leigh's 2014 film, *Mr Turner*, showing Timothy Spall in the title role retouching a work on one of the 'Varnishing Days'.**

Fig. 35 John Constable RA, *The Opening of Waterloo Bridge*
(*'Whitehall Stairs, June 18th, 1817'*), 1832. Oil on canvas,
130.8 x 218 cm. Tate: Purchased with assistance from the National
Heritage Memorial Fund, the Clore Foundation, the Art Fund, the
Friends of the Tate Gallery and others 1987, T04904

Fig. 36 Joseph Mallord William Turner RA, *Helvoetsluys:
The City of Utrecht, 64, Going to Sea*, 1832. Oil on canvas,
91.4 x 122 cm. Tokyo Fuji Art Museum, Tokyo

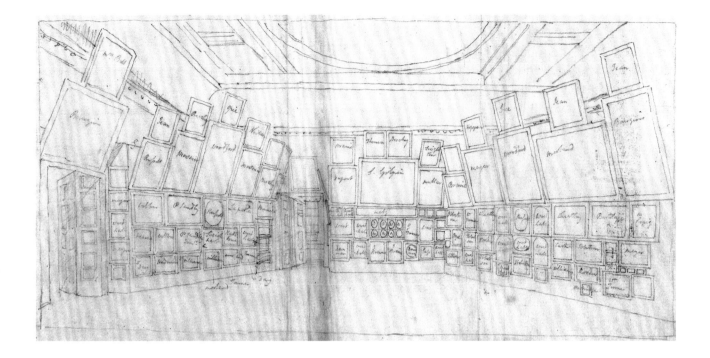

Callcott, was born in 1779. Working in tandem with other talented practitioners of the same generation, and shaping the work of those younger painters such as William Havell and Clarkson Stanfield who followed in their trail, these artists, and the dynamics of collaboration, competition and emulation that shaped their relationships, helped to ensure that landscape painting, like the genre painting with which it so often competed for attention, became a vital part of the late-Georgian summer display.

THE LANDSCAPE WATERCOLOUR: TURNER AND GIRTIN

To trace the beginnings of this striking development, we can return once again to the drawings that Thomas Sandby made of the 1792 Annual Exhibition – more particularly, to the study he produced of the Antique Room at Somerset House (fig. 37).[5] In that year, this first-floor room was used to display not only a selection of oil paintings and pastels, but also a large number of the watercolours that had been accepted for the exhibition. The fact that such works tended to be kept out of the Great Room that stood on the top floor of the building testifies to the fact that the practice of watercolour painting on paper was granted less esteem than that of oil painting on canvas in this

period.[6] Nevertheless, rather than serving as an aesthetic backwater, the Antique Room – together with the adjoining Council Room, which became the main display space for watercolours from 1795 onwards – was a vibrant arena of artistic innovation and experimentation, in which young landscape watercolourists had the opportunity to showcase their talents in the company of long-established practitioners in the genre. The seventeen-year-old J. M. W. Turner, for instance, who was already in his third exhibition, exhibited two watercolours in 1792, one of which was of Malmesbury Abbey (fig. 38). The picture can be glimpsed within the assemblage of works depicted by Sandby: carrying the scrawled inscription 'W. Turner', it is to be found hanging just under the line in the far corner of the right-hand wall. In the Antique Room that year, works such as this had the chance to be compared with the pictures of such older and more celebrated watercolour artists as Thomas Hearne and Paul Sandby, both of whom had specialised in depicting similarly picturesque subjects during their long careers.[7]

These inherently competitive viewing conditions not only provided a spur for young artists; they could also help to prompt fresh thinking on the part of veterans. Up until this period, exhibited landscape watercolours had been defined

Fig. 37 Thomas Sandby RA, *The Royal Academy Annual Exhibition of 1792: The Antique Academy*, 1792. Pencil on thin laid paper, 25 x 44.4 cm. Royal Academy of Arts, London, 07/4840

by their strongly topographic focus, in which the pictured landscape was tied to a specific building or a recognisable place. As the 1790s progressed, however, watercolour artists became ever more interested in combining this kind of topographical specificity with other iconographic and formal strategies, including those approximating the effects of oil paintings. Thus, the 1795 Annual Exhibition saw Paul Sandby displaying a landscape (fig. 39) that, even though it offered a view of the town of Bridgnorth, on the River Severn, was given the more abstracted title of 'Morning'; in its large size and heavy use of bodycolour, furthermore, it enjoyed a grandeur of scale and a material weight that was more normally associated with the oil paintings that were also on display at Somerset House. Most tellingly of all, perhaps, an interest

in the architectural details of a particular place is here subordinated to a very different kind of pictorial focus: the high drama of the astonishingly animated beech tree in the foreground, the branches of which spiral and writhe with the energy of a great classical sculpture such as the Laocoön.

Both Turner and his fellow artist Thomas Girtin, who first exhibited at the Academy in 1794, and who became close friends and collaborators in the middle of the decade, were also experimenting with the topographical watercolour at this time.[8] In 1798 the two artists exhibited watercolour views of ancient landmarks – *Norham Castle on the Tweed, Summer's Morn* and *Rievaulx Abbey, Yorkshire* (fig. 40) respectively – that flaunted their increasingly innovative treatment of light, setting and handling. By the following year, they were being bracketed

Fig. 38 Joseph Mallord William Turner RA, *Malmesbury Abbey*, c. 1791-92 (exh. 1792). Watercolour and brown ink on paper, 54 x 38.3 cm. Norfolk Museums Service (Norwich Castle Museum and Art Gallery), 1899.14

Fig. 39 Paul Sandby RA, *Morning*, 1794 (exh. 1795). Watercolour and bodycolour on paper, 69 x 103 cm. Victoria and Albert Museum, London, FA.383

as two especially talented young adepts of their medium, whose work told of an intimate dialogue between their practices. A review of the 1799 Annual Exhibition in the *Whitehall Evening Post* reported that 'there are two young artists who display the most promising talents in this line of the arts – Mr Turner and Mr Girtin. Their specimens are exquisite.'[9] That year, Girtin exhibited the work that first brought him widespread critical and artistic praise: his *Near Beddgelert (A Grand View of Snowdon)* (cat. 23). The image is structured around the sublime contrast it offers between the flat and relatively featureless valley below, traversed by the tiny figures who walk along the track, and the rugged mountains that encircle the valley, rising into a dramatic, cloud-filled sky. Girtin flaunts his ability to represent the most distant

and visually elusive features of the landscape – the silvery streams and tributaries that run down the mountain on the right, for example, and the sheep that dot its surface – with thrilling exactitude, while also offering connoisseurs the pleasure of enjoying the complex calligraphy of his brush, especially evident in the pattern of marks that make up the rocky face of the mountain on the left.

Such qualities prompted one critic, who admitted he had not heard of the artist beforehand, and who suggested that Girtin's work was something in the style of Turner's, to declare that he 'exhibits all the bold features of Genius'.[10] They also helped to ensure that his *Grand View of Snowdon* became the focus of attention for other artists. One such figure was the seventeen-year-old son of a Reading drawing-

master, William Havell, who later recorded having carefully meditated upon Girtin's work as it hung at the exhibition.[11] The impact of *Beddgelert* on Havell was, indeed, unusually profound, and his memory of having been entranced by the image must have taken on an extra charge following Girtin's tragically early death in 1802. Two years later, at the 1804 Annual Exhibition, Havell submitted a watercolour that paid a silent but eloquent tribute to the late artist, and to that earlier encounter: the *Valley of Nant Ffrancon, North Wales* (fig. 41). Even as it served to demonstrate his own precocious talents, this watercolour offered an extended, meditative reworking of Girtin's earlier picture, and one that gave its imagery fresh life.

Cat. 23 **Thomas Girtin,** *Near Beddgelert (A Grand View of Snowdon),* **c. 1799 (exh. 1799). Watercolour over pencil on paper, 60.9 x 91.4 cm. Amgueddfa Cymru - National Museum Wales. Purchased with the assistance of the National Art Collections Fund, NMWA 22730**

It is as if all the same ingredients of the earlier landscape – the bare valley, the diminutive figures, the lonely silhouettes of trees, the spidery streams, the sublime mountains – have been lovingly reassembled and reconfigured. Yes, the Academy's exhibition could be a sphere of competition and rivalry; but, as Havell's watercolour demonstrates, it could also serve to stimulate extended forms of artistic emulation and remembrance.[12]

THE LANDSCAPE OIL: TURNER AND CALLCOTT

In the same year that Havell exhibited his tribute to Girtin, Turner opened a specially converted gallery space adjoining his studio in Harley Street, London.[13] Visitors to the gallery had the chance to enjoy a display of new pictures by the artist, and to peruse a number of older, previously exhibited works that remained on his hands. The latter included examples of the landscape oil paintings that Turner had begun displaying alongside his watercolours from the 1796 exhibition onwards. Over the previous eight years, the oils he had displayed at Somerset House had pulled landscape painting in a series of wildly different directions – into the past as well as the present, the foreign as well as the British, the sublime as well as the picturesque, and towards the sea as well as the land. Those who travelled to Harley Street in the spring of 1804 had the opportunity of enjoying this pictorial variety. They could look again at such

Fig. 41 William Havell, *Valley of Nant Ffrancon, North Wales*, 1804.
Watercolour on paper, 47.2 x 67.8 cm. Private collection

canvases as *The Tenth Plague of Egypt* (Tate), which the artist had exhibited in 1802, and which took landscape painting deep into the kinds of biblical and apocalyptic imagery associated with the most bleak and spectacular forms of history painting. At the same time, they could enjoy a picture like *Calais Pier* (National Gallery, London) which Turner had exhibited in 1803, and which offered a dramatic exercise in marine painting, centred upon the tilted sail of a passenger boat caught in a raging sea.[14]

Turner's example proved both inspiring and daunting for the other landscape painters of his generation. One such artist was Augustus Wall Callcott, who, in the years following Girtin's death, came to assume the role of, variously, Turner's acolyte, friend, foil and rival.[15] He had started exhibiting in 1799, and his landscape offerings over the following decade saw him testing out different kinds of artistic strategy, including ones that aligned his practice with that of his more celebrated contemporary. This has led to the

rather misleading assumption that Callcott was little more than a slavish if skilful follower of Turner; however, the dynamics of the two men's artistic relationship was far less one-sided than this might suggest. Indeed, it seems more accurate to see each of them prompting creative advances in the work of the other, and, in doing so, spearheading new developments in landscape painting itself. On the one hand, it is entirely true that Callcott sought to learn from, and in part to model his practice upon, Turner's example; a copy that he made after the latter's *Sheerness and the Isle of Sheppey* in 1807–08 (fig. 42) offers a telling symbol of this form of artistic study and emulation. On the other hand, it seems just as productive to see Turner himself as someone who, on occasion, creatively responded to Callcott's example, and who did so in the very public arena of Somerset House.[16]

One such response seems to have been triggered by Callcott's exhibition of his large painting *Entrance to the Pool of London* (fig. 43)

Fig. 42 **Sir Augustus Wall Callcott** RA (after Joseph Mallord William Turner RA), *Sheerness and the Isle of Sheppey, c.* 1807–08. Oil on canvas, 69.8 x 89.5 cm. Tate: Bequeathed by John Meeson Parsons 1870, N00813

at the summer display of 1816. This canvas, which was far more obviously indebted to the Dutch seventeenth-century marine painter Aelbert Cuyp than it was to the work of any contemporary British artist, was one of the pictures of note in that year's display – indeed, one reviewer described it as being 'universally admired'.[17] Another, more waspishly, remarked that 'Mr Turner may now take useful lessons from Mr Callcott, instead of Mr Callcott from Mr Turner.'[18] Two years later, in 1818, Turner exhibited his great painting of *Dort or Dordrecht: The Dort Packet-Boat from Rotterdam Becalmed* (fig. 44) which he exhibited in 1818, and which has long been regarded as a competitive retort to Callcott's work.[19] However, a fresh comparison of the two paintings, in which we suspend our assumptions

about the inevitable superiority of Turner's pictures to those of Callcott, encourages a more nuanced understanding of the pictorial dialogue that took place across the exhibitions of 1816 and 1818. Given the friendship that the two men seem to have enjoyed in this period, it seems hard to imagine that Turner's work, so similar to that of his contemporary, was intended as an aggressive or dismissive form of pictorial rejoinder. Rather, it is better appreciated as the expression of an ongoing pictorial conversation between the two artists, which played itself out over the unfolding history of the Summer Exhibition itself, and in which they each essayed complementary variations on a revered pictorial model, that of Cuyp, and on the same maritime theme.

ANOTHER PATH: CONSTABLE

The 1818 exhibition, as well as including Turner's *Dort*, featured a painting that was far more modest in its dimensions and character: John Constable's *Dedham Lock and Mill* (fig. 45).[20] Constable had an unusual background for an artist of this period

Fig. 43 **Sir Augustus Wall Callcott** RA, *Entrance to the Pool of London*, 1815 (exh. 1816). Oil on canvas, 152.4 x 221 cm. Bowood House and Gardens, Wiltshire

Fig. 44 **Joseph Mallord William Turner** RA, *Dort or Dordrecht: The Dort Packet-Boat from Rotterdam Becalmed*, 1818. Oil on canvas, 157.5 x 233.7 cm. Yale Center for British Art, Paul Mellon Collection, B1977.14.77

69

– he was the son of a wealthy Suffolk merchant and mill-owner, and had embarked upon a career in painting in the face of a great deal of parental opposition. Furthermore, he had long exhibited at the Academy without generating much in the way of sales or critical notice. The landscapes that he submitted were, for many years, of a character that easily led to their being overlooked in the crowded and colourful displays at Somerset House. They were relatively small in scale, and, for the most part, depicted a landscape – the Stour valley in which he had grown up – that would have been unfamiliar to most exhibition visitors, and that was bereft of any notable landmarks. Most importantly of all, perhaps, his exhibition pictures were painted in a manner that eschewed many of the eye-catching conventions and effects associated with landscape art in this period, and that had been taken to new heights by Turner. Constable built his practice upon a patient, laborious and time-consuming observation of nature in the outdoors. Though this process

generated studio works that are, to our eyes, supremely naturalistic, those same works, to those contemporaries who noticed them, often seemed humdrum not only in their content but also in their manner: in the diarist Joseph Farington's words, they were deficient in 'variety of colour & effect'.[21]

Paintings such as *Dedham Lock and Mill*, however, were beginning to generate new critical attention for the artist, which often focused on Constable's skill in capturing the subtle effects of changing weather conditions on the local atmosphere. In the words of one reviewer, this picture expressed something 'of the glittering freshness congenial to the effect of summer rain'.[22] However, it was only in the following year, with the exhibition of *The White Horse* (fig. 46) – a far larger canvas than those he had previously submitted – that this hitherto unsung painter came to enjoy a new and far higher artistic profile. This work kick-started a remarkable, unfolding pictorial sequence of large-scale exhibition landscapes that stretched

Fig. 45 John Constable RA, *Dedham Lock and Mill*, 1818. Oil on canvas, 71 x 90.2 cm. Private collection

into the middle of the following decade – paintings that, thanks to his use of canvases six-foot wide, have become known as Constable's 'six-footers'.

These took spectators on a succession of fascinating visual journeys through the rural environments they depicted. In *The White Horse*, for example, as in the painting of the previous year, the foreground riverbank provides our launching point, into a scene in which a barge is shown carrying a horse from one side of the River Stour to the other, and in which we, too, are invited to imagine travelling along and across the river, either down the strip of water that forks to the left, and that runs past the boathouse into a deeply shadowed copse, or else over to the right, past the drinking cows, and onto the muddy pathway that itself flows onwards, towards the strip of horizon

glimpsed through an avenue of trees. As in *Dedham Lock and Mill*, a cluster of buildings that were intimately familiar to Constable serve to occupy the pictorial middle-ground, the architectural details of which are half-hidden – systematically, we might suggest – behind the leafy veils of a succession of trees and hedgerows. From our position on this side of the river, we can only, as yet, peer into this shrouded world of cottages, barns and farmyards; it is as if we will need a vessel – the empty boat, perhaps, that lies just across the river – to take us up to the far riverbank, and into the secret yet inviting territory that lies at the painting's heart.

Critics, too, were becoming ever more interested in exploring Constable's pictures, and in appreciating their naturalism as they did so. Robert Hunt, after offering the back-handed

Fig. 46 John Constable RA, *The White Horse*, 1819. Oil on canvas, 131.4 x 188.3 cm. The Frick Collection, New York, 1943.1.147

compliment that the painter 'has none of the poetry of Nature like Mr Turner, but he has more of her portraiture,' went on to note that *The White Horse* offered a more accurate depiction of 'the outward lineament and look of trees, water, boats, &c., than any of our landscape painters'.[23] Another critic, writing of the same painting in *The Literary Chronicle and Weekly Review*, was even more enthusiastic: 'What a grasp of everything beautiful in rural scenery!'[24] The similarly monumental and brightly lit works that Constable exhibited over the next few years, in which he orchestrated a series of complex variations on his distinctive pictorial repertoire – including *Stratford Mill* in 1820, *The Hay Wain* in 1821, the *View on the Stour near Dedham* in 1822, and, after a year's absence, *The Lock* in 1824, before, finally, *The Leaping Horse* in 1825 – garnered similar kinds of attention and praise.

Much of this praise continued to focus on the success of Constable's pictures in capturing the freshness of nature, and more particularly the freshness of a fine day in the English countryside; and it also touched regularly on the freshness of his own handling of paint and colour, which became increasingly vigorous and adventurous as the decade progressed. Thus, in 1820, one writer described *Stratford Mill* as a work in which 'the freshness and complete air of Nature are beautifully depicted', while another described its depiction of shadowed verdure as 'deliciously fresh'.[25] In 1821, Robert Hunt lauded *The Hay Wain* for its 'open air and fresh and leafy look'; another critic praised the painting's 'fine freshness of colouring'.[26] In 1822, a writer in the *New Monthly Magazine* wrote of the *View on the Stour near Dedham* that it was 'replete with the freshness and truth of nature' while in 1824, critics praised *The Lock* for being 'very fresh, clear and pure in colour' and as 'a landscape composition, which for depth, sparkling light, freshness and vigorous effect, exceeds any of his former works.'[27]

The Leaping Horse (cat. 24), the final picture in this sequence of large landscapes, which Constable worked upon obsessively both before and after the 1825 exhibition, sees the artist straining to his utmost to articulate forms of mark-making that offer an approximation to the appearance and the experience of a landscape that, in his own words, was both 'lively – & soothing, calm and exhilarating, fresh – & blowing'.[28] This is a painting that is intended to convey – in part through its use of sparkling dots of white paint and its visibly busy brushwork – the bracing freshness of a wind-blown day in the open spaces of the Suffolk countryside, when clouds race across the sky and even the largest trees lean backwards as they are buffeted by the breeze. At the same time, of course, the painterly gestures and traces that animate the picture's surface would have helped Constable's work stand out from the crowd of paintings with which it was surrounded at Somerset House. By this point, we can conclude, he had become a true exhibition painter: a landscape artist who was now extremely adept at courting the eyes of visitors with canvases that swirled with life and liveliness. If this meant that, for some critics, his pictures were a 'little too meretriciously sparkling', then that was the price he was going to have to pay.[29]

TURNER LARGE AND SMALL

Constable's relentless pursuit of his own path of landscape painting was always, in part, defined by the conscious difference it offered to the far more obviously varied and cosmopolitan output of his famous contemporary, Turner, whose talent he nevertheless found awe-inspiring, and whose increasingly light-filled exhibition pictures he described in 1828 as 'golden visions, glorious and beautiful'.[30] Throughout the 1820s Turner continued to exhibit both oil paintings and the occasional watercolour at the Annual Exhibition, the former

of which included, in the year of the *Leaping Horse*, a large-scale, radiant oil depicting the harbour of Dieppe (fig. 47).[31] From the early 1830s onwards, Turner confined his submissions to oil paintings, many of which maintained the grandiloquent scale and spectacular effects of pictures such as *Dieppe*. The artist could be sure that monumental canvases like these would continue to attract – in fact, dominate – attention at the Academy. At the same time, he seems to have been keen to display smaller oils that, in many ways, maintained the qualities of transparency and lightness associated with the more modestly scaled watercolours for which he had long been famous. Turner knew that,

in the exhibition space, such works, especially when they were granted what reviewers of his paintings repeatedly described as their distinctive pictorial 'glow', could provide moments of exquisite visual pleasure within the display as a whole.[32] One good example is his picture *Calais Sands at Low Water: Poissards Collecting Bait* (cat. 25), which the artist exhibited in 1830, and which is characterised by a striking form of pictorial economy. Great stretches of beach are emptied of detail. The picture's stooping protagonists, French fisherwomen collecting bait, are faceless cyphers. And the famous landmark of Fort Rouge, out on the horizon, is a murky square of shadow. We are

Cat. 24 **John Constable** RA, *The Leaping Horse*, 1825. Oil on canvas, 142 x 187.3 cm. Royal Academy of Arts, London. Supported by the Thompson Family Charitable Trust, 03/1391

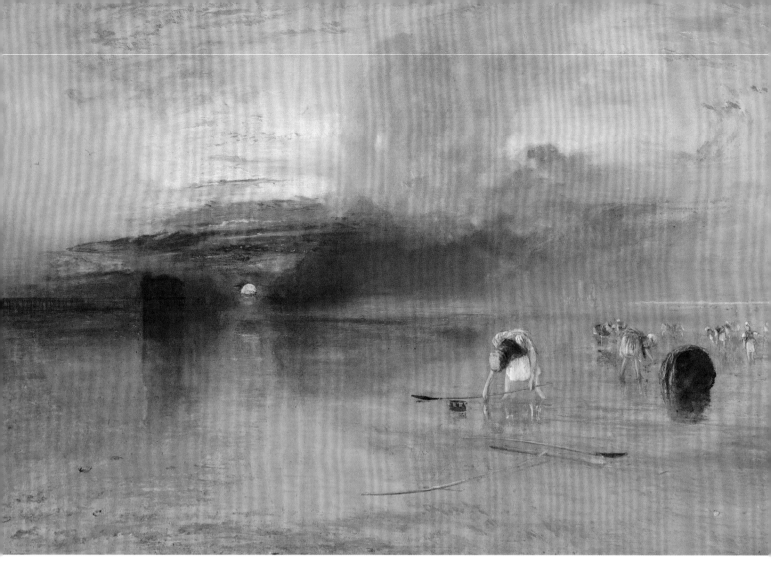

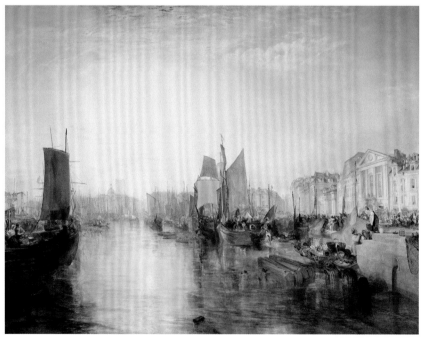

Cat. 25 Joseph Mallord William Turner RA,
Calais Sands at Low Water: Poissards Collecting Bait, 1830.
Oil on canvas, 68.8 x 103.8 cm. Bury Art Museum,
Greater Manchester, BUYGM.0114.1901

Fig. 47 Joseph Mallord William Turner RA, *Harbour of Dieppe.*
Changement de Domicile, 1825 (exh. 1825; subsequently
dated 1826). Oil on canvas, 173.7 x 225.4 cm. The Frick Collection,
New York, 1914.1.122

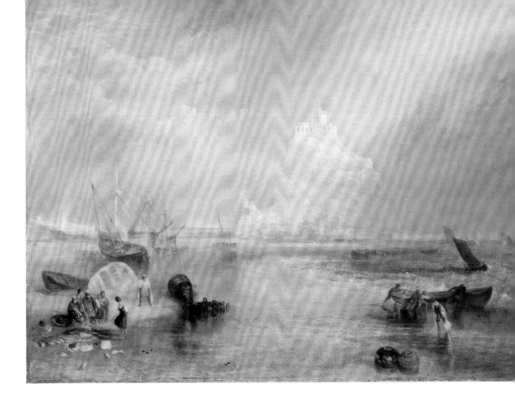

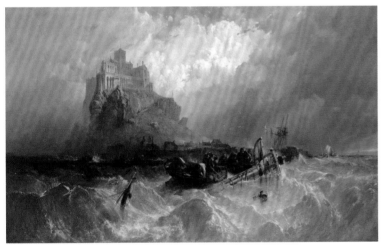

left with little other than the image of a glorious sunset reflected in wet sand, centred upon a simple disc of pale yellow paint that prefigures the 'scarlet seal' that was to be painted by Turner on his *Helvoetluys: The City of Utrecht* two years later, and that in this case prompted one critic to declare, rhapsodically, that 'the sun is positively shining'.[33]

Calais Sands, which Turner seems likely to have conceived as a tribute to the recently deceased young landscape artist Richard Parkes Bonington, shared space in the 1830 exhibition with an especially spectacular work by yet another talented and increasingly prominent practitioner in the genre, Clarkson Stanfield.[34] The latter's *Mount St Michael, Cornwall* (fig. 48) was one of the hits of that year's show, and was lauded by one critic as 'the lion of the place; and a magnificent lion it is – roaring … and lashing out its tail'.[35] Another critic, later in the same year, went further, and began placing Stanfield in the orbit of the painter who for so long had been accepted as the true king of the artistic jungle: 'Truth and vigour eminently characterise STANFIELD'S pictures, poetry and grandeur those of TURNER.'[36] The latter, as always, had the final word – but he did so in a painting that, rather than duplicating the exclamatory rhetoric of his new rival's work, translated its subject-matter into something that was far quieter in tone. In Turner's more modestly scaled *St Michael's Mount, Cornwall* (cat. 26), displayed at the Annual Exhibition in 1834, the central pictorial motif of the celebrated Cornish landmark, which in Stanfield's painting rises with heroic ruggedness out of a raging sea, is recast entirely, and turned into something that resembles, rather, a fragile, shimmering mirage, hovering with what a reviewer described as 'unsubstantial and visionary' lightness over another humble working beach.[37] Grandeur, the older artist seems to be suggesting, can be expressed through a whisper, as well as a roar.

Fig. 48 **Clarkson Stanfield** RA, *Mount St Michael, Cornwall*, 1830. Oil on canvas, 153.2 x 244 cm. National Gallery of Victoria, Melbourne. Gift of J. R. Hartley, 1931, 4514-3

Cat. 26 **Joseph Mallord William Turner** RA, *St Michael's Mount, Cornwall*, c. 1834 (exh. 1834). Oil on canvas, 61 x 77.4 cm. Victoria and Albert Museum, London. Given by John Sheepshanks, 1857, FA.209[O]

TURNER AND THE EXHIBITION WATERCOLOUR: *RISE OF THE RIVER STOUR AT STOURHEAD*

JESSICA FEATHER

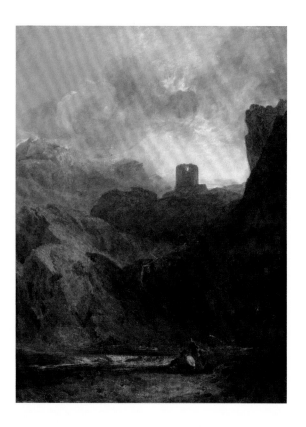

In the late 1810s and early 1820s J. M. W. Turner only occasionally displayed watercolours at the Academy. Instead, he chose to save many such works for venues that were more sympathetic to showing this medium. The handful of watercolours that he did continue to exhibit were images he sought to make stand out from the hundreds of other pictures on display. Some of the strategies he employed to achieve this can be observed in one such watercolour, his *Rise of the River Stour at Stourhead*, exhibited at the Academy in 1825 (cat. 27).

At 66 x 102 cm, *Rise of the River Stour at Stourhead* was more than double the size of the majority of Turner's watercolours, suggesting that scale was one of his exhibition strategies. Turner had long employed this in his exhibition oil paintings: in works such as *Dolbadern Castle, North Wales* (fig. 49) he used both the sense of scale within the image and the physical scale of the picture itself to overwhelm and impress the viewer.

Rise of the River Stour was among a growing group of Turner's Academy watercolours that were remarkable for another reason: the artist's incomparable use of tonal control and intensity of colour to suggest shimmering, dazzling light. Turner had, of course, always been concerned with the representation of light. But his exhibition watercolours of the 1820s benefit from changes in his understanding of light that occurred as a result of his first visit to Italy in 1819. Works such as *Rise of the River Stour* gained a remarkable intensity of colour: using only a very carefully limited range of yellow and pink tones in the sky, Turner nevertheless ensured that the setting sun casts a

Fig. 49 **Joseph Mallord William Turner** RA, *Dolbadern Castle, North Wales*, 1800. **Oil on canvas, 119.4 x 90.2 cm. Royal Academy of Arts, London, 03/1383**

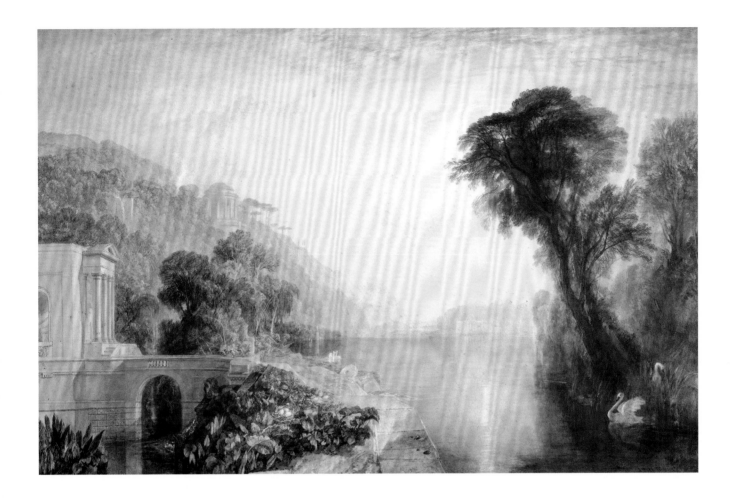

powerful luminescent glow, leaving
Stourhead's Pantheon shimmering
in the far background, and seeming
almost to disappear into the horizon.

Here, it is light that enhances
the meaning of the work. Based on
the idyllic gardens of Stourhead in
Wiltshire, *Rise of the River Stour* is,
however, an idealised representation,
in which Turner uses artistic licence
to make his watercolour bear a strong
resemblance to a poetic fantasy by
Claude Lorrain. The light is Italianate,
emphasising Claudian notions of
ideal beauty. Although Turner's other
works had often received negative
responses because of the increasing
yellowness of his palette, in this case
critics praised the work's 'effulgence'
as well as its harmonies of chiaroscuro
and the prismatic, glowing light that
suffuses the picture.[1] His treatment of
light, which gives the work its ethereal
quality, allowed critics to overlook the
fact that it was not a literal re-creation
of a scene, but instead one that focused
on Stourhead's magical and poetic
qualities. As the correspondent for the
European Magazine wrote, it was 'very
poetically treated, without violating
or exaggerating any of the truths of
nature, or the rules of art'.[2] This was
indeed a watercolour that succeeded
in standing out from the crowd.

Cat. 27 **Joseph Mallord William Turner** RA,
Rise of the River Stour at Stourhead, c. 1824 (exh. 1825).
**Watercolour on paper, 66 x 102 cm. Sudeley Castle,
Winchcombe, Gloucestershire**

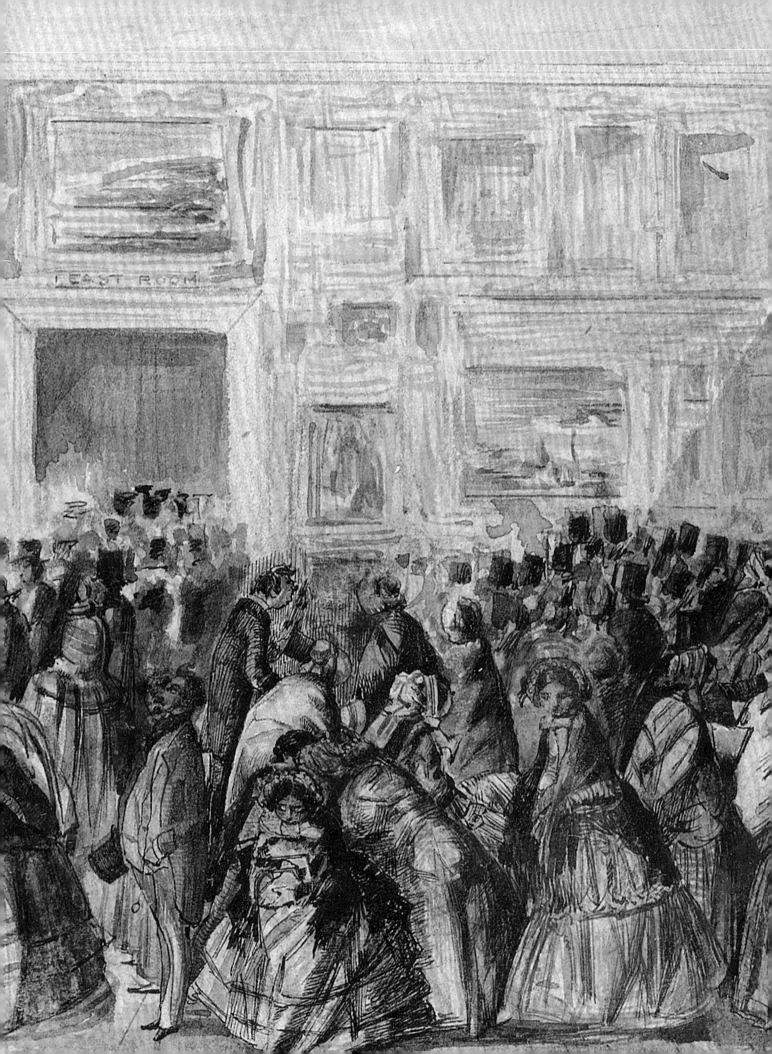

THE PRE-RAPHAELITES ARRIVE

SARAH VICTORIA TURNER

Isabella (cat. 28) was John Everett Millais's first Pre-Raphaelite painting. It was also the only work he submitted to the Royal Academy exhibition in 1849. An enigmatic monogram containing the initials 'PRB' followed the artist's signature, and was also painted to look as if it had been carved into the wooden bench on which the picture's leading protagonist, Isabella, demurely sits. This was not, however, the first time that these strange initials

had been seen in London. The first work to declare itself openly as 'Pre-Raphaelite' through the use of such a monogram was Dante Gabriel Rossetti's *The Girlhood of Mary Virgin* (fig. 50), which had been exhibited a few months earlier at the Free Exhibition of Modern Art less than half a mile away at Hyde Park Corner. Rossetti had intended to submit his painting to the Royal Academy, but a last-minute change of heart caused him to send it instead

Left: Detail of cat. 1
Above: Cat. 28 **Sir John Everett Millais Bt PRA,** *Isabella*, **1849.**
Oil on canvas, 103 x 142.8 cm. National Museums Liverpool,
Walker Art Gallery, WAG 1637

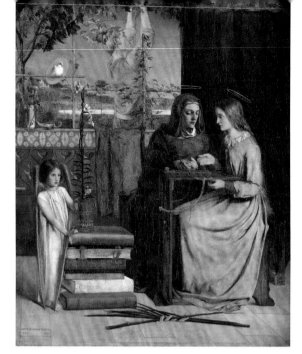

to the juryless Free Exhibition. This rival event opened in March, in order to garner the attention of the press and public before the much larger Annual Exhibition opened at the Royal Academy at the beginning of May. The Pre-Raphaelite Brotherhood – the 'PRB' of the monogram featured in both pictures – had been founded only a few months before, in 1848.[1] Significantly, an encounter at the Academy's annual display that year had provided the catalyst for the formation of this artistic grouping. On seeing William Holman Hunt's *The Flight of Madeline and Porphyro During the Drunkenness Attending the Revelry (The Eve of St Agnes)* (Guildhall Art Gallery, London) at the Academy, Rossetti sought out Hunt, declaring that the 'picture of "The Eve of St Agnes" was the best in the collection'.[2] Along with Rossetti and Hunt, whose friendship developed after this meeting, the other members of the group were John Everett Millais, Rossetti's brother William Michael Rossetti, James Collinson, Thomas Woolner and F. G. Stephens. Ford Madox Brown, although never officially a member, was closely associated with the PRB.

This artistic grouping is now so well known in Britain and internationally, and so firmly woven into the histories of British art, that it takes some historical imagination to travel back to the cultural contexts of 1849 to understand why their paintings were seen as significantly different to those of their contemporaries when they went on display for the first time at the Royal Academy's Annual Exhibition in the early summer of that year, causing an even greater critical storm at the exhibition of 1850.

When the Annual Exhibition opened in May 1849, Millais and William Holman Hunt, as very young and relatively unknown artists, would no doubt have been pleased with the placement of their works by the Academy's Hanging Committee. Alongside *Isabella* in the Middle Room of the display – a prime spot in the exhibition on the all-important 'line' – hung Hunt's *Rienzi Vowing*

to Obtain Justice for the Death of His Younger Brother, Slain in a Skirmish between the Colonna and Orsini Factions* (fig. 51). Another painting in the exhibition bearing the 'PRB' monogram was James Collinson's *Italian Image-Boys at a Roadside Alehouse* (fig. 52).[3] This proximity of display not only allowed for easy comparison of these pictures, but also, and perhaps more significantly, distinguished them from neighbouring canvases. The visual cacophony of the Annual Exhibition hang could drown a painting, but in 1849, Millais and Hunt both succeeded in making their works speak loudly from the wall, capturing the attention of press and public. In the words of William Michael Rossetti these works 'stood out conspicuously from their surroundings'.[4] The more impartial critic of the *Art Journal* noted of *Isabella* that it was 'the most remarkable of the whole collection; it cannot fail to establish the fame of the young painter'.[5]

The Annual Exhibition's reputation as a site of critique and contestation had been underscored on numerous occasions in preceding decades and these young artists (Millais and Hunt were just 19 and 22 respectively) were well aware of the scrutiny of the press and public at the Academy's exhibition, which was still very much the highlight of the cultural calendar in the mid-nineteenth century and certainly the biggest artistic event of its kind in Britain. London in the late 1840s and early 1850s was not only the capital of the United Kingdom, but also the

Fig. 50 **Dante Gabriel Rossetti,** *The Girlhood of Mary Virgin,* **1848–49. Oil on canvas, 83.2 x 65.4 cm. Tate: Bequeathed by Lady Jekyll 1937, N04872**

centre of a growing empire that was sustained by burgeoning transport, industrial and communication systems. To exhibit at the Royal Academy in this period was to exhibit on a world stage to a very large public. News of the exhibition spread fast, especially through the pages of the expanding national and international press; it was thus a place in which controversies could be generated, and reputations could be made (or undone) very quickly.

Those features that made Millais's painting 'remarkable' included its subject-matter, drawn from a historical source, but also the sense that this painting offered a radical new style. Put simply, Millais's paintings, along with Hunt's, appeared very different to the work of their academic contemporaries, with their powerful, emotionally loaded storylines of love and justice inspired by fourteenth-century Italy and their bright, jewel-like colours. This was also partly to do with their compositions and their management of pictorial space: the deliberate lack of depth in both paintings

compresses the complex action and narrative, and gives the works a frontality that pushes the figures towards the viewer. Furthermore, the strongly delineated forms and highly individualised faces of each character (both had used friends

Fig. 51 **William Holman Hunt,** *Rienzi Vowing to Obtain Justice for the Death of His Younger Brother, Slain in a Skirmish between the Colonna and Orsini Factions,* 1848–49. Oil on canvas, 83 x 117 cm. Private collection

Fig. 52 **James Collinson,** *Italian Image-Boys at a Roadside Alehouse,* 1849. Oil on panel, 78.7 x 109.2 cm. Private collection

and family as sitters, including Dante Gabriel and William Michael Rossetti) were painted with small, fine brushes. Detail is painstakingly rendered in both *Isabella* and *Rienzi*: the particular folds and creases in the textiles; the sheens of the velvets and brocaded costumes; the smooth, hard surfaces of the majolica plates; the individual hairs on the muzzle of the greyhound tenderly resting its head on Isabella's lap; each feather of the hawk to the left of that same canvas; the blades of grass and the wisps of the dandelion clock in the foreground of the *Rienzi*. Pre-Raphaelite painting demanded (and continues to demand) close attention on the part of the viewer. To take all this in, a casual glance was certainly not enough. Millais and Hunt were forcing exhibition-goers to pause and to spend time with their paintings; to give them a more sustained look than the jostle of the Annual Exhibition would normally allow. Theirs was a crisp, clear and deeply compelling new aesthetic language.

OUTSIDERS FROM WITHIN

Millais, Hunt and Rossetti had been students at the Royal Academy Schools and were thoroughly inculcated in their teachings and traditions. Like their fellow students, they had grown up as artists through drawing from casts of classical sculpture, sometimes for three years, before progressing to draw from the life model. Millais was infused with the doctrine of academic training earlier than most, having become the youngest ever student to attend the Schools at the age of eleven in December 1840, after a spell at Sass's Academy in Bloomsbury. As students of the Academy, Millais and Hunt were thus in many ways insiders; yet, in the summer of 1849, they used the space of the exhibition strategically, to position themselves as outsiders from within. Millais, Hunt and their fellow

PRB colleague James Collinson had all exhibited at the Academy before, so they were not complete newcomers.[6] There was, however, something about the effort of exhibiting, collectively, as PRB artists that succeeded in getting their manifestoes-in-paint noticed at the 1849 exhibition – perhaps it was using 'PRB' to subversively mimic the way that Royal Academicians often used 'A.R.A.' and 'R.A.' after their names.[7] The paintings Millais and Hunt sent to the Academy that year declared their differences to their academic training and their teachers through the medium of paint. More particularly, their highly detailed and finely executed style offered a dramatic contrast to the broader handling and tenebrous forms of chiaroscuro that – following on from the teachings and example

Fig. 53 **William Etty** RA, *Britomart Redeems Faire Amoret*, 1833. Oil on canvas, 90.8 x 66 cm. Tate: Purchased 1958, T00199

of Joshua Reynolds (nicknamed 'Sir Sloshua' by the PRB artists) – had become conventional in the history and genre paintings exhibited at the Academy in 1830s and 1840s by artists such as the late David Wilkie, William Hilton, William Etty (fig. 53), Edwin Landseer and Charles Robert Leslie.

These ambitious works also stood out from those of their Academy forebears and peers because of their unusual and yet highly engaging subject-matter. The storylines of *Isabella* and *Rienzi* both depicted scenes of Italian history translated via contemporary and popular sources. For the *Rienzi* painting, Hunt drew on Edward Bulwer Lytton's *Rienzi, the Last of the Roman Tribunes*, a novelisation set in the fourteenth century and published in 1835, which was also the source of an early opera by Richard Wagner, first performed in Dresden in 1842.[8] Meanwhile, Millais came to his subject – Isabella and her tragic and much-disapproved-of love for Lorenzo, a lowly clerk in her Florentine family's business – via the poet John Keats and his poem 'Isabella; or the Pot of Basil' (1818), which was in its turn inspired by the fourteenth-century Italian writer Giovanni

Boccaccio.[9] Quotations from the first and twenty-first stanzas of Keats's poem were printed in the exhibition catalogue. This text, along with the narrative and symbolic details contained within the picture itself, made it clear that the tension expressed in the exchange of a blood orange between Isabella and Lorenzo, and in the aggressive gestures of her brothers, cracking walnuts and aiming a pointedly extended leg at the lovers, would end in misery. Indeed, the pot of basil on the windowsill in the background prefigures the horrible culmination of the story, whereby Isabella rescues the severed head of her murdered lover, hides it in a pot of basil and waters it with her tears. Quoting from poetry or literary sources in exhibition catalogues, to explain or reinforce the subject-matter or meaning of a work of art, was not unusual at this time. Millais, however, used this device to particularly good effect, again encouraging the viewer to linger over his work, to look, to read and potentially to be imaginatively transported, through the captivating qualities of his canvas, into a fictional scene in medieval Florence.

Such works suggested a new kind of 'history painting' that was of a very different order to that normally encountered at the Annual Exhibition: to the scenes of nationalistic naval and military history that were popular and ever-present; to the scenes of classical mythology and Renaissance literature associated with artists such as Etty and Hilton; and to the more anecdotal and often humorous scenes of history and literature associated with such early nineteenth-century artists as Charles Robert Leslie. By choosing two scenes drawn from tragic forms of late-medieval Italian romance literature (albeit via nineteenth-century sources), these first Pre-Raphaelite artists made an argument for a kind of history painting that had strong links with its

Fig. 54 **Jan van Eyck, *Portrait of Giovanni(?) Arnolfini and His Wife (The Arnolfini Portrait)*, 1434. Oil on panel, 82.2 x 60 cm. The National Gallery, London, NG 186**

contemporary moment but also looked into the deep past for sources of inspiration and renewal. More specifically, with these paintings, Millais and Hunt argued that artists, in looking backwards, should aim far beyond the British tradition and the Renaissance masters lauded by the Royal Academy in its Schools, notably Raphael, Leonardo and Titian, and examine instead late medieval and early Renaissance art – art that was quite literally pre-Raphael. These young Pre-Raphaelite artists were searching for new points of origin and inspiration in the past in order to change the future.

This search was very much rooted in the contemporary circumstances of London's art institutions.[10] For the young Pre-Raphaelites, the paintings of fifteenth-century Italy and Northern Europe were only a short walk from the doors of the Academy itself. The royal institution, housed in Trafalgar Square between 1837 and 1868, shared premises with the National Gallery (the Academy occupied the East Wing and the National Gallery the West Wing) where such works as the *San Benedetto*

Altarpiece, now attributed to Lorenzo Monaco, had been on view since July 1848. A few years earlier, in 1842, the National Gallery had acquired Jan van Eyck's *Portrait of Giovanni Arnolfini(?) and His Wife*, or *The Arnolfini Portrait* as it is more commonly known (fig. 54), a painting that quickly attained 'the status of a cult image'.[11] This not only highlights the importance of such historical precedents for the radically new art that the Pre-Raphaelite Brotherhood was creating; it also demonstrates how important it is to view events at the Royal Academy and its annual exhibitions in relation to the wider cultural landscape in which they operated. The PRB are frequently romanticised as bohemian outsiders, but their rebellion was fuelled by institutions and institutional networks from which they sought to break free. Proximity can breed contempt; but, as in this case, it can also lead to new pictorial discoveries and an awareness of surprising artistic affinities.

Millais's submission to the Royal Academy exhibition in 1850, *Christ in the House of His Parents (The Carpenter's Shop)* (fig. 55), met with

Fig. 55 **Sir John Everett Millais Bt PRA**, *Christ in the House of His Parents (The Carpenter's Shop)*, 1849–50. Oil on canvas, 86.4 x 139.7 cm. Tate: Purchased with assistance from the Art Fund and various subscribers 1921, N03584

an altogether different response to the warm intrigue that surrounded his 'remarkable' *Isabella*.[12] A storm of vituperative criticism rained down on this work, which depicts Christ as a child wounded by a nail in Joseph's carpenter's workshop, thus prefiguring the stigmata from the nails of his future crucifixion. The critical onslaught was partly provoked by the 'low' setting in which Millais had set this religious scene, and the minutely detailed way in which he had depicted this environment: 'the meanest details of a carpenter's shop, with no conceivable omission of misery, of dirt, of even disease, all finished with loathsome minuteness', as the reviewer for *The Times* put it.[13] The attacks were also prompted by what was considered by some writers to be a predilection within the image for Roman Catholic beliefs and rituals (a topic of religious controversy at this time when anti-Catholic sentiments were running high).

There was also increasing suspicion about the almost cultic aspects of a group of young artists exhibiting together as the 'PRB'.[14] Repeating the

pattern of the preceding year, Millais's *Christ in the House of His Parents* hung near Hunt's *A Converted British Family Sheltering a Christian Missionary from the Persecution of the Druids* (fig. 56). The pictures' proximity once again emphasised their connections in terms of their similar compositional format and the loaded symbolism of their religious subjects, accompanied by piercingly realistic details painted from nature. One of the best-loved novelists of the Victorian period, himself a proponent of realism, Charles Dickens, intervened in the debate and his attack testifies to the emotional response that could be raised by such pictures. Writing in his journal *Household Words*, Dickens described the figure of Christ in Millais's painting as 'a hideous, wry-necked, blubbering, red-headed boy, in a bed-gown', and his mother, Mary, as 'so horrible in her ugliness, that (supposing it were possible for any human creature to exist for a moment with that dislocated throat) she would stand from the rest of the company as a Monster, in the vilest cabaret in France, or the lowest ginshop in England'.[15] Most accounts of this

Fig. 56 **William Holman Hunt, *A Converted British Family
Sheltering a Christian Missionary from the Persecution of the Druids*,
1850. Oil on canvas, 111 x 141 cm. Ashmolean Museum,
University of Oxford, WA1894.1**

episode in early Pre-Raphaelite history concentrate on this more sensational negativity, although it is important to point out that there was praise as well as contempt, with the reviewer for the *Illustrated London News* describing the 'excellence' and 'thousand merits' of Millais's *Christ in the House of His Parents*.[16] Millais and Hunt were certainly not the first artists to be on the receiving end of scathing critique at the Academy's exhibition. In many ways, it was probably the response they had expected (and were surprised not to receive) in 1849. Furthermore, they would have known that art reviewing was conditioned, then as now, by its own rituals and conventions, as well as by personal and professional likes and dislikes.[17]

THE PRB AND RELIGION

As Millais's work of 1850 – and the response it helped to generate – makes apparent, religious painting played an important and controversial part in launching the Pre-Raphaelite style at the Royal Academy. In the following year, Charles Allston Collins exhibited *Convent Thoughts* (fig. 57), painting the flowers in the background of his work during a painting trip near Oxford in the company of Millais, who was himself working on *The Woodman's Daughter*, one of his submissions to the 1851 Annual Exhibition. By 1854, when Hunt exhibited *The Light of the World* (cat. 29) at the exhibition, along with its pendant piece *The Awakening Conscience* (Tate), audiences and critics were becoming well acquainted with Pre-Raphaelite style and techniques. The copious reviews published in response to their exhibited paintings had also developed a language – both positive and negative – for describing this kind of work. One of the most ardent supporters of Millais, Hunt and their circle was the art writer and painter John Ruskin. His intervention in the public debate created by the Pre-Raphaelite pictures and, in 1854, by Hunt's works in particular, was mounted in the spirit of defence, but also with a sense of moral purpose. Writing to the editor of *The Times* on 5 May 1854, Ruskin reported that he had spent 'upwards of an hour' standing by *The Light of the World* the previous day watching

how exhibition-goers interacted with it.[18] After writing about the possibility of personal salvation presented by the painting, Ruskin declared that, 'for my own part, I think it one of the very noblest works of sacred art ever produced in this or any other age'.

Inspired by a passage in the Book of Revelation in the Bible – 'Behold I stand at the door, and knock: if any man hear my voice, and open the door, I will come in to him, and will sup with him, and he with me'[19] – Hunt's painting contains an implied message about the creation of moments of intimate, religious communication between God and the believer. However, for several summer months in 1854, this image of private religious experience hung in the busy surroundings of the Academy's Annual Exhibition. As Ruskin hinted at, these conditions were hardly ideal for intimate religious communion or even sustained and careful looking. The scale of the exhibition and the press of other spectators pushed the visitor onwards.

The Light of the World also demonstrates the importance of the exhibition as a form of advertisement, and as a stepping-off point for works of art. Hunt's painting was to take on another life beyond the exhibition in the following years, when it became one of the most recognised and widely reproduced images of the

Fig. 57 **Charles Allston Collins,** *Convent Thoughts*, **1851.**
Oil on canvas, 84 x 59 cm. Ashmolean Museum,
University of Oxford, WA1894.10

Cat. 29 **William Holman Hunt,** *The Light of the World,*
1851–53 (exh. 1854). Oil on board, 122 x 60.5 cm. Warden,
Fellows and Scholars of Keble College, Oxford, PCF24

nineteenth century. In engravings, copies and public tours throughout Britain and the empire, the painting left the institutional confines of the Royal Academy behind and circulated through the channels of public culture, entering homes in the form of cheap prints (both legal and illegal).[20] These copies and reproductions secured the iconic status of this image long after it had first been exhibited at the Royal Academy.

FRIENDSHIP AND FOLLOWERS

If the reviewer of the *Art Journal* could describe the Pre-Raphaelites as the 'revolutionary faction – the young England section' at the 1850 Royal Academy exhibition, by the mid-1850s the revolutionaries (or some of them at least) had become far more accepted and their painting style was very much a regular fixture in the annual exhibitions.[21] Millais, for instance, had already become an Associate of

Cat. 30 **John Brett** ARA, *The Val d'Aosta*, 1858 (exh. 1859). **Oil on canvas, 87.6 x 68 cm. Private collection**

the Royal Academy in 1853, becoming a full Royal Academician in 1863; later, for a few months in 1896, he was to become its President. The PRB revolution was a short-lived one, but Pre-Raphaelite technique, subject-matter and ethos were absorbed and adapted by a younger generation of artists. Thus, in the later years of the 1850s and in the 1860s, the walls of the Annual Exhibition featured the work of those who had encountered the Pre-Raphaelite style either through personal contact or through the study of exhibited works.

One such artist was John Brett, who exhibited works at the Academy along with his sister, the artist Rosa Brett, who displayed her paintings under the pseudonym 'Rosarius' so as to remove any hint of her gender. Both artists were disciples of Ruskin's 'truth to nature' approach, developing a new kind of minutely described landscape painting that they then displayed to a mass audience at Trafalgar Square. Brett had devoured the fourth volume of Ruskin's *Modern Painters* (1856) with its theme 'Of Mountain Beauty' and had spent time with the artist John Inchbold in the mountains of Italy; he had also visited Ruskin while in Turin. Painted on the spot, Brett's *The Val d'Aosta* (cat.

30) captured the view from Mont Torretta with penetrating perspicacity, documenting the scene using an astonishing range of tints and hues.

Arthur Hughes, like Brett, came into contact with the Brotherhood fairly early, having met Hunt and Rossetti in 1850, and then quickly became part of the extended network of artists that made up the Pre-Raphaelite circle. His Academy exhibit of 1863, *Home from Sea* (cat. 31), was a reworking of his 1857 painting *A Mother's Grave*. *Home from Sea* was also painted in the open air, but a little closer to home, in the graveyard of All Saints' Church in Chingford, Essex. Here exactitude of detail is combined with the pathos of a tragic contemporary event, one that recalls the kind of storyline found in the earlier genre paintings of such artists as William Mulready: a young boy has returned home from naval service to find his mother has died. These paintings communicate the endurance of Pre-Raphaelite ideas, style and experimentation long after the days of the Brotherhood's secretive foundation; they also testify to the lasting impact that could still be made by a new mode of art when it was exhibited as part of the Academy's summer display.

Cat. 31 Arthur Hughes, *Home from Sea*, 1862 (exh. 1863).
Oil on panel, 50 x 65 cm. Ashmolean Museum, University of Oxford.
Presented by Vernon Watney, 1907, WA1907.3

PRE-RAPHAELITE SCULPTURE AND BEYOND

SARAH VICTORIA TURNER

Cat. 32 Alexander Munro, *Paolo and Francesca*, 1851–52 (exh. 1852). Marble, 66 x 67.5 x 53 cm. Birmingham Museums Trust on behalf of Birmingham City Council, 1960P29

Alexander Munro's only submission to the Royal Academy's Annual Exhibition of 1852 was a marble sculpture of Dante's tragic lovers Paolo and Francesca (cat. 32). It was listed in the catalogue in Italian and accompanied by a translation from *The Divine Comedy*. Quivering with illicit desire – a sentiment captured even in the hard, cool material of marble – Paolo leans in to embrace Francesca, his brother's fiancée, tenderly. While reading the story of Lancelot and Guinevere, the two fall in love – a forbidden romance that will ultimately lead to their murders. Their story was hugely popular in the nineteenth century and one with which exhibition-goers would have been familiar. Munro, a friend of the Pre-Raphaelite circle, creates in this work the closest sculptural equivalent to the formal precision and youthful ardour of the first Pre-Raphaelite paintings, which had caused such a stir in the exhibitions of 1849 and 1850. After seeing a plaster version at the Great Exhibition in Hyde Park in 1851, William Gladstone MP (who was to become Prime Minister in the next decade) commissioned this version in marble. Dante Gabriel Rossetti, a huge admirer of Dante, also owned a plaster copy that Munro had given him. The delicacy of Paolo's touch as his fingers wrap around Francesca's own on the fateful open book points to the interlacing of love, literature and history from which Munro and his friends took inspiration.

It is perhaps hard now to see this sculpture as experimental. Its genteel depiction of desire and the cool, polished surface of the marble contribute to a sense of quiet accomplishment, rather than technical bravura; however, it certainly offered a sculptural contribution to the debates

about Pre-Raphaelitism at the Royal Academy. However, it was not until later in the nineteenth century that sculpture at the Summer Exhibition was more explicit in its experiments with surface techniques and the addition of colour. The Royal Academy's summer exhibitions, especially under the presidency of the painter-sculptor Frederic Leighton, were important in the development of sculptural practice and debate – the art critic Edmund Gosse coined the phrase 'The New Sculpture' to describe these innovations – and were characterised by a physical dynamism, an experimental approach to creating texture through the medium of bronze, and a devotion to the nude form. According to Gosse, the New Sculpture updated academic traditions for modern times: he wrote that these works were 'modern in sentiment and antique in form, blending the present and the past by sympathy rather than by antiquarian study'.[1] This approach found expression both in small statuettes and in life-sized figures, as in Alfred Gilbert's *Icarus*, Leighton's *Sluggard* and Edward Onslow Ford's *The Singer*. In 1884, Auguste Rodin exhibited *The Age of Bronze* (cat. 33) at the Summer Exhibition, an already infamous work that had caused great controversy when exhibited at the Paris Salon of 1877 when it attracted suspicion that it had been cast directly from a live model. Rodin's approach to materials, surface treatment and the human figure was significant for the New Sculpture movement in Britain. *The Age of Bronze* was enthusiastically received in the British press and by fellow artists and the public. William Ernest Henley, editor-in-chief of the *Magazine of Art*, wrote: 'In the sculpture galley, incomparably the best thing of all is

M. Rodin's *Age of Bronze*', adding a gripe that was common to the display of much sculpture at the Academy in the period: 'It is badly placed; so that only one of its aspects is to be studied.'[2] Sculpture has had to fight hard for attention at the Summer Exhibition, where painting has predominated (and arguably still does). Nevertheless, many sculptural objects have stood out within the display and made their claim on its history.

Cat. 33 **Auguste Rodin, *The Age of Bronze*, 1877 (exh. 1884). Bronze, 181 x 66 x 63 cm. Victoria and Albert Museum, London. Given to the Victoria and Albert Museum by Rodin in 1914, A.33-1914**

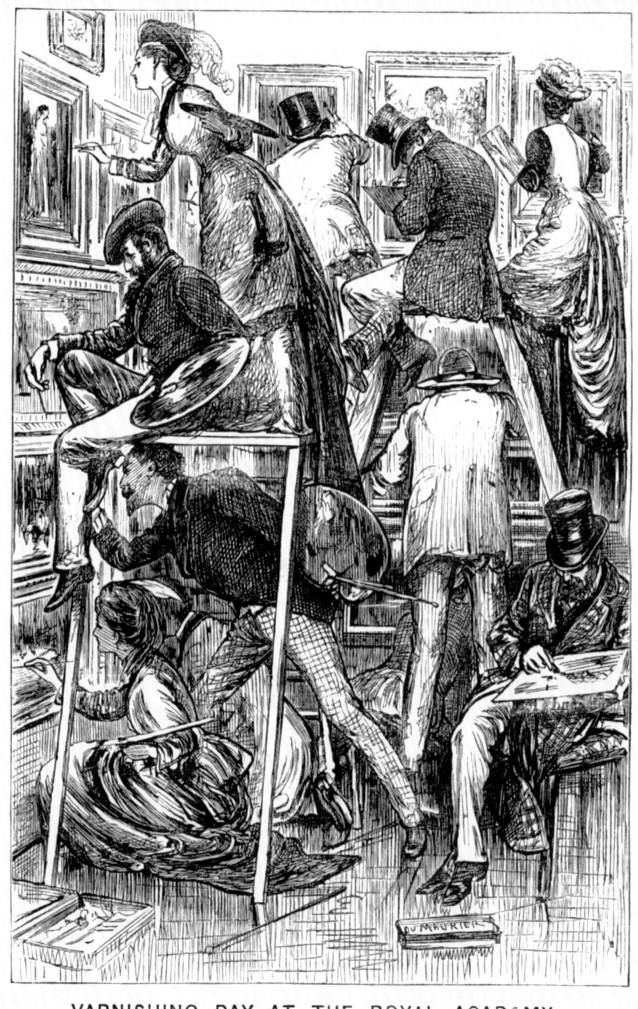

VARNISHING DAY AT THE ROYAL ACADEMY.

VICTORIAN ACCLAIM

SARAH VICTORIA TURNER

Edwin Landseer's magisterial stag – now better known as *The Monarch of the Glen* (fig. 59) – stands in splendid isolation on windswept grasses and heathers, framed by a backdrop of lonely mist-shrouded mountains. Reproduced in many contexts, from whisky labels to biscuit tins, Landseer's stag has come to encapsulate an enduring, mythic image of the Scottish Highlands. However, when displayed to the public for the first time in 1851, the stag had plenty of company. Placed centrally on a corner wall of the East Room in the Academy's Trafalgar Square premises, the painting shared this small portion of the exhibition with no fewer than twenty other paintings of differing shapes and sizes, not to mention styles and subjects. The Polish painter Károly (he was listed as Charles in the catalogue) Brocky's *Psyche* was placed directly above Landseer's work, while Thomas Webster's *A Chimney Corner*, William Dyce's *A Bacchanal – A Study* and George Jones's *Castor and Pollux* were displayed nearby; the hang was topped by the material red swag that festooned the walls of the gallery. We know this thanks to a meticulously hand-drawn, fold-out diagram produced, at least in part, by Henry Eyre, the RA's Clerk (fig. 60), which allows us to re-create something of the urban exhibition environment in London that provided the stag's unnatural surroundings for that short summer period in 1851.

In the catalogue for that year, Landseer's painting was listed without its now eponymous name, but was accompanied by a poem from the collection known as *Legends of Glenorchay*, which contained the lines 'Uprose the monarch of the glen,

/ Majestic from his lair'.[1] The picture was an instant success, enjoying popularity from the moment of its exhibition, and it was widely reproduced around the world in engraved form.[2] Attentive visitors to the Annual Exhibition would no doubt have associated this stag with other deer painted by Landseer, most notably in *The Sanctuary*, which had been exhibited at the Academy in 1842, and which showed an exhausted stag fleeing the hunt.[3] With his 1851 submission, Landseer took the popular genre of animal painting to new heights, imbuing the animal with anthropomorphic qualities that immediately captivated the attention of the Victorian public.

In terms of wider exhibition histories, 1851 was an extraordinary year. The 83rd Annual Exhibition had particularly stiff competition in the form of the Great

Fig. 59 **Sir Edwin Landseer RA,** *The Monarch of the Glen*, 1851.
Oil on canvas, 163.8 x 168.9 cm. Purchased by the National Galleries of Scotland as a part gift from Diageo Scotland Ltd, with contributions from the Heritage Lottery Fund, Dunard Fund, the Art Fund, the William Jacob Bequest, the Turtleton Trust and through public appeal 2017. National Galleries of Scotland, Edinburgh, NG 2881

Fig. 58 **George du Maurier,** *Varnishing Day at the Royal Academy*, illustration in *Punch*, 19 June 1877. Engraving, 18.5 x 12 cm. Private collection

Exhibition of the Industry of All Nations, housed just down the road in Joseph Paxton's enormous Crystal Palace in Hyde Park. This attracted over six million visitors to view an incredible 14,000 inventions, manufactured wares and decorative objects from all over the world. The reviewer for *The Times* noted the physical proximity of the Great Exhibition to the Academy's premises, but distinguished the latter's exhibition as offering a more carefully edited selection of fine art that demonstrated 'the progress in the highest branches of taste'.[4] However, the continuing expansion of London's exhibition calendar in the second half of the nineteenth century, nationally and internationally, brought increasing challenges to the Royal Academy's supremacy, especially from the growing private and commercial gallery sector. In fact, many other galleries and exhibition spaces, such as the Grosvenor and Dudley Galleries, were set up in direct competition to the Academy, often offering

Fig. 60 **Henry Eyre,** *Diagram of the Hang of Works at the Summer Exhibition in the East Room at Trafalgar Square*, **1851. Royal Academy of Arts, London, RAA/SEC/23/1/4**

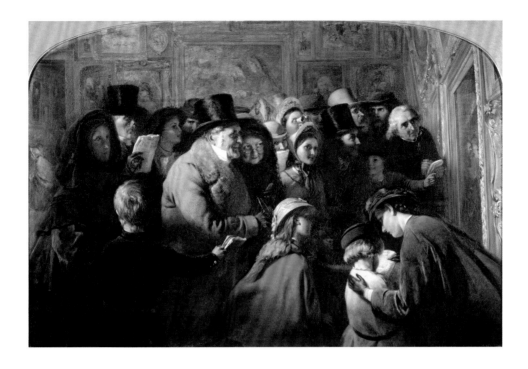

alternative ways of showing works in response to the infamous crowded hangs of its summer displays. The Royal Academy's annual exhibition, or the 'Summer Exhibition' as it was officially called from 1870 when the annual 'Winter Exhibitions' were instigated, was different and distinct – there was nothing quite like it in terms of its scale, its history and traditions – and yet it also fed into and fed off these surrounding displays. Although the Academy often presented itself as superior to, or somewhat aloof from, other exhibitions and exhibition spaces, it should be understood as part of these complex networks of display in which art and artists met their publics. The move to Burlington House in 1868 and the staging of the Annual Exhibition in specifically designed galleries (as discussed on pp. 18–19), allowed the event, and many of the works displayed in it, to grow significantly in size.[5] The diversity of style and subject-matter was dazzling, and attracted a remarkable cross-section of Victorian society. Works of art at the Summer Exhibition were the blockbusters of their day, widely discussed and illustrated in the press. This chapter discusses just a small selection of those works that caught the attention of the Victorian exhibition goers.

CROWD CONTROL: W. P. FRITH'S *RAMSGATE SANDS*

With the growing popularity of the Academy's exhibitions, crowd control became a pressing concern for the Academy's officers. It was not unusual for over 250,000 people to visit the Royal Academy's Annual Exhibition during this period. George B. O'Neill's painting *Public Opinion* (fig. 61) depicts both the crush of the salon hang and the viewers surrounding an unidentified painting. Catalogues in hand, an eager crowd visually consume the picture, with their gazes and the odd outstretched hand crossing the red barrier erected in front of the painting (of which we catch a glimpse just to the right of the young girl in the bright red coat). Several layers deep, the crowd is depicted as a collection of active and attentive viewers, typified by the woman who is equipped with opera glasses so as to ensure a better look at the works on display from a more decorous distance.[6]

An excited crush of exactly this kind had been caused in 1854 by one of the most popular paintings of its day, William Powell Frith's *Ramsgate Sands*, or, to give it the title with which it was exhibited, *Life at the Seaside* (cat. 34). A guard rail was erected in front of the painting to protect it from the press of bodies and from fingers pointing at the picture's copious details. Thirty-two years

Fig. 61 George B. O'Neill, *Public Opinion*, 1863. Oil on canvas, 53.2 x 78.8 cm. Leeds Museums and Galleries (Leeds Art Gallery)

95

Cat. 34 William Powell Frith RA, *Ramsgate Sands*
(*Life at the Seaside*), 1851–54 (exh. 1854). Oil on canvas, 77 x 155.1 cm.
The Royal Collection / HM Queen Elizabeth II, RCIN 405068

previously, David Wilkie's *Chelsea Pensioners Reading the Waterloo Despatch* (see cat. 22) had set the standard of popular success when a similar guard rail was installed around it. The crowds were drawn to this picture in 1822 by its subject, stirring patriotic memories of a recent war.[7] Frith's painting was undoubtedly less heroic, but saw genre painting being adapted for the tastes of the Victorian public. In *Ramsgate Sands*, members of the urban middle class were both the subjects *and* the viewers of a crowded beach scene at the popular Kent resort.[8] Frith followed up this painting with *The Derby Day* (fig. 62) and *The Railway Station* (1862; Royal Holloway, University of London), which also proved publicly successful 'crowd-scene'

paintings. The artist was delighted to observe the excitement generated by his works: 'Couldn't help going to see the rail, and there it was sure enough; and loads of people.'[9] We are reminded here that the artist could also be an exhibition-goer.

Ramsgate Sands also highlights the growing commercial potential of exhibiting at the Annual Exhibition. Frith had sold the painting to the art dealers Messrs Lloyd for 1,000 guineas just before the display opened. This became an increasingly common practice throughout the Victorian period. In such circumstances, public exhibition and art criticism would serve to consolidate an already purchased work's fame or reputation rather than help the artist to find a buyer. In this

Fig. 62 **William Powell Frith RA**, *The Derby Day,* 1856–58. Oil on canvas, **101.6 x 223.5 cm. Tate: Bequeathed by Jacob Bell 1859, N00615**

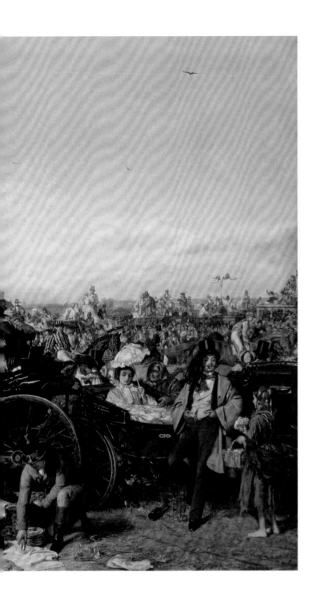

of exhibition display, commerce, patronage and image-making coming together for mutual benefit.

Though little known today, the Art Unions of the Victorian period, which operated across Europe, the United States, Australia and New Zealand, were a simple and effective institutional form of private patronage aimed at the growing middle classes.[12] They asked subscribers for an annual fee (one guinea in London) in return for a copy of the Union's annual report, a copy of at least one commissioned engraving, and the chance to win original works, distributed to members via a lottery. Although a red dot placed next to a work of art in an exhibition to indicate that it has been sold is now a commonplace across the world, it was a practice instigated by the Art Union of London in 1865, which complained that its members could not determine which works were still for sale at the Royal Academy's exhibitions.[13] The catalogue for the Academy's 1865 exhibition mentioned this new addition: 'A Red Star affixed to the Frame denotes that the Picture is Sold.'[14]

SERIALISING SUCCESS

A popular Annual Exhibition painting like *Ramsgate Sands* would enter the home of one private owner, in this case the royal household of Queen Victoria, but would also find its way, in different graphic forms, into hundreds and sometimes thousands of others. Frith's image, for instance, was not only available as an independent print, but also serialised in the widely circulated *Illustrated London News*. A series of details from the picture were reproduced in successive issues of this famous publication, each accompanied by commentary on the 'characters' shown.[15] Borrowing this idea of serialisation from the contemporary periodical press (including the novels of Charles Dickens, each of which was published in serial form), some artists exhibiting at the Royal Academy adopted this strategy in their annual submissions, thereby building public interest across two or more exhibitions. Henry Nelson O'Neil met instant success when he exhibited

instance, matters were complicated by the fact that Queen Victoria, on seeing Frith's work at the exhibition, expressed an interest in buying it (she had holidayed in Ramsgate several times in the 1820s and again in 1835). Not wanting to risk royal disapproval, Messrs Lloyd offered to sell it to the Queen for the same price they had paid when they purchased it, on one condition: that they could borrow the painting to make an engraving from it for which they would have rights of distribution. The engraving, made by Charles William Sharpe, was finally ready in 1859.[10] The plate was then sold to the Art Union of London, and proved their largest (at 53.3 x 106.7 cm) and most popular engraving to date.[11] Here we see the networks

Eastward Ho! August 1857 (fig. 63), which depicted British soldiers leaving for India to fight the Indian Uprising, as did a number of other works in that year's exhibition, such as Noel Paton's *In Memoriam*. Around 40,000 troops were dispatched to India, more than had fought in the Crimea, making this an extremely topical and politically fraught subject. The response to O'Neil's work was undoubtedly fuelled by a militaristic patriotism that ran high in this year. Only Frith's *Derby Day* eclipsed *Eastward Ho!* in terms of its popularity at the 1858 exhibition. O'Neil followed this up with his companion piece *Home Again* (fig. 64), which he exhibited in 1860.

Millais exhibited *My First Sermon* (cat. 35) in 1863 and *My Second Sermon* the following year (cat. 36). Both pictures depicted a young girl (the model was his daughter, Effie) in her 'Sunday best' outfit of a bright red cape and matching socks. In the first painting, she sits upright and attentive against the high-backed pew, painted on the spot in a church near Millais's parents'

home at Kingston upon Thames. In the second work, the little girl has discarded her feathered hat and has fallen asleep, clearly overcome by the 'soporific influence of the pulpit'.[16] The paintings were an immediate hit, combining humour with a charming subject. Though they are now often read as products of Victorian sentimentality, these works, when set back within the context of their display at the Annual Exhibition, can be seen as consciously responding to and negotiating with the wider dynamics of serialisation within the contemporary commercial sphere of the Victorian art world. Serialised works were not guaranteed success, but their obvious connections to works in previous exhibitions helped to generate publicity and provided an already established narrative that viewers could watch develop.

Fig. 63 Henry Nelson O'Neil ARA, *Eastward Ho! August 1857*, 1858. Oil on canvas, 92 x 72 cm. Museum of London. Purchased with the assistance of the Heritage Lottery Fund and the Art Fund, 2004.152/1

Fig. 64 Henry Nelson O'Neil ARA, *Home Again*, 1858 (exh. 1860). Oil on canvas, 135 x 107 cm. National Army Museum, London. Purchased with the assistance of the Art Fund, 1988-06-49-1

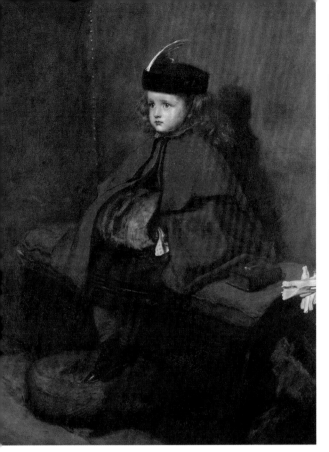

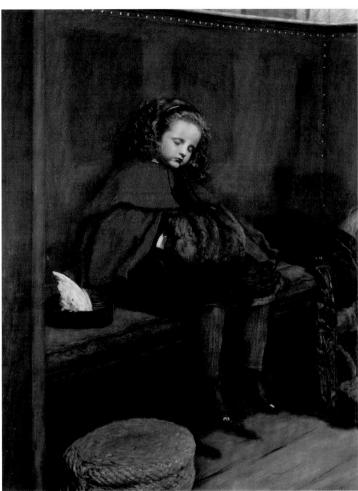

CRITICAL TRUTHS

The growth of the Summer Exhibition in the late nineteenth century coincided with an increase in periodical and newspaper publishing in Britain, facilitated by new and faster printing and distribution technologies, including the laying of international telegraph communication networks. The Academy responded by instituting the first ever formal Press View, which was introduced for the 1871 Summer Exhibition, and was designed to 'meet the wishes of the Art Critics of the Press, and to prevent the annoyance to which they were subjected on the day of the Private View'. A day was thus set aside 'for their special benefit, that they might have every facility in their careful examination of the Works'.[17] If the Academy had ring-fenced a special day for members of the press to attend unhindered, they were also aware of the desires of

the public to be part of the spectacle. When the government instigated an annual August Bank Holiday, also in 1871, the exhibition was prolonged by one day and late-night openings introduced for the last week, which also had a half-price entry fee.[18]

The challenge of reviewing a large exhibition was felt by many. A common gripe, often repeated to this day, was the impossibility of viewing, assessing and writing about an ensemble of over a thousand works of art. Some critics, however, made their names as arbiters of taste and aesthetic judgement thanks to their reviews of the Academy's exhibitions. Adversarial and ardent, John Ruskin launched his first *Notes on Some Principal Pictures Exhibited in the Rooms of the Royal Academy* in 1855, which he published until 1859, before reviving them in 1875 for one year only. Even a critic of

Cat. 35 Sir John Everett Millais Bt PRA, *My First Sermon*, 1863. Oil on canvas, 92 x 76.8 cm. Guildhall Art Gallery, City of London, 701

Cat. 36 Sir John Everett Millais Bt PRA, *My Second Sermon*, 1864. Oil on canvas, 97 x 71.7 cm. Guildhall Art Gallery, City of London, 702

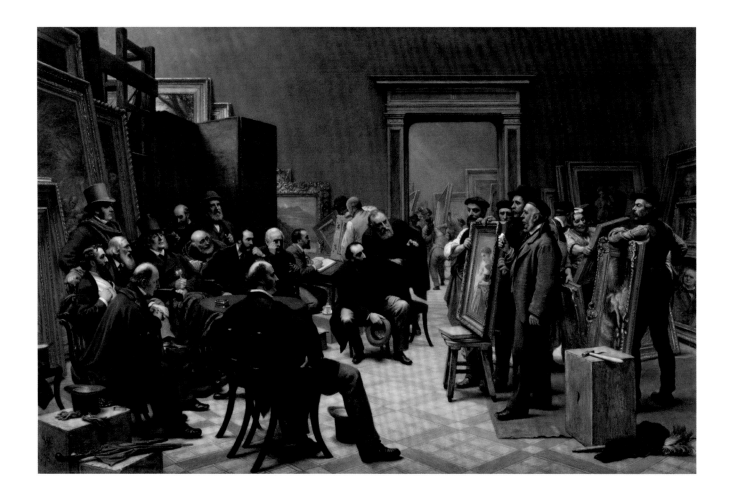

Ruskin's powers felt the pressure of reviewing the Summer Exhibition, describing the work of the *Academy Notes* as 'always be done hastily', but adding 'it will never be done thoughtlessly'.[19] Ruskin admired art that combined aesthetics with morality, criticising the 'illustrative' art that depicted historic and contemporary scenes in a crowd-pleasing, gaudy manner. He was not alone in giving voice to an anxiety about a culture of excess on the walls of the Academy, which was caused in part by the inexorable rise in the number of submissions on which the Selection Committee had to pass judgement – a task captured by Charles West Cope in his *The Council of the Royal Academy Selecting Pictures for the Exhibition, 1875* (fig. 65) – and which the Hanging Committee and the teams of art handlers at the Academy had then to prepare for display in a matter of a few short weeks, as is still the case today. The panoply of styles on the walls also gave renewed vigour to a critique that had

been made throughout the first hundred years of the Academy's history: that Britain had no unified or dominant 'school' of art. For some, mediocrity was in danger of becoming the 'house style'. Perhaps to counter this aesthetic confusion, Ruskin wrote his *Academy Notes* in a magisterially confident tone, and selected only 35 to 40 works to discuss, from the overwhelming mass of over one thousand on the walls. In doing so, he provided an alternative to the dense, numerically arranged and frankly quite dull Royal Academy catalogue. Offering a short opinion piece on each chosen work, he provided what many contemporaries considered a trustworthy and respected judgement of the works on display.[20] Ruskin's criticism wielded great power and his words were judged by some to be the making – or the breaking – of a career, as satirised in a 'Poem by a Perfectly Furious Academician' that was published in *Punch* in 1856:

Fig. 65 **Charles West Cope** RA, *The Council of the Royal Academy Selecting Pictures for the Exhibition, 1875*, **1876. Oil on canvas, 145.2 x 220.1 cm. Royal Academy of Arts, London, 03/1288**

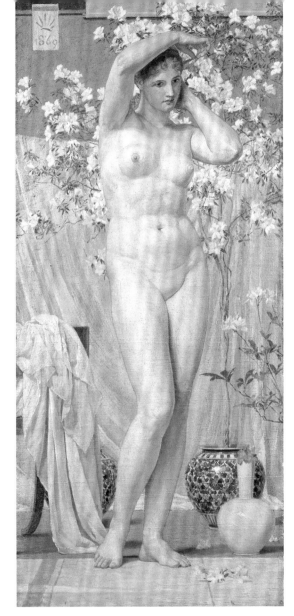

I takes and paints,
Hears no complaints,
And sells before I'm dry;
Till savage RUSKIN
He sticks his tusk in,
Then nobody will buy.[21]

Ruskin was not alone in attempting this kind of pamphleteering. In 1868 William Michael Rossetti and Algernon C. Swinburne co-authored their *Notes of the Royal Academy Exhibition*.[22] In the late nineteenth century, there was another flowering of criticism prompted by the annual event of the Summer Exhibition and the vigorous debates it provoked about style, as witnessed in the articles produced by artists and critics Walter Sickert and D. S. MacColl, the writer Henry James, and art writers R. A. M. Stevenson, George Moore, Charles Whibley, Alice Meynell and Helen Zimmern. Accompanying the acclaim and praise were also texts of dissent and dismay, criticising the increasing power of the Academy, the homogenising of taste and style and what was perceived as the gross commercialism of the exhibition. 'The reckless squandering' of the Chantrey Bequest, an incredibly generous sum left to the Academy by Sir Francis Chantrey RA on the death of his widow in 1875 for the purpose of forming a national collection of British art, was also brought under scrutiny by critics, who viewed the purchase of works that were primarily by the Academicians as a monopoly.[23]

SUCCESS AND SCANDAL

Thanks in part to the increasing power of the press, and the increasingly outspoken voice of the art critic, scandal was as common as success at the Victorian Annual Exhibition. Controversies about the public display of the nude in the late nineteenth century were fuelled by exhibits at the Royal Academy, further underscoring the Academy's continued role as an arbiter of taste and morality. Albert Moore's *A Venus* (fig. 66) encapsulates the issues of aesthetics and technique that were hotly discussed in relation to the nude by the critics

and the public at the time.[24] Moore's painting was a daring experiment in form, colour and style, blending reference to classical antique sculpture with Japanese decorative elements. Purposely devoid of any obvious narrative intent, such paintings prompted Swinburne to declare that they were the 'worship of things formally beautiful … their reason for being is simply to be'.[25] Most critics alighted not so much on the sensuality of this muscular female form but on the thinly applied paint that Moore had laid on his heavy-grained canvas. This was a politics not so much of nudity, but of paint. Due to the negative reception of *A Venus*, Moore waited until 1885 before sending another large-scale nude to the Academy for

Fig. 66 Albert Moore, *A Venus,* 1869 (exh. 1870).
Oil on canvas, 166 x 79 cm. York Museums Trust, YORAG: 698

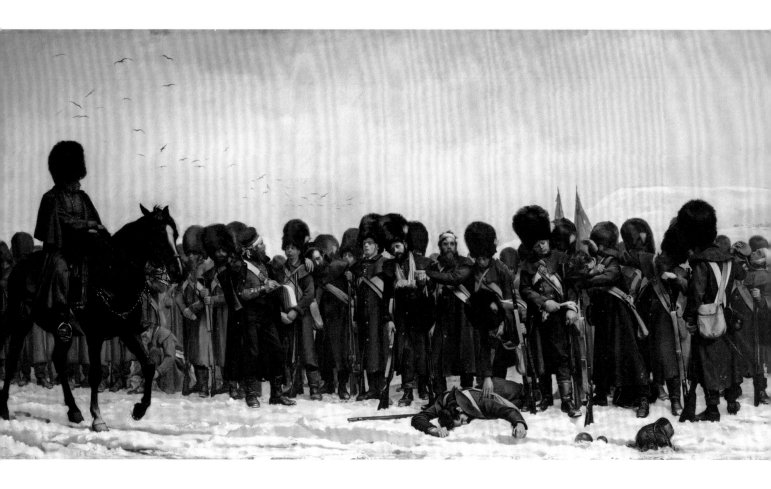

exhibition – an infelicitous year for this subject.[26] In 1885, the preponderance of nudes at the Academy incited a letter (and numerous responses) to *The Times* signed by a 'British Matron' which warned of the threat to moral standards.[27] An example of such works was Edward John Poynter's *Diadumenè* (exh. 1885), which was referenced by John Callcott Horsley, Treasurer of the Royal Academy from 1882 to 1897, and vociferous in his opposition to the increase of nude painting. Such imagery was not limited to the female nude, as Poynter demonstrated with his spectacular naked and scantily clad athletic Roman soldiers in the painting *The Catapult* (Laing Art Gallery, Newcastle upon Tyne), exhibited at the Academy in 1868. An important spokesperson for the Aesthetic Movement and arts education in Britain, Poynter published his *Ten Lectures* in 1872 in which he claimed 'that the moral nature of beauty is of a kind that cannot be expressed in painting or sculpture; that therefore, as far as art is concerned, ideas of beauty are and must be purely aesthetic'.[28]

WOMEN AND MOTHERS AT THE ROYAL ACADEMY

Within the growing body of submissions to the Summer Exhibitions was an increasing number of works by women artists, and a rise in the number of women reviewing them.[29] Despite its often rancorous and rivalrous nature, the system of selection by jury nevertheless allowed artists to submit their pieces in an open competition. It offered women artists an opportunity to display their works publicly on a scale that was certainly not available anywhere else in Britain. However, many women disguised their gender or exhibited under pseudonyms. After the election of two women as founding Royal Academicians in 1768, no woman artist was elected a Royal Academician again until Laura Knight in 1936; furthermore, the Selection and Hanging Committees were to remain all-male affairs until well into the twentieth century. Despite such barriers, women artists met with success at the Academy, sometimes sensationally

Cat. 37 Elizabeth Butler, *The Roll Call: Calling the Roll after an Engagement, Crimea*, 1874. Oil on canvas, 93.3 x 183.5 cm. The Royal Collection / HM Queen Elizabeth II, RCIN 405915

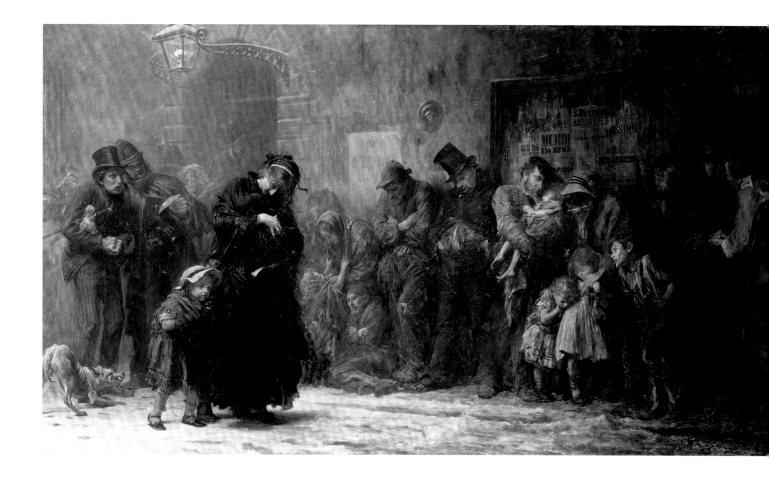

so, as highlighted by *The Roll Call: Calling the Roll after an Engagement, Crimea* by Elizabeth Thompson (later Lady Butler) (cat. 37). Following the opening of that year's Summer Exhibition, Butler wrote that she awoke and 'found myself famous…'[30] Such was the clamour of many of that year's 332,365 visitors to get close to her work, which depicted, as the *Art Journal* noted, 'a line of soldiers worn out with conflict', that a policeman was stationed next to the painting in order to regulate the crowds who took their own turn to wait in line and to see it for themselves.[31] Significantly, the kinds of vocabulary used to describe *The Roll Call* – words such as 'honesty' and 'truth' – were also applied to another painting in the same exhibition, also depicting a line of people in a destitute state: Luke Fildes's *Applicants for Admission to a Casual Ward* (fig. 67).

The Roll Call met with cheers from the members of the Selection Committee when it was brought before them. It was subsequently hung 'on the line', where it won admiration from artists – who, Butler reported, gave her an ovation on Varnishing Day, the atmosphere of which is wryly captured in George du Maurier's cartoon for *Punch* showing a scrum of artists, including a number of women, adding finishing touches to their works in 1877 (fig. 58). Butler's painting was singled out by Prince Albert in his speech at the Academy Banquet, the Queen sent for the picture and it was taken to Florence Nightingale's bedside. The *Magazine of Art* reported that some 250,000 photographs were sold of Butler's painting within a few weeks, demonstrating that fame for a canvas at the Summer Exhibition could translate into celebrity for the artist. But the fanfare and fortune surrounding a painting upon its first public display do not always assure its creator a place within the histories of art that are written long after the exhibition has closed. Conversely, as we have already seen in the case of Constable's early paintings, a work's initial neglect at the Annual

Fig. 67 Sir Luke Fildes RA, *Applicants for Admission to a Casual Ward*, 1874. Oil on canvas, 137.2 x 243.8 cm. Royal Holloway, University of London. Purchased for Thomas Holloway, 1883, THC 0021

Exhibition can occasionally be followed by a belated recognition of its greatness. To give another telling example: James Abbott McNeill Whistler's *Arrangement in Grey and Black No. 1: Portrait of the Painter's Mother* (fig. 68), after almost being rejected by the Selection Committee, was hung so high in 1872's exhibition as to make the sombre tones of the composition difficult to see from the floor; unsurprisingly, perhaps, it received a muted reaction (so muted, indeed, that Whistler never sent another painting to the Academy). Also in that year's exhibition hung Walter Crane's depiction of his wife reading (cat. 38), referencing, as in Whistler's painting, the latest fashions of artistic interior decoration. Whistler's painting of his mother is now, of course, one of the most famous works by an American artist to be held in a European collection.

How do we account for these dramatic swings in reception? Has Butler's 'Victorian' popularity, built around military subjects, counted against her? Has her gender? Whereas Whistler's painting (exhibited only two years before Butler's) is nowadays frequently lauded as a harbinger of modernist abstraction, Butler's busy canvas is more easily related to a kind of Victorian narrative painting that became deeply unfashionable in the twentieth century. The uniquely long and uninterrupted history of the Summer Exhibition allows us to consider these vagaries of fashion, fame and taste.

Fig. 68 **James Abbott McNeill Whistler**, *Arrangement in Grey and Black No. 1: Portrait of the Artist's Mother*, 1871. Oil on canvas, 144.3 x 162.5 cm. Musée d'Orsay, Paris, RF 699

THE END OF AN ERA?

The Academy's Summer Exhibition undoubtedly contributed to the fame and fortune of a significant number of Victorian artists. 'Show Sundays' in April became part of the London season, when visitors would often queue outside the studio homes of star artists such as Frederic Leighton, Alma-Tadema, Val Princep, Frith and Marcus Stone, among others (many of whom lived in close proximity in fashionable Holland Park), some eager to see new works destined for the Summer Exhibition and others desperate to have a snoop around. It was a gruelling schedule for many artists to get a good number of works finished in time over the winter months and ready for exhibition in the spring.[32] By the end of the century, the popularity and reputation of the major painters of the day was often built on the extremely large and complex compositions that they submitted to the Academy, such as Lawrence Alma-Tadema's sumptuous, flower-filled *Spring* exhibited in 1895 (fig. 69), which achieved even greater fame through reproductive prints almost as soon as it was exhibited. It would be later used as inspiration by the director Cecil B. DeMille for his 1934 film *Cleopatra*. Classically inspired scenes and subjects continued to be extremely popular at the end of the nineteenth century until well into

beginning of the twentieth century. Works by John William Waterhouse remained in demand at the Academy until his death in 1916. His *Ulysses and the Sirens* of 1891 was purchased directly from the Summer Exhibition of 1891 for the National Gallery of Victoria, Melbourne, in Australia by Sir Hubert von Herkomer, demonstrating the importance of the Academy exhibitions for building collections of contemporary art, public and private, around the world.[33] It was widely acclaimed by the critics. M. H. Spielmann was particularly effusive in the *Magazine of Art*, describing the painting as 'a very startling

Cat. 38 **Walter Crane, *At Home: A Portrait*, 1872. Gouache on paper laid on wood, 71.1 x 40.6 cm. Leeds Museums and Galleries (Leeds Art Gallery. Bought with the Harding Fund, 1932), LEEAG. PA.1932.0009.0003**

Fig. 69 **Sir Lawrence Alma-Tadema RA, *Spring*, 1894 (exh. 1895). Oil on canvas, 178.4 x 80.3 cm. The J. Paul Getty Museum, Los Angeles, 72.PA.3**

Cat. 39 Frederic, Lord Leighton PRA, *Clytie*, c. 1895-96 (exh. 1896).
Oil on canvas, 156 x 136 cm. Leighton House Museum, The Royal
Borough of Kensington and Chelsea, LH3015

triumph … a very carnival of colour, mosaiced and balanced with a skill more consummate than even the talented artist was credited with'.[34]

The catalogue for the Summer Exhibition of 1896 lists only one work by Frederic Leighton. This was *Clytie* (cat. 39), hung to great effect in Gallery III. The painting had already received a great deal of attention in the press, thanks to its having stood at the head of the coffin of the artist, who had died on 25 January 1896. In its unfinished state, this vibrant depiction of the nymph Clytie, whom Leighton had described as 'in admiration before the setting sun, whose last rays are permeating her whole being',[35] became a fitting memorial to one of the Academy's most successful presidents. Leighton had been elected a full Royal Academician in 1868 and had held the office of President since 1878, coinciding with what Oscar Wilde described

as the 'English Renaissance of Art' and the heyday of the Academy in terms of audience figures and critical acclaim.[36] Deeply loyal to the Academy – his dying words were supposedly 'my love to the Academy' – Leighton also strove to support artists who found themselves outside the establishment. He exhibited at galleries such as the Grosvenor Gallery, which had been set up in reaction to the Academy and its hanging style. At the Summer Exhibition itself, Leighton's contribution to sculpture was felt as much as his impact on the sphere of painting, with his *An Athlete Wrestling with a Python* (fig. 70) and *Sluggard* heralding the beginnings of what was described as the 'New Sculpture'. He was the first artist to receive a peerage, though so soon before his death (just one day), that his is also among the shortest-lived peerages in history. Perhaps something of Leighton's success – both inside and outside the Summer Exhibition – lay in his ability to blend tradition and modernity; a talent for achieving reform but with a respect for established ways. This balancing act in many ways epitomises the delicate negotiation that continues at the Academy, and its annual displays, even today. The death of Leighton represented in many ways the end of an era for the Academy, but the influence of the styles and techniques developed in the heyday of the Victorian Academy continued to be felt well into the new century.

Fig. 70 **Frederic, Lord Leighton** PRA, *An Athlete Wrestling with a Python*, 1877. Bronze, 174.6 x 984 x 109.9 cm. Tate: Presented by the Trustees of the Chantrey Bequest 1877, N01754

WHISTLER'S ETCHINGS

JESSICA FEATHER

In 1860 the twenty-six-year-old artist James Abbott McNeill Whistler, at that point relatively little known in the London art world, exhibited a handful of etchings at the Annual Exhibition, only the second time that he had shown works at the Academy. They were displayed in the octagon room, the compact and unfavourably positioned space that was normally set aside for the small number of black and white prints submitted to the Academy during its time at Trafalgar Square. The room was dominated by reproductive engravings after well-known paintings – the most common type of print historically exhibited at the Academy, though it was one that had long been

Cat. 40 **James Abbott McNeill Whistler,**
Black Lion Wharf, **1859 (exh. 1860). Etching,**
26.7 x 36.3 cm. The British Museum,
London, 1973,0915.15

weighed down by its associations with copying.[1] In this context, Whistler's innovative etchings, which were based on his own original designs, must have looked arrestingly avant-garde.

For a start, his subject-matter was new and different, focusing as it did on an unusual contemporary milieu – that of the working men of East London's wharves and dockyards. *The Lime Burner* (cat. 41), for example, entitled in the catalogue 'W. Jones, lime burner, Thames Street', shows its subject leaning on a barrel, with a large sieve – one of the tools of his trade – lying at his feet. The view of East London's Lime Wharf and the River Thames in the background situates the viewer in the reality of the present day. But beyond the novel element of these prints' subject-matter, Whistler's innovative construction of picture space was what made his works so radical. In *Black Lion Wharf* (cat. 40) the artist's elimination of detail and his use of blank paper, reminiscent of contemporary photography as well as Japanese prints, would have looked modern to contemporary eyes. In *The Lime Burner*, Whistler experimented with another form of composition, which was to become a familiar trope in many of his prints, and in which he used the device of frames within frames to represent spatial recession.

Critics did not generally spend very long in the octagon room. Prints tended not to feature in reviews of the Academy's exhibitions, so it is unsurprising that there was only a limited critical response to Whistler's new works. One correspondent, however, did write about them extremely enthusiastically. This was the artist and critic for *The Athenaeum*, F. G. Stephens, a former member of the

Pre-Raphaelite circle, who described 'an admirable series of etchings' by 'this gentleman, whose name is quite new to us'.[2] Stephens was to continue championing Whistler's etchings at the Academy throughout the 1860s, writing of his disgust one year when one of the artist's etchings was 'skied in the dismal octagon room'.[3] Contemporaries pointed to the Hanging Committee's continued partiality for reproductive work over original etchings, a preference that may reflect the taste for

the high finish of professional engraving over the sketchy quality of artist's etchings.[4] Whatever the reasons for this, Whistler had to resort to smaller and more sympathetic venues outside the Academy to gain more visibility for his etchings. Other artist-etchers had to do the same, suggesting that the Annual Exhibition was not only an unfavourable venue for showing prints more generally, but one that was particularly inimical – in this period, at least – to innovative forms of printmaking.

Cat. 41 **James Abbott McNeill Whistler,** *The Lime Burner*, 1859 (exh. 1860). Etching, 36.2 x 26.7 cm. The British Museum, London, 1973,0915.18

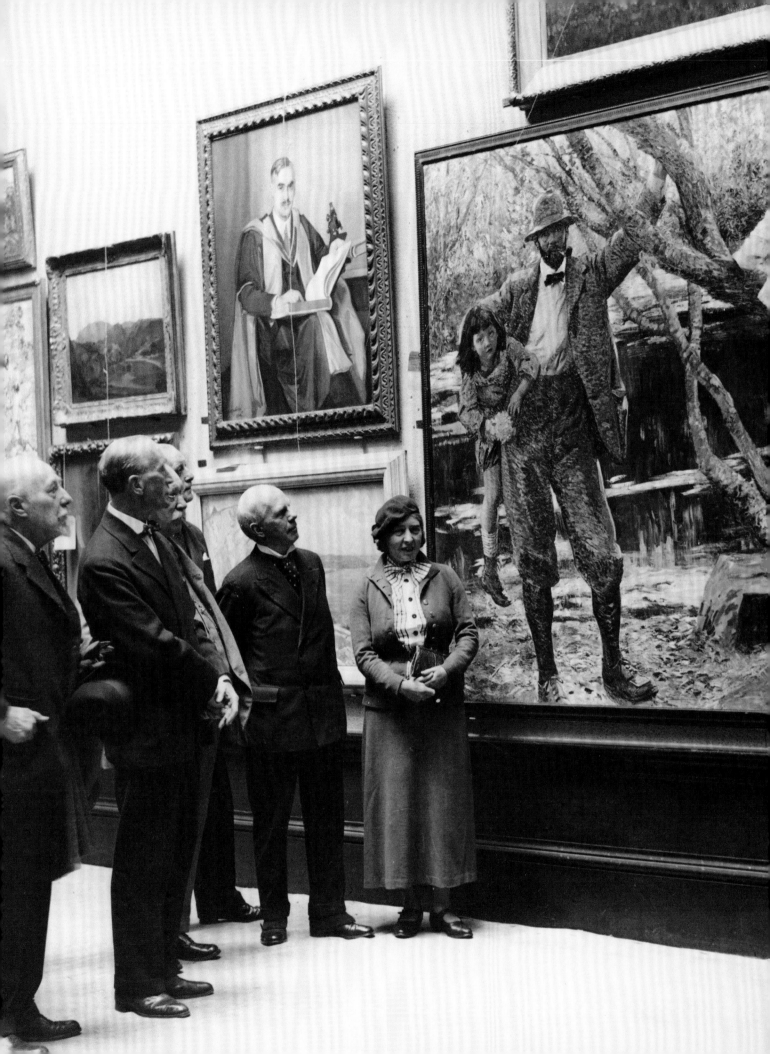

DEALING WITH THE MODERN

SARAH VICTORIA TURNER

The Summer Exhibition of 1900 offered a broad bill of fare, from miniatures to monumental sculpture. That year's Annual Report documents the fact that there were no fewer than 13,462 artworks submitted for consideration – a record number of submissions – of which 2,057 were displayed at the exhibition.[1] Dominating the galleries were large and spectacular paintings based on historical and literary subjects, such as Frank Dicksee's dazzling *The Two Crowns* (fig. 72). Dicksee's scene of a triumphantly crowned medieval prince glancing towards a crucifix was executed in such a way as to make it an active participant in all the pageantry and tradition of the Summer Exhibition. The artist deployed pictorial formats and conventions that had been developed over the royal institution's 132-year history, and that demonstrated the continued importance of history painting, as outlined by the Academy's first President, Joshua Reynolds, in his *Discourses*.[2]

Thus, the dawn of the new century did not herald any suddenly seismic ruptures or radical shifts in the Academy's exhibition rituals. Although it was not impervious to modernisation, one of the Academy's chief responsibilities – at least for many of its Royal Academicians and supporters – was to maintain artistic tradition and a sense of continuity with the past, rather than to follow the whims of fashion or ride the destabilising waves of change. However, discussion about the Royal Academy's relationship with the modern was already rumbling by 1900. Using *The Two Crowns* to comment on the institution's links with the past, the critic for *The Times* commented that 'the picture is sure to have great popular success; among the good judges

all those who have not gone over with bag and baggage to the camp of the moderns will justly admire its many formal perfections ... It is certainly a leading example of an art founded upon an English tradition, with many most admirable qualities, though they are qualities which are finding less and less favour among progressive painters here and abroad.'[3] The 'camp of the moderns' was, if we are to believe this critic, already firmly established by 1900.

If the history of the Royal Academy in the twentieth century has been characterised as a war between two camps – those on the side of tradition and those for the modern – the works of

art exhibited in 1900 demonstrate that the battle
lines were not always so clearly drawn. Described
as one of the 'most ambitious … and one of the
most admired' works of art in that year's display was
George Frampton's mixed-media sculpture *Lamia*
(cat. 42).[4] Lamia's downcast eyes, the deathly pallor
that is suggested by the smooth and creamy pale
ivory, the snake scales delicately tooled onto the
surface of her neck, and the exquisitely modelled
bronze of her medievalised headdress – all hint
at the work's tragic narrative. Frampton's work
was inspired by John Keats's poem of the same
name (written in 1819), in which Lamia, a beautiful
serpent-like creature, assumes female form in order
to win the love of the mortal Lycius. Frampton
evoked sculpture's traditions through his use of
bronze for Lamia's clothing, and yet he gave his
work a decidedly modern feel by incorporating
other materials such as ivory and precious stones. It
flaunted its debts to the New Sculptors who had first
come to prominence at the Summer Exhibitions in
the 1870s, while also pointing ahead to the twentieth
century's redefinition of the sculpted object. It was
not until 1956 that the Academy had its first sculptor
president, Charles Wheeler, whose experiments with
direct carving into his materials – for example the
trunk of a piece of lime wood to create an object
with such a time-honoured subject as his *Mother
and Child* (cat. 43) – demonstrate that such delicate
negotiations between tradition and modernity
were not limited solely to the turn of the century.

Cat. 42 **George Frampton** RA, *Lamia*, 1899-1900 (exh. 1900). Ivory,
bronze, opals and glass, 61 x 55.3 x 25.4 cm. Royal Academy of Arts,
London, 03/1723

Cat. 43 **Sir Charles Wheeler** PRA, *Mother and Child,* 1926-27 (exh. 1926).
Limewood with lead base, 182.9 x 39 x 33 cm approx. Wolverhampton
Arts and Culture, S17

PRODIGAL DAUGHTERS: 'PROBLEM PICTURES' AND WOMEN AT THE ACADEMY

One of the most popular works submitted to the Summer Exhibition in the early years of the twentieth century presented its female protagonist in an altogether more active position than Frampton's somnambulant *Lamia*. Drawing upon the conventions of narrative painting that had been developed in the nineteenth century to such public acclaim, and giving them a contemporary twist, John Maler Collier exhibited his much-discussed 'problem picture', *The Prodigal Daughter* (cat. 44), in 1903. This was a type of painting that was developed in the second half of the nineteenth century specifically for display at the Summer Exhibition. The narrative drama is suggested but neither confirmed nor resolved by the painting's details and title. If Frampton's *Lamia* had been interpreted as seductively mysterious, then the mystery surrounding Collier's modern woman was interpreted much more salaciously. Where had she been? What had she done? Crowds gathered around the work to ponder such questions and critics had a field day inventing possibilities. The *Morning Post* reported that there was 'always a group gathered' around the painting, 'debating as to whether the bedizened young lady is supposed to have been just returned home, or be upon the eve of departure'.[5]

Collier set out to provoke debate and discussion, knowing from the success of his earlier works of this kind that the Summer Exhibition audience was especially receptive to narrative paintings depicting social issues and moral dilemmas, and was eager to engage in the ritual of group discussion around a particular work. Virginia Woolf's somewhat sardonic observation in 1919 that the 'point of a good Academy picture is that you can search the canvas for ten minutes or so and still be doubtful whether you have extracted the whole meaning' suggests the persistence of

Cat. 44 John Maler Collier, *The Prodigal Daughter*, 1903. Oil on canvas, 166 x 217 cm. The Collection: Art & Archaeology in Lincolnshire (Usher Gallery, Lincoln), LCNUG: 1927/186

regardless of torn clothes', according to the reporter of the *Daily Graphic*.[8] A ruckus in Gallery III was the cause of this commotion, instigated by an attack on John Singer Sargent's portrait of Henry James (cat. 45). A suffragette named Mary Wood had entered the Summer Exhibition on the opening day, much like other members of the public, except that hidden within the folds of her gown was a meat cleaver, which she used to slash the canvas, cutting across James's face (fig. 73). The violence of Wood's actions met with a strident response from members of the public in the room who, it was widely reported, 'rushed at her'; furthermore, a man who had come to her protection was 'handled with some roughness'. Cries of 'lynch her' from other women in the room were reported by the more sensational *Daily Sketch*. This attack on Sargent's portrait of James – both cultural Titans by this point in the early twentieth century – would have been doubly shocking to an exhibition audience in 1914. Sargent was internationally famous for his 'grand manner' portraits of celebrities, wealthy families and distinguished personalities, many of which had been great successes when displayed at the Summer Exhibitions of the 1890s and the Edwardian period.

the craze for this genre of narratively ambiguous modern-day subject paintings well into the twentieth century.[6] Collier's *Prodigal Daughter*, and other 'talking-point' pictures, raised issues in a debate that extended well beyond the frame.[7] And indeed, for many observers, this was no repentant prodigal daughter returned to the bosom of her family, but a symbol of the 'New Woman' of the early twentieth century, who was on the cusp of leaving home to find independence.

On the morning of 4 May 1914, the debate about gender representation and the role of women in society rose from the level of animated chatter to angry cries in the galleries. Startled 'out of its decorum', the 'fashionable Royal Academy Crowd' was sent 'running from one room to the other and pushing through the doorways of Burlington House, forgetting pictures and catalogues, and

After Wood's assault on Sargent's painting, the Summer Exhibition became the focus of a further two attacks by suffragettes.[9] A portrait of the *Duke of Wellington* by Hubert von Herkomer and George Clausen's nude *Primavera* were also attacked on 12 and 26 May.[10] Following the media storm created by Mary Richardson's attack on Velázquez's *Rokeby Venus* at the National Gallery

Cat. 45 **John Singer Sargent** RA, *Henry James*, 1913 (exh. 1914). Oil on canvas, 85.1 x 67.3 cm. National Portrait Gallery, London, NPG 1767

Fig. 73 **John Singer Sargent** RA, *Henry James*, 1913. Detail of the damaged painting. Silver gelatin print mounted on card, 25 x 28.3 cm. Royal Academy of Arts, London, 10/1584

The number of women exhibiting at the Royal Academy rose steadily throughout the early years of the twentieth century, with women representing around 30% of all exhibitors by the inter-war period.[12] *Liverpool Street Station* (cat. 46) by Marjorie Sherlock, which hung in the 1917 exhibition, reminds us that works that deviated from the 'Academy aesthetic' and the academic style advocated by the then President, Edward Poynter, did occasionally make it past the eagle eyes of the Royal Academicians who comprised the Selection and Hanging Committees.[13] A pupil of Walter Sickert and Harold Gilman, Sherlock had also worked with André Dunoyer de Segonzac (who was made an Honorary Academician in 1947) and André Lhote in Paris. Like many of the women who played a part in the networks of modern painting, she has remained on the peripheries of art history, but her connections with Sickert and the Camden Town Group are evident in this depiction of London life at rush hour, bursting as it is with the electrified visual culture of a metropolitan railway station. Modern art and modern life did feature in the Summer Exhibitions of the early twentieth century, but they often did so in the work of artists such as Sherlock (who was to exhibit over 50 times at the Academy), whose name, like those of so many other women artists of her generation, has remained pretty much absent from the history of modern art, as well as from the institutional histories of the Royal Academy.

It was not until 1922 – an astonishing 154 years after the election of Angelica Kauffman and Mary Moser as foundation Royal Academicians – that another woman was elected to the Academy. This was Annie Swynnerton, who was elected an Associate. And, as we have seen, it was not until 1936 that Dame Laura Knight was elected as a full RA. A photograph in the Academy's archives of Knight presenting her 1934 exhibit *Lamorna Birch and His Daughters* (cat. 47) to

in March of the same year, the display provided a high-profile scene of protest for the suffragettes' cause, which had only had small-scale interaction with the Academy previously, most notably in the form of a Votes for Women poster stuck on top of Solomon J. Solomon's portrait of the Prime Minister, Herbert Henry Asquith, in 1909. The fact that the Summer Exhibition was a selling show also allowed Wood to make an argument about the difference in commercial value between work made by men and women. After being told that her actions had caused a depreciation in the value of the painting of between £100 and £300, she is reported to have said: 'I quite understand; if a woman had painted it, it would not have been worth so much.'[11] This was an iconoclastic protest that struck at the heart of the cultural establishment, raising such issues as the visibility and value of women artists as a result.

Cat. 46 **Marjorie Sherlock**, *Liverpool Street Station*, **1917.**
Oil on canvas, 116.5 x 89.5 cm. UK Government Art Collection.
Purchased 1986, GAC 16474

Cat. 47 **Dame Laura Knight** RA, *Lamorna Birch and His Daughters*, 1913, reworked 1934 (exh. 1934). Oil on canvas, 215 x 261 cm. The University of Nottingham, UON.071

Fig. 74 **Dod Procter** RA, *Morning*, 1926 (exh. 1927). Oil on canvas, 76.2 x 152.4 cm. Tate: Presented by the *Daily Mail* 1927, N04270

her fellow Academicians, entirely male (fig. 71), highlights this isolation. She is pointing to her large canvas, originally painted in 1916, and to which she had made some additions before sending it for display at the Academy in 1934.

Between 1922 and 1948, only five women artists were elected to the Royal Academy, including Dod Procter, who painted the tremendously popular *Morning* (fig. 74), bought for the nation by the *Daily Mail* after the sensation it caused at the Summer Exhibition in 1927. The picture toured to 23 galleries in Britain before being given to the Tate. The Academy's pitiful record of women members is perhaps one of the key areas in which the institution failed to register and respond to the social and cultural changes that were underway both beyond and within its walls, as the number of female exhibitors, as well as women art critics, grew.[14] As Katy Deepwell has noted, although it appears to be 'significant that the first of these elections in 1922 occurred within a few years of the passing of the

Sex Disqualification (Removal) Act of 1919, there is no indication in the Royal Academy Council's own records that the election occurred as a direct result of the clause which opened up societies with Royal Charters to women members'.[15] Exclusion still abounded, especially on the Selection and Hanging Committees, and the Academy Banquet remained an all-male preserve until 1967, when female ARAs and RAs were at last admitted after a campaign by the sculptor and engraver Gertrude Hermes. A proactive stance to diversifying the membership was not to occur until much later in the century.

ARCADIA INTERRUPTED: THE ACADEMY IN THE CONTEXT OF THE FIRST AND SECOND WORLD WARS

Charles Sims's *Clio and the Children* (cat. 48) has three significant dates associated with it. The first is 1913; the second 1915; and the third 1916. In 1913 Charles Sims painted a light-filled landscape in which a blue sky dotted with cotton-wool clouds

Cat. 48 **Charles Sims** RA, *Clio and the Children*, **1913 and 1915 (exh. 1916). Oil on canvas, 114.3 x 182.9 cm. Royal Academy of Arts, London, 03/1215**

filled nearly two thirds of the canvas. The rolling West Sussex Downs, near Sims's family home, provide the English rural idyll of the background. Gathered on the grass of the field in the foreground of the painting are nine children of different ages. The critic of *The Connoisseur* described the combination of the children and 'the stretching English landscape' to be in 'perfect unison'.[16] So far, this all seems to present a reassuring image of domestic life in the English countryside. However, the idyll is interrupted by the addition of the solitary figure of Clio, the muse of history, who is shown slumped over her scroll. In trying to figure out this narrative message, visitors to the 1916 Summer Exhibition, in which this painting was exhibited as Sims's Diploma Work, would have no doubt noticed that Clio's scroll had been daubed with red paint. After hearing that his eldest son had been killed fighting in 1915, Sims blotted this rural arcadia, bringing the violence of the trenches onto English soil. His painting suggests that history, within the context of the current war, was dripping with blood.

This idea that the Summer Exhibition could become a space of memorial had already been established through the display of the work of recently deceased Royal Academicians, as we have seen in the case of Frederic Leighton. Within the context of war, this form of commemoration was adapted by exhibitors who wanted to memorialise the death of soldiers. George Clausen's submission in 1916, *Youth Mourning* (cat. 49), the same year as Sims's *Clio and the Children*, expressed an equally personal response to war. Clausen takes the conventions of the academic nude, collapses the figure into a position of distraught grief, and places it against a stark, almost abstract background, which originally featured a number of white crosses that were later painted out. This is a painting as radical as any by the much younger and better-known official war artists such as Paul Nash and C. W. Nevinson. Clausen was by this time a figure of the Academy; but he had once been a member of

the progressive New English Art Club, which had been formed in 1886 as a protest against the staid traditions of the royal institution, and which looked to French painting for inspiration, especially the *plein-air* paintings of Jules Bastien-Lepage. Along with Stanhope Forbes, Clausen brought these ideals into the Academy – another form of artistic rebellion that became absorbed by the establishment. Painted in response to the news that his daughter's fiancé had died in action, Clausen's work offered a haunting evocation of the trauma and grief of the families left behind. These were sentiments shared by many visitors at the wartime Summer Exhibitions. Such collective viewing experiences potentially offered a space of solace, or even of shared grief and anger at the catastrophic events of war.

Capturing passing storms and sunny afternoons, timeless rural idylls and encroaching modern sprawl, familiar fields and faraway places, the genre of landscape painting, as earlier chapters in this book have demonstrated, had always served a prominent role within the Academy, especially within debates about the relationship of British art to national life, traditions and values. In the

Cat. 49 Sir George Clausen RA, *Youth Mourning*, 1916. Oil on canvas, 91.4 x 91.4 cm. IWM (Imperial War Museums), Art.IWM ART 4655

late nineteenth century and early decades of the twentieth century, artists such as George Vicat Cole and Alfred East, had specialised in scenes of the English countryside drawing directly on the inspiration offered by past masters such Constable and Turner, which often met with both popular and critical approval when displayed at the Academy. In the period after the First World War, the Academy in many ways aimed at a return to order, and at re-establishing the Arcadia that had been threatened by catastrophic conflict, even though the war had not actually been fought on British soil.

Landscape painting encompassed both the representation of real places and imagined ones. A visionary bent had long permeated British landscape painting; this seemed to intensify in the inter-war period. Frederick Cayley Robinson was one of those artists who wove together the symbolic and spiritual potential of landscape with a close observation of the natural world. He was absorbed between 1916 and 1920 in painting a series of monumental, allegorical works for the Middlesex Hospital in London, *The Acts of Mercy*, which took as their subject the traumatic experience in the

First World War of patients and hospital workers. Cayley Robinson's submission to the 1924 Summer Exhibition, *Pastoral* (cat. 50), had many elements in common with his *Acts of Mercy* series. A flat, almost decorative background, containing a setting sun, a windmill and a stylised glade of trees, dominates the canvas. Right at the very front, a family group of shepherds keep watch over their flock. Both humans and animals are painted with meticulous detail. Imbued with a meditative atmosphere, the painting seems reassuring: the new lives of the lambs are being safely guarded. *Pastoral* reminds us of the quiet, restorative work that art could do.

In many ways, warfare forced the Academy to deal with the conditions of modernity, both institutionally and in terms of providing a home for art representing the subject of war itself. Its central London location was a dangerous one; in September 1917, a bomb dropped from a German plane damaged Gallery IX. In the Second World War, there was more damage during the Blitz, with Galleries IV, V, VI and VII on the northwest of the building being written off and the roof damaged by nearby explosions in September and

Cat. 50 Frederick Cayley Robinson ARA, *Pastoral*, 1923-24 (exh. 1924). Oil on canvas, 90.3 x 116.4 cm. Tate: Presented by the Trustees of the Chantrey Bequest 1924, N03954

November 1940. Many artists and students were called up in both conflicts. Run by a skeleton staff, the Academy decided to remain open during both wars. As well as hosting the Summer Exhibition, it held other important wartime exhibitions, including the War Relief Exhibition in 1915 (a show of work by living British artists, the proceeds of which were split between the Red Cross and the Artists' General Benevolent Fund); a camouflage exhibition in 1919; and, in the same year, 'The Nation's War Paintings and Other Records', which showcased works that had been commissioned or acquired by the state during the conflict, among them pictures that have now become some of the most iconic of the period, such as John Singer Sargent's *Gassed* and Paul Nash's *The Menin Road* (both in the Imperial War Museums).

In the Second World War, when the national art collections had been evacuated out of London, and when most other major galleries and museums in London were closed, or had reduced opening hours, the continuation of the Summer Exhibition acted like a cultural beacon.[17] Changes were, however, made to rules and regulations. The Council decided to hang no works by natives of enemy countries, naturalised or not. As the Annual Report

recorded, the President and Council also decided 'that it would be impossible to hold the Annual Dinner and Soirée without infringing the Police Regulations with regard to lighted roof areas...'[18]

Some criticised the Academy for not displaying more work relating to the war, although there is good evidence that there were many relationships and connections between artists who worked for the state-funded War Artists' Advisory Committee (WAAC) and those who displayed their work at the Royal Academy. Richard Eurich was one of these artists. The theme of the events at Dunkirk in 1940 was suggested by Eurich to this Committee, and he went on to paint a series of works on the subject, including *Dunkirk Beaches* (cat. 51), which he showed at the Academy in the following year. A cloud of toxic black smoke hangs over the lines of soldiers waiting to be evacuated. Eurich was skilled at constructing panoramic scenes in which he conveyed destruction, drama and the epic scale of warfare, even in relatively small canvases.

One area that flourished at the wartime Summer Exhibitions was portraiture, both military and civilian, suggesting that there was an appetite to record the human contribution and sacrifice to war. One of the most remarkable was Meredith

Cat. 51 Richard Eurich RA, *Dunkirk Beaches*, 1940 (exh. 1941). Oil on cardboard on panel, 31.5 x 54.3 cm. IWM (Imperial War Museums), Art.IWM ART LD 2277

Frampton's group portrait of Sir Ernest Gowers, Lt Col. A. J. Child and K. A. L. Parker in the London Regional Civil Defence Control Room (cat. 52), exhibited in the Summer Exhibition of 1943 and commissioned by the WAAC. Frampton, son of Sir George Frampton, the sculptor of *Lamia* (cat. 42), was by this time well known for his meticulously executed paintings with highly polished surfaces. Confronted by the accoutrements of the work of intelligence-gathering and civil defence – maps and telegraph messages, along with the more prosaic details of the milk bottle and tea cup – the exhibition-goer of 1943 could not fail to be reminded of the extraordinary work of this unit in maintaining the capital's infrastructure under increasingly strenuous circumstances. In 1942 the Royal Academy's Planning Committee had exhibited *London Planned* in the Architecture Room and, in response to public comment, revised plans were exhibited in the summer of 1943. The Summer Exhibition viewer was getting used to seeing maps and charts in the galleries.

ACCEPTANCE, REJECTION, READMISSION

Acceptance and rejection have always been a fundamental part of the process of the Summer Exhibition and the wider Academy. By 1938 the Selection Committees had rejected thousands of works over the exhibition's history. It was usually the works selected for the exhibition that caused a sensation, not those that had been sent home. However, in this year a rejected picture caused a sensation. In many ways, Wyndham Lewis's *Portrait of T. S. Eliot* (cat. 53) is fairly conventional. As in

Cat. 52 Meredith Frampton RA, *Sir Ernest Gowers, Lieutenant Colonel A. J. Child, and K. A. L. Parker*, 1943. Oil on canvas, 148 x 168.5 cm. IWM (Imperial War Museums), Art.IWM ART LD 2905

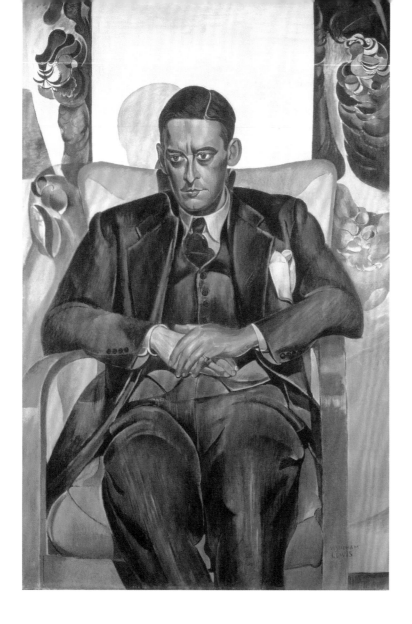

Sargent's depiction of Henry James, Eliot is dressed soberly and smartly in a formal, dark, business-like suit. This quiet portrait of a serious man (by this time Eliot was running the publishers Faber & Faber) was one of the 11,221 works sent in that year and one of the 9,955 works to be rejected. Not one of the Selection Committee raised a hand in favour of the painting, otherwise it would have been classified as 'doubtful' and would have progressed on to the next stage, for the Hanging Committee to consider. As with most other works that fell into the rejected category, we would not have much of a record of this event in the painting's history were it not for what happened next. Again, the role of the press is crucial here. Following the rejection of his work, Lewis was interviewed by several papers and recorded by the BBC, and he used his talents as a wordsmith and agent provocateur to whip up a media storm. 'ACADEMY CALLED A "FILTH BAZAAR"' exclaimed the headline of the *Daily Herald*. The debates surrounding the Academy's relationship with modern art became the central issue, rather than the merits of the painting itself. Lewis attacked what he saw as the Academy's prejudice against modern art, declaring that 'nothing short of radical transformation can possibly do any good. Their selections are all alike – last-century impressionism, or coloured photographs which they call portraits … This was the first time I sent a picture. Its rejection shows that the Academy is prejudiced against present-day art.'[19]

Why the Committee rejected Lewis's painting is not recorded. The reasoning behind such decisions, which have to be made relatively quickly in order that the thousands of works sent in for consideration can be seen, are never written down, although one Committee member is reported to have remarked that 'it was not so good as others that were passed'.[20] This decision had caused a war of words that rumbled on for several weeks. Augustus John, who had been an ARA since 1921, resigned in protest. 'This resignation', fumed Lewis, '…should be a mortal blow to the Royal Academy – if it is possible for one to use the expression "mortal blow" with reference to a corpse'.[21] Amid the furore, the Academy carried on. The life blood that had pumped through it for 160 years continued to circulate. The 1938 Annual Banquet was broadcast live on the BBC's Home Service, with Winston Churchill MP proposing the toast (the next year would see the first television broadcast from the Academy). Against the noisy hubbub of the Lewis scandal, Churchill's speech struck pointedly measured tones, even as it reused and redirected the rhetoric deployed by the fulminating artist.

'The function of such an institution', he opined, 'is to hold a middle course between tradition and innovation. Without tradition art is a flock of sheep without a shepherd. Without innovation it is a corpse.'[22] Whether Churchill was responding directly to Lewis's comments, we do not know, but the message was clear. The recent blows suffered by the Academy were most definitely not mortal. And for Churchill, himself an amateur painter, the Academy's 'middle course' also allowed a whole swathe of artists, not represented by galleries or dealers, to exhibit at the heart of the art establishment. Indeed, some ten years on, in 1947, under his thinly veiled pseudonym David Winter, Churchill's own *Winter Sunshine, Chartwell* (cat. 54) was accepted for inclusion by the Selection Committee, along with another of his works. Churchill was made Honorary Academician Extraordinary, the only such holder of this singular honour, in 1948. As well as works of art, the Summer Exhibition also put the relationships, and tensions, between the accepted and the rejected, the amateur and the professional, the insiders and the outsiders, and the traditional and the modern, on very prominent display.

Cat. 54 **Sir Winston Churchill**, *Winter Sunshine, Chartwell*, **1924–25 (exh. 1947). Oil on millboard, 35.6 x 50.8 cm. National Trust Collections (Chartwell, The Churchill Collection), NT 1102496**

THE EXHIBITION POSTER

SARAH VICTORIA TURNER

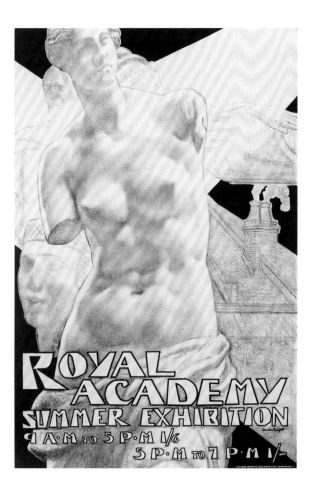

The Royal Academy adopted the poster – one of the most modern forms of visual communication – reluctantly; anxious, perhaps, that an institution famous for its artistic traditions should collaborate so explicitly with the tools of commercial design.[1] The first poster advertising the Summer Exhibition, showing fashionable crowds viewing the display and socialising in the galleries, appeared in 1913. It was designed by Tony Scragg for a series promoting the attractions of London. Although the Academy no doubt benefited from the London Underground's promotion of the exhibition as premier entertainment, it did not harness the benefits of advertisement until after the First World War. With attendance figures rapidly declining, it realised that proactive work would have to be done to rekindle the public's interest in the show. The official poster published in 1918 was so reticent that it included only the most basic of information and no images.

The idea of using its body of in-house expertise, the Academicians, was reached nervously. William Orpen was the first artist to be commissioned in 1924, but no copies of this poster survive. Most striking among these early posters is the one by Laura Knight made in 1937: a strange cross-cultural collage of figures, unusual typography and smoking chimneys (fig. 75). A number of posters have engaged with the Academy's history, especially the illustrious first President, Joshua Reynolds, who makes several appearances, most humorously as one of a ghostly pair with Angelica Kauffman looking curiously at an abstract painting, in a witty poster by Betty Swanwick (fig. 76). Carel Weight's *Turner Goes to Heaven*, used for

Fig. 75 **Dame Laura Knight RA, poster for the 1937 Summer Exhibition**

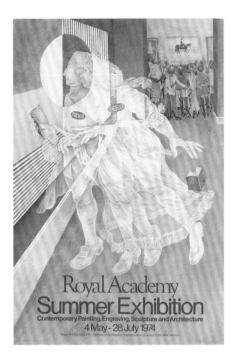

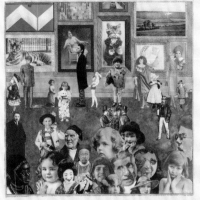

Royal Academy 207th Summer
Exhibition of Contemporary
Paintings, Engravings, Sculpture
and Architecture

3 May to 27 July 1975
Admission 60p. Mondays 30p.
Weekdays 10 to 6 Sundays 2 to 6

the 1989 poster (see fig. 119), does similar work of reviving old ghosts.

Other posters have used the unique atmosphere of the Summer Exhibition as an inspiration. Edward Ardizzone's 1969 poster plays with the social juxtapositions of bored children, gossiping grannies and a thoroughly miserable-looking younger couple. Peter Blake brought the multi-figure collage techniques that he had used to spectacular effect on the Beatles' *Sgt. Pepper's Lonely Hearts Club Band* album cover to the Summer Exhibition poster (fig. 77). The posters of the 1960s register a change in attitude towards design from within the Academy. The use of modern, eye-catching sans-serif typography and splashes of bright colour was an innovation of the graphic designer Theo Ramos, who was brought in to take charge of the Academy's posters. His collaborations with Chris Prater and Gordon House of the Kelpra Press resulted in posters that held their own on the busy streets of the capital. In 1966 the Council

decided that a Royal Academician should be tasked with designing the poster, and John Bratby's ceremonial illustration of Britishness began this sequence. A photograph of the exterior of Burlington House shows Leonard Rosoman's 1971 poster of a semi-naked girl (see fig. 4) enlarged to fill the spaces of the entrance arch. In the 1980s and 1990s, posters increasingly focused on a single work that was to be found inside the exhibition or in

the courtyard. In 1997 the subject was rather the artist, invoked through a striking photograph of John Hoyland's boots on his paint-spattered studio floor (fig. 78). Since the mid-2000s, the Academy has used professional graphic designers to connect its posters with its other branding and visual campaigns (fig. 79). Overall, these posters provide an alternative history of the Summer Exhibition – as first noticed from the outside, on the Tube or in the street.

Fig. 76 **Betty Swanwick RA and Gordon House, poster for the 1974 Summer Exhibition**
Fig. 77 **Sir Peter Blake and Gordon House, poster for the 1975 Summer Exhibition**

Fig. 78 **Poster for the 1997 Summer Exhibition featuring the boots and studio floor of John Hoyland RA**
Fig. 79 **Poster for the 2012 Summer Exhibition designed by Harry Pearce, Pentagram**

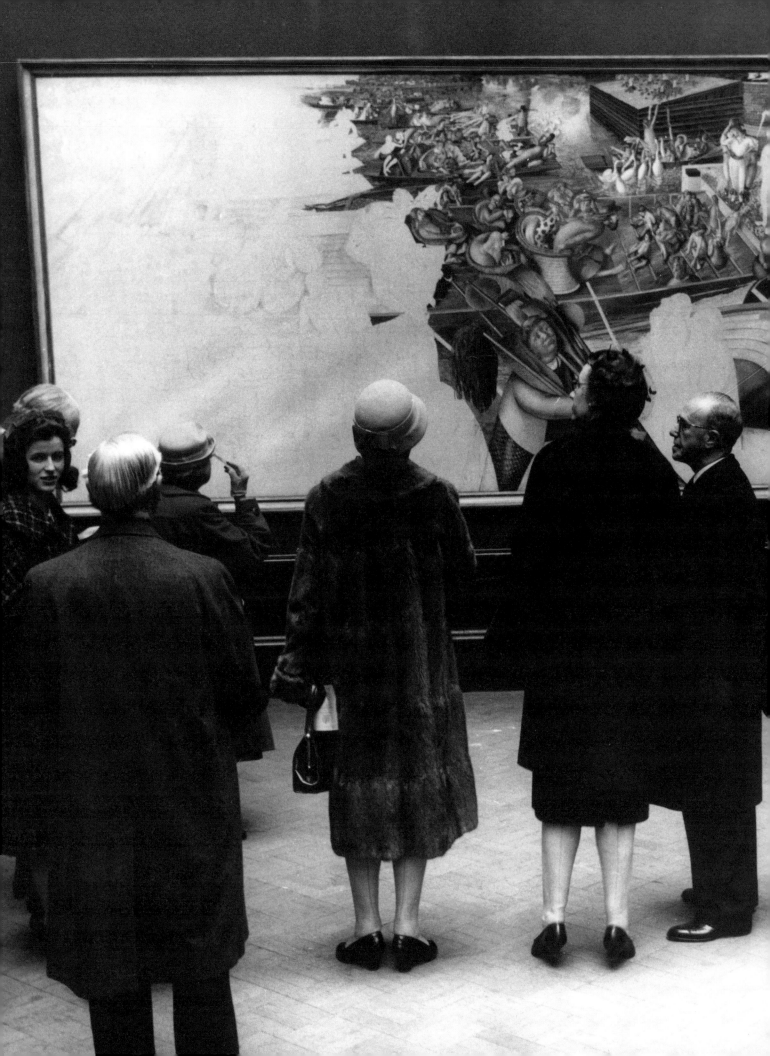

POST-WAR VISIONS AND NEW GENERATIONS

SARAH VICTORIA TURNER

In 1960 the art critic for the *Observer*, Alan Clutton-Brock, was accompanied around that year's Summer Exhibition by the Royal Academician James Fitton.[1] An active member of the London Group and a founder member of the left-wing Artists' International Association, Fitton regularly exhibited scenes of urban life at the Academy – works that typically depicted melancholic figures marooned against the backdrop of a frenetic modernity (fig. 81). The Summer Exhibition was by this stage in the twentieth century, Clutton-Brock observed, a 'non-conformist gathering'.[2] Together, the two men looked at several pictures in the exhibition. Stanley Spencer had died the previous year and was represented by six works, including the large, unfinished *Christ Preaching at Cookham Regatta* (fig. 80). Next, they moved on to *Nell and Roc Sandford* by John Bratby ('very shocking in a rather good way' according to Clutton-Brock). Then came the Scottish artist William Gear, who had never previously shown at the Royal Academy, and who was represented by his *Phantom Landscape*, which signalled the arrival of abstraction at the Summer Exhibition. There was also William Roberts's *TV* (cat. 55), depicting a family watching a boxing match on television. In Gallery IV, these 'non-conformist' pictures rubbed shoulders with what Clutton-Brock said was exactly what 'one expects to see in the Academy. A fantastically photographic portrait, two *trompe-l'œil* landscapes, two sham Dutch flower pictures and a portrait group of artists who look like as though they'd come out of a bad detective story.' As they reached the end of their discussion,

Fitton reflected on the circumstances of seeing work in the context of the Summer Exhibition:

> FITTON: Pictures are certainly transformed by the company round them. I can imagine not recognising one's own painting.
> CLUTTON-BROCK: It's more clear than ever that the Academy is in a state of abrupt transition.
> FITTON: Would you say that we're going in the right direction?
> CLUTTON-BROCK: Yes, but with a great many brakes of the vehicle.[3]

Fig. 81 James Fitton RA, *Violin with Orchestra (Paganini Variations)*, 1965. Oil on canvas with collage, 115 x 86 cm. Newport Museum and Art Gallery, South Wales, NPTMG:1966.8

Fig. 80 Guests at the private view of the 1960 Summer Exhibition view Stanley Spencer RA's *Christ Preaching at Cookham Regatta*

Transition with the brakes on. This is an astute assessment of the Summer Exhibition, and of the wider Academy, as it sought to adapt within the rapidly changing circumstances of the art world in the decades following the Second World War. Sir Hugh Casson (who would become President in 1976), writing in the same newspaper the previous year, had not been so generous when he described the Summer Exhibition as 'a provincial show of no interest to anybody but ourselves'. He recommended radical reform, including swapping the schedule of the Summer and Winter Exhibitions: 'Once clear of the Ascot-Wimbledon-Season circus, it would be taken more seriously and could become more serious.'[4] Casson was not alone and the calls to reform the Summer Exhibition grew louder and more vociferous throughout this period.

REBUILDING TRADITIONS, RETURNING TO ORDER

The Second World War had reduced the exhibiting system of the nation, as Margaret Garlake has noted, to 'a skeleton that would not be fully fleshed out until the 1960s'.[5] Within this deserted landscape, the Royal Academy remained Britain's most prominent artist-led society and the Summer Exhibition continued to provide the largest exhibition venue for contemporary art. Alongside a smattering of commercial galleries, it was an important means for artists to sell their works, largely to middle-class patrons at affordable prices. The aesthetic friction of the sheer range of style, subject-matter and technique of work submitted was keenly felt in the decades after the war, continuing to challenge and inspire those responsible for selecting, hanging and promoting the Summer Exhibition. The reviewer for *Apollo*, discussing current exhibitions in 1945, remarked on the 'red star of commerce' that dominated the walls of the Summer Exhibition, especially in the watercolour room.[6] It is interesting to note how sales rallied towards the end of the war and immediately afterwards. Whereas only 152 works had sold from the whole of the Summer Exhibition in 1940, 739 sold in 1945. However, making art under wartime conditions could be extremely difficult, as T. W. Earp, critic for the *Daily Telegraph*, observed when writing about the sculpture section in 1950. This part of the

Cat. 55 **William Roberts** RA, *TV*, 1960. Oil on canvas, 101.7 x 183 cm. Aberdeen Art Gallery & Museums Collections. Purchased in 1960 with income from the Macdonald Bequest, ABDAG003924

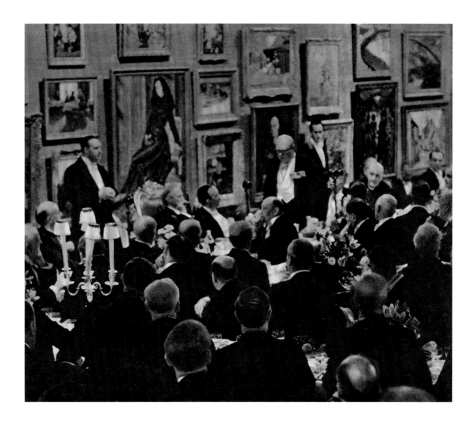

display, he felt, reflected 'the sculptor's difficulty in obtaining materials, their cost and the cost of casting, and the dearth of studio space'.[7] As a result, many sculptural works were much smaller in size. Across the display more broadly, images of rebuilding the nation and of returning to order proliferated in the immediate post-war period. A particularly prominent symbol of reconstruction appeared at the Summer Exhibition of 1952. This was the model for the new Coventry Cathedral designed by Basil Spence, which, as *The Times* reported, had been the 'subject of much criticism and controversy'.[8]

As we have seen, criticism and controversy are never far from the door of the Academy and especially the Summer Exhibition. However, more than any painting hung at the Summer Exhibition, one event that occurred shortly before the opening of the exhibition in 1949 has come to characterise the Royal Academy in the period following the Second World War. At the first Academy Banquet to be held after the end of the war Sir Alfred Munnings, the retiring President, gave an infamous speech, broadcast live on the radio by the BBC,

addressing the Academy's difficult relationship to modern art (fig. 82).[9] This was a subject that refused to go away and one which the artist returned to in a witty painting entitled *Does the Subject Matter?* (cat. 56), exhibited at the Summer Exhibition of 1956. Munnings's picture fired another shot across the bow, reaffirming the exhibition as an arena of public debate about the role and value of the visual arts. The 1956 summer display opened three months after the closing of the exhibition 'Modern Art in the United States' at the Tate Gallery, which brought Abstract Expressionism and painters such as Jackson Pollock to the attention of the British art world and public. Munnings clearly felt that his own important contribution to British painting and his dedication to the Academy and its traditions, were being gradually eroded by a new generation.

RETURN AND REJECTION

1950 witnessed the return to the Summer Exhibition of one of the Academy's prodigal sons, Stanley Spencer, who had resigned in 1935 when he was asked by the Secretary to 'withdraw from the exhibition your two pictures *St Francis and the Birds*

and *The Lovers (The Dustman)*, as [the Hanging Committee] do not think that these works [are] of advantage to your reputation or the influence of the Academy.'[10] Spencer re-joined the royal institution as a full Academician in 1950, and exhibited the central piece of a series on the theme of resurrection, purchased by the Tate Gallery under the Chantrey Bequest. His Diploma Work, *The Farm Gate* (cat. 57), which was exhibited in 1951, demonstrated that Spencer's compositional experimentation had only increased during his time away from the Academy. Other artists did not return to the fold in this way. One was Walter Sickert, who had also resigned in 1935 in protest at the lack of support offered by the Academy to the sculptor Jacob Epstein, following the defacement of his sculptures on Rhodesia (now Zimbabwe) House in the Strand.[11]

Some artists, despite their desire to join the ranks of the Academy, were never invited. John Minton is one example. While friends and fellow members of staff at the Royal College of Art, such as Ruskin Spear and Edward Bawden, had been made Associates of the Royal Academy in the 1940s, Minton – as his fellow-artist Carel Weight remembered – would wait by the telephone in the Senior Common Room at the RCA on election day each year, waiting for the Academy's call.[12] If the telephone did ring, it was not for him. Minton's *The Death of Nelson (after Daniel Maclise)* (cat. 58), hung in the 1952 Summer Exhibition, was a conscious intervention within the genre of academic history painting, which had been defined and redefined at the Academy's annual exhibitions ever since 1769. Reworking the subject of a nineteenth-century mural in the House of Lords by the painter and Royal

Cat. 56 **Sir Alfred Munnings** PRA, *Does the Subject Matter?*, 1953–56 (exh. 1956). Oil on canvas, 76.2 x 108.6 cm. The Munnings Art Museum, Dedham, Essex, CH53

Cat. 57 **Sir Stanley Spencer** RA, *The Farm Gate*, 1950 (exh. 1951). Oil on canvas, 91.5 x 58.5 cm. Royal Academy of Arts, London, 03/198

Academician Daniel Maclise, Minton created his most successful grand narrative painting: 'From now on I'm going to work big,' he told Ronald Searle in 1952. 'I've discovered that one can paint anything so long as it's BIG! It gives a subject an importance that little paintings don't have.'[13] Known for his work as an illustrator and his smaller paintings of bohemian life, Minton took on the traditionally elevated genre of history painting with this work. Freely adapting and omitting details from Maclise's canvas, Minton constructed a complex new composition, centering on the moment of masculine tenderness as the dying admiral is cradled by his shipmate. Surrounded by more modest landscapes

and urban scenes in that year's Summer Exhibition, Minton's huge canvas, measuring nearly two metres high and two and a half long, made an ambitious statement about the development of history painting in Britain and the role of the modern artist in depicting such tragic scenes on a large scale.

Yet, this kind of engagement with the conventions of history painting did not always bring success and was, it could be argued, a risky strategy. Edward Bawden, who fought to have Minton elected as an Academician, observed that it was a fight to no avail, 'there being a strong prejudice against his painting of the Death of Nelson'.[14] Prejudice operated not only against Minton's painting; it was

Cat. 58 John Minton, *The Death of Nelson (after Daniel Maclise)*, 1952.
Oil on canvas, 183 x 245 cm. Royal College of Art Collection, RCACC/291

also widely thought that homophobia kept him out of the Academy.[15] Minton committed suicide in 1957 at the age of 39. In his short career, he had blurred the lines between post-war bohemia and the more traditional, rarefied world of Burlington House, but it was a boundary crossing that was ultimately not to win him acceptance.

EXHIBITIONS IN THE TELEVISION AGE

1955 was a hot summer, but despite this the exhibition of that year was a particular success (it was usually the rain that encouraged the public inside). Many visitors made a beeline for one painting: Pietro Annigoni's *Queen Elizabeth II*

(cat. 59), commissioned by the Worshipful Company of Fishmongers. Annigoni's portrait depicted the young and recently crowned queen standing against an imaginary background, which included a small self-portrait of the artist fishing for salmon (to please the Fishmongers, so he told the *Daily Mail*).[16] The portrait, which maintained the exhibition's long history of royal portraiture and display, was frequently surrounded by crowds ten-deep and the opening hours of the exhibition had to be extended on account of its popularity.[17] Significantly, the record attendance figures in 1955, generated in large part by this portrait, were not to be broken until the exhibition of 2015. According to the art critic Myfanwy Piper, there was no need to go and see Annigoni's portrait in the flesh because there was 'a reproduction in almost every periodical in the country', again demonstrating the power of reproductive technologies to put an image into circulation even as the original hung at the exhibition.[18] Despite such criticism, images of this hugely popular work catapulted Annigoni to popular fame, with his portrait appearing in various forms: in prints, on banknotes and on postage stamps. The painting itself, however, entered the private collection of a City of London Company; it has only twice been exhibited in public since 1955.[19]

A spike in television ownership in Britain can be attributed to the broadcast of the Queen's coronation in 1953. Between 1956 and 1960, the number of households with a television almost

Cat. 59 Pietro Annigoni, *Queen Elizabeth II*, 1955. Tempera grassa on Japanese paper laid on canvas, 150.2 x 100 cm. The Fishmongers' Company

doubled from 5.7 million to 11 million.[20] As we have seen, painting nevertheless still had the power to pull the crowds – to offer a sense of spectacle and social occasion, to educate and to entertain. Visitors wanted to be informed and to learn about the work on show. During the printing dispute of 1959 – a national stoppage that affected the whole of the British printing and publishing industry – the Academy hired out the exhibition catalogues it had managed to have printed to satisfy the demand of visitors.[21] There was a sense that exhibitions in the post-war period had to compete with new forms of mass-media entertainment – that they had to offer both an escape from, and a connection to, the realities of everyday life. In 1960 the *Illustrated London News* included William Roberts's *TV* (cat. 55), noted at the beginning of this chapter, as a lead image in the first part of its Summer Exhibition supplement, 'The R.A. in the Television Age: Paintings of Wit and Sentiment'. We might see Roberts's picture as a wry comment on the leisure pursuits of modern life, gesturing to the ways in which the television screen had replaced the static two-dimensional image as a means to capture the rapt attention of the nation. Yet, rather than lamenting such technological change, Roberts's painting seems instead to celebrate it, and to use it to tell a story of modern life on a substantial scale. Critics commented that this was the first time that a television had been seen within the hallowed spaces of the Royal Academy.[22] Several more decades were to pass, however, before screens themselves entered the exhibition in the form of video art or as moving-image practice.

Roberts's picture was not alone in turning its focus on the everyday routines of modern life. As well as portraits of royals, aristocrats, the rich and famous, and generals and heroes, paintings with subjects of a more mundane and familiar kind were increasingly featured on the walls of Burlington House. There were the soap-packet and chip-pan-laden interiors of the 'Kitchen Sink School' represented by painters such as Jean Cooke and John Bratby (fig. 83). Along with the suburban gardens and country lanes that were also to be found pictured on the exhibition's walls, L. S. Lowry exhibited his now iconic scenes of the northern industrial landscape. This was all starting to look very non-academic. Were the brakes on transition starting to be released? The journalists certainly perceived some change: 'Pop art and abstract art have invaded', wrote the critic for the *Daily Telegraph*, 'but John Bratby's immense crucifixion picture … dominates the exhibition'.[23] In 1965 Peter Blake exhibited *The Toy Shop* (cat. 60). At once a

Fig. 83 **Jean Cooke** RA, *Early Portrait of John Bratby, RA*, 1954. Oil on canvas, 122 x 91.4 cm. Royal Academy of Arts, London, 03/850

reduced-scale facsimile of an everyday shopfront and an archive of his personal collection of childhood memorabilia, the work was quickly recognised as a provocative intervention into the familiar milieu of the Academy's summer show. Not quite painting nor sculpture, more a cabinet of curiosities, *The Toy Shop* playfully assimilated assemblage and collage, popular culture and fine art, social documentary and self-portraiture, British bits and bobs and the products of Americana. Furthermore, *The Toy Shop* offered visitors to the 1965 show a playful and miniaturised form of counterpoint to the Summer Exhibition itself. Its crowded assemblage of popular, ephemeral and brightly coloured materials served as a kind of Pop-art version of the similarly dense collage of pictures that hung on the Academy's walls. An alternative to the Academy – comic strips, children's masks, football cards and pop-star photographs – is put on show within *The Toy Shop*'s windows.

Significantly, there had been a conscious effort to create a fresh impact that year. The then senior member of the Hanging Committee, Thomas Monnington (who was to become President in 1966), spent £1,000 on refurbishing four galleries with 'white wall coverings and velariums – low gauze ceilings that soften the light'. The Committee even considered allowing smoking in one gallery.[24] A different mood and a more modern environment were being sought, to be created not only by the pictures themselves but also by the kind of visitors who frequented the show. It seemingly worked. 'Beatniks and Dowagers Crowd the Academy' reported the *Daily Telegraph* of the 1965 private view. Fashion was an indicator of change: 'Long-haired beatniks in jeans jostled with dowagers in diamonds yesterday… the young men as long-haired as the girls. Their private-view day outfits: trousers, scruffy duffels and crepe-soled "sneakers"… let the delicate wince, but it will be a "fun" Academy.'[25]

Cat. 60 **Sir Peter Blake**, *The Toy Shop*, 1962 (exh. 1965).
Wood, glass, paper, plastic, fabric and other materials,
156.8 x 194 x 34 cm. Tate: Purchased 1970, T01175

FIGURATION/ABSTRACTION

The depiction of the human figure – and the debates that surrounded such depictions – had dominated the Academy from its foundation in the eighteenth century. Euan Uglow's submission to the 1964 Summer Exhibition, *Nude* (cat. 61), offers a meditation on the structural analysis that underpins the representation of the human figure and on the artistic labour required to produce such meticulous figuration. Built-up layers of colour produce the solidity of this body; the juxtaposition of fleshy tones makes paint approximate skin. The bare studio environment forces the viewer's attention back to the tense, rigid and labouring body, challenging the artistic clichés that had come to dominate this strand of painting. Here, rather than placing his model in a supine and erotically inviting pose – as was often the case in paintings and sculptures submitted to the summer show – Uglow renders this particular female form as inward-turning and deliberately awkward. Refusing to look at the viewer, the model's face is obscured. Uglow's picture was one of five deemed important enough by the President and Council to be offered to the Tate Gallery under the terms of the Chantrey Bequest, yet despite *Nude*'s evident success, Uglow never exhibited at the Summer Exhibition again, having rejected the offer to become an RA in 1961. Whereas some artists craved the Academy's approval, for others, institutional distance was important, productive even.

The clothed bodies in Frank Bowling's *Mirror* (cat. 62), shown careering down a vertiginous spiral staircase, are similarly unfamiliar and awkward. This monumental painting was first displayed in public at the Summer Exhibition of 1966. Bowling, who was born in Guyana, had graduated from the Royal College of Art in 1961 with the Silver Medal for Painting. *Mirror* put into conversation a virtuoso range of painterly modes that Bowling had already demonstrated as a student. The painting places different pictorial vocabularies in dynamic interaction: forms of figuration alluding to the work of Francis Bacon mix with the pictorial languages of Op art and post-painterly abstraction, and with the precise kinds of draughtsmanship that had already

Cat. 61 **Euan Uglow, *Nude*, 1962–63 (exh. 1964). Oil on canvas, 163.2 x 116.8 cm. Tate: Presented by the Trustees of the Chantrey Bequest 1964, T00659**

become associated with such RCA contemporaries of Bowling's as R. B. Kitaj and David Hockney. Even as it offers a manifesto of eclecticism, the picture is also a memoir of Bowling's time at the Royal College, which housed the spiral staircase that is seen twisting down the centre of his painting. *Mirror*, in its vortex-like forms and the protagonists it depicts, draws on the artist's dramatic personal and emotional trajectory as a student at the Royal College – someone, indeed, who had been temporarily ejected from his course because of his marriage to a member of the administrative staff, Paddy Kitchen. A photograph of Kitchen forms the basis for the standing figure shown in the upper reaches of the painting, while the doubled image of Bowling himself (again derived from photographs) simultaneously spins out of control and descends the pictured staircase. This form of self-portraiture was of a very different order to that conventionally associated with the Summer Exhibition. *Mirror* reminds us, too, of other forms of institutional inclusion and exclusion: in 2005 Bowling became the first black Royal Academician, nearly 40 years after he had first exhibited his striking canvas at the Summer Exhibition.

The future of the figure – and of figurative art more generally – was a central issue at the Academy as the pressure of abstraction was increasingly felt. This tension was negotiated not only on canvas, but also in the sculpted works submitted to the Summer Exhibition. A commitment to sculptural figuration was particularly visible in the post-war period in the work of émigré sculptors associated with the Academy, such as Siegfried Charoux (fig. 84), Uli Nimptsch and Willi Soukop. Elisabeth Frink's sculpture, too, demonstrated an unerring commitment to exploring the human form, particularly within the medium of bronze. By

Cat. 62 Frank Bowling RA, *Mirror*, 1966. Oil on canvas, 310 x 216.8 cm. Tate: Presented by the artist, Rachel Scott, and their 4 children: Benjamin and Sacha Bowling, Marcia and Iona Scott 2013, T13936

the time she exhibited the lithe, athletic *Running Man* (cat. 63) at the Summer Exhibition of 1979, Frink had been elected a full Academician. In 1984 there were also moves to make the 54-year-old sculptor – by then a Dame – the first female President of the Academy. Concurrently, the Academy held a retrospective of her work entitled 'The Dominant Male'. Frink did not want the post, however, and it went to the Academy's Treasurer Roger de Grey, succeeding Hugh Casson, both of whom pushed for reform during financially difficult years. There has still been no female President in the Academy's 250-year history.

The press coverage of the Summer Exhibition in the 1960s and 1970s provides a glimpse of individual displays, and of the changing conceptual and material character of the works that were being put on show. In 1966, for instance, the press was quick to notice the fact that a decision had

Fig. 84 Siegfried Charoux RA, *Youth, c.* 1948 (exh. 1948). Terracotta, 180.1 x 72 x 60 cm. Tate: Presented by the Trustees of the Chantry Bequest 1948, N05863

Cat. 63 Dame Elisabeth Frink RA, *Running Man*, 1978 (exh. 1979). Bronze, 190.5 x 129.5 x 65.4 cm. The Executors of the Frink Estate and Archive

Cat. 64 Sandra Blow RA, *Green and Red Variations,* 1978 (exh. 1979).
Oil and collage on canvas, 137.2 x 121.9 cm. Royal Academy of Arts,
London, 03/818

been made to group together works by a single artist (those who were Academicians), regardless of medium, creating mini-exhibitions within the larger schema of the summer show. The *Illustrated London News* deemed this a success: the 'visitor realises, possibly for the first time, that not all the Academicians are primarily oil painters'.[26] Painting had dominated the Summer Exhibition, but the printmakers and watercolourists in particular benefited from this new arrangement.

In its own selection of works from that same display, the *Illustrated London News* chose what it described as a 'non-conformist' mix, including pieces by Fitton, Tristram Hillier, John Nash, a woodblock print by Gertrude Hermes, and Frank Bowling's *Mirror*. Five years later, in 1971, *Country Life* captured the 'apparently outrageous appearance of a beam on three piles of gravel'[27] – Geoffrey Clarke's *Blueprint* – in front of a large abstract painting by Sandra Blow. Blow's increasingly large and often mixed-media abstract canvases were regularly included in the Summer Exhibition. Her Diploma Work, *Green and Red Variations*, exhibited in 1979 (cat. 64), demonstrates her inventive and scavenger-like approach to making abstract works, in which she used materials such as felt and even tea in combination with oil paint – an experimental approach she had developed early in her career while working and living with the Italian artist Alberto Burri

in Rome after the Second World War. Blow's large canvases, with their surprising contrasts of colour and material, brought abstraction into the halls of the Academy in a bold way, something also achieved by the work of artists such as Gillian Ayres, Paul Huxley and John Hoyland.

'IS THE ROYAL ACADEMY LOSING ITS APPEAL?'

This stark question was posed to readers of *The Times* on 20 June 1985, superimposed on a photograph of crowds queuing in the Academy's courtyard, then still being used as a car park, as part of a full-page advertisement generated by a competition run by the Academy and *The Times* (fig. 85).[28] The Academy's finances were in dire straits at this time, and the institution needed £6 million to remain operational. Was the Academy losing its appeal? The public were invited by *The Times* to judge for themselves, based on what

Fig. 85 'Is the Royal Academy losing its appeal?', advertisement by Sears and Nelson for the Royal Academy of Arts, *The Times*, 20 June 1985, p. 8

were described as exhibitions of international acclaim, an art school 'bursting with young talent' and a Summer Exhibition that was 'as much part of the season as strawberries and cream'. It was, the advertisement declared, unthinkable 'that all this could end, after 200 years, simply for lack of money'. Financial changes had already been made to try and harness the commercial success of the Summer Exhibition; in 1977 a 15% commission on sales was introduced for the first time and in 1983 the computer firm IBM became the Summer Exhibition's first commercial sponsor.

For some, however, especially in the case of critics and certain celebrated artists, the Academy had long lost its appeal; indeed, for a number of particularly well-known figures, it had never had any appeal whatsoever. Francis Bacon, for instance, resolutely refused to join despite numerous invitations. Yet even he ended up making an

appearance in the Summer Exhibition of 1985, in a portrait by Ruskin Spear (or Augustus John Ruskin Spear, to give him his appropriately artistic full name) (cat. 65). Spear was a stalwart of the exhibition and the Academy, having been made an Associate Royal Academician in 1944 and a full Academician in 1954. Often working from photographs, and very consciously engaging with the work of artists he admired, especially Walter Sickert, Spear synthesised different styles and techniques to create works that often walk a fine line between satire and seriousness. Bacon stares out at us from Spear's portrait with a quizzical look, which appears to ask: 'What am I doing here?' The following year, the press made much of the fact that another long-term absentee from the Summer Exhibition's ranks – David Hockney – was now displaying his works at the Academy's annual display, following his election as an Associate of the Royal Academy (although this was not in fact the first time he had exhibited; astonishingly, that had been in 1957). At a time when the future of the Academy was at stake, both in terms of its financial health and its artistic reputation, the presence of such celebrated artists at the Summer Exhibition was all the more necessary. Celebrity alone would not ensure the continuing success of the display, however; the kind of artistic fame enjoyed by Hockney needed to be harnessed to more fundamental forms of transformation and redefinition.

Cat. 65 **Ruskin Spear** RA, *Francis Bacon*, **1984 (exh. 1985).**
Oil on board, 76.2 x 63.2 cm. National Portrait Gallery, London,
NPG 5818

THE SELECTION COMMITTEE

MARK HALLETT

The Royal Academy's Selection Committee plays a crucial role in the Summer Exhibition. Comprising members of the Academy's Council, and typically chaired by the President, it sifts through the enormous number of works of art that are submitted by non-Academicians each year, and decides upon those that it deems of sufficient quality and interest to be exhibited. Given the importance of this Committee, it is no surprise to see that it has been pictured on a number of occasions, most famously by Charles West Cope in 1876 (fig. 65). A rather less grandiose representation of its workings was to be found, however, in the *Royal Academy Illustrated* during the 1970s.

A series of photographs taken for this in-house publication's pages during this decade offers not only a visual record of the Committee's membership, but also an intriguing pictorial insight into the everyday workings of the British cultural establishment.[1] It feels right that they are in black and white: for they picture a ritual that is full of the grey traces of boredom and exhaustion as well as those of conversation and aesthetic judgement. The images capture, too, both the rigidities and the subtleties of institutional hierarchy within the Academy: the then-President, Sir Thomas Monnington, is repeatedly shown at their centre, besuited and stern-faced; elsewhere, differences of seniority are suggested by clothing, expression and body language. And, of course, they capture the gender imbalances that characterised not only the Academy but all leading cultural organisations of the period. In 1972 the Academician Gertrude Hermes was the only woman on the Committee; in one of the photographs from that year's *Royal Academy Illustrated* (fig.

Fig. 86 **Selection Committee, 1972, with Gertrude Hermes at far left**
Fig. 87 **Selection Committee, 1972**

86) she is shown sitting on the far edge of the gathered male assembly; in another, she is excluded altogether (fig. 87). In the following year's edition, she is pictured up-close with her fellow Committee member Olwyn Bowey (fig. 88); but in the adjacent, larger, group photograph (fig. 89), she sits with her head downturned amid a semicircle of men whose faces seem variously saturated with concentration, grumpiness and tiredness. In this photograph, Bowey seems to have been effaced altogether: but is that a glimpse

of her hair behind Hermes's head? Then, in 1974, it is Jennifer Dickson's turn to sit in such a semicircle (fig. 90), alongside her young fellow-Associate Anthony Green, and to raise her arm in eager approbation while, nearby, someone from a very different generation, the Royal Academician William Dring, sits with arms and legs firmly crossed.

The photographs, looked at together, offer a remarkably revealing and accidentally subversive form of group portraiture. Though no doubt intended, like Cope's earlier

painting, to reinforce the Academy's seriousness and expertise as an arbiter of contemporary art, and the reputation of the Academicians themselves for fair-mindedness and collegiality, they can also be read very differently: that is, as images that unwittingly expose the bureaucratic forms of repression, prejudice and hierarchy that clung like the layers of a tightly buttoned three-piece suit to the activities of the Selection Committee in the 1970s.

Fig. 88 **Selection Committee, 1973: Olwyn Bowey and Gertrude Hermes**
Fig. 89 **Selection Committee, 1973**

Fig. 90 **Selection Committee, 1974, including Jennifer Dickson, Anthony Green and William Dring**

145

NEW SENSATIONS

MARK HALLETT

At the beginning of the 1990s many British art critics, when reviewing the Academy's Summer Exhibition, were content to fall back on the clichés that, for good reasons as well as bad, had come to define the show. In the words of Marina Vaizey, writing for *The Sunday Times* in 1991, the Academy's summer display was an event that was 'hardly ever at the cutting edge, but more … an affirmation of the safe, tried, and tested views of middle England'.[1] Two years later, in a more acidic vein, the *Sunday Telegraph*'s John McEwen bemoaned the grotesque juxtapositions that he saw being thrown up by the display: 'hideous abstractions on one hand and kitsch representation on the other with, in between, acres of paintings by competent part-timers who all seem to live in Purley. People say "The dear old summer exhibition, it cuts across the barriers. It's so jolly, such fun." Well, yes, if you call mediocrity fun.'[2]

This kind of commentary still clings to the Summer Exhibition on occasion; and it is true, too, that many of the most interesting younger British artists of today do not think of the display as one in which they might participate, in part because they perceive it as relevant, rather, to older, more well-established practitioners. However, from another perspective, the past quarter of a century can be seen to have witnessed an important series of changes in the character and appeal of the Academy's summer display – changes that have opened it up to the energy and impetus of a new, celebrated generation of artists, and brought it far closer to the central concerns and characteristics of the contemporary art world. Further confounding the journalistic cliché that the Academy's show, in the words of Brian Sewell, 'has no artistic merit whatsoever' and amounts to little more than 'flowered hats and blue rinses', recent Summer Exhibitions have also demonstrated, as can now be explored, new kinds of artistic bite and conceptual rigour.[3]

SANDRA THREE

Exhibitions – even the crowded and miscellaneous Summer Exhibition – can sometimes be electrified by an individual work of art. In 1997 visitors to the Academy's show, as they walked into Gallery II at

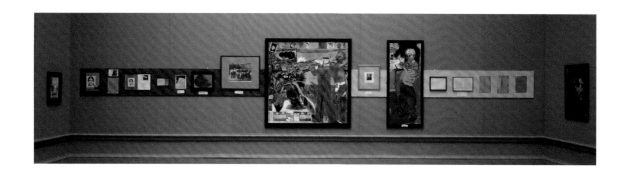

Fig. 91 **Installing Gary Hume** RA's *Purple Pauline* (cat. 67) in Gallery I for the 1998 Summer Exhibition

Fig. 92 **R. B. Kitaj** RA, *Sandra Three*, incorporating *The Killer-Critic Assassinated by His Widower, Even* (cat. 66), 1997

Burlington House, encountered a work that was like no other in the display: R. B. Kitaj's *Sandra Three* (fig. 92), an installation of paintings, photographs and text that stretched across an entire wall of the gallery.[4] The work's distinctiveness was, in part, due to its raging and embittered attack on the kinds of art critics who had long rounded on the Summer Exhibition itself. Three years earlier, in 1994, Kitaj, an American-born artist who had been an important figure on the British art scene since the 1960s, and who had been elected an Academician in 1991, had received a series of unusually vicious press reviews for a retrospective exhibition of his works at the Tate Gallery. To add to his misfortunes, his wife, the painter Sandra Fisher, had died suddenly of a brain aneurysm soon after the retrospective had closed. Convinced that her death had been caused in part by the viciousness of the reviews he and his work shown at the Tate had suffered, Kitaj used the Academy's Summer Exhibition to showcase a sequence of works that dealt with these events, and that he aligned with the format of a journal. They served as an unfolding pictorial memorial to his dead wife and as an extended instrument of artistic revenge.

In his initial piece, *Sandra One* (fig. 93), which was exhibited at the 1996 Summer Exhibition, a portrait of Fisher, granted pristine isolation in the work's version of a title page, and surrounded by studiously neat and underlined script, is counterbalanced by a dislocated and graffiti-like inscription declaring that 'The Critic Kills', the first word of which is framed in bloody red ink. Having published a work called *Sandra Two* in paper form in the autumn of 1996, Kitaj maintained his artistic attack in 1997 with *Sandra Three*. This piece centres upon a painting, *The Killer-Critic Assassinated by His Widower, Even* (cat. 66), that alludes in its title to Marcel Duchamp's famous early twentieth-century art work *The Bride Stripped Bare by Her Bachelors, Even*, and which also revises the iconography and narratives of Edouard Manet's nineteenth-century painting *The Execution of Maximilian*, a photograph of which Kitaj included as part of his overall installation. In the painted centrepiece, which shouted out from the Academy's muted green walls with its lurid red palette and shocking imagery, Kitaj pictures himself as one of a group of figures firing at point-blank range into the monstrous, multi-eyed and blood-bespattered head of the eponymous 'Killer-Critic'.

Kitaj's work – as was acknowledged even in the broadsheet press itself – helped to generate a new polemical edge and sense of artistic urgency within the exhibition.[5] *Sandra Three*'s importance in relation to the Summer Exhibition was due as much, however, to the distinctiveness of its format as to the shock of its contents. Expanding upon the 'journal' structure he had inaugurated with *Sandra One* the year before, the work invited the viewer not only to absorb the disturbing messages of its dominant visual element – *The Killer-Critic* – but also

Fig. 93 **R. B. Kitaj** RA, *Sandra One: The Critic Kills*, 1996. Oil on canvas on board with collage, 51 x 204.2 cm. Collection of Max Kitaj

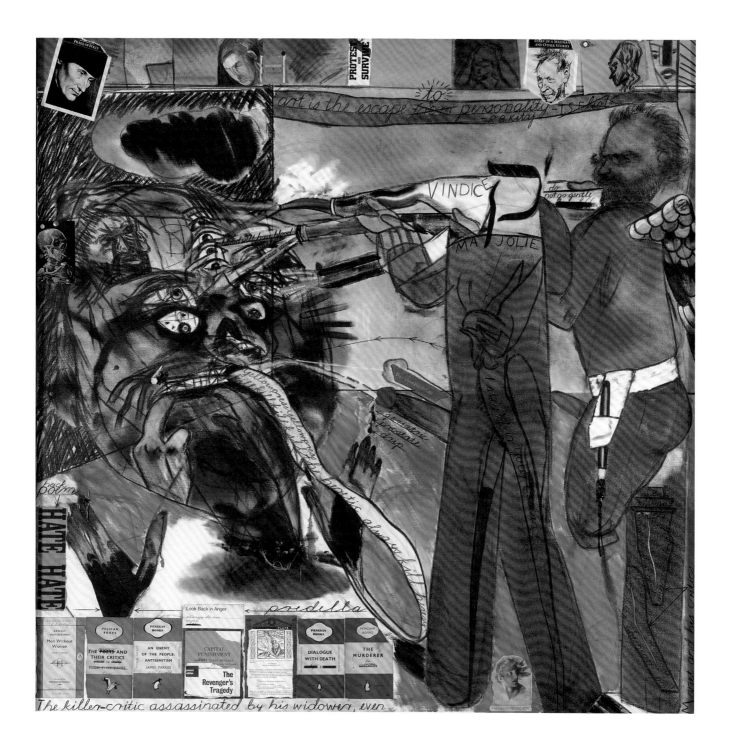

to mull over the wide range of other pictorial and textual materials, both appropriated and invented, that made up the work in its entirety, and which extended in a linear sequence across the gallery wall. Here it is crucial to note that the Academy's exhibition, even at this late date, rarely included – or gave such prominent space to – mixed-media assemblages or installations of this kind. *Sandra Three* can now be seen to have harnessed its explosive iconography of revenge and memorial to a format that, though relatively familiar to anyone versed in the history of avant-garde artistic practice, seemed strikingly novel within the continuingly conservative exhibition spaces of Burlington House.[6]

Cat. 66 **R. B. Kitaj** RA, *The Killer-Critic Assassinated by His Widower, Even*, **1997. Oil and collage on canvas, 152.4 x 152.4 cm. Astrup Fearnley Collection, Oslo**

THE 'SENSATION' GENERATION

The pictorial shock-value and the iconoclastic mixture of materials that *Sandra Three* brought to the 1997 Summer Exhibition were, in that very same year, taken in a fresh direction by a new generation of British artists, whose works were once again to be found hanging on the Academy's hallowed walls. This was not at the Summer Exhibition itself, however, but at the exhibition that immediately followed it in that year's programme: 'Sensation', which opened in September 1997, and which introduced a wider public to the artists known as the YBAs (Young British Artists).[7] This notoriously controversial and well-attended show, based on the collection of the advertising mogul and leading art-world figure Charles Saatchi, featured a raft of works by recently graduated British artists. Many of their pieces married an interest in the vernacular storylines and abject materials of British popular culture with forms of presentation that were knowingly provocative, and that systematically undermined mainstream expectations concerning the proprieties of fine art (fig. 94). Within the spaces of an institution that was still, by many, considered a bastion of traditional cultural values and artistic forms, this kind of provocation enjoyed extra traction; predictably, perhaps, the show earned the ire of

certain Academicians, and was quickly exploited by the contemporary press as a means to drum up manufactured forms of outrage.[8] At the same time, however, the exhibition represented a breach of artistic and institutional decorum that allowed other, more sympathetic Academicians to begin opening up their institution – and the Summer Exhibition it sponsored – to the possibility of colonising at least some of the youthful energy, artistic inventiveness and popular appeal of 'Sensation'.

The first sign of such a change was to be found in the following year's Summer Exhibition, which gave prominence to a work by Gary Hume, one of the artists who had shown in 'Sensation'. His *Purple Pauline* (cat. 67, fig. 91), painted in enamel on aluminium, and which offered a visually bold but highly enigmatic reworking of the female nude, was put on display in Gallery I, the first space that visitors entered as they walked through the exhibition. There, Hume's strange, sci-fi-like figure, crafted in ways that are both finely

Fig. 94 **Sarah Lucas, *Bunny*, 1997. Tan tights, black stockings, plastic and chrome chair, clamp, kapok, wire, 102 x 90 x 64 cm. Private collection**

Cat. 67 **Gary Hume RA, *Purple Pauline*, 1997 (exh. 1998). Enamel on aluminium panel, 208.5 x 117 cm. Private collection**

tuned and deliberately clumsy, and painted in a colour that was described by the critic Martin Gayford as a 'shrieking' purple, made a striking contrast to many of its more familiar-looking and soberly hued pictorial companions.[9] In the words of Gayford, who showed some sympathy with Hume's piece, *Purple Pauline* enjoyed an 'agreeably strong and tasteless presence' in the show.[10]

The symbolic charge carried by Hume's participation in the 1998 display was to be further enhanced by the introduction of a far larger group of works by the 'Sensation' artists in the 2001 Summer Exhibition. That year's Senior Hanger, who supervised the overall arrangement of the display, was Peter Blake, who had long been interested in reanimating the summer show, and who was also a self-declared fan of many of the artists championed by Saatchi. Blake introduced a series of major changes to the 2001 display, including that of exhibiting the works of Academicians in separate galleries from those of non-members. He also

revived a strategy that he had first managed to get accepted during an earlier stint on the Hanging Committee, in 1976: that of devoting a single gallery to the works of non-Academicians whom he had himself invited to participate in the show.[11]

In 2001 the artists whose works he brought into the display in this manner included not only older, widely revered non-Academicians such as Richard Smith and Bridget Riley, but also a group of the younger practitioners who had proved so controversial in 1997, including Damien Hirst, Sarah Lucas and Tracey Emin. The latter was represented by a piece (cat. 68) that flaunted her innovative and highly personalised practice, in which she transformed her grandmother's humble chair into a piece of appliqué sculpture. Such an object, in the company of exhibits such as Lucas's *Willy* (fig. 95), helped to turn the Academy's Large Weston Room into a gallery that must have seemed to many visitors like an irreverent, very Blake-like cabinet of curiosities. More significantly, however, this same room could also be appreciated as a space in which at least some aspects of that alternative history of modern British art that had found expression outside the Summer Exhibition – stretching back to the work of Riley and Smith in the 1960s, and coming right up to the 'Sensation' moment four years earlier – had been brought, however

Cat. 68 Tracey Emin RA, *There's a Lot of Money in Chairs*, 1994 (exh. 2001). Appliquéd armchair, 69 x 53.5 x 49.5 cm. Private collection

Fig. 95 Sarah Lucas, *Willy*, 2000. Plastic gnome, cigarettes, 86 x 42 x 34 cm. Arts Council Collection, London

Fig. 96 **Installation view of Anselm Kiefer Hon** RA's *Aperiat terra et germinet Salvatorem*, 2007

temporarily, into the Academy's fold. For a number of the artists who had featured in this alternative history, this form of institutional incorporation was to prove longer-lasting: today, for example, six of the artists featured in 'Sensation' – Emin, Hume, Michael Landy, Jenny Saville, Yinka Shonibare and Gillian Wearing – are Royal Academicians.

GOING BIG

One of the other innovations introduced by Peter Blake in 2001 was that of inviting all the Academy's Honorary Academicians – that is, leading foreign artists who have been elected to the institution – to send in individual works, which in turn were grouped together within the display. Since then, the presence of large-scale pieces by such internationally celebrated non-British artists as Robert Rauschenberg, Anselm Kiefer and Georg Baselitz has become an increasingly prominent part of the Summer Exhibition, and has helped the show to rebut the charge of parochialism and triviality to which it is still sometimes subject. Kiefer, for example, who was elected an Honorary Academician in 1996, has consistently exhibited monumentally sized and sublimely themed pieces at the summer display. His *Aperiat terra et germinet Salvatorem* (fig. 96) was submitted in 2007, and was

described by Paul Huxley, a Senior Hanger that year, as the heaviest painting the exhibition had ever seen: 'I could scarcely believe my eyes when it was going up … it needed two cranes, seven technicians, and I don't know how much modern technology.'[12] Once erected, Kiefer's astonishing work blazed forth as a visually overwhelming pictorial meditation on war, memory and renewal. Carrying an inscription in Latin from the book of Isaiah that translates as 'let the earth be opened', and erupting with apocalyptic allusions to disaster and resurrection, the work centres on the rusted model of a submarine, shown on a collision course with a hanging thorn-bush, and imagined as swimming through a landscape of cracked mud and bespattered yet brightly coloured poppies. Though steeped in the iconography of twentieth-century warfare, this is a work that carries, too, the echoes of a far older strand of battle-scarred landscape painting exhibited at the Academy, stretching right back to such canvases as Turner's *Field of Waterloo* (see fig. 31), shown almost two hundred years beforehand, and which offered a similarly sublime form of pictorial post-mortem on the narratives of conflict.[13]

Another artist who has helped grant the Summer Exhibition a new artistic weight over the past three decades has been David Hockney, who

Cat. 69 **David Hockney** RA, *Double Study for 'A Closer Grand Canyon'*, 1998 (exh. 1999). Oil on canvas, 181.6 x 121.3 cm. Royal Academy of Arts, London, 03/891

Fig. 97 **Installation view of David Hockney** RA's *Bigger Trees near Warter*, 2007

for a long period has enjoyed an extraordinary popularity among the British public.[14] As was noted at the end of the previous chapter, Hockney had begun to submit pieces to the annual display on a regular basis from the late 1980s; since then, he has periodically exhibited a succession of large-scale works that have provided spectacular centres of pictorial attention within the Summer Exhibition as a whole. Thus, in 1999, his series of brightly coloured, panoramic views of the Grand Canyon took over an entire gallery, their dazzling visual effects multiplied by the use of large, angled mirrors to reflect their contents (cat. 69). In 2007, the year of Kiefer's great *Aperiat terra et germinet Salvatorem*, Hockney made an even more dramatic intervention, displaying what was described, again by Paul Huxley, as the 'largest painting' ever included in the show: *Bigger Trees near Warter* (fig. 97), which took over the entirety of one wall in Gallery III.[15]

This enormous work, made up of 50 canvases arranged into one vast rectangular landscape, was the product of an extended period of painting outdoors on Hockney's part, in which he would spend days working in front of his motif: a cluster of trees in his home county of Yorkshire. Each evening, Hockney reviewed digital images of the work's different components, so as to ensure consistency across the emergent image; unsurprisingly, the resultant painting is unabashedly modern in feel, with its flattened composition and bright colours.[16] At the same time, however, it can be compared,

like Kiefer's very different landscape, to famous precedents at the Summer Exhibition itself. Isn't what Hockney does in this work rather similar to what Constable did in a picture such as *The White Horse* (see fig. 46), the product, too, of long hours of painting the landscape that the artist knew best, and an image that similarly explores the iconography of a bank of trees shielding a cluster of houses deep in the heart of the English countryside? And isn't the interplay of this work and Kiefer's, which hung together in Gallery III in 2007, a modern if more accidental re-run of the productive and inspiring interplay between Constable's and Turner's landscapes in the early nineteenth century? Only in part, perhaps – but the comparison is suggestive of the ways in which the Summer Exhibition continues to play off ambitious works of art against each other, as it does the celebrated artists who produce them.

BLACK AND WHITE AND BLUE AND PINK

The heavyweight presence of Hockney and Kiefer at the 2007 Summer Exhibition helped the display to attract a larger number of visitors – 159,894 – than it

Cat. 70 **Cornelia Parker** RA, *Stolen Thunder III*, **2015.**
Digital print, 78 x 78 cm. Jessie Ware

had received for nearly thirty years, and more than twice as many than it had attracted only two years previously, in 2005.[17] Since this blockbuster year, the Summer Exhibition, its direction shaped not only by senior Academicians but also by the ambitious and street-smart curator Edith Devaney, has continued to attract similarly large audiences. It has done so not only thanks to the increasing celebrity enjoyed by so many of its participants, including, in recent years, artists such as Emin and Grayson Perry, but also because of the increasingly innovative ways in which the exhibition has been conceived and designed. This was certainly the case in both 2014 and 2015, which witnessed two especially bold experiments in the presentation of works in the display.

The first such experiment was devised and orchestrated by Cornelia Parker, an Academician since 2009, and an artist whose own annual submissions to the Academy's shows have been marked by a lucid, inventive and often surprising engagement with different kinds of materials.[18] In the case of a sequence of works exhibited from 2013 onwards under the title of *Stolen Thunder (Red*

Spot) (cat. 70) they have also offered an obliquely witty meditation on one of the most familiar little details of the Burlington House display – the red dot signifying a sale – and on the emotions (including the envious desire to steal another artist's success) that can be stimulated by sight of a line of such dots snaking around the edges of a popular print.

Parker brought the same kind of inventiveness to her labours on the Hanging Committee for the 2014 show. In what was becoming an accepted convention, she was invited to fill the Lecture Room – the last gallery in the exhibition – with works by artists of her own choosing. She responded with a visually stunning display structured around the theme of 'black and white' (fig. 98). This brought the works of leading non-Academicians of the contemporary art scene, including Fiona Banner, Jeremy Deller and Mona Hatoum, into dialogue with those of established and new Academicians, the latter of whom included the artist known as Bob and Roberta Smith, who exhibited an especially striking text-piece that railed against the contemporary Conservative government's attack

Cat. 71 **Wolfgang Tillmans** RA, *Greifbar 1*, **2014.**
Inkjet print on paper, clips, 253 x 355 cm.
Courtesy of the artist and Maureen Paley, London

on the teaching of art in schools.[19] Described by Parker as a space that offered a conscious contrast to the 'riot of colour' found earlier in the display, and that offered 'a kind of firebreak' at the end of the exhibition, the gallery's simple visual logic served only to amplify the impact of the works chosen by Parker, and the subtle forms of interaction – political as well as visual – that she orchestrated between them.[20] Finally, in a striking form of visual counterpoint, Wolfgang Tillmans's spectacular photographic print *Greifbar 1* (cat. 71), was hung just outside one of the Lecture Room's doorways, thus providing a rippling, blood-red backdrop to the monochromatic objects gathered within.

This kind of curatorial control over the display was taken a radical step further by the following year's Senior Hanger, Michael Craig-Martin, who had not only enjoyed a long and influential career as an artist and teacher by this point, but more than a decade as an especially active and outward-looking Academician.[21] Like Blake and Parker, Craig-Martin has played an important part in opening up the institution and its exhibitions to new generations of artists, including those associated with the 'Sensation' exhibition, which he had played a part in facilitating.[22] Furthermore, his own exhibition submissions over many years have introduced a distinctive strand of conceptual painting into the fabric of the display. In much of his output, an intellectually rigorous examination of the lineaments and associations of everyday objects, and of the meanings that might be generated by their juxtaposition, is carried out in tandem with the creative exploration of a palette that exhibits an electric brightness, and that shines like neon in the company of more conventionally coloured paintings. On occasion, these same preoccupations have been trained on the imagery of the Old Masters: thus, at the 2007 summer display, Craig-Martin exhibited a picture (cat. 72) that re-makes

Fig. 98 **View of the Lecture Room with works selected by Cornelia Parker RA, including Mona Hatoum's *Grater Divide* (2002) in the foreground, Summer Exhibition, 2014**

Seurat's nineteenth-century masterpiece *Bathers at Asnières* for the age of the computer screen, and in which great, flattened planes of complementary colours – shades of green, orange and violet – clash and vibrate with a crackling visual intensity.

For the 2015 Summer Exhibition, Craig-Martin decided to impose a dramatic curatorial agenda not only over a particular room, but also the show as a whole.[23] It was one in which the experiments with colour and juxtaposition that had long characterised his own work were extrapolated outwards to inform the design of the display itself. This was evident to visitors even as they walked into the Academy's Front Hall, which Craig-Martin had decided should serve as an extension of the exhibition: there, the institution's famous staircase, covered in colourful strips of vinyl by the Turner Prize nominee Jim Lambie, was turned into a visually thrilling installation in its own right (see fig. 3). Having ascended the

staircase, exhibition-goers walked into a gallery – the Wohl Central Hall – that had been painted a bright turquoise (see fig. 2), which in turn led on to Gallery III, which was decorated in a similarly vibrant magenta (fig. 99). In both galleries, the works of art on display were granted an unusual degree of breathing space: like the objects that feature in Craig-Martin's own paintings, they seemed to float free on seas of blue and pink. And though other galleries were allowed to retain a more familiar and subdued colour scheme of whites and pale greys, the Lecture Room that once again helped bring the show to a close, painted in a vivid blue, served only to confirm the exhibition's overriding visual logic. It was as if the entire display had been conceived, not metaphorically but actually, as a work of art, or, more specifically, as a form of installation art – one that was designed to catch the viewer's eyes with the insistence of the flashing digital billboards of nearby Piccadilly Circus.

Cat. 72 **Sir Michael Craig-Martin** RA, *Reconstructing Seurat (Orange)*, 2004 (exh. 2007). Acrylic on aluminium panel, 187 x 280 cm. Private collection. On loan to Davis Art Museum, Wellesley College

TOWARDS A NEW VISUAL POLITICS

Even as it has been thoroughly redefined and repackaged in recent years, the Summer Exhibition remains an event in which participating Academicians are granted a remarkable amount of freedom in deciding what they might submit. Some, like the current President, Christopher Le Brun, use the opportunity to showcase works that explore the formal and lyrical possibilities of the medium of painting itself (cat. 73). His large-scale, shimmering abstracts, in which innumerable layers of brush strokes manage, somehow, to retain a sense of lightness and translucency, provide the kinds of visual oases in the exhibition space that used to be provided by the similarly shimmering and poetic works of Gainsborough or Turner.[24] Others, very differently, have used the event to exhibit

strikingly politicised and sometimes confrontational works of art. These latter pieces have given recent displays another kind of interest: that is, as spaces of visual polemic. Thus, in 2007, the year of Kiefer and Hockney's weighty landscapes, the Academician Michael Sandle submitted a similarly monumental three-part charcoal drawing entitled *Iraq Triptych* (fig. 100), which marked the departure of Tony Blair from office, and which presents an excoriating critique of his decision to take Britain into war in Iraq. The work pictured Blair and his wife Cherie as the naked and shamed Adam and Eve being expelled from Paradise: on one side, manacled and hooded Iraqi prisoners are shown being beaten by a British solider; on the other, the sprawled figures of the war's victims pile up in front of a grotesque gallery of butchered body parts.[25]

Fig. 99 **Gallery view of the 2015 Summer Exhibition**

Cat. 73 **Christopher Le Brun** PRA, *Always Almost*, **2017.**
Oil on canvas, 215.2 x 270.2 cm. Courtesy of the artist

161

More recent exhibitions have seen other artists maintain this kind of political agenda, if in a less strident pictorial register. Indeed, some have done so on a regular basis, over successive displays.[26] Thus, Yinka Shonibare has exhibited a sequence of screen-prints that offer swirling, collage-like responses to some of the central debates of our times. These works have included his *Bunch of Migrants* (cat. 74), which was on display at the Academy at the time of the Brexit referendum vote of 2016, and the title of which is taken from a callous phrase uttered by the Prime Minister, David Cameron, earlier that year, when discussing refugees sheltering at a camp in Calais.[27] Given that he has spent so much of his career producing work that meditates upon Britain's imperial history, and given that such issues as immigration had been exploited to toxic effect in the run-up to the Brexit referendum, it was especially timely that Shonibare should have been offered an invitation to curate one of the galleries in the Summer Exhibition of 2017, and that he should have used this invitation to celebrate the work of a diverse group of practitioners from across the world.

These included Abe Odedina, a British-based artist who was born in Lagos, and whose *Deep Cut*, produced in response to the Brexit vote, beamed a troubled image of the Union Jack – the lines of which seem to slice into the image's scissor-wielding black subject – across Shonibare's crowded and colourful gallery (fig. 101).[28] In another corner of the same gallery, meanwhile, visitors encountered the miniaturised limewood figures that populate the work of the London-based Japanese sculptor Tomoaki Suzuki, in this instance representing some of his fellow residents in the Metropolitan Borough of Hackney (fig. 102). Seen in the company of the much larger works that surrounded them, these figures offered a diminutive but powerful intervention into the display as a whole. From one perspective, Suzuki's figures invited exhibition-

Fig. 100 **Michael Sandle** RA, *Iraq Triptych*, 2007.
Charcoal and black chalk on paper, 197 x 450 cm.
Private collection

Cat. 74 Yinka Shonibare RA, *Bunch of Migrants*, 2016.
Screen print with gold leaf, 99 x 99 cm. Courtesy of the artist

Fig. 101 Installation view of Gallery VI, curated by Yinka Shonibare RA, including Abe Odedina's *Deep Cut*, Summer Exhibition, 2017

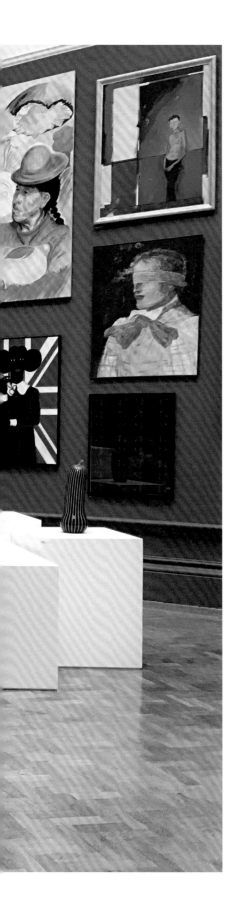

goers to read them as a random cluster of urban individuals, cocooned in their own space, clothing and identity; from another, they were open to being appreciated as an interconnected, multi-racial collective, standing defiantly together in the face of an overwhelming world. Like the rest of the works gathered in Shonibare's room, they confirm that the Summer Exhibition is now fully capable of expressing and exploring both the divisions and the commonalities of a modern, urbanised and globalised society. In this gallery, at least, Middle England seemed a long way away.

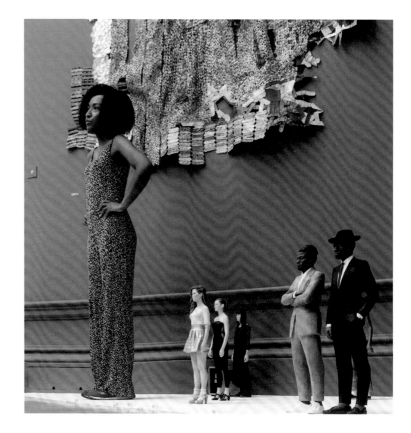

Fig. 102 **Gallery VI with a group of works by Tomoaki Suzuki, Summer Exhibition, 2017**

THE EXHIBITION ON CAMERA

SARAH VICTORIA TURNER

The photographic record of the Summer Exhibition tells a different story to the one narrated on the walls of the exhibition itself and in its official documents, such as the catalogue and the Academy's Annual Report. In many photographs, the focus is not so much on the works of art, but on the people involved in making the Summer Exhibition. Through a series of images taken for the *Mail on Sunday* in 1990, we follow the arrival of a large painting strapped on top of a Mini (figs 103, 104) through to its judging before the Selection Committee, perched on the famous rotating stool. Other images document eager artists arriving with their works tucked under their arms, or proudly displaying them for the camera. These are moments of optimism, even if the works were later to be rejected and sent back to their owners. The drama of 'Sending-in Day', with the hubbub of the queue of hopeful artists (fig. 105), was replaced by digital submission in 2014.

Once submitted, artworks are taken before the Selection Committee, some striking photographs of which, from the 1970s, are discussed elsewhere in this book (see pp. 144–45). In one of the more unusual photographs of this Committee at work (fig. 106), the famous 'X' and 'D' sticks are shown at rest on a table. These sticks were introduced in the nineteenth century to help the Selection Committee deal with the increasingly arduous task of assessing the large quantity of work being sent in to the Summer Exhibition. If a work is unanimously accepted by the Committee (a very rare thing, it seems, according to the official records of the exhibition's 250-year history), it is marked with an 'A'. 'D' is given for 'Doubtful', which leaves the decision to the members of the Hanging

Figs 103 and 104 **Delivery of a painting on 'Sending-in Day', 1990**

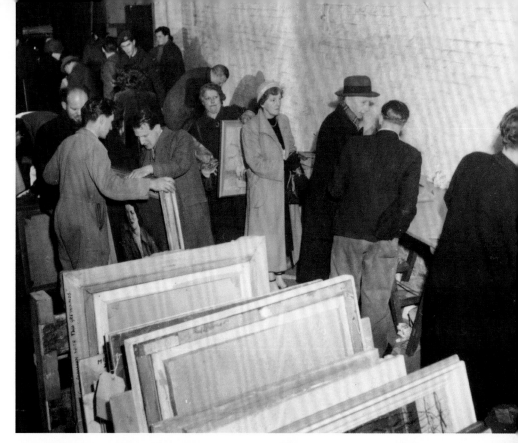

Committee – it is for them to decide whether there will be space on the wall. 'X' is used if a submitted picture is to be rejected outright. A poem called *A Rap at the R.A. – A Satire*, published in 1875, captured the disappointment shared by many artists who were often critical of the speed with which the Committee made its judgement:

The toil of months, experience of years,
Before the dreaded Council
now appears: –
It's left their view as soon as in it. –
They damn them at the rate
of three a minute. –
Scarce time for even faults
to be detected,
The cross is chalked: –
'tis flung aside 'REJECTED'.[1]

The Hanging Committee then goes to work, dealing with the mammoth task of trying to make sense of the selection, and of arranging all the works across the Academy's galleries (figs 107, 108, 109). The labour of this process is also documented in the photographic archive, as porters, art handlers and technicians ascend ladders and scaffolding to create the dense installation for which the Summer Exhibition is famous. All this work has to be completed in a matter of weeks. Floors are polished, exhibition texts and catalogues are printed and, then, finally, the doors are opened and in come the visitors to judge the exhibition for themselves.

Fig. 105 **Members of the public queue to leave works for possible selection, 1953**
Fig. 106 **The Selection Committee at work, with 'D' and 'X' markers to hand**
Fig. 107 **Recording submitted works, 1953**
Fig. 108 **Members of the Hanging Committee examining selected works**
Fig. 109 **Paintings stacked for selection, 1953**

EXHIBITING ARCHITECTURE

JESSICA FEATHER

The corner room given to Sister Architecture is only patronised by old ladies, who take refuge in it to devour the contents of their luncheon baskets; fat old gentlemen who wish to get cool; and thin young men who want to get married, and can spoon undisturbed.[1]

Harry Furniss's caustic remarks, suggesting that there is little to see on the walls of the architecture room at the 1890 Summer Exhibition, but plenty to otherwise occupy its inhabitants, belong to a long history of caricature of the annual exhibition going back to its earliest incarnations at Somerset House. Nevertheless, there is something interesting in his critique that speaks to the heart of the problems facing architects exhibiting at the Academy. Furniss went on to point out the 'injustice of electing "drawers of builders' plans in place of Artists of genius"', a comment that refers to a perceived discrepancy between the functional skills of the architect, who merely drew plans, and the idea of artistic genius. This tension goes back to the earliest years of the Academy, and to the first years of the exhibitions, when the architectural profession felt under threat by the rapid professionalisation of other specialised skills.[2] The twin institution of the Royal Academy Schools (where architects learnt their craft) and of the annual exhibition (which allowed architect-Academicians to show off their achievements) was intended to provide some resolution to this problem. The aspiration to bring equivalence between the various arts was enshrined in the Academy's Instrument of Foundation, with painting,

sculpture and architecture equally described therein as the 'Arts of Design'. This suggestion of parity has continued to this day, with Academicians in all these disciplines still being described as 'artists'. Despite these attempts at equality, the issue of architects' status within the annual display and their struggle to establish and maintain this status in relation to the other arts is a constant that runs throughout the exhibition's history.

Whereas architects have played key roles in the annual exhibition (they are always represented on the Selection and Hanging Committees, for example), their works have often made only a meagre appearance on the walls. This of course reflects the lower number of architectural submissions, but the result is a diminished visual intensity. In the early years of the Academy, its three principal architect-founders, William Chambers (cat. 75), Thomas Sandby and George Dance the Younger, exhibited only a handful of views over the period 1769–83.[3] Meanwhile, established architects such as Robert Adam and Henry Holland chose not to exhibit.[4] In the North Galleries at Somerset House, architectural drawings were not positioned in the central Great Room, but were placed in adjacent rooms such as the Library. In the mid-nineteenth century, a renewed interest in architecture and the proliferation of architectural competitions, as well as the rapidly growing number of works submitted, led to an increase in the amount of display space dedicated to architecture at the exhibition's new home in William Wilkins's building at Trafalgar Square. Despite this, architectural drawings and models still represented

Cat. 75 **Sir William Chambers** RA / **John Yenn** RA, *Design for the Temple of Diana, Blenheim Palace, c.* 1774 (exh. 1774). **Watercolour with pen and black and brown ink on paper, 62.4 x 40.5 cm. Royal Academy of Arts, London, 04/961**

only a small percentage of the total number of exhibits. Even today, the show's architectural exhibits are typically shown in a discrete room.

AN EXHIBITION OF DRAWINGS: THE FIRST THIRTY YEARS

As we have seen, drawings have always been at the heart of the architectural display at the Academy's exhibition, although today, they increasingly vie with models (see pp. 186–87) and other forms of media, including paintings, prints and photography.[5] This historic focus on drawings as a means of architectural expression was derived from the way in which architects were trained at the Royal Academy Schools, where the practice of drawing from elements of buildings and from extant London buildings was central to the curriculum. However, the Academy's exhibition, as distinct from the Schools, encouraged a particular trajectory for the architectural exhibition drawing, by which architects experimented with ways of attracting attention to their works.

From the early days of the exhibition, the type of drawing exhibited was by no means restricted to the matter-of-fact office-drawn plan, elevation or section used by an architect to explain a design to a client, or to lay out instructions to a builder (the main purposes for architects' drawings outside the exhibition). Instead, such architects as William Chambers in his *Design for a Mausoleum for Frederick, Prince of Wales* (fig. 111) embraced the format of the architectural perspective, to which was often added – as here – a naturalised landscape setting. Moreover, in contrast to the limited palette and barest of washes that were prevalent in architects' drawings of the pre-exhibition era, architects in the late eighteenth-century exhibitions began to employ colour. Here, for instance, Chambers includes striking blue and brown washes. This was an approach that was also to be seen in the highly skilled perspective drawings by Thomas Malton the Younger (see for example his *Interior of St Paul's Cathedral*; cat. 76). Both of these developments, which gave architectural drawings something of the look of the watercolours that were also a standard feature of the annual exhibition, allowed for a degree of slippage between the different genres.

Cat. 76 **Thomas Malton the Younger**, *Interior of St Paul's Cathedral*, *c.* 1792 (exh. 1797). Watercolour with pen and black ink over graphite on paper, 66.7 x 91.8 cm. Yale Center for British Art, Paul Mellon Collection, B1977.14.6220

Some of the strategies used to attract the public's attention are dramatically exemplified in the exhibited drawings of John Yenn (see for example cat. 77), who worked as Chambers's right-hand man for much of his adult life. Yenn, who never established himself as an original architect in his own right, used the opportunity of the exhibition to let his imagination run riot, showing over 30 mainly theoretical designs between 1771 and 1797.[6] These works see him casting around and then settling upon a formula for the visual qualities that would

most effectively draw attention to his skills as a designer and draughtsman. Unlike Chambers, Yenn does not embrace the perspective view; instead, his drawings are notable for their flat elevations and for a range of pictorial innovations. In works such as *Principal Front of a Town Mansion* (fig. 114) he briefly adopted a strategy of adding a chequerboard foreground, a visual device that he probably borrowed from Dutch seventeenth-century paintings of interiors and churches. He also experimented with adding striking, contrasting pink and blue

Fig. 111 **Sir William Chambers** RA, *Design for a Mausoleum for Frederick, Prince of Wales, to be Built in Kew Gardens*, 1751. Watercolour with pen and brown ink over graphite on paper, 49 x 70 cm. Sir John Soane's Museum, London

Cat. 77 **John Yenn** RA, *Design for a Bath or a Mansion*, 1777. Watercolour with pen and brown ink on paper, 39.8 x 55.8 cm. Royal Academy of Arts, London, 09/622

Fig. 112 Thomas Sandby RA, *A Bridge of Magnificence*, 1781.
Pen and brown ink and wash on paper. 65 x 523 cm. RIBA
Collections, FRA/SAND/1

Fig. 113 John Yenn RA, *Principal Front of a Green-house*, 1775.
Watercolour with pen and black and brown ink and gouache on paper,
47.5 x 64 cm. Royal Academy of Arts, London, 09/280

bodycolour to his work. By the mid-1770s, Yenn had taken this idea to its most dramatic development yet, employing almost full bodycolour for works such as the *Principal Front of a Green-house* (fig. 113) in the same heightened colour palette, a formula that at least in technique begins to look increasingly like the opaque watercolour landscapes of Yenn's fellow Academician Paul Sandby; a visual similarity that would not have been lost on contemporaries.

'A VERY MAGNIFICENT EXHIBITION OF ARCHITECTURE'

These were the words used by one reviewer to describe Thomas Sandby's monumental drawing *A Bridge of Magnificence* (fig. 112), which dazzled the crowds at the exhibition of 1781.[7] Although Paul Sandby was a landscape artist, his brother Thomas – whose drawings of the annual exhibition itself have featured in earlier chapters – was first and foremost an architect. His watercolour, which pictured an imagined bridge over the River Thames, offered the first of a series of such visionary works to be displayed at the Academy by a variety of artists. These submissions not only gave free rein to the architect's creative fantasies but drew on powerful visual effects in order to give them dramatic expression. The imaginative compositions produced by the architectural draughtsman Joseph Michael Gandy for the architect-Academician John Soane throughout the early 1800s offer a striking demonstration of the ways in which such works could be used to publicise both Soane's architectural skill and Gandy's remarkable draughtsmanship. The forum

of the exhibition allowed Gandy and Soane to develop a monumental format for their drawings, which scaled new heights in terms of their size and complexity of composition; it also allowed them to give their architecture an epic, heroic character.

Public and Private Buildings Executed by John Soane between 1780 and 1815 (cat. 78) represented – at 72.5 x 129.3 cm– a grandiloquent pictorial tribute to Soane, but one issued under Gandy's name and direction.[8] The setting is an imagined space: a cavernous room, without windows, which transports the work immediately from the prosaic to the epic. This interior is filled with over a hundred models and pictures of Soane's architecture, the space brimming over with architectural vistas and variously scaled replicas of the architect's life's work.[9] It is also a complex and innovative exercise in dramatic lighting effects: the interior is illuminated by one artificial light source at the bottom left, which serves to spotlight – in the picture's middle ground – the magnificent spectacle of Soane's models of the Bank of England and Dulwich Picture Gallery, two of his most important buildings. In the early 1800s this was a type of imaginative spectacle that competed in its grandeur and extravagance with even the most sublime forms of oil painting or watercolour being displayed within the annual exhibitions.

Expressing architectural ideas in such fantastical style persisted for some years. In 1849, at the Academy's new premises in Trafalgar Square, Charles Robert Cockerell's monumental watercolour *The Professor's Dream* (cat. 79) seems to have been hung favourably in the architecture room, where it was placed in the prestigious lower

Fig. 114 John Yenn RA, *Principal Front of a Town Mansion*, 1773.
Watercolour with pen and black and brown ink on paper, 48.4 x 63.9 cm.
Royal Academy of Arts, London, 09/374

part of the gallery.[10] In case exhibition-goers were in any doubt as to what the work represented, it was accompanied by a long caption in the catalogue which described Cockerell's work as 'a synopsis of the principal architectural monuments of ancient and modern times, drawn to the same scale, in forms and dimensions ascertained from the best authorities, and arranged on four terraces – Egyptian, Grecian, Roman, and Mediaeval and Modern'. This description was not lost on the critics. One reviewer praised Cockerell's remarkable drawing in which 'Egyptian temples and statues occupy the foreground, followed in an upper terrace by Athenian Temples and then Roman buildings such as the Coliseum and the Pantheon; whilst on the upper terrace were buildings representing medieval skill such as the Campanile at Pisa and Cologne Cathedral; as well as the modern buildings of Western architecture such as Wren's St Paul's Cathedral and St Peter's, Rome.'[11] Above them all, at the apex of the picture, is the outline of the Great Pyramid at Giza, the oldest and still the tallest structure on Earth in Cockerell's time.

Cockerell was Professor of Architecture at the Academy (a successor to Thomas Sandby and John Soane in this role), and his drawing was associated with the didactic aim of illustrating his views on the history of architecture.[12] The work is closely linked to an earlier drawing Cockerell used to illustrate his lectures in the Royal Academy Schools, in which the architect drew attention to 63 of the world's most important buildings. While the drawing has been lost, a small version by Cockerell's pupil, J. E. Goodchild in the RIBA Drawing Collection suggests what it would have looked like. Indeed, Cockerell drew attention to this drawing in his catalogue entry for *The Professor's Dream* in the 1849 display. However, the earlier drawing, intended for students

of architecture, is scientific and comparative, with textual labelling included alongside the drawing; by the time Cockerell presented what seemed like a similar subject at the Academy's exhibition, notable differences had emerged between the two. In *The Professor's Dream*, Cockerell's skilful use of colour and shading adds a mesmeric quality to the work, in which buildings appear to dissolve

Cat. 78 **Joseph Michael Gandy** ARA, *Public and Private Buildings Executed by John Soane between 1780 and 1815*, 1818. Watercolour and gouache with pen and brown ink over graphite on paper, 72.5 x 129.3 cm. By courtesy of the Trustees of Sir John Soane's Museum, London, SMP87

before our eyes. Whereas the earlier work was closely related to the long tradition of using images of buildings as exemplars, *The Professor's Dream* suggests instead that these buildings no longer simply serve only as models to be compared, contrasted and copied; rather, they are magically transformed into 'mnemonic touchstones' for the imagination to revisit and refresh itself – the very

essence of a dream.[13] The drawing brings together elements of the functional with the pedagogic, but is above all a work of artistic creativity.

Cockerell's remarkable submission to the 1849 show represented a high-water mark for this type of work. The grand-scale imaginative presentation of architecture, seen first in Sandby's work, then in the collaborations of Gandy and

Cat. 79 Charles Robert Cockerell RA, *The Professor's Dream*, 1848 (exh.
1849). Watercolour with pen and grey ink over graphite on three sheets
of paper, 112.2 x 171.1 cm. Royal Academy of Arts, London, 03/4195

Soane, and latterly in Cockerell's *The Professor's Dream*, was not to reappear at subsequent Academy exhibitions in any significant way. The later Victorian era and succeeding periods were to be dominated, instead, by drawings depicting designs for building projects, whether executed or not.

VIRTUOSO PERSPECTIVES AND THE POLITICS OF PROTEST

The exhibition of George Gilbert Scott's unexecuted gothic revival design for a large government building in Whitehall in 1864 (fig. 115) was both a proud statement of achievement (the architect presented the drawing to the Academy as his Diploma Work) and an act of public protest. Despite the fact that he had previously entered and lost the 1857 competition to design this new building, Scott was, in a strange turn of events, ultimately to find himself appointed its architect. His original designs for a gothic revival building, a taste which had become all the rage, were vetoed by the new Prime Minister, Lord Palmerston, who told Scott to alter his design to a classical style.[14] He was forced to remodel the building (today the Foreign and Commonwealth Office) a number of times, and it was eventually built in a classical style derived from the Italian Renaissance. Evidently piqued by the episode, which represented an attack on his own favoured gothic revival style, Scott had a perspective drawing of his original design made up especially for the 1864 exhibition. This, he made very clear in the catalogue, was 'in the style designed by the architect', and he exhibited it alongside his other gothic revival drawings in the South Rooms at Trafalgar Square. His decision to commission the drawing was, as he described it, a 'silent protest against what was going on' and a dramatic public demonstration of his commitment to his original design, despite his being forced to give it up.[15]

Scott's drawing also demonstrates the prevalence of the perspective drawing on the walls of the later nineteenth-century Academy

exhibition. This type of work was popular with the public but also became the subject of criticism, often on the part of architects themselves. Part of the reason for this criticism was that the production of these increasingly large and complex pieces was outsourced to teams of assistants. Scott's junior colleagues would have worked for many weeks to create this drawing. Initially, they had to create a sufficiently large piece of paper for the work by carefully joining together several sheets. This then had to be stretched and mounted onto a drawing board or table. Then, they had to engage with the complicated task of turning Scott's plans into a perspective drawing that looked both life-like and accurate. Members of the studio would have undertaken the painstaking task of drawing in the main body of the design in ruled lines of pen and black ink, and Scott would almost certainly have employed a skilled watercolourist to add the pictorial setting, including the figures – soldiers on parade, workers mending the railings and gentlefolk going about their daily business – all of whom added human interest for the viewer.

Scott was not alone in employing assistants and freelance specialists to make these increasingly complex drawings; indeed, the practice had begun earlier, with Soane's and Gandy's collaborations. It is easy to see how the practice laid itself open to criticism, however, with a number of architects arguing that, as drawing lay at the heart of design and was the cornerstone of their training at the Royal Academy Schools, they should not be farming out this skill to outsiders. Such complaints came

Fig. 115 **Sir George Gilbert Scott** RA, *Design for Government Offices, Whitehall, Westminster, London*, 1864. Watercolour with pen and black ink and gouache on paper, 83.8 x 172.7 cm. Royal Academy of Arts, London, 03/6167

to a head in 1874, when the architect George Edmund Street petitioned the Council of the Academy to accept the resolution that, at the Summer Exhibition, 'preference … be given in the selection of Architectural Drawings as much as possible to those which were evidently the work of the Architects themselves'.[16] Street's request, which was in fact declined, suggests the anxieties over this matter within the context of the exhibition.

Street went on to argue that 'elevations and details of buildings should be admitted as well as perspectives', a passage pointing to a tension for architects that has always lain at the heart of their relationship with the Academy's Summer Exhibition. On the one hand, given that they were always competing to get their works noticed in this venue alongside oil paintings and watercolours, architects were increasingly adopting many aspects of these same media to give added impact to their submissions; indeed, *The Builder* referred to Scott's drawing somewhat negatively as 'splashily coloured'.[17] On the other hand, such exhibited works ended up having a very different character to the type of working drawing (the elevation, or the plan) used by most architects in

their offices during this period. For some architects, it seemed as if members of their profession were selling out to the demands of the exhibition.

Many of these tensions were to resurface at the Academy exhibitions of the early twentieth century, where perspective views continued to have a strong presence (as they did, in fact, right through to the 1970s). These tensions were exacerbated, in turn, by the increasing fashion for new techniques and bolder, more painterly creations. In 1936 the architect Charles Holden commissioned Raymond Myerscough-Walker, one of the best and most popular architectural draughtsmen of this period, to produce a perspective of Senate House, Holden's recently completed monumental Art-Deco masterpiece for the University of London (fig. 116). In works such as these, Myerscough-Walker took the perspective drawing in radical new directions. In this instance, he adopts a dramatically low viewpoint to accentuate the drama of Senate House's soaring tower, which he surrounds with dark, cloud-filled skies and eerily shaped trees. Myerscough-Walker moved away from the traditional pencil and watercolour media used by many Victorian producers of architectural views,

Fig. 116 **Raymond Myerscough-Walker,** *University of London, Bloomsbury. View from the Southwest at Night,* **1936. Watercolour with pen and black ink on paper, 53.2 x 74.8 cm. RIBA Collections, PA1438/AHP[149](97)**

embracing the use of gouache or, as here, poster paint, often on coloured paper. In his creation of the unusual scene of Senate House by night, Myerscough-Walker was no doubt influenced by the new fashion for architectural photographs that depicted floodlit buildings; but comparisons can also to be made to the aesthetics of contemporary painters such as Meredith Frampton, Dod Procter and Gerald Brockhurst, all of whom were also to be found exhibiting their works at the Academy.

Some of the criticism surrounding architects' use of non-studio artists for their exhibited perspectives was deflected by the fact that architects were now encouraging their draughtsmen to sign their creations, either alongside the architects themselves, or, as with this work, on their own. Yet, more often than not, architects were still listing the works in the catalogue under their own names, as indeed was the case with Holden in 1936. Myerscough-Walker's work was commissioned once Senate House was almost completed: this was a drawing of record specifically created with the Academy exhibition in mind, and was therefore a deliberate attempt at not-so-discreet self-publicity in the arena of the display on Holden's part. In the context of works such as *University of London, Bloomsbury*, perhaps it was not surprising that some of the strongest criticism of such artistic collaborations now came not from the architects, but from painter-Academicians, who felt threatened by the inclusion of architectural drawings that claimed the traditional status of works of fine art. In the post-war period, the now-traditional perspective drawing continued to be exhibited, but it was increasingly sidelined by the rise of the simple line drawing as well as by the architectural model.

MEDIATING MODERNISM: 1950-90

The post-war years were a difficult time for architects exhibiting at the Academy, as the institution struggled to find common ground between the older, classical values of the Academician-architects who had been trained in the Beaux-Arts drawing tradition and those loyal to the rising tide of modernism outside the Academy. The architect-President, Sir Albert Richardson, epitomised the more reactionary side of the debate when he expressed his disdain for 'those who think tall buildings a symbol of progress'.[18] It was in this context that the Hanging Committee for the 1953 exhibition gave pride of place to Basil Spence's working drawings for the rebuilding of Coventry Cathedral (including cat. 80). This image encapsulated an architectural project that, though it incorporated aspects of modernism in its design (and featured commissioned works by such modernist British painters as Graham Sutherland), was seen by critics outside the Academy as not being sufficiently avant-garde. Spence's traditionalism extended to his choice of a perspective format for his exhibited work, here one beautifully articulated in coloured chalks; a choice remarked upon by one critic as unusual, and as being produced by

Cat. 80 **Sir Basil Spence** RA, *Design for the Cathedral Church of St Michael, Coventry*, 1953. Coloured chalks on paper, 91 x 83 cm. **Royal Academy of Arts, London, 04/2420**

'Mr Spence's own hand', a rare event following the rise of the professional draughtsman.[19]

It took the appointment of a new architect-President at the Academy in 1976 in the form of Hugh Casson to herald a new, more welcoming atmosphere that brought a younger generation of post-war modernist architects such as Maxwell Fry, Ernö Goldfinger and Denys Lasdun into the Summer Exhibition for the first time. Works by these individuals were displayed alongside architectural designs relying on more traditional pictorial conventions, such as Leonard Manasseh's moonlight scene *Design for Radipole Lake Pumping Station, Weymouth* (cat. 81). Goldfinger's cut-away design for the Trellick Tower (fig. 117), a block of flats for social housing in west London, was exhibited in 1977, and submitted by the architect as his Diploma Work on his appointment as a Royal Academician. In the geometries of its Brutalist concrete environment, and with its figures reminiscent of Le Corbusier's Modulor Man, this is a dramatic visual illustration of the concerns of the modern movement in architecture.[20] Goldfinger had made the original drawing in the late 1960s, but on the occasion of his election he made a print from the original: a fitting demonstration of the concerns of a new mechanised world.[21]

A NEW ERA?

As recently as 2016, and in an echo of the remarks by Harry Furniss that opened this chapter, the critic Mark Hudson, writing in the *Daily Telegraph*, expressed the view that one of the 'inalienable factors' of the current Summer Exhibitions was the knowledge that the architecture section would be '…worthy, technically peerless but incredibly boring'.[22] Hudson was clearly in pursuit of hyperbole and it would be unfair to read too much into his dismissal of a display that included such exhibits as Zaha Hadid's monumental *Aerial View, Cardiff Bay Opera House* (cat. 82), originally made in 1994 but exhibited not long after the architect's untimely death in 2016. Nevertheless, Hadid's work and Hudson's comments do point to one of the central and enduring difficulties still faced

Cat. 81 Leonard Manasseh RA, *Design for Radipole Lake Pumping Station, Weymouth, Dorset: Plan, Elevation and Section*, 1979. Print with graphite and grey, blue and turquoise crayons, 83.5 x 98 cm. Royal Academy of Arts, London, 04/2376

Fig. 117 Ernö Goldfinger RA, *Design for Trellick Tower, Edenham Street, Kensington and Chelsea, London*, 1976 (exh. 1977). Print with coloured chalks, 77.8 x 67.1 cm. Royal Academy of Arts, London, 04/2358

Cat. 82 Dame Zaha Hadid RA, *Aerial View, Cardiff Bay Opera House, Cardiff, Wales, Competition 1994-1996*, 1994 (exh. 2016). Acrylic on black cartridge paper, 198.5 x 144.5 cm. Courtesy of the Zaha Hadid Foundation

by architects showing at the Summer Exhibition today: how do you make a functional depiction of a building scheme in a form that is not only easily accessible to the public, but also able to compete with what are arguably seen as the more creative forms of artistic expression found elsewhere in the exhibition?[23]

Hadid's answer is, in part, not to compete but to create an individualised vocabulary for her architecture, which is shaped by the use of perspective and space in Russian Suprematist and Constructivist paintings, as well as by the incorporation of digital technologies into architectural practice. Her design for *Cardiff Bay Opera House*, a 'bird's-eye' view of the projected building, is, at first glance, hard to read as a building at all; instead, we are provided with an abstracted vision of the Opera House and its waterfront setting, in which the structure takes the form of a series of silvery-white blocks of colour, which seem to hover in space against a dark background. When viewed in the context of the tradition of architectural drawings, it is clear that Hadid's work overturns many of their conventions.

At the opposite end of the visual spectrum, other architects have persisted in exhibiting freehand drawings, a technique that appears intended to avoid or deflect the negative associations of the computer-generated drawing.

In Edward Cullinan's competition design for a secondary school in Lagny, France (cat. 83), exhibited in 1993, this is combined with subject-matter that puts the human figure back into architectural drawing. Cullinan's cheerful work is a clever play on the more technical 'bird's-eye' view: here, we see the proposed school building from the perspective of four picnicking hot-air balloonists, whose basket soars above the trees, tennis courts and arriving schoolchildren down below. Replete with charming details, such as a basket full of French baguettes, these humans are cast as characters in a narrative, bringing to the architectural drawing a humanist perspective. Cullinan's is an approach that contrasts with what are sometimes seen as the cold and abstract qualities of contemporary architectural designs.

Although critical prejudice in the mainstream press might run deep, it is hard to deny that one of the guiding principles of recent years has been the Summer Exhibition's ability to embrace a range of architectural vocabularies and media. These encompass the highly technical drawing or model, including the wholly computer-generated drawings by architects such as David Chipperfield; the painterly mixed-media output of Hadid; but also the freehand drawings of Cullinan. Moreover, despite protests from the profession, the Academy's summer display remains the major exhibition to which most architects aspire to submit. In part this offers a testament to the increasingly high profile of architecture both within and outside the Academy, but the continuing importance of the show to architects has also been encouraged in recent years by the institution's own parallel initiatives in the field of architecture, which have included large-scale loan exhibitions devoted to such architect-Academicians as Richard Rogers, as well as the establishment, for the first time, of the post of curator of architecture. Given such developments, we can be sure that architecture will continue to make a distinctive and varied, if sometimes rather anxious, contribution to the Summer Exhibition.

Cat. 83 **Edward Cullinan** RA, *Lycée Privé (Private Secondary School)*, **1992 (exh. 1993). Pen and black ink on tracing paper, 61.4 x 72.6 cm. Royal Academy of Arts, London, 03/4207**

THE ARCHITECTURAL MODEL

JESSICA FEATHER

Drawings rather than models dominated the architectural displays at the Academy's Summer Exhibition, at least until the late twentieth century. Drawing was an integral part of the way architects were trained at the Royal Academy Schools; indeed, up until 1901, when the Architectural Association opened its own day school, the Academy was the only place one could formally study architecture. It was therefore with a drawing exhibited at the Academy that an architect demonstrated his achievement and authority in the field. Models, by contrast, were not widely exhibited. They were used in architects' own practices: often, like working drawings, they functioned as a way of testing out ideas and most would have been quickly executed, rough affairs.

However, those models that were shown in the Royal Academy's annual displays (and only a small number of these have survived) seem to have been extremely sophisticated, sometimes involving the commissioning of specialist, professional model-makers –

Fig. 118 **Office of Sir John Soane** RA, *Model of the Principal Front of a Design for Completing the Buildings at Whitehall, North and South of Downing Street,* *c.* 1830 (exh. 1834). Plaster, 12.7 x 106.7 cm. Sir John Soane's Museum, London, L91

a testament to the fact that the annual exhibition was a unique opportunity for architects to demonstrate their skill and expertise. John Soane was one who believed in the value of the architectural model, commissioning quite a number of these replicas of completed building projects. His model of the principal front of a design for two buildings for the Civil Service at Whitehall, on either side of Downing Street, is one of a handful he exhibited at the Summer Exhibition in the early nineteenth century (fig. 118). Shown at the exhibition of 1834, but based on a scheme proposed by Soane in 1822, the model comprises a minutely detailed carving in plaster of designs for the Board of Trade and the Privy Council Offices on the right, a façade which was intended to be repeated on the other side, although only part of the right-hand section was actually built.

Whereas most models that have historically been shown at the Summer Exhibition are related to specific building projects, a more unusual contemporary form of model

is not. *Intangible* by Stanton Williams (exhibited at the Royal Academy in 2016) is a case in point (cat. 84). A single, elegant free-standing column cast in Jesmonite (a concrete-like material) is designed so that the viewer circumnavigates the negative spaces of four very different buildings: the Pantheon in Rome; the rock-hewn Church of St George at Lalibela, Ethiopia; Le Corbusier's Church of Saint-Pierre at Firminy; and Louis Kahn's Phillips Exeter Academy Library, New Hampshire. *Intangible* is a conceptual proposal for a 'museum of negative space', bringing together

the architects' interest in solid and void, positive and negative, light and shade, as well as a fascination with the process of making.[1] Designed in part as a research and development tool, which gave Stanton Williams a chance to investigate the intricate casting methods needed to create these 'negative' spaces, it is also a playful exploration of their ideas about exterior and interior space. Conceived both as architecture and sculpture, *Intangible* was a fitting addition to an exhibition which prides itself not only on inclusion of all the arts but also breaking down the boundaries between them.

Cat. 84 **Stanton Williams, *Intangible*, 2015 (exh. 2016).
Jesmonite, 150 x 35 x 27 cm. Stanton Williams**

Turner goes to Heaven.

Carel Weight

ENDNOTES

INTRODUCTION
MARK HALLETT AND
SARAH VICTORIA TURNER (PAGES 12–25)

1 *London Chronicle*, 27–29 April 1769.
2 All references in this book to admissions figures for the Summer Exhibition, numbers of works exhibited and the number of participating artists, are drawn from *The Royal Academy Summer Exhibition: A Chronicle, 1769–2018*, www.chronicle250.com.
3 For the origins of the Royal Academy, and for the history of the institution's first two centuries, see the invaluable account of Sidney C. Hutchison, *The History of the Royal Academy, 1768–1986*, second edition, London, 1986, pp. 23–32. For other informative accounts, see Charles Saumarez Smith, *The Company of Artists: The Origins of the Royal Academy of Arts in London*, London, 2012; James Fenton, *School of Genius: A History of the Royal Academy of Arts*, London, 2006, pp. 88–101; Holger Hoock, *The King's Artists: The Royal Academy of Arts and the Politics of British Culture, 1760–1840*, Oxford, 2003; Matthew Hargraves, *Candidates for Fame: The Society of Artists of Great Britain, 1760–1791*, New Haven and London, 2005, pp. 89–109.
4 For the eighteenth-century history of the French Academy's 'Salon' exhibitions, see Thomas E. Crow, *Painters and Public Life in Eighteenth-century Paris*, New Haven and London 1985.
5 The Instrument of Foundation is printed in full in Appendix A of Hutchison's *History of the Royal Academy*, pp. 245–49.
6 The designation 'Summer Exhibition' came into use to distinguish the display from the Academy's 'Winter Exhibitions', which were held from 1870 onwards. See Hutchison, *History of the Royal Academy*, pp. 113–15.
7 Ibid., pp. 33–44. The Academy's first venue was located on the south side of Pall Mall, in a building that had previously housed the auctioneers Aaron Lambe, and then Richard Dalton's print warehouse.
8 For the first decade of exhibitions in England, the best source is Hargraves, *Candidates for Fame*, pp. 1–88. See also David H. Solkin, *Painting for Money: The Visual Arts and the Public Sphere in Eighteenth-century England*, New Haven and London, 1993, pp. 174–90. For the French Salon exhibitions of the eighteenth century, see Crow, *Painters and Public Life in Eighteenth-century Paris*.
9 See *A Catalogue of the Pictures, Sculptures, Designs in Architecture, Models, Drawings, Prints [Exhibited] by the Society of Artists of Great Britain*, London, 1768.
10 For the annual exhibitions that took place at Somerset House, see David H. Solkin (ed.), *Art on the Line: The Royal Academy Exhibitions at Somerset House, 1780–1836*, exh. cat., Courtauld Art Gallery, London, 2001.
11 For the dynamics of the hang at Somerset House, and the forms of pictorial interaction they set up, see John Sunderland and David H. Solkin, 'Staging the Spectacle', in Solkin (ed.), *Art on the Line*; Mark Hallett, 'Reading the Walls: Pictorial Dialogue at the British Royal Academy', *Eighteenth-century Studies*, 37, 4, Summer 2004, pp. 581–604; and Mark Hallett, *Reynolds: Portraiture in Action*, New Haven and London, 2014, pp. 383–423.

12 For more on the move to Trafalgar Square, see Hutchison, *History of the Royal Academy*, pp. 83–89.
13 Nevile Wallis (ed.), *A Victorian Canvas: The Memoirs of W. P. Frith, R.A.*, London, 1957, p. 93.
14 Hutchison, *History of the Royal Academy*, pp. 103–04.
15 *Report of the Commissioners Appointed to Inquire into the Present Position of the Royal Academy*, London, 1863.
16 Hutchison, *History of the Royal Academy*, p. 105.
17 Ibid., p. 107.
18 For the reviews of the Georgian period, see Mark Hallett, '"The Business of Criticism": The Press and the Royal Academy Exhibition in Eighteenth-century Britain', in Solkin (ed.), *Art on the Line*, pp. 65–76.
19 For an introduction to Ruskin's *Academy Notes*, see Tim Hilton, *John Ruskin*, New Haven and London, 2002, pp. 226–44.
20 Richard Dorment, 'A Triumph of Colour', *Daily Telegraph*, 2 June 2004.
21 Robert Vernon and John Sheepshanks are examples of two nineteenth-century collectors who regularly bought works on display at the annual exhibitions; for the former, see Robin Hamlyn, *Robert Vernon's Gift: British Art for the Nation 1847*, London, 1993; for the latter, and for further information on Vernon and other contemporary collectors, see Dianne Sachko Macleod, *Art and the Victorian Middle Class: Money and the Making of Cultural Identity*, Cambridge, 1996.
22 Annual Report 1977, p. 14.
23 For a stimulating discussion of the exhibition's early audiences, see C. S. Matheson, '"A Shilling Well Laid Out": The Royal Academy's Early Public', in Solkin (ed.), *Art on the Line*, pp. 39–54.
24 https://www.royalacademy.org.uk/event/summer-exhibition-preview-party-2017.
25 For an extended response to Rowlandson's image, see K. Dian Kriz, '"Stare Cases": Engendering the Public's Two Bodies at the Royal Academy of Arts', in Solkin (ed.), *Art on the Line*, pp. 55–63.
26 Searle's image appeared in *Punch*, 7 May 1958. For a major publication (in German) on Searle that includes this work alongside many others, see Gisela Vetter-Liebenow (ed.), *Ronald Searle*, exh. cat., Wilhelm Busch Museum, Hanover, 1996.

WELCOME TO THE EXHIBITION
JESSICA FEATHER (PAGES 26–27)

1 This can be worked out by comparing the catalogue with Thomas Sandby's detailed depiction of the Antique Room display in the 1792 Royal Academy Exhibition (see fig. 37). I am grateful to Mark Hallett for drawing this to my attention.
2 John Withers was senior porter from 1770 until 1802. Information from Mark Pomeroy, Royal Academy archivist.

1 A GEORGIAN PARADE
MARK HALLETT (PAGES 28–41)

1 For a discussion of this image, and of a number of the works exhibited at the 1771 display, see David H. Solkin's essential introduction to the art of this period, *Art in Britain 1660–1815*, New Haven and London, 2015, pp. 163–67.
2 For Barry's *The Temptation of Adam*, see Solkin, ibid., pp. 166–67, and William L. Pressly, *The Life and Art of James Barry*, New Haven and London, 1981, pp. 16–20.

3 For the best discussions of Kauffman's career, see Angela Rosenthal, *Angelica Kauffman: Art and Sensibility*, New Haven and London, 2006, and Wendy Wassyng Roworth (ed.), *Angelica Kauffman: A Continental Artist in Georgian England*, exh. cat., Royal Pavilion, Art Gallery and Museums, Brighton, 1992.
4 For an influential modern analysis of West's *Wolfe*, and for a discussion of the picture by Edward Penny to which it partly responded, see David H. Solkin, *Painting for Money: The Visual Arts and the Public Sphere in Eighteenth-century England*, New Haven and London, 1993, pp. 206–13.
5 For a detailed analysis of Reynolds's portraiture, including the exhibition portraits discussed here, see Mark Hallett, *Reynolds: Portraiture in Action*, New Haven and London, 2014.
6 *Public Advertiser*, 10 May 1769.
7 *Morning Post and Daily Advertiser*, 4 December 1776.
8 For Gainsborough's Academy pictures, including that of the Linley sisters, see Christine Riding's exemplary catalogue entries in Michael Rosenthal and Martin Myrone (eds), *Gainsborough*, exh. cat., Tate Britain, London, 2002, pp. 110–43.
9 *Morning Chronicle*, 25 April 1777.
10 *Morning Herald*, 30 April 1783.
11 *Public Advertiser*, 2 May 1783.
12 For this fall-out, see John Hayes (ed.), *The Letters of Thomas Gainsborough*, New Haven and London, 2001, pp. 158–60, and Michael Rosenthal, *The Art of Thomas Gainsborough: 'A Little Business for the Eye'*, New Haven and London, 1999, pp. 99–117.
13 Moser's practice and career remain largely unstudied. For the best introduction to her work, see Wendy Wassyng Roworth's entry on the artist in the *Oxford Dictionary of National Biography*.
14 See Judy Egerton, *George Stubbs, Painter. Catalogue Raisonné*, New Haven and London, 2007, nos 268–69, pp. 496–99.
15 The best modern account of Wright's work is to be found in Judy Egerton, *Wright of Derby*, London, 1990.
16 John Langhorne, *The Country Justice. A Poem. Part the First*, London, 1774, p. 18.
17 For Copley's career in England, see Emily Ballew Neff and William L. Pressly, *John Singleton Copley in England*, London, 1995; Jules David Prown, *John Singleton Copley*, vol. 2, *In England, 1773–1815*, Ailsa Mellon Bruce Studies in American Art, Cambridge, MA, 1966.
18 For the Shakespeare Gallery, see Rosie Dias, *Exhibiting Englishness: John Boydell's Shakespeare Gallery and the Formation of a National Aesthetic*, New Haven and London, 2013.
19 For a good recent survey of Lawrence's career, see A. Cassandra Albinson, Peter Funnell and Lucy Peltz (eds), *Thomas Lawrence: Regency Power and Brilliance*, New Haven and London, 2010.
20 *London Chronicle*, 28–30 April 1789.
21 For the relationship between Reynolds and Lawrence, as filtered through the 1790 Academy exhibition, see Hallett, *Reynolds*, pp. 434–38.
22 For this painting, see Albinson, Funnell and Peltz (eds), *Thomas Lawrence*, pp. 224–27.

Fig. 119 **Carel Weight RA, *Turner Goes to Heaven*, detail from the poster for the 1989 Summer Exhibition**

AGOSTINO CARLINI AND THE ROYAL IMAGE
MARK HALLETT (PAGES 42–43)

1 Joseph Baretti, *A Guide through the Royal Academy*, London, 1781. Baretti anglicised his name for the publication.

2 Ibid., pp. 17, 30.

3 *The Exhibition of the Royal Academy, MDCCLXIX. The First*, London, 1769, p. 4; *The Exhibition of the Royal Academy, MDCCLXXIII. The Fifth*, London, 1773, p. 34.

4 Two early examples are Gainsborough's spectacular full-lengths of King George III and Queen Charlotte (Royal Collection), exhibited at the Annual Exhibition in 1781.

5 For these pictures, which still belong to the Academy, see David Mannings, *Sir Joshua Reynolds: A Complete Catalogue of His Paintings*, 2 vols, New Haven and London, 2000, 'Text', nos 717 and 718, pp. 214–15. See also Nicholas Penny (ed.), *Reynolds*, London, 1986, pp. 285–86.

2 THE RISE OF GENRE PAINTING
MARK HALLETT (PAGES 44–57)

1 For an earlier discussion of Sandby's 1792 drawings, see John Sunderland and David H. Solkin, 'Staging the Spectacle', in Solkin (ed.), *Art on the Line: The Royal Academy Exhibitions at Somerset House, 1780–1836*, exh. cat., Courtauld Art Gallery, London, 2001, pp. 23–38.

2 For more on this painting, see Helmut von Erffa and Allen Staley, *The Paintings of Benjamin West*, New Haven and London, 1986, no. 67, pp. 199–200.

3 For Lawrence's submission to the 1792 exhibition, see Michael Levey, *Sir Thomas Lawrence: The Artist*, New Haven and London, 2005, pp. 119–21, and A. Cassandra Albinson, Peter Funnell and Lucy Peltz (eds), *Thomas Lawrence: Regency Power and Brilliance*, New Haven and London, 2010, pp. xv, 2–5, 105–07.

4 See Olivier Lefeuvre, *Philippe-Jacques de Loutherbourg 1940–1812*, Paris, 2012, no. 231, pp. 63, 283.

5 For a recent discussion of Bigg, and of Morland's *Benevolent Sportsman*, see David H. Solkin, *Art in Britain 1660–1815*, New Haven and London, 2015, pp. 240–41.

6 My thanks to Esther Chadwick, who helped me with my research on this print.

7 *General Evening Post*, 1–3 May 1792.

8 For a recent study of Morland and his career, see Nick Grindle (ed.), *George Morland: Art, Traffic and Society in Late Eighteenth-century England*, exh. cat., Stanley and Audrey Burton Gallery, University of Leeds, 2015.

9 For Penny's imagery of horse-bound charity – more particularly, his 1765 portrait of the Marquess of Granby relieving a wounded soldier – see David H. Solkin, *Painting for Money: The Visual Arts and the Public Sphere in Eighteenth-century England*, New Haven and London, 1993, pp. 199–206.

10 *The World*, 1 May 1792; *Morning Chronicle*, 18 May 1792.

11 For Wheatley's career, see Mary Webster, *Francis Wheatley*, London, 1970.

12 For the best modern monographic study of Wilkie, see Nicholas Tromans, *David Wilkie: The People's Painter*, Edinburgh, 2007; for a comprehensive and highly suggestive analysis of genre painting in the period, to which this chapter is heavily indebted, see David H. Solkin, *Painting Out of the Ordinary: Modernity and the Art of Everyday Life in Early Nineteenth-century Britain*, New Haven and London, 2008. The former book discusses the *The Village Politicians* on pp. 6–9; the latter examines the same work in great detail on pp. 7–35.

13 *Monthly Magazine*, June 1806, XXI, p. 451.

14 *Morning Post*, 6 May 1806.

15 *La Belle Assemblée*, I, May 1806, p. 216.

16 For a more detailed account of Bird's picture, see Solkin, *Painting Out of the Ordinary*, pp. 40–43.

17 *The Examiner*, 21 May 1809, p. 332.

18 Ibid., p. 331.

19 For Mulready's art and career, see Kathryn Moore Heleniak, *William Mulready*, New Haven and London, 1980, and Marcia Pointon, *Mulready*, exh. cat., Victoria and Albert Museum, London, 1986.

20 For another recent discussion of this work, see Solkin, *Painting Out of the Ordinary*, pp. 119–26.

21 *The Examiner*, 4 June 1815.

22 *Repository of Arts*, June 1816, n.s., I, p. 355.

23 See Solkin, *Painting Out of the Ordinary*, pp. 126–32.

24 *New Monthly Magazine*, 1 July 1816, p. 543.

25 *The Examiner*, 4 June 1815, p. 365.

26 *European Magazine*, LXXXI, 1822, p. 466.

27 *The Exhibition of the Royal Academy, MDCCCXXII. The Fifty-fourth*, London, 1822, p. 10.

28 Jones's painting was listed as no. 313 in that year's catalogue; the picture's title, *Battle of Waterloo*, is followed by five paragraphs of accompanying text, in which its leading protagonists are described at great length.

29 *European Magazine*, LXXXI, 1822, p. 466.

30 One such work was Edward Rippingille's *The Recruiting Party*, which is discussed at length by Solkin in *Painting Out of the Ordinary*, pp. 204–10.

31 Confirming the status of the soldier as a veteran of the battle, the painting was engraved in Mulready's lifetime with the title *The Convalescent from Waterloo*: see George Thomas Doo, after Mulready, *The Convalescent from Waterloo*, 1847.

32 *The Examiner*, 23 June 1822, p. 397.

33 For Turner's *Waterloo*, see Martin Butlin and Evelyn Joll, *The Paintings of J. M. W. Turner*, revised edition, 2 vols, New Haven and London, 1984, 'Text', no. 138, pp. 104–05.

TWO EARLY CATALOGUES
MARK HALLETT (PAGES 58–59)

1 *The Exhibition of the Royal Academy, MDCCLXIX. The First*, London, 1769, pp. 6–7.

2 *The Exhibition of the Royal Academy, MDCCXCII. The Twenty-fourth*, London, 1792.

3 Ibid., p. 3.

4 Unsurprisingly, given their level of detail and the speed at which they were produced, the catalogues were not immune to printers' errors – thus, the initial of Morland's first name is here given as 'J', rather than 'G'.

3 THE TRIUMPH OF LANDSCAPE
MARK HALLETT (PAGES 60–75)

1 For the institution of the Varnishing Days in 1809, see Sidney C. Hutchison, *The History of the Royal Academy, 1768–1986*, London, second edition, 1986, p. 70.

2 See Tom Taylor (ed.), *Autobiographical Recollections. By the Late Charles Robert Leslie*, London, 1860, vol. 1, p. 202.

3 Ibid.

4 For a good summary of these issues, and an important recent discussion of the landscape painting of this period, see David H. Solkin, *Art in Britain 1660–1815*, New Haven and London, 2015, Chapter 18.

5 For more on Sandby's drawing of the Antique Room, and of the works within it, see Eric Shanes, 'More Art on the Line: The Royal Academy's Antique Room in the Exhibition of 1792', *Burlington Magazine*, 150, 1261, April 2008, pp. 224–31.

6 For a good discussion of this issue, see Greg Smith, *The Emergence of the Professional Watercolourist: Contentions and Alliances in the Artistic Domain, 1760–1824*, Aldershot, 2002, pp. 23–33.

7 For Hearne, see David Morris, *Thomas Hearne and His Landscape*, London, 1989; for the best recent account of Sandby's career, see John Bonehill and Stephen Daniels (eds), *Paul Sandby: Picturing Britain*, exh. cat., Royal Academy of Arts, London, 2009.

8 For a recent and extremely detailed account of Turner's artistic practice in the 1790s, see Eric Shanes, *Young Mr Turner: The First Forty Years, 1775–1815*, (J. M. W. Turner: A Life in Art, 1), New Haven and London, 2016, Chapters 3–11. For Girtin, see Greg Smith, *Thomas Girtin: The Art of Watercolour*, exh. cat., Tate Britain, London, 2002.

9 *Whitehall Evening Post*, 27–30 April 1799.

10 *Lloyd's Evening Post*, 10–13 May 1799.

11 See Felicity Owen and Eric J. Stanford, *William Havell 1782–1857: Paintings, Watercolours, Drawings and Prints*, exh. cat., Reading Museum and Art Gallery, 1981, p. 8.

12 Havell's watercolour is also reproduced and discussed in Smith, *Thomas Girtin*, p. 247.

13 For the opening of the gallery, and the pictures on view, see Shanes, *Young Mr Turner*, p. 254.

14 For more on the *Tenth Plague of Egypt* and *Calais Pier*, see Martin Butlin and Evelyn Joll, *The Paintings of J. M. W. Turner*, revised edition, 2 vols, New Haven and London, 1984, 'Text', nos 17 and 48, pp. 16–17, 37–38.

15 For Callcott's art and career, and the relationship of his work to Turner's, see David Blayney Brown, *Augustus Wall Callcott*, exh. cat., Tate Gallery, London, 1981.

16 In 1807, for example, the year after Callcott had exhibited a view of figures bargaining for fish on the English coast, Turner himself exhibited *The Sun Rising through Vapour: Fishermen Cleaning and Selling Fish*, which duplicates much of the fundamental iconography of his friend's canvas.

17 *British Lady's Magazine*, June 1816, p. 421.

18 *The Champion*, 12 May 1816.

19 See Butlin and Joll, *The Paintings of J. M. W. Turner*, 'Text', no. 137, pp. 102–04. For a more recent discussion of the same issue, see David H. Solkin (ed.), *Turner and the Masters*, exh. cat., Tate Britain, London, 2009, pp. 164–65.

20 For a recent analysis of this painting, see the discussion in Anne Lyles (ed.), *Constable: The Great Landscapes*, exh. cat., Tate Britain, London, 2006, pp. 118–21. For what remains the best general introduction to Constable's work of this period, see Michael Rosenthal, *Constable: The Painter and His Landscape*, New Haven and London, 1983.

21 Joseph Farington, *The Diary of Joseph Farington*, 16 vols, New Haven and London, 1978–98, vol. IX, pp. 3431–32, 3 April 1809.

22 *The Literary Gazette*, 20 June 1818, p. 394, quoted in Judy Crosby Ivy's invaluable *Constable and the Critics, 1802–1837*, Woodbridge, 1991, p. 78.

23 *The Examiner*, 27 June 1819, quoted in Ivy, *Constable and the Critics*, p. 82.

24 *The Literary Chronicle and Weekly Review*, 29 May 1819, quoted in Ivy, *Constable and the Critics*, p. 81.

25 *Annals of the Fine Arts* V, 1820, p. 390, and *The British Freeholder*, I, 1 July 1820, p. 357, both quoted in Ivy, *Constable and the Critics*, pp. 85, 86.

26 *The Examiner*, 27 May 1821, pp. 331–32, and *Observer*, 25 June 1821, both quoted in Ivy, *Constable and the Critics*, pp. 88, 90.

27 *New Monthly Magazine*, VI, 1 June 1822; *London Magazine*, IX, June 1824, p. 669, and *Somerset House Gazette*, II, 10 April 1824, all quoted in Ivy, *Constable and the Critics*, pp. 96, 106 and 105.

28 R. B. Beckett, *John Constable's Correspondence*, VI, 'The Fishers', Suffolk Records Society, vol. XII, 1968, p. 198.

29 *The Monthly Magazine*, LIX, 1 June 1825, p. 1825, quoted in Ivy, *Constable and the Critics*, p. 114.

30 Quoted in Charles Robert Leslie, *Memoirs of the Life of John Constable, Esq., R.A.: Composed Chiefly of His Letters*, London, 1845, republished in Phaidon's series *Landmarks in Art History*, Oxford, 1995, p. 166.

31 For a recent study of Turner's *Dieppe*, in the context of his other port scenes, see Susan Grace Galassi et al., *Turner's Modern and Ancient Ports: Passages of Time*, New York, 2017.

32 The term is used, for example, by reviewers of Turner's RA submissions in 1830, in both the *Dublin Literary Gazette*, 1830, p. 315, and *The Gentleman's Magazine*, June 1830, p. 542.

33 *La Belle Assemblée*, June 1830, p. 273.

34 For Turner's relationship with Bonington's work, see Solkin (ed.), *Turner and the Masters*, pp. 198–99, and Butlin and Joll, *The Paintings of J. M. W. Turner*, 'Text', p. 188. Stanfield and his work remain largely unexplored in recent scholarship; but see the very useful catalogue *The Spectacular Career of Clarkson Stanfield 1793–1867: Seaman, Scene-painter, Royal Academician*, Newcastle upon Tyne, 1979, written by Peter van der Merwe and Roger Took.

35 *The Literary Gazette and Journal of the Belles Lettres*, 1830, p. 338.

36 *The Spectator*, 14 August 1830, p. 614.

37 *The Spectator*, 10 May 1834, quoted in Butlin and Joll, *The Paintings of J. M. W. Turner*, 'Text', p. 207. Interestingly, the reviewer used this phrase in a comparison of Turner's works with those of Callcott.

TURNER AND THE EXHIBITION
WATERCOLOUR: *RISE OF THE
RIVER STOUR AT STOURHEAD*
JESSICA FEATHER (PAGES 76–77)

1 'The Fifty-seventh Annual Exhibition of the Royal Academy', *European Magazine*, LXXXVII, 1825, p. 465.

2 Ibid.

4 THE PRE-RAPHAELITES ARRIVE
SARAH VICTORIA TURNER (PAGES 78–89)

1 There is much mythology surrounding the founding of the Pre-Raphaelite Brotherhood. See Elizabeth Prettejohn, *The Art of the Pre-Raphaelites,* London, 2000, pp. 23–29 for a fuller discussion.

2 Quoted in Raymond Watkinson, *Pre-Raphaelite Art and Design*, London, 1970, p. 40.

3 Although James Collison was a founder member of the PRB, he resigned the following year.

4 William M. Rossetti, 'The Pre-Raphaelite Brotherhood', *The Magazine of Art*, 4, 1881, p. 436.

5 *Art Journal*, June 1849, p. 171.

6 Millais first exhibited at the Academy in 1846 at the age of sixteen with *Pizarro Seizing the Inca of Peru* (no. 594), a picture now in the collection of the Victoria and Albert Museum in London. In 1848, his *Cymon and Iphigenia* was rejected from the Royal Academy Annual Exhibition.

7 Morna O'Neill, 'Arts and Crafts Painting: The Political Agency of Things', *British Art Studies*, 1, https://doi.org/10.17658/issn.2058-5462/issue-01/moneill/p18.

8 Tim Barringer, Jason Rosenfeld and Alison Smith, *Pre-Raphaelites: Victorian Avant-garde*, exh. cat., Tate Britain, London, 2012, p. 44.

9 Keats had been brought to attention of the Pre-Raphaelite painters by the publication in 1848 of Richard Monckton Milnes's *Life, Letters, and Literary Remains*, which was avidly read and much discussed in Victorian literary and artistic circles. Many thanks to Elizabeth Prettejohn for bringing my attention to these connections for the *Rienzi* and *Isabella* paintings.

10 As discussed by Elizabeth Prettejohn, *Modern Painters, Old Masters: The Art of Imitation from the Pre-Raphaelites to the First World War*, New Haven and London, 2017, particularly pp. 105–09, and Barringer and Rosenfeld and Smith, *Pre-Raphaelites*, p. 10.

11 Prettejohn, *Modern Painters, Old Masters*, p. 58.

12 It was not exhibited with this title at the exhibition of 1850. Instead, a quotation was printed from Zechariah, 13, 6: 'And one shall say unto him, What are these wounds in thine hands? Then shall he answer, Those with which I was wounded in the house of my friends.'

13 'The Exhibition of the Royal Academy', *The Times*, 9 May 1850, p. 5.

14 Ibid.

15 Charles Dickens, 'Old Lamps for New Ones', *Household Words*, 12, 15 June 1850, pp. 265–66. It is worth noting that despite the scorn Dickens poured on this painting, he and Millais became good friends. Millais even drew a touching portrait of the writer on his deathbed in 1870.

16 'Exhibition of the Royal Academy', *Illustrated London News*, 14 May 1850, p. 336.

17 See Elizabeth Prettejohn, 'Aesthetic Value and the Professionalization of Victorian Art Criticism 1837–78, Journal of Victorian Culture, 2, 1, 1 March 1997, pp. 71–94.

18 [John Ruskin], 'To the Editor of *The Times*', *The Times*, 5 May 1854.

19 Book of Revelation, 3, 20.

20 See Jeremy Maas, *Holman Hunt and The Light of the World*, London, 1984 for a full discussion of the different versions of this painting.

21 'Royal Academy: The Eighty-third Exhibition, 1851', *Art Journal*, 13, 1 June 1850, pp. 153–63.

PRE-RAPHAELITE SCULPTURE AND BEYOND
SARAH VICTORIA TURNER (PAGES 90–91)

1 For an excellent discussion of this subject, see Sarah Hyde, 'Printmakers and the Royal Academy Exhibitions, 1780–1836', in David H. Solkin (ed.), *Art on the Line: The Royal Academy Exhibitions at Somerset House, 1780–1836*, exh. cat., Courtauld Art Gallery, London, 2001, pp. 217–28.

2 F. G. Stephens, 'The Royal Academy', *The Athenaeum*, 19 May 1860, p. 685.

3 F. G. Stephens, 'The Royal Academy', *The Athenaeum*, 16 May 1863, p. 655.

4 Elizabeth Robins and Joseph Pennell, *The Life of James McNeill Whistler*, 2 vols., London and Philadelphia, 1908, vol. 1, pp. 101–2.

5 VICTORIAN ACCLAIM
SARAH VICTORIA TURNER (PAGES 92–109)

1 *Catalogue of the Eighty-third Exhibition of the Royal Academy of Arts*, London, 1851.

2 A favourite of Queen Victoria, a fact confirmed by his knighthood conferred in 1850, Landseer also had a long relationship with the Royal Academy, first exhibiting there at the age of 13. He was a pupil at the Schools, was elected an Associate Royal Academician at the early age of 24, and was admitted as a full Royal Academician in 1831.

3 This was purchased by Queen Victoria as a present for Prince Albert in 1842. Its first owner, William Wells of Redleaf, 'gave it up' to the Queen when she requested it.

4 'Exhibition of the Royal Academy. Private View. First Notice', *The Times*, 3 May 1851, p. 8.

5 Mark Hallett, Sarah Victoria Turner and Jessica Feather (eds), *The Royal Academy Summer Exhibition: A Chronicle, 1769–2018*, London, 2018, www.chronicle250.com.

6 Kate Flint, *The Victorians and the Visual Imagination*, Cambridge, 2000, p. 176.

7 Rosemary Treble, *Great Victorian Pictures: Their Paths to Fame*, exh. cat., Arts Council of Great Britain, London, 1978, p. 7.

8 Caroline Arscott, 'Ramsgate Sands, Modern Life and the Shoring Up of Narrative', in Brian Allen (ed.), *Towards a Modern Art World*, New Haven and London, 1995, pp. 157–68.

9 William Powell Frith, *My Autobiography and Reminiscences*, 2 vols, London, 1887, vol. 1, p. 289.

10 The Royal Academy was certainly slow to recognise the talent of the engravers within its own ranks and the public role that they played. In 1855 Samuel Cousins became the first engraver to become 'R.A. Elect'. Originally excluded from the Academy, engravers had been admitted as Associate Royal Academicians in 1769, the year after foundation, but were prevented from becoming full Royal Academicians until membership numbers were increased in 1853 to 40, including two engravers.

11 Joy Sperling writes: 'It cost the AUL almost £7,000, roughly half of its 1859 budget and £2,300 more than it spent on prizes, but AUL subscription revenue jumped 30 percent, from £11,710 in 1858 to £15,210 in 1859, and one thousand prizes (and prize-coupons) were distributed by lot.' Joy Sperling, '"Art, Cheap and Good": The Art Union in England and the United States, 1840–60', *Nineteenth-century Art Worldwide*, 1, 1, Spring 2002, http://www.19thc-artworldwide.org/spring02/196-- qart-cheap- and-goodq- the-art-union-in-england-and- the-united- states-184060.

12 Ibid.

13 Sidney C. Hutchinson, *The History of the Royal Academy 1768–1986*, second edition, London, 1986, p. 101.

14 *Catalogue of the Ninety-seventh Exhibition of the Royal Academy of Arts*, London, 1865, p. 5.

15 Arscott, 'Ramsgate Sands', p. 166.

16 John Guille Millais, *The Life and Letters of Sir John Everett Millais, President of the Royal Academy*, 2 vols, London, 1899, vol. 1, pp. 378–79.

17 *Annual Report from the Council of the Royal Academy to the General Assembly of Academicians for the Year 1871*, London, 1872, pp. 7–8.

18 MaryAnne Stevens, 'The Royal Academy of Arts, 1768–1918', in *Genius and Ambition: The Royal Academy of Arts, London, 1768–1918*, exh. cat., Bendigo Art Gallery, Australia, and Japanese venues, 2014, p. 25.

19 John Ruskin, *Notes of Some of the Principal Pictures Exhibited in the Rooms of The Royal Academy and The Society of Painters in Water-Colours*, London, 1856, p. 10.

20 Kristine Ottesen Garrigan, 'Bearding the Competition: John Ruskin's "Academy Notes"', *Victorian Periodicals Review*, 22, 4, Winter 1989, pp. 148–56.

21 *Punch*, 24 May 1856, p. 209.

22 William M. Rossetti (part I) and Algernon C. Swinburne (part II), *Notes on the Royal Academy Exhibition 1868*, London, 1868; reprint London, 1976.

23 A. U. [Elizabeth Robins Pennell], 'Art and Artists', *Star*, 9 May 1892, quoted in Anna Gruetzner Robins, '1892', in Mark Hallett, Sarah Victoria Turner and Jessica Feather (eds), *The Royal Academy Summer Exhibition: A Chronicle, 1769–2018*, London, 2018, www.chronicle250.com. See also Stevens, 'The Royal Academy of Arts, 1768–1918', p. 27.

24 Alison Smith, *The Victorian Nude: Sexuality, Morality and Art*, Manchester and New York, 1996.

25 Algernon C. Swinburne in Rossetti and Swinburne, *Notes on the Royal Academy Exhibition 1868*, part II, p. 32.

26 Alison Smith (ed.), *Exposed: The Victorian Nude*, exh. cat., Tate Britain, London, 2001, p. 94.

27 Ibid., p. 122.

28 Caroline Arscott, 'Poynter and the Arty', in Elizabeth Prettejohn (ed.), *After the Pre-Raphaelites: Art and Aestheticism in Victorian Britain*, Manchester, 1999, p. 140.

29 For more on women art critics in this period, see Meaghan Clark, *Critical Voices: Women and Art Criticism in Britain 1880–1905*, Aldershot, 2005.

30 Lady Elizabeth Butler, *Autobiography*, London, 1922, p. 110.

31 Quoted in Treble, *Great Victorian Pictures*, p. 80.

32 Caroline Dakers, *The Holland Park Circle: Artists and Victorian Society*, New Haven and London, 1999, p. 238.

33 For a detailed provenance history of this painting, see https://www.ngv.vic.gov.au/explore/collection/work/4457/.

34 M. H. Spielmann, *Magazine of Art*, January 1891, p. 220.

35 'Death of Lord Leighton, P.R.A.', *Daily Telegraph*, 27 January 1896, p. 5.

36 Oscar Wilde delivered 'The English Renaissance of Art' for the first time as a lecture in New York on 9 January 1882. The text was printed in *Essays and Lectures*, London, 1913.

WHISTLER'S ETCHINGS
JESSICA FEATHER (PAGES 110–11)

1 For an excellent discussion of this subject, see Sarah Hyde, 'Printmakers and the Royal Academy Exhibitions, 1780–1836', in David H. Solkin (ed.), *Art on the Line: The Royal Academy Exhibitions at Somerset House, 1780–1836*, exh. cat., Courtauld Gallery, The Courtauld Institute of Art, London, 2001, pp. 217–28.

2 F. G. Stephens, 'The Royal Academy', *The Athenaeum*, 19 May 1860, p. 685.

3 F. G. Stephens, 'The Royal Academy', *The Athenaeum*, 16 May 1863, p. 655.

4 Elizabeth Robins and Joseph Pennell, *The Life of James McNeill Whistler*, 2 vols., London and Philadelphia, 1908, vol. 1, pp. 101–2.

6 DEALING WITH THE MODERN
SARAH VICTORIA TURNER (PAGES 112–25)

1 Two special committees were formed in 1899 and 1901 to discuss the large numbers of submissions being received. In 1903 a decision was made to restrict members to six works and non-members to three. This remains the rule to this day. There had been 13,163 works submitted in 1899.

2 Imogen Hart, 'History Painting, Spectacle, and Performance', in Angus Trumble and Andrea Wolk Rager (eds), *Edwardian Opulence: British Art at the Dawn of the Twentieth Century*, New Haven and London, 2013, p. 111.

3 'The Royal Academy', *The Times*, 5 May 1900, p. 14.

4 *The Times*, 29 June 1900, p. 15. Dicksee himself had missed out on the presidency in the competition for it following Leighton's death, with Edward Poynter winning the appointment until his resignation in 1918; Dicksee was to be elected President in 1924 and served until 1928.

5 'Art and Artists', *Morning Post*, 11 May 1903, p. 9.

6 Woolf was discussing Alfred Priest's *Cocaine* (c. 1919), on sale at £474.10s. It found no takers. See Pamela M. Fletcher, *Narrating Modernity: The British 'Problem Picture', 1895–1914*, Aldershot, 2003, for a thorough discussion of 'the problem picture' craze.

7 Fletcher, *Narrating Modernity*, p. 7.

8 'Amazing Scenes at the Academy', *Daily Graphic*, 5 May 1914.

9 Quoted in Helena Bonett's blog entry 'Deeds Not Words: Suffragettes and the Summer Exhibition', https://www.royalacademy.org.uk/article/deeds-not-words-suffragettes.

10 Alfred Munnings's report of the incident is quoted in James Fenton, *School of Genius: A History of the Royal Academy of Arts*, London, p. 251–52.

11 'Coverage Resulting from A Suffragette Action', May 1914, Royal Academy Archives, RAA/PRE/1/1.

12 Katy Deepwell, *Women Artists Between the Wars*, Manchester, 2010, p. 100. Post-1945 this slipped from a third to a quarter.

13 MaryAnne Stevens, 'A Quiet Revolution', in MaryAnne Stevens (ed.), *The Edwardians and After: The Royal Academy 1900–1950*, exh. cat., IBM Gallery of Art and Science, New York, and other American venues, 1988, p. 15.

14 By the turn of the twentieth century there were over 30 women art critics writing for London journals, with some, for example, Alice Meynell, earning over £400 a year. Press Day at the Royal Academy, for the annual Summer Exhibition, accommodated women critics by changing viewing times to safer daylight hours. Maggie Humm, 'Editing Virginia Woolf and the Arts: Woolf and the Royal Academy', in Eleanor McNees and Sara Veglahn (eds), *Woolf Editing / Editing Woolf: Selected Papers from the Eighteenth Annual Conference on Virginia Woolf*, Clemson, SC, 2009, pp. 154–59.

15 Deepwell, *Women Artists Between the Wars*, p. 105.

16 Current Art Notes', *The Connoisseur*, 45, 178, June 1916, p. 123.

17 Brian Foss, *War Paint: Art, War, State and Identity in Britain, 1939–1945*, New Haven and London, 2007, p. 179.

18 Royal Academy Annual Report, 1915, pp. 16, 34.

19 Both the *Daily Herald* headline and Lewis's attack are cited in Paul O'Keefe, *Some Sort of Genius: A Life of Wyndham Lewis*, London, 2000, p. 381.

20 Taken from a statement by an anonymous member of the Selection Committee printed in the *Daily Herald*, 23 April 1938. Cited in O'Keefe, *Some Sort of Genius*, p. 381.

21 Cited in ibid., p. 383.

22 Cited in ibid., p. 386.

THE EXHIBITION POSTER
SARAH VICTORIA TURNER (PAGES 126–27)

1 For a complete history of Summer Exhibition posters, see Mark Pomeroy's excellent *Posters: A Century of Summer Exhibitions at the Royal Academy of Arts*, London, 2015.

7 POST-WAR VISIONS AND NEW GENERATIONS
SARAH VICTORIA TURNER (PAGES 128–43)

1 Fitton was elected an Associate in 1944.

2 'New Non-Conformists', *Observer*, 1 May 1960, pp. 18–19.

3 Ibid., p. 19.

4 Sir Hugh Casson, 'Our Royal Academy', *Observer*, 16 August 1959, quoted in James Fenton, *School of Genius: A History of the Royal Academy of Arts*, London, 2006, p. 290.

5 Margaret Garlake, *New Art, New World: British Art in Postwar Society*, New Haven and London, 1998, p. 22.

6 Perspex, 'Current Shows and Comments', *Apollo*, 42, 246, August 1945, p. 180.

7 T. W. Earp, 'A Traditional Academy Absorbs the Moderns', *Daily Telegraph*, 29 April 1950, p. 4.

8 'New Coventry Cathedral', *The Times*, 3 May 1953, p. 3.

9 Munnings's speech was reported in several newspapers the next day as well as its live radio broadcast.

10 'Correspondence from Stanley Spencer, RA', Royal Academy Archives, RAA/SEC/4/127.

11 'If the RA cannot throw its shield over a great sculptor, what is the Royal Academy for?', letter from Sickert to Sir William Llewellyn PRA, 19 May 1935, Royal Academy Archives, RAA/SEC/4/121/7.

12 Frances Spalding, *John Minton: Dance till the Stars Come Down*, Aldershot, revised edition, 2005, p. 200.

13 Ronald Searle to Frances Spalding, 7 March 1989. Quoted in ibid., p. 169.

14 Edward Bawden to Frances Spalding, 9 August 1988. Quoted in ibid., p. 200.

15 This is suggested in ibid., p. 200.

16 David Wynne-Morgan, 'I Saw Her Looking into the Future', *Daily Mail*, 18 March 1955, p. 1.

17 'Success of R.A. Exhibition', *The Times*, 13 August 1955, p. 8.

18 Myfanwy Piper, 'The Royal Academy', *The Sunday Times*, 1 May 1955, p. 7.

19 Pietro Annigoni was born in Milan in 1910 and was admitted to the Accademia di Belle Arti in Florence in 1927. He was a signatory of the manifesto of Modern Realist Painters, and had refused to paint both Hitler and Mussolini.

20 Broadcasters' Audience Research Board, http://www.barb.co.uk/resources/tv-ownership/.

21 Reported in 'R.A. Pictures Fetch £43,441', *Daily Telegraph*, 17 August 1959, p. 12.

22 Roberts exhibited at the Summer Exhibition for the first time in 1948 and thereafter continued to exhibit at least one work every year until his death in 1980. In 1961, the year following the exhibition of *TV*, the Calouste Gulbenkian Foundation presented Roberts with an award for services to British painting.

23 'Bratby Work Dominates Academy', *Daily Telegraph*, 30 April 1965, p. 1.

24 'Smoke without Fire', *Sunday Telegraph*, 14 March 1965, p. 3.

25 Beatniks and Dowagers Crowd the Academy', *Daily Telegraph*, 1 May 1965, p. 11.

26 'The Academy Mounts Its Summer Show', *Illustrated London News*, 7 May 1966, pp. 24–25.

27 Christopher Neve, 'A Question of Function: The Royal Academy Summer Exhibition', *Country Life*, 6 May 1971, p. 1082.

28 The winning entry was designed by the advertising agency Sears and Nelson. In March *The Times* had advertised the competition in association with the Royal Academy. The winning entry was placed free of charge in *The Times* and the winning team was given £500 to spend at the Summer Exhibition. All 90 entries were displayed in the Summer Exhibition of 1985.

THE SELECTION COMMITTEE
MARK HALLETT (PAGES 144–45)

1 Here, I have focused on the *Royal Academy Illustrated* for the years 1972–74; similar photographs are found in other issues of the publication from the period.

8 NEW SENSATIONS
MARK HALLETT (PAGES 146–65)

1 *The Sunday Times*, 9 June 1991.

2 *Sunday Telegraph*, 6 June 1993.

3 Brian Sewell, quoted in Jonathan Margolis, 'The Hanging Debate', *The Sunday Times*, 6 June 1993.

4 The work, and more particularly the context from which it emerged, have been usefully discussed in Marco Livingstone, *Kitaj*, revised and expanded edition, London, 1999, pp. 49–54. See also Cilly Kugelmann, '"I Accuse!" Kitaj's "Tate-War" and an Interview with Richard Morphet', in Cilly Kugelmann, Eckhart Gillen and Hubertus Gaßne, *Obsessions: R. B. Kitaj 1932–2007*, exh. cat., Jewish Museum, Berlin, 2012, pp. 195–201.

5 See William Feaver's review in the *Observer*, 1 June 1997.

6 Kitaj's piece can be usefully related not only to Duchamp's example but also to the assemblages of artists such as Robert Rauschenberg. In some of its aspects, furthermore, it seems to enjoy a correspondence with the more recent precedents of conceptual and neo-conceptual art, in which we often find a similar mix of photographs, found materials and texts that ranged from the personal to the theoretical, all organised into carefully calibrated grids and sequences. Here, however, this sequence of materials incorporates two major paintings in oil on canvas, of a kind that seems entirely antithetical to the norms of conceptual art. Kitaj, as so often, seems keen on mixing together a multiplicity of seemingly contradictory artistic strategies in his work.

7 For more on this exhibition, the starting point is its catalogue: Norman Rosenthal (ed.), *Sensation: Young British Artists from the Saatchi Collection*, exh. cat., Royal Academy of Arts, London, 1997. For a critique of the kinds of artistic practice celebrated by the show, see Julian Stallabrass, *High Art Lite: British Art in the 1990s*, London, 1999; for a more sympathetic approach to the kinds of art associated with 'Sensation', and one that places them in a far longer history, see the epilogue to Thomas Crow, *The Long March of Pop: Art, Music and Design 1930–1995*, New Haven and London, 2014, especially pp. 378–86.

8 For a press discussion of the impact that the show had on the Academicians themselves, see Lucinda Berlin, 'Meltdown at the Academy', *Daily Telegraph*, 27 September 1997.

9 Martin Gayford, 'Slim Pickings', *The Spectator*, 6 June 1998, p. 39.

10 Ibid.

11 Blake outlined all these changes in an article published in the *Guardian*: 'Go Hang', *Guardian*, 30 May 2001; he also described his policy in Peter Blake (ed.), *Royal Academy Illustrated*, 2001, p. 8.

12 Quoted in Frank Whitford, 'Introduction', in Bill Woodrow (ed.), *Royal Academy Illustrated 2007*, London, 2007, p. 8.

13 For a characteristically fizzy but also quite brilliant critical response to this phase of Kiefer's practice, see Simon Schama's review of the White Cube exhibition 'Anselm Kiefer: Aperiatur Terra', which opened in January 2007: Simon Schama, 'Trouble in Paradise', *Guardian*, 20 January 2007.

14 For a recent survey of Hockney's career, which takes in his work of the 2000s, see Chris Stephens and Andrew Wilson (eds), *David Hockney*, exh. cat., Tate Britain, London, 2017, particularly pp. 172–83.

15 Frank Whitford, 'Introduction', in Bill Woodrow (ed.), *Royal Academy Illustrated 2007*, London, 2007, p. 8.

16 Arifa Akbar, 'Hockney's Bridlington Phase', *Independent*, 26 May 2007.

17 Royal Academy Archives, RAA/TRE/13/1/1-6. The 2005 show attracted 70,807 visitors. The 2007 display was also boosted by a BBC documentary series on the year's Summer Exhibition; three programmes were broadcast on three successive days in late June 2007. See http://www.bbc.co.uk/arts/summerexhibition/tvprogramme/, accessed 4 January 2018.

18 For Parker and her work, see Iwona Blazwick, *Cornelia Parker*, London, 2014.

19 The work concerned is Bob and Roberta Smith's *Letter to Michael Gove*, 2011.

20 Cornelia Parker, 'An Introduction to the 246th Summer Academy Exhibition', Royal Academy website, https://www.royalacademy.org.uk/article/an-introduction-to-the-246th-summer, accessed 17 November 2017.

21 For Craig-Martin's work and career, see Richard Cork, *Michael Craig-Martin*, exh. cat., Irish Museum of Modern Art, Dublin, 2006; and the artist's own memoir/primer, *On Being an Artist*, London, 2015.

22 As a member of the Hanging Committee in 2011, for instance, Craig-Martin put together an especially striking arrangement of works by recently elected female Academicians, including Jenny Saville, Tacita Dean, Lisa Milroy, Gillian Wearing and Alison Wilding.

23 As the Academy's President Christopher Le Brun declared in his foreword to that year's *Summer Exhibition Illustrated*, Craig-Martin's role in shaping and configuring the display was, perhaps, more extensive and ambitious than that of any of his predecessors in the show's long history. See Christopher Le Brun, 'President's Foreword', in Michael Craig-Martin (ed.), *Summer Exhibition Illustrated 2015*, London, 2015, p. 11.

24 For sensitive discussions of Le Brun's work see the essays by Edmund de Waal and David Anfam in *Christopher Le Brun, New Paintings*, London, 2014, pp. 9–14, 15–19.

25 For a discussion of this work by the artist, in the context of his wider practice, see 'Michael Sandle in Conversation with Benedict Read', in *3rd Dimension*, 7 April 2016, https://3rd-dimensionpmsa.org.uk/interviews/2016-04-27-michael-sandle-in-conversation-with-benedict-read, accessed 4 January 2018.

26 The artist Bob and Roberta Smith, for instance, followed up his 2014 *Letter to Michael Gove* with, in the following year, another large-scale text-piece that transcribed a radio interview with David Hatt, a surgeon who had just returned from tending wounded victims of the war in Syria.

27 For Cameron's comment, and some of the responses it generated, see Rowena Mason and Frances Perraudin, 'Cameron's "bunch of migrants" jibe is callous and dehumanising, say MPs', *Guardian*, 27 January 2016.

28 As Odedina himself noted of the works, 'the very strong graphic representation of the flag itself seems to suggest cut lines – in a way it is a gentle warning that we are dealing with powerful forces'. Quoted by Adriana La Lime, in 'Yinka Shonibare MBE: Putting Africa on the Map at the RA', http://www.sothebys.com/en/news-video/blogs/all-blogs/out-of-africa/2017/07/yinka-shonibare-putting-africa-on-the-map-royal-academy.html, accessed 4 January 2018.

THE EXHIBITION ON CAMERA
SARAH VICTORIA TURNER (PAGES 166–67)

1 John Edward Soden, *A Rap at the R.A. – A Satire*, London, 1875.

9 EXHIBITING ARCHITECTURE
JESSICA FEATHER (PAGES 170–85)

1 Harry Furniss, *Royal Academy Antics, with Over Sixty Original Illustrations*, London, 1890, p. 65.

2 These included the building trade, but also surveyors and engineers who began to form professional bodies.

3 See Nicholas Savage, 'The "Viceroy" of the Academy: Sir William Chambers and the Royal Protection of the Arts', in John Harris and Michael Snodin (eds), *Sir William Chambers: Architect to George III*, exh. cat., Courtauld Art Gallery, London, 1996, pp. 193–98.

4 Part of the reason for this may have been Chambers's partisan approach at the Academy in promoting some individuals and not others.

5 As this essay derives from the choices made for the present exhibition, it focuses mainly upon drawings rather than any other media.

6 Nicholas Savage (ed.), *John Yenn R.A.: Pioneer of the Architectural Exhibition Drawing*, exh. pamphlet, Library Print Room, Royal Academy of Arts, London, 2010.

7 'Exhibition, 1781', *Public Advertiser*, 4 May 1781, p. 2. Two drawings by Thomas Sandby were shown at the exhibition of 1781: no. 450, *A Bridge of Magnificence*, designed for the sixth lecture on architecture, and no. 462, *View from the Entrance on the Bridge*. *A Bridge of Magnificence* seems most likely to be the large drawing at RIBA (FRA/SAND/1). Another drawing also at RIBA (SD104/1), which is sometimes referred to as *A Bridge of Magnificence*, is more likely to have been the *View from the Entrance on the Bridge*.

8 The full title in the exhibition catalogue (no. 915) was *A Selection of Parts of Buildings, Public and Private, Erected from the Designs of John Soane, Esq, R.A. in the Metropolis and Other Places in the United Kingdom Between the Years 1780 and 1815*.

9 Brian Lukacher, *Joseph Gandy: An Architectural Visionary in Georgian England*, London and New York, 2006, pp. 136–38.

10 *The Builder*, 12 May 1849, p. 217.

11 Ibid.

12 For a discussion of this drawing see Anne Bordealeau, *Charles Robert Cockerell, Architect in Time: Reflections around Anachronistic Drawings*, Farnham, 2014, pp. 11–36.

13 Nicholas Savage, 'C. R. Cockerell RA: The Professor's Dream', exh. pamphlet, Tennant Room, Royal Academy of Arts, London, 2005.

14 This episode is recounted in George Gilbert Scott, *Personal and Professional Recollections: A Facsimile of the Original Edition with New Material and a Critical Introduction*, Gavin Stamp (ed.), Stamford, CT, 1995.

15 Quoted in Ralph Hyde et al., *Getting London in Perspective*, exh. cat., Barbican Art Gallery, London, 1984, pp. 53–54.

16 RAA/PC/10, Annual Report, 1874, p. 16. Quoted in Neil Bingham, *Masterworks: Architecture at the Royal Academy of Arts*, London, 2011, p. 31.

17 *The Builder*, 22, 1864, p. 326.

18 Sir Albert Richardson PRA, 'Tall Storeys', *Times Educational Supplement*, 25 March 1955.

19 'Architecture at the Academy', *The Times*, 4 May 1953, p. 4.

20 Neil Bingham, *Masterworks: Architecture at the Royal Academy of Arts*, London, 2010, p. 34.

21 Ibid.

22 Mark Hudson, 'A Cranky but Loveable Institution', *Daily Telegraph*, 7 June 2016.

23 It is of course true that many contemporary architects such as Peter Cook RA view their submissions to the exhibition as a form of artistic expression and design in its own right.

THE ARCHITECTURAL MODEL
JESSICA FEATHER (PAGES 186–87)

1 Press release, Stanton Williams, undated.

BIBLIOGRAPHY

COMPILED BY THOMAS POWELL

Mark Hallett, Sarah Victoria Turner and Jessica Feather (eds), *The Royal Academy Summer Exhibition: A Chronicle, 1769–2018*, London, 2018, www.chronicle250.com This is a digital publication produced by the Paul Mellon Centre for Studies in British Art to coincide with *The Great Spectacle* exhibition and catalogue. The *Chronicle* features a year-by-year account of the exhibition's history, written by some 80 authors, and makes the catalogues for every single Royal Academy Summer Exhibition available online as fully searchable texts.

A. Cassandra Albinson, Peter Funnell and Lucy Peltz (eds), *Thomas Lawrence: Regency Power and Brilliance*, exh. cat., Yale Center for British Art, New Haven, and National Portrait Gallery, London, 2010

Brian Allen (ed.), *Towards a Modern Art World*, New Haven and London, 1995

Richard D. Altick, *The Shows of London*, Cambridge, MA, 1978

Tomoko Ando, 'Rodin's Reputation in Great Britain: The Neglected Role of Alphonse Legros' *Nineteenth-Century Art Worldwide*, 15, 3 (Autumn 2016), http://www.19thc-artworldwide.org/autumn16/ando-on-rodin-reputation-in-great-britain-neglected-role-of-alphonse-legros

Caroline Arscott, 'Ramsgate Sands, Modern Life and the Shoring Up of Narrative', in Brian Allen (ed.), *Towards a Modern Art World*, New Haven and London, 1995, pp. 157–68

Caroline Arscott, 'Poynter and the Arty', in Elizabeth Prettejohn (ed.), *After the Pre-Raphaelites: Art and Aestheticism in Victorian Britain*, Manchester, 1999, pp. 135–51

John Barrell, *The Dark Side of the Landscape: The Rural Poor in English Painting 1730–1840*, Cambridge, 1980

Joseph Baretti, *A Guide through the Royal Academy*, London, 1781

Tim Barringer, *Reading the Pre-Raphaelites*, New Haven and London, 1999

Tim Barringer, *Men at Work: Art and Labour in Victorian Britain*, New Haven and London, 2005

Tim Barringer, *Opulence and Anxiety: Landscape Paintings from the Royal Academy of Arts*, exh. cat., Compton Verney, Warwickshire, 2007

Tim Barringer and Elizabeth Prettejohn (eds), *Frederic Leighton: Antiquity, Renaissance, Modernity*, New Haven and London, 1999

Tim Barringer, Edith Devaney, Margaret Drabble, Martin Gayford, Marco Livingstone and Xavier F. Salomon, *David Hockney: A Bigger Picture*, exh. cat., Royal Academy of Arts, London, 2012

Tim Barringer, Jason Rosenfeld and Alison Smith (eds), *Pre-Raphaelites: Victorian Avant-garde*, exh. cat., Tate Britain, London, 2012

Susan Beattie, *The New Sculpture*, New Haven and London, 1983

Keith Bell, *Stanley Spencer: A Complete Catalogue of the Paintings*, London, 1992

Ann Bermingham (ed.), *Sensation and Sensibility: Viewing Gainsborough's 'Cottage Door'*, exh. cat., Yale Center for British Art, New Haven, and Huntington Library, Art Collections and Botanical Gardens, San Marino, 2005

Mark Bills and Vivien Knight (eds), *William Powell Frith: Painting the Victorian Age*, exh. cat., Guildhall Art Gallery, London, and Mercer Art Gallery, Harrogate, 2006

Neil Bingham, *Masterworks: Architecture at the Royal Academy of Arts*, London, 2010

Michael Bird, *Sandra Blow*, Aldershot, 2005

Iwona Blazwick, *Cornelia Parker*, London and New York, 2013

John Bonehill and Stephen Daniels (eds), *Paul Sandby: Picturing Britain*, exh. cat., Royal Academy of Arts, London, 2009

John Bonehill and Stephen Daniels, '"Real Views from Nature in this Country": Paul Sandby, Estate Portraiture and British Landscape Art', *British Art Journal*, 10, 1, Spring/Summer 2009, pp. 72–77

Anne Bordeleau, *C. R. Cockerell RA, 1788–1863, The Professor's Dream: An Introduction and Guide to the Display*, exh. cat., Royal Academy of Arts, London, 2005

Anne Bordealeau, *Charles Robert Cockerell, Architect in Time: Reflections around Anachronistic Drawings*, Farnham, 2014

Andrew Brighton, '"Where are the Boys of the Old Brigade?": The Post-war Decline of British Traditionalist Painting', *Oxford Art Journal*, 4, 1, July 1981, pp. 35–43

Rosie Broadley, *Laura Knight: Portraits*, exh. cat., National Portrait Gallery, London, 2013

Judith Bronkhurst, *William Holman Hunt: A Catalogue Raisonné*, New Haven and London, 2006

David Blayney Brown, *Augustus Wall Callcott*, exh. cat., Tate Gallery, London, 1981

Julius Bryant, 'The Royal Academy's "Violent Democrat": Thomas Banks', *British Art Journal*, 6, 3, Winter 2005, pp. 51–58

Lady Elizabeth Butler, *An Autobiography*, London, 1922

Martin Butlin and Evelyn Joll, *The Paintings of J. M. W. Turner*, revised edition, 2 vols, New Haven and London, 1984

Meaghan Clarke, *Critical Voices: Women and Art Criticism in Britain 1880–1905*, Aldershot, 2005

V. Irene Cockcroft, *New Dawn Women: Women in the Arts and Crafts and Suffrage Movements at the Dawn of the Twentieth Century*, exh. cat., Watts Gallery, Compton, Surrey, 2005

David Peters Corbett and Lara Perry (eds), *English Art 1860–1914: Modern Artists and Identity*, Manchester, 2000

Richard Cork, *Michael Craig-Martin*, exh. cat., Irish Museum of Modern Art, Dublin, 2006

Michael Craig-Martin, *On Being an Artist*, London, 2015

Sarah Crellin, *The Sculpture of Charles Wheeler*, Farnham, 2012

Thomas E. Crow, *Painters and Public Life in Eighteenth-century Paris*, New Haven and London 1985

Thomas Crow, *The Long March of Pop: Art, Music and Design 1930–1995*, New Haven and London, 2014

Caroline Dakers, *The Holland Park Circle: Artists and Victorian Society*, New Haven and London, 1999

Lucy Davis and Mark Hallett, *Joshua Reynolds: Experiments in Paint*, exh. cat., Wallace Collection, London, 2015

Katy Deepwell, *Women Artists Between the Wars*, Manchester, 2010

Rafael Cardoso Denis and Colin Trodd (eds), *Art and the Academy in the Nineteenth Century*, Manchester, 2000

Chris Dercon and Helen Sainsbury, *Wolfgang Tillmans: 2017*, exh. cat., Tate Modern, London, 2017

Rosie Dias, *Exhibiting Englishness: John Boydell's Shakespeare Gallery and the Formation of a National Aesthetic*, New Haven and London, 2013

Judy Egerton, *Wright of Derby*, London, 1990

Judy Egerton, *George Stubbs, Painter: Catalogue Raisonné*, New Haven and London, 2007

Patrick Elliot and Sacha Llewellyn, *True to Life: British Realist Painting in the 1920s and 1930s*, exh. cat., National Galleries of Scotland, Edinburgh, 2017

Helmut von Erffa and Allen Staley, *The Paintings of Benjamin West*, New Haven and London, 1986

Joseph Farington, *The Diary of Joseph Farington*, vols 1–6, Kenneth Garlick and Angus Macintyre (eds); vols 7–16, Kathryn Cave (ed.); index, Evelyn Newby; New Haven and London, 1978–98

James Fenton, *School of Genius: A History of the Royal Academy of Arts*, London, 2006

The First Hundred Years of the Royal Academy 1769–1868, exh. cat., Royal Academy of Arts, London, 1951

Pamela M. Fletcher, *Narrating Modernity: The British 'Problem Picture' 1895–1914*, Aldershot, 2003

Pamela M. Fletcher, 'Narrative Painting and Visual Gossip at the Early Twentieth-century Royal Academy', *Oxford Art Journal*, 32, 2, 2009, pp. 245–62

Pamela M. Fletcher, 'Human Character and Character-reading at the Edwardian Royal Academy', *Visual Culture in Britain*, 14, 1, 2013, pp. 21–35

Kate Flint, *The Victorians and the Visual Imagination*, Cambridge, 2000

Brian Foss, *War Paint: Art, War, State and Identity in Britain, 1939–1945*, New Haven and London, 2007

James Fox, *British Art and the First World War 1914–1924*, Cambridge, 2015

William Powell Frith, *My Autobiography and Reminiscences*, 2 vols, London, 1887

Peter Fullerton, 'Patronage and Pedagogy: The British Institution in the Early Nineteenth Century', *Art History*, 5, 1, March 1982, pp. 109–20

Harry Furniss, *Royal Academy Antics, with Over Sixty Original Illustrations*, London, 1890

Susan Grace Galassi, Patrick Monahan, Pablo Pérez d'Or, Elizabeth Prettejohn and Daniel Robbins, *Flaming June: The Making of an Icon*, exh. cat., Leighton House Museum, London, 2016

Susan Grace Galassi et al., *Turner's Modern and Ancient Ports: Passages of Time*, New York, 2017

Margaret Garlake, *New Art, New World: British Art in Postwar Society*, New Haven and London, 1998

Kristine Ottesen Garrigan, 'Bearding the Competition: John Ruskin's "Academy Notes"', *Victorian Periodicals Review*, 22, 4, Winter 1989, pp. 148–56

Genius and Ambition: The Royal Academy of Arts, London, 1768–1918, exh. cat., Bendigo Art Gallery, Australia, and Japanese venues, 2014

Tony Godfrey, *Conceptual Art*, London, 1998

Mel Gooding, *Frank Bowling*, London, 2011

Jean Goodman, *AJ: The Life of Alfred Munnings, 1878–1959*, Norwich, 2000

Algernon Graves, *The Royal Academy of Arts: A Complete Dictionary of Contributors and Their Work from Its Foundation in 1769 to 1904*, 4 vols, London, 1905–06; reprint, Wakefield, 1970

Nicholas Grindle (ed.), *George Morland: Art, Traffic and Society in Late Eighteenth-century England*, exh. cat., Stanley and Audrey Burton Gallery, University of Leeds, 2015

Christoph Grunenberg and Laurence Sillars, *Peter Blake: A Retrospective*, exh. cat., Tate, Liverpool, 2007

Mark Hallett, 'Reading the Walls: Pictorial Dialogue at the British Royal Academy', *Eighteenth-century Studies*, 37, 4, Summer 2004, pp. 581–604

Mark Hallett, *Reynolds: Portraiture in Action*, New Haven and London, 2014

Robin Hamlyn, *Robert Vernon's Gift: British Art for the Nation 1847*, London, 1993

Matthew Hargraves, *Candidates for Fame: The Society of Artists of Great Britain, 1760–1791*, New Haven and London, 2005

John Harris and Michael Snodin (eds), *Sir William Chambers: Architect to George III*, exh. cat., Courtauld Art Gallery, London, 1996

John Hayes, *The Landscape Paintings of Thomas Gainsborough: A Critical Text and Catalogue Raisonné*, 2 vols, London, 1982

John Hayes, *The Art of Thomas Rowlandson*, exh. cat., toured by Art Services International, Alexandria, VA, 1990

John Hayes (ed.), *The Letters of Thomas Gainsborough*, New Haven and London, 2001

Kathryn Moore Heleniak, *William Mulready*, New Haven and London, 1980

Andrew Hemingway, *Landscape Imagery and Urban Culture in Early Nineteenth-century Britain*, Cambridge and New York, 1992

Robert Hewison (ed.), *Ruskin's Artists: Studies in the Victorian Visual Economy*, Papers from the Ruskin Programme at Lancaster University, Aldershot, 2000

Tim Hilton, *John Ruskin*, New Haven and London, 2002

Charles Holme (ed.), *The Royal Academy: From Reynolds to Millais*, London, 1904

Holger Hoock, *The King's Artists: The Royal Academy of Arts and the Politics of British Culture, 1760–1840*, Oxford, 2003

Maggie Humm, 'Editing Virginia Woolf and the Arts: Woolf and the Royal Academy', in Eleanor McNees and Sara Veglahn (eds), *Woolf Editing / Editing Woolf: Selected Papers from the Eighteenth Annual Conference on Virginia Woolf*, Clemson, SC, 2009, pp. 154–59

Sidney C. Hutchison, 'The Royal Academy Schools, 1786–1830', *Journal of the Walpole Society*, 38, 1962, pp. 123–91

Sidney C. Hutchison, *The History of the Royal Academy, 1768–1986*, second edition, London, 1986

Ralph Hyde et. al., *Getting London in Perspective*, exh. cat., Barbican Art Gallery, London, 1984

Judy Crosby Ivy, *Constable and the Critics, 1802–1837*, Woodbridge, 1991

John Paul M. Kanwit, *Victorian Art Criticism and the Woman Writer*, Columbus, OH, 2013

Rachel Kent (ed.), *Yinka Shonibare MBE*, revised and expanded edition, Munich, 2014

Jongwoo Jeremy Kim, *Painted Men in Britain, 1868–1918: Royal Academicians and Masculinities*, Farnham, 2012

Laura Knight, *Oil Paint and Grease Paint: The Autobiography of Laura Knight*, London, 1936

Laura Knight, *The Magic of a Line: The Autobiography of Laura Knight DBE, RA*, London, 1965

Cilly Kugelmann, Eckhart Gillen and Hubertus Gaßner, *Obsessions: R. B. Kitaj 1932–2007*, exh. cat., Jewish Museum, Berlin, 2012

Walter R. M. Lamb, *The Royal Academy: A Short History of Its Foundation and Development to the Present Day*, London, 1935; revised and enlarged edition, London, 1951

Andrew Lambirth, *Kitaj*, London, 2004

Catherine Lampert, Antoinette Le Normand-Romain, Norman Rosenthal and MaryAnne Stevens (eds) *Rodin*, exh. cat., Royal Academy of Arts, London, 2006

Catherine Lampert (ed.), *Euan Uglow: The Complete Paintings*, New Haven and London, 2007

Christopher Le Brun, *New Paintings*, London, 2014

Olivier Lefeuvre, *Philippe-Jacques de Loutherbourg 1740–1812*, Paris, 2012

Charles Robert Leslie, *Memoirs of the Life of John Constable, Esq., R.A.: Composed Chiefly of His Letters*, London, 1845

Michael Levey, *Sir Thomas Lawrence: The Artist*, New Haven and London, 2005

Mervyn Levy, *Ruskin Spear*, Chicago, 1986

Marco Livingstone, *Kitaj*, revised and expanded edition, London, 1999

Katharine A. Lochnan and Carol Jacobi (eds), *Holman Hunt and the Pre-Raphaelite Vision*, exh. cat., Art Gallery of Ontario, Toronto, 2008

Brian Lukacher, *Joseph Gandy: An Architectural Visionary in Georgian England*, London and New York, 2006

Anne Lyles (ed.), *Constable: The Great Landscapes*, exh. cat., Tate Britain, London, 2006

Jeremy Maas, *Holman Hunt and The Light of the World*, London, 1984

Kenneth McConkey, *George Clausen and the Picture of English Rural Life*, Edinburgh, 2012

John McEwen, *The Sculpture of Michael Sandle*, London, 2002

Dianne Sachko Macleod, *Art and the Victorian Middle Class: Money and the Making of Cultural Identity*, Cambridge, 1996

David Mannings, *Sir Joshua Reynolds: A Complete Catalogue of His Paintings*, 2 vols, New Haven and London, 2000

Simon Martin and Frances Spalding, *John Minton: A Centenary*, exh. cat., Pallant House Gallery, Chichester, 2017

Peter van der Merwe and Roger Took, *The Spectacular Career of Clarkson Stanfield 1793–1867: Seaman, Scene-painter, Royal Academician*, Newcastle upon Tyne, 1979

John Guille Millais, *The Life and Letters of Sir John Everett Millais, President of the Royal Academy*, 2 vols, London, 1899

Sarah Monks (ed.), John Barrell and Mark Hallett, *Living with the Royal Academy: Artistic Ideals and Experiences in England, 1768–1848*, Farnham, 2013 Richard Morphet, *Meredith Frampton*, exh. cat., Tate Gallery, London, 1982

David Morris, *Thomas Hearne and His Landscape*, London, 1989

Alfred J. Munnings, *The Autobiography of Sir Alfred Munnings*, 3 vols, London, 1950–52

Munnings v. The Moderns, exh. cat., Manchester City Art Galleries, 1986

Martin Myrone, *Bodybuilding: Reforming Masculinities in British Art 1750–1810*, New Haven and London, 2005

Emily Ballew Neff and William L. Pressly, *John Singleton Copley in England*, London, 1995

Christopher Newall, '"Val d'Aosta": John Brett and John Ruskin in the Alps, 1858', *Burlington Magazine*, 149, 1248, March 2007, pp. 165–72

Benedict Nicolson, *Joseph Wright of Derby: Painter of Light*, 2 vols, London, 1968

Paul O'Keefe, *Some Sort of Genius: A Life of Wyndham Lewis*, London, 2000

Morna O'Neill, 'Arts and Crafts Painting: The Political Agency of Things', *British Art Studies*, 1, https://doi.org/10.17658/issn.2058-5462/issue-01/moneill

Richard Ormond and Elaine Kilmurray, *Sargent: Portraits of Artists and Friends*, exh. cat., National Portrait Gallery, London, 2015

Felicity Owen and Eric J. Stanford, *William Havell 1782–1857: Paintings, Watercolours, Drawings and Prints*, exh. cat., Reading Museum and Art Gallery, 1981

Marcia Pointon, *Mulready*, exh. cat., Victoria and Albert Museum, London, 1986

Marcia Pointon, *Hanging the Head: Portraiture and Social Formation in Eighteenth-century England*, New Haven and London, 1993

Marcia Pointon, 'Working, Earning, Bequeathing: Mary Grace and Mary Moser – "Paintresses"', in *Strategies for Showing: Women, Possession, and Representation in English Visual Culture 1665–1800*, Oxford, 1997

Mark Pomeroy, *Posters: A Century of Summer Exhibitions at the Royal Academy of Arts*, London, 2015

Martin Postle, *Sir Joshua Reynolds: The Subject Pictures*, Cambridge, 1995

Martin Postle, 'The Royal Academy at Somerset House: The Early Years', *British Art Journal*, 2, 2, Winter 2000–01, pp. 29–35

Martin Postle (ed.), *Joshua Reynolds: The Creation of Celebrity*, exh. cat., Tate Britain, London, 2005

William L. Pressly, *The Life and Art of James Barry*, New Haven and London, 1981

Elizabeth Prettejohn, *The Art of the Pre-Raphaelites*, London, 2000

Elizabeth Prettejohn, *Modern Painters, Old Masters: The Art of Imitation from the Pre-Raphaelites to the First World War*, New Haven and London, 2017

Jules David Prown, *John Singleton Copley*, vol. 2, *In England, 1773–1815*, Ailsa Mellon Bruce Studies in American Art, Cambridge, MA, 1966

John Pye, *Patronage of British Art: An Historical Sketch*, London, 1845

Annette Ratuszniak, *Elisabeth Frink: Catalogue Raisonné of Sculpture 1947–93*, Farnham, 2013

Graham Reynolds, *The Later Paintings and Drawings of John Constable*, 2 vols, New Haven and London, 1984

Graham Reynolds, *The Early Paintings and Drawings of John Constable*, 2 vols, New Haven and London, 1996

Joshua Reynolds, *Discourses on Art*, third edition, Robert R. Wark (ed.), New Haven and London, 1997

Christine Riding and Richard Johns, *Turner and the Sea*, London and New York, 2013

Leonard Roberts and Stephen Wildman, *Arthur Hughes: His Life and Works, A Catalogue Raisonné*, Woodbridge, 1997

Elizabeth Robins and Joseph Pennell, *The Life of James McNeill Whistler*, 2 vols., London and Philadelphia, 1908

Jason Rosenfeld and Alison Smith, *Millais*, exh. cat., Tate Britain, London, 2007

Angela Rosenthal, *Angelica Kauffman: Art and Sensibility*, New Haven and London, 2006

Michael Rosenthal, *Constable: The Painter and His Landscape*, New Haven and London, 1983

Michael Rosenthal, *The Art of Thomas Gainsborough: 'A Little Business for the Eye'*, New Haven and London, 1999

Michael Rosenthal and Martin Myrone (eds), *Gainsborough*, exh. cat., Tate Britain, London, 2002

Norman Rosenthal (ed.), *Sensation: Young British Artists from the Saatchi Collection*, exh. cat., Royal Academy of Arts, London, 1997

William M. Rossetti and Algernon C. Swinburne, *Notes on the Royal Academy Exhibition 1868*, London, 1868; reprint, London, 1976

Wendy Wassyng Roworth (ed.), *Angelica Kauffman: A Continental Artist in Georgian England*, exh. cat., Royal Pavilion, Art Gallery and Museums, Brighton, 1992

Royal Academy of Arts Bicentenary Exhibition 1768–1968, exh. cat., Royal Academy of Arts, London, 1968

Royal Academy Exhibitors 1905–1970: A Dictionary of Artists and Their Work in the Summer Exhibitions of the Royal Academy of Arts, 4 vols, Wakefield, 1973–82; reprint, 1985–87

John Ruskin, *The Complete Works of John Ruskin*, E. T. Cook and Alexander Wedderburn (eds): vol. 14, *Academy Notes, Notes on Prout and Hunt, and Other Art Criticisms, 1855–1888*, London, 1904

William Sandby, *The History of the Royal Academy: From Its Foundation in 1786 to the Present Time, with Biographical Notices of All the Members (A Facsimile Reprint)*, London, 1970

Charles Saumarez Smith, *The Company of Artists: The Origins of the Royal Academy of Arts in London*, London, 2012

Nicholas Savage, 'C. R. Cockerell RA: The Professor's Dream', exh. pamphlet, Tennant Room, Royal Academy of Arts, London, 2005

Nicholas Savage (ed.), *John Yenn R.A.: Pioneer of the Architectural Exhibition Drawing*, exh. pamphlet, Library Print Room, Royal Academy of Arts, London, 2010

George Gilbert Scott, *Personal and Professional Recollections: A Facsimile of the Original Edition with New Material and a Critical Introduction*, Gavin Stamp (ed.), Stamford, CT, 1995

Brian Sewell, *The Reviews That Caused the Rumpus: And Other Pieces*, London, 1994

Brian Sewell, *Outsider II: Always Almost, Never Quite*, London, 2012

Eric Shanes, *The Genius of the Royal Academy*, London, 1981

Eric Shanes, 'More Art on the Line: The Royal Academy's Antique Room in the Exhibition of 1792', *Burlington Magazine*, 150, 1261, April 2008, pp. 224–31

Eric Shanes, *Young Mr Turner: The First Forty Years, 1775–1815* (*J. M. W. Turner: A Life in Art*, 1), New Haven and London, 2016

Susan Sloman, *Gainsborough in Bath*, New Haven and London, 2002

Sam Smiles, '"Splashers, Scrawlers and Plasterers": British Landscape Painting and the Language of Criticism, 1800–1840', *Turner Studies*, 10, 1, Summer 1990, pp. 5–11

Alison Smith, *The Victorian Nude: Sexuality, Morality and Art*, Manchester and New York, 1996

Alison Smith (ed.), *Exposed: The Victorian Nude*, exh. cat., Tate Britain, London, 2001

Greg Smith, *The Emergence of the Professional Watercolourist: Contentions and Alliances in the Artistic Domain, 1760–1824* (*British Art and Visual Culture Since 1750: New Readings*), Aldershot, 2002

Greg Smith, *Thomas Girtin: The Art of Watercolour*, exh. cat., Tate Britain, London, 2002

John Edward Soden, *A Rap at the R.A. – A Satire*, London, 1875

David H. Solkin, *Richard Wilson: The Landscape of Reaction*, exh. cat., Tate Gallery, London, 1982

David H. Solkin, 'Edward Penny's *Marquis of Granby* and the Creation of a Public for English Art', *Huntington Library Quarterly*, 49, 1, Winter 1986, pp. 1–24

David H. Solkin, *Painting for Money: The Visual Arts and the Public Sphere in Eighteenth-century England*, New Haven and London, 1993

David H. Solkin (ed.), *Art on the Line: The Royal Academy Exhibitions at Somerset House, 1780–1836*, exh. cat., Courtauld Art Gallery, London, 2001

David H. Solkin, *Painting Out of the Ordinary: Modernity and the Art of Everyday Life in Early Nineteenth-century Britain*, New Haven and London, 2008

David H. Solkin (ed.), *Turner and the Masters*, exh. cat., Tate Britain, London, 2009

David H. Solkin, *Art in Britain 1660–1815*, New Haven and London, 2015

Frances Spalding, *John Minton: Dance till the Stars Come Down*, Aldershot, revised edition, 2005

Joy Sperling, '"Art, Cheap and Good": The Art Union in England and the United States, 1840–60', *Nineteenth-century Art Worldwide*, 1, 1, Spring 2002, http://www.19thc-artworldwide.org/spring02/196-qart-cheap-and-good-the-art-union-in-england-and-the-united-states-184060

Julian Stallabrass, *High Art Lite: British Art in the 1990s*, London, 1999

Chris Stephens and Andrew Wilson (eds), *David Hockney*, exh. cat., Tate Britain, London, 2017

MaryAnne Stevens (ed.), *The Edwardians and After: The Royal Academy 1900–1950*, exh. cat., IBM Gallery of Art and Science, New York, and other American venues, 1988

Brandon Taylor, *Art for the Nation: Exhibitions and the London Public, 1747–2001*, Manchester, 1999

Dennis Toff, *The Painter RAs: A Guide to the Painter Members of the Royal Academy of Arts with Examples of Their Work*, London, 2008

Rosemary Treble, *Great Victorian Pictures: Their Paths to Fame*, exh. cat., Arts Council of Great Britain, London, 1978

Nicholas Tromans, *David Wilkie: Painter of Everyday Life*, exh. cat., Dulwich Picture Gallery, London, 2002

Nicholas Tromans, *David Wilkie: The People's Painter*, Edinburgh, 2007

Angus Trumble and Andrea Wolk Rager (eds), *Edwardian Opulence: British Art at the Dawn of the Twentieth Century*, New Haven and London, 2013

Paul Usherwood, 'Elizabeth Thompson Butler: A Case of Tokenism', *Woman's Art Journal*, 11, 2, Autumn 1990 – Winter 1991

Gisela Vetter-Liebenow (ed.), *Ronald Searle*, exh. cat., Wilhelm Busch Museum, Hanover, 1996

Nevile Wallis (ed.), *A Victorian Canvas: The Memoirs of W. P. Frith, R.A.*, London, 1957

Giles Waterfield (ed.), *Palaces of Art: Art Galleries in Britain 1790–1990*, exh. cat., Dulwich Picture Gallery, London, 1991

Ellis Waterhouse, 'The First Royal Academy Exhibition, 1769', *The Listener*, 43, 1114, 1 June 1950, pp. 944–46

Ellis Waterhouse, *Painting in Britain 1530 to 1790*, New Haven and London, 1994

Raymond Watkinson, *Pre-Raphaelite Art and Design*, London, 1970

Mary Webster, *Francis Wheatley*, London, 1970

R. V. Weight, *Carel Weight: A Haunted Imagination*, Newton Abbot, 1994

William T. Whitley, *Artists and Their Friends in England 1700–1799*, 2 vols, London and Boston, 1928

William T. Whitley, *Art in England 1700–1799*, 2 vols, reissue, New York, 1973

Andrew Wilton, *The Life and Work of J. M. W. Turner*, London, 1979

Christopher Wood, *William Powell Frith: A Painter and His World*, Stroud, 2006

Robert Wraight (ed.), *Hip! Hip! Hip! RA: An Unofficial Book for the Royal Academy's Bicentenary, 10 December 1968*, London, 1968

Robert Wraight, *Pietro Annigoni: An Artist's Life*, London, 1977

LENDERS TO THE EXHIBITION

Her Majesty The Queen

Aberdeen Art Gallery

ANN ARBOR
University of Michigan Museum of Art

BIRMINGHAM
Barber Institute of Fine Arts
Birmingham Museum and Art Gallery

Bury Art Museum

CAMBRIDGE
Fitzwilliam Museum

CARDIFF
Amgueddfa Cymru – National
Museum Wales

COLCHESTER
Munnings Art Museum

Durban Art Gallery

EDINBURGH
Scottish National Galleries

The Executors of The Frink
Estate and Archive

Zaha Hadid Foundation

Christopher Le Brun PRA

Leeds Museums and Galleries

LINCOLN
Usher Gallery

LIVERPOOL
Walker Art Gallery

LONDON
Apsley House
British Museum
Courtauld Art Gallery
Dulwich Picture Gallery
Fishmongers' Company
Government Art Collection
Guildhall Art Gallery
Imperial War Museums
Leighton House Museum
National Portrait Gallery
Royal College of Art
Sir John Soane's Museum
Stanton Williams
Tate
Victoria and Albert Museum

Earl of Mansfield, Scone Palace

National Trust, Waddesdon Manor

National Trust Collections:
Chartwell, The Churchill Collection
Saltram, The Morley Collection

NEW HAVEN
Yale Center for British Art

The University of Nottingham

OSLO
Astrup Fearnley Museum of Modern Art

OXFORD
Ashmolean Museum
Keble College

A Pope Family Trust

Yinka Shonibare MBE RA

Wolfgang Tillmans RA

Jessie Ware

WINCHCOMBE
Sudeley Castle

Wolverhampton Art Gallery

*and all those who wish
to remain anonymous*

PHOTOGRAPHIC ACKNOWLEDGEMENTS

All works of art are reproduced by kind permission of the owners. Every attempt has been made to trace copyright holders. We apologise for any inadvertent infringement and invite appropriate rights holders to contact us. Specific acknowledgements are as follows:

CREDITS

Aberdeen, Aberdeen Art Gallery & Museums Collections: cat. 55

Ann Arbor, The University of Michigan Museum of Art: cat. 15

Birmingham, © The Henry Barber Trust, The Barber Institute of Fine Arts, University of Birmingham: cat. 16

Birmingham, Birmingham Museums Trust: cat. 32

© Mike Bruce. Courtesy of the artist and Gagosian: cat. 72

Bury, © Bury Art Museum, Greater Manchester, UK: cat. 25

Cambridge, © Fitzwilliam Museum: cat. 19

Cardiff, © National Museum of Wales: cat. 23

Colchester, The Munnings Art Museum: cat. 56

Edinburgh, National Galleries of Scotland: cat. 11

© James Harris: fig. 99

© Historic England Photo Library: cat. 22

Lincoln, The Collection: Art and Archaeology in Lincolnshire (Usher Gallery): cat. 44

Liverpool, courtesy National Museums Liverpool, Walker Art Gallery: cat. 28

London, Alamy Stock Photo / Paul Fearn: fig. 43

London, © Bridgeman Images: cats 38 (Leeds Museums and Galleries; Leeds Art Gallery), 53 (Durban Art Gallery), 58 (Royal College of Art, London); figs 16 (The Huntington Library, Art Collections & Botanical Gardens); 19 (Arthur Ackermann Ltd., London); 28, 29 (photo © Christie's Images); 36 (Tokyo Fuji Art Museum, Tokyo, Japan); 48 (National Gallery of Victoria, Melbourne / Gift of J. R. Hartley, 1931); 51 (Private collection); 52 (Private collection / Photo © Peter Nahum at The Leicester Galleries, London); 59 (National Galleries of Scotland, Edinburgh); 61 (Leeds Museums and Galleries; Leeds Art Gallery); 64 (National Army Museum, London); 67 (Royal Holloway, University of London); 81 (Newport Museum and Art Gallery, South Wales)

London, British Museum © The Trustees of the British Museum: cats 12, 40, 41; figs 18, 25, 26

London, courtesy Sadie Coles HQ: fig. 94

London, Dulwich Picture Gallery: cat. 10

London, Frith Street Gallery: cat. 70

London, Getty Images: figs 5 (Evening Standard / Hulton Archive); 80 (Central Press); 96, 97 (photo: Rosie Greenway)

London, Government Art Collection, © Crown Copyright: UK Government Art Collection: cat. 46

London, Guildhall Art Gallery, City of London / Collage: cats 35, 36

London, © John Hoyland Studios LLP: fig. 10 (photo: Colin Mills)

London, Imperial War Museum © Imperial War Museum: cats 49, 51, 52

London, Leighton House Museum: The Royal Borough of Kensington and Chelsea: cat. 39

London, courtesy Marlborough Fine Art: figs 92, 93

London, © Mary Evans Picture Library / Illustrated London News Ltd: figs 11, 82

London, © Museum of London: fig. 63

London, © The National Gallery, London 2018: figs 17, 27, 54

London, © National Portrait Gallery: cats 17, 45, 65

London, Maureen Paley: cat. 71

London, Private collection, courtesy Gagosian: fig. 9

London, © PUNCH Magazine Cartoon Archive: fig. 13

London, RIBA Collections: figs 112, 116

London, © Royal Academy of Arts, London: cats 13, 24 (Photo: John Hammond); 2, 3, 7, 18, 42, 48, 57, 64, 69, 75, 77, 79, 80, 81, 83, 84; figs 21 (photo: Paul Highnam); 22, 23 (photo: John Hammond); 37, 113 (Prudence Cuming Associates); 65 (photo: John Hammond); 95, 98, 110 (John Bodkin, DawkinsColour); 114 (photo: Miki Slingsby – Fine Art Photography); 4, 6, 7, 8, 12, 21, 24, 32, 33, 49, 60, 71, 73, 75, 76, 77, 78; 79, 83, 86, 87, 88, 89, 90, 91, 105, 106, 107, 108, 109, 115, 117

London, The Samuel Courtauld Trust, The Courtauld Gallery: cat. 6

London, © Sara Faith, courtesy of Artlyst 2017: fig. 101

London, © Sir John Soane's Museum, London: cat. 78; figs 111, 118

London, © Tate, 2018: cats 50, 60, 61, 62; figs 15, 31, 35, 42, 50, 53, 55, 62, 70, 72, 74, 84

London, Times Newspapers Ltd: fig. 85

London, © Victoria and Albert Museum: cats 21, 26, 33; figs 30, 39, 40

London, Image courtesy of Wonderlusting.co.uk: fig. 102

London, Zaha Hadid Foundation: cat. 82

Los Angeles, J. Paul Getty Museum. Digital image courtesy of the Getty's Open Content Program: fig. 69

© National Trust Images / John Hammond: fig. 8

New Haven, Yale Center for British Art, Paul Mellon Collection: cats 1, 4, 5, 14, 76; fig. 44

New York, © The Frick Collection: figs 46, 47

New York, The Metropolitan Museum of Art, Universal License (CC0 1.0): fig. 20

Norfolk Museums Service (Norwich Castle Museum & Art Gallery): fig. 38

Nottingham, The University of Nottingham: cat. 47

Oslo, Astrup Fearnley Collection: cat. 66 (Photo: Thomas Widerberg)

Ottawa, National Gallery of Canada. Photo: NGC: fig. 14

Oxford, © Ashmolean Museum, University of Oxford: cat. 31; figs 56, 57

Oxford, Keble College, University of Oxford: cat. 29

Oxford, © Paul Black, 2015: fig. 2

Paris, Photo © RMN-Grand Palais (Musée d'Orsay) / Jean Schormans: fig. 68

Perth, Scone Palace Collection, by kind permission of Lord Mansfield: cat. 20

Private collection: cat. 30; figs 45, 58

Royal Collection Trust / © Her Majesty Queen Elizabeth II 2018: cats 34, 37

© Thin Man Films Ltd.: fig. 34 (photo Simon Mein)

Waddesdon Image Library, PCF: cat. 9

Wakefield, Yorkshire Sculpture Park: cat. 63 (Photo: © Jonty Wilde Photography Ltd.)

© Keith Waldegrave / Mail on Sunday / Solo Syndication: figs 103, 104

© Stephen White: cat. 67

Winchcombe, Sudeley Castle: cat. 27

Wolverhampton, Wolverhampton Arts and Culture: cat. 43

York, York Museums Trust (York Art Gallery): fig. 66

ADDITIONAL COPYRIGHT

El Anatsui © Courtesy of the artist and October Gallery, London: cover

Pietro Annigoni © Camera Press, London: cat. 59

Peter Blake © Peter Blake. All rights reserved, DACS 2018: cat. 60; fig. 77

Sandra Blow © The Sandra Blow Estate Partnership. All rights reserved, 2018: cat. 64

Frank Bowling © Frank Bowling. All rights reserved, DACS 2018: cat. 62

Winston Churchill © Churchill Heritage Ltd. Reproduced with permission of Anthea Morton-Saner on behalf of Churchill Heritage Ltd: cat. 54

Michael Craig-Martin © Michael Craig-Martin: cat. 72

Edward Cullinan © Edward Cullinan RA: cat. 83

Tracey Emin © Tracey Emin. All rights reserved, DACS / Artimage 2018. Image courtesy White Cube: cat. 68

James Fitton © by permission of Judy and Tim Fitton: fig. 81

Elizabeth Frink © The Executors of the Frink Estate and Archive. All rights reserved, DACS 2018: cat. 63

Zaha Hadid © Zaha Hadid Foundation: cat. 82

David Hockney © David Hockney: cat. 69; fig. 97

Gordon House © The Estate of Gordon House: fig. 77

John Hoyland © The John Hoyland Estate. All rights reserved, DACS 2018: figs 10, 78

Gary Hume © Gary Hume. All rights reserved, DACS 2018: cat. 67; fig. 91

Keystone © Ron Case / Keystone / Hulton Archive / Getty Images: fig. 1

Anselm Kiefer © Anselm Kiefer: fig. 96

R. B. Kitaj © R. B. Kitaj Estate: cat. 66; figs 92, 93

Laura Knight © Reproduced with permission of The Estate of Dame Laura Knight DBE RA 2018. All rights reserved: cat. 47; figs 71, 75

Maurice Lambert © The Estate of Maurice Lambert: fig. 5

Jim Lambie © Jim Lambie, courtesy Sadie Coles HQ, London: fig. 3

Christopher Le Brun © Christopher Le Brun: cat. 73

Wyndham Lewis © The Wyndham Lewis Memorial Trust / Bridgeman Images: cat. 53

Sarah Lucas © Copyright the artist, courtesy Sadie Coles HQ, London: figs 94, 95

Leonard Mannaseh © Estate of Leonard Mannaseh: cat. 81

John Minton © Royal College of Art: cat. 58

Alfred Munnings © Estate of Sir Alfred Munnings, Dedham, Essex. All rights reserved, DACS 2018: cat. 56

Raymond Myerscough-Walker © The Estate of Raymond Myerscough-Walker: fig. 116

Cornelia Parker © Courtesy the artist and Frith Street Gallery, London: cat. 70

Harry Pearce © Harry Pearce (Pentagram): fig. 79

William Roberts © Estate of John David Roberts. By permission of the Treasury Solicitor: cat. 55

Michael Sandle © Michael Sandle, Courtesy of Flowers Gallery: fig. 100

Jenny Saville © Courtesy Gagosian: fig. 9

Ronald Searle © PUNCH Magazine Cartoon Archive: fig. 13

Yinka Shonibare RA © Courtesy of the artist and Stephen Friedman Gallery, London: cat. 74; fig. 101

Basil Spence © The Estate of Basil Spence: cat. 80

Stanley Spencer © The Estate of Stanley Spencer / Bridgeman Images: cat. 57; fig. 80

Betty Swanwick © The Estate of Betty Swanwick / Bridgeman Images: fig. 76

Tomoaki Suzuki © Courtesy of the artist and Corvi-Mora, London: fig. 102

Wolfgang Tillmans © Wolfgang Tillmans: cat. 71

Joe Tilson © Joe Tilson, courtesy Marlborough Fine Art: fig. 99

Euan Uglow © The Estate of Euan Uglow: cat. 61

Carel Weight © The Estate of Carel Weight / Bridgeman Images: fig. 119

Charles Wheeler © Estate of Sir Charles Wheeler: cat. 43

Stanton Williams © Stanton Williams: cat. 84

INDEX

All references are to page numbers, those in **bold** type indicate catalogue plates; and those in *italic* type indicate essay illustrations

Abington, Frances 36
Abstract Expressionism 131
abstraction 131, 137, 139, 142
Acland, Colonel *31*, 32
Adam, Robert 171
Aesthetic Movement 104
Albert, Prince Consort 105
Alison, Archibald 61
Alma-Tadema, Sir Lawrence 107
 Spring 107, *107*
Anatsui, El
 TSIATSIA – searching for connection 4
Angerstein, Mr and Mrs Julius 45
Annigoni, Pietro
 Queen Elizabeth II 135, **135**
Annual Exhibition *see* Summer Exhibition
Apollo 130
Architectural Association 186
architecture 171–87
Ardizzone, Edward 127
Ariosto, Ludovico
 Orlando Furioso 36
Art Journal 80, 88, 105
Art Union of London 99
Artists' General Benevolent Fund 122
Artists' International Association 129
Asquith, Henry Herbert 117
The Athenaeum 111
August Bank Holiday 101
Australia 99, 107
Ayres, Gillian 142

Bacon, Francis 138, 143, **143**
Bank of England 175
Banner, Fiona 157
Baretti, Giuseppe
 A Guide through the Royal Academy 42
Barnard, William
 The Plundering Vagrants 48
Barry, James 29
Baselitz, Georg 155
Bastien-Lepage, Jules 120
Bawden, Edward 132, 134
BBC 124, 125, 131
The Beatles 127
Beaux-Arts tradition 182
La Belle Assemblée 52
Belvedere Torso 26
Bigg, William Redmore 45–48, 50
 The Gypsies Detected 45
 The Plundering Vagrants 45, 48, *48*
Bird, Edward
 Good News 52, 55
Blair, Tony 161
Blake, Peter 127, 151, 155
 Sgt. Pepper's Lonely Hearts Club Band 127
 1975 Summer Exhibition poster *127*
 The Toy Shop 137, **137**
Blitz 121–22
Blow, Sandra 142
 Green and Red Variations **141**, 142
Board of Trade 187
Boccaccio, Giovanni 83

Bonington, Richard Parkes 75
Book of Revelation 86
Booth, Cherie 161
Bowey, Olwyn 145, *145*
Bowling, Frank
 Mirror 138–39, **139**, 142
Boydell, John 40
Brandoin, Michel Vincent 'Charles'
 The Exhibition at the Royal Academy in Pall Mall in 1771
 28, 29, **29**, 30
Bratby, John 127, 136, *136*
 Nell and Roc Sandford 129
Brett, John 89
 The Val d'Aosta **88**, 89
Brett, Rosa ('Rosarius') 89
Brexit referendum (2016) 162
Brockhurst, Gerald 182
Brocky, Károly
 Psyche 93
Brown, Ford Madox 80
Brutalism 183
The Builder 181
Burlington Gardens 18
Burlington House 18–19, 95, 127
Burney, Edward Francis
 East Wall of the Great Room, Somerset House 36, **36**
 West Wall of the Great Room, Somerset House 36, *37*
Burri, Alberto 142
Butler, Lady Elizabeth
 *The Roll Call: Calling the Roll after
 an Engagement, Crimea* **104**, 104–7
buyers 20–22

Callcott, Sir Augustus Wall 61–63, 68–69
 Entrance to the Pool of London 68–69, *69*
 Sheerness and the Isle of Sheppey 68, *68*
Camden Town Group 117
Cameron, David 162
Cardiff Bay Opera House 183, **184**, 185
Carlini, Agostini
 George III 42, **42**
 Model for an Equestrian Statue of King George III 42, *42*
Casson, Sir Hugh 130, 140, 182–83
catalogues 26, 58–59, *58–59*, 136, 166, 167
Chambers, Sir William 13, 15, 171, 173
 Design for the Temple of Diana, Blenheim Palace **170**, 171
 Design for a Mausoleum for Frederick, Prince of Wales
 172, *173*
Chantrey, Sir Francis 103
Chantrey Bequest 103, 132, 138
Charlotte, Queen 43, *43*
Charoux, Siegfried 139, *140*
 Youth 140
chiaroscuro 77, 82
Child, Lt Col. A. J. 123, **123**
Chipperfield, David 185
Church of St George, Lalibela, Ethiopia 187
Church of Saint-Pierre, Firminy 187
Churchill, Winston 125
 Winter Sunshine, Chartwell 125, **125**
Clarke, Geoffrey
 Blueprint 142
Claude Lorrain 77
Clausen, Sir George
 Primavera 116
 Youth Mourning 120, **120**
Cleopatra (film) 107

Clutton-Brock, Alan 129
Cockerell, Charles Robert
 The Professor's Dream 175–80, **178-79**
Cole, George Vicat 121
collage 126–27, 137
collectors 21–22, 107
Collier, John Maler
 The Prodigal Daughter 115–16, **115**
Collins, Charles Allston
 Convent Thoughts 86, *86*
Collinson, James 80, 82
 Italian Image-Boys at a Roadside Alehouse 80, *81*
Committee of Arrangement *see* Hanging Committee
The Connoisseur 120
Conservative Party 157
Constable, John 61–63, 69–72, 121
 Dedham Lock and Mill 69, 70, *70*, 71
 The Hay Wain 72
 The Leaping Horse 72, 73, **73**
 The Lock 72
 The Opening of Waterloo Bridge 61, *62*
 Stratford Mill 72
 View on the Stour near Dedham 72
 The White Horse 70–72, *71*, 156
Constructivism 185
Cooke, Jean 136
 Early Portrait of John Bratby 136
Cope, Charles West 144, 145
 *The Council of the Royal Academy Selecting Pictures
 for the Exhibition, 1875* 102, *102*
Copley, John Singleton 40
Council Room 42, 43, 63
Country Life 142
Coventry Cathedral 131, 182, *182*
Craig-Martin, Michael 25, 158–59
 Reconstructing Seurat (Orange) 159, **159**
Crane, Walter 106
 At Home: A Portrait 106, **107**
critics 20, 101–3, 119, 147, 148
Cullinan, Edward
 Lycée Privé (Private Secondary School) 185, **185**
Cuyp, Aelbert 69

'D' sticks 166–67
Daily Graphic 116
Daily Herald 124
Daily Mail 119
Daily Sketch 116
Daily Telegraph 20, 130, 136, 137, 183
Dance, George the Younger 171
Dante Alighieri
 The Divine Comedy 90
de Grey, Roger 140
Deepwell, Katy 119
Deller, Jeremy 157
DeMille, Cecil B. 107
Devaney, Edith 157
Devonshire, Georgiana, Duchess of 32
Dickens, Charles 85, 99
Dicksee, Sir Frank
 The Two Crowns 113, *113*
Dickson, Jennifer 145, *145*
'The Dominant Male' exhibition (1984) 140

Dorment, Richard 20
drawings, architectural 171–85, 186
Dring, William 145, *145*
du Maurier, George 105
 Varnishing Day at the Royal Academy 92, 105
Duchamp, Marcel
 The Bride Stripped Bare by Her Bachelors, Even 148
Dudley Gallery, London 94
Dulwich Picture Gallery 175
Dunkirk 122
Dutch paintings 173
Dyce, William
 A Bacchanal – A Study 93

Earlom, Richard
 *The Exhibition at the Royal Academy
 in Pall Mall in 1771* **28**, 29, **29**, 30
Earp, T. W. 130
East, Alfred 121
Eastlake, Charles 18
Edinburgh *Gazetteer* 50
Eliot, T. S. 123–25, **124**
Elizabeth II, Queen 135, **135**
Emin, Tracey 155, 157
 There's a Lot of Money in Chairs 151, **151**
Epstein, Jacob 132
etchings, Whistler's 110–11
Etty, William 83
 Britomart Redeems Fair Amoret 82
Eurich, Richard
 Dunkirk Beaches 122, **122**
European Magazine 55, 77
Evans, Edmund
 View of the Old Royal Academy in Pall Mall 14
The Examiner 52, 55
Eyck, Jan van
 The Arnolfini Portrait 83, 84
Eyre, Henry
 *Diagram of the Hang of Works at the 1851
 Summer Exhibition…* 93, 94

Farington, Joseph 70
Farren, Elizabeth *40*, 41
figurative art, future of 138–39
Fildes, Sir Luke
 Applicants for Admission to a Casual Ward 105, *105*
First World War 120–21, 122
Fisher, Sandra 148
Fitton, James 129–30, 142
 Violin with Orchestra (Paganini Variations) 129, *129*
flower paintings 35–36
Forbes, Stanhope 120
Ford, Edward Onslow
 The Singer 91
Foreign and Commonwealth Office 180
Frampton, Sir George 123
 Lamia 114, **114**, 115
Frampton, Meredith 182
 *Sir Ernest Gowers, Lieutenant Colonel A. J. Child
 and K. A. L. Parker* 122–23, **123**
Free Exhibition of Modern Art 79–80
French Academy of Painting and Sculpture 15

French Revolution 50
Frink, Elisabeth 139–40
 Running Man 140, **140**
Frith, William Powell 107
 The Derby Day 16, 98, *98–99*
 A Private View at the Royal Academy, 1881
 18–19, **19**
 The Railway Station 98, 100
 Ramsgate Sands (Life at the Seaside) 95–98, **96-97**, 99
Front Hall 159
Fry, Maxwell 183
Furniss, Harry 171, 183

Gainsborough, Thomas 13, 14, 33–35, 39, 40, 61, 161
 The Blue Boy 33, *33*, 34
 Elizabeth and Mary Linley 33, **33**
 Rocky Landscape 34–35, **35**
 The Watering Place 34, *34*
Gandy, Joseph Michael 175, 177, 180
 *Public and Private Buildings Executed by John Soane
 between 1780 and 1815* 175, **176-77**
Garlake, Margaret 130
Garrard, George
 *Loading the Drays at Whitbread Brewery,
 Chiswell Street, London* 36, 38, *38*
Gayford, Martin 151
Gear, William
 Phantom Landscape 129
genre painting 41, 45–57, 63
George, Prince of Wales (later George IV) 38
George III, King 13, 42–43, *42*, *43*
Gérôme, Jean-Léon 18
Gibson, John 18
Gideon, Maria Marow **40**, 41
Gideon, William **40**, 41
Gilbert, Alfred
 Icarus 91
Gilman, Harold 117
Girtin, Thomas 61, 64–65, 68
 Near Beddgelert (A Grand View of Snowdon) 65–67, **66**
 Rievaulx Abbey, Yorkshire 64, 65
Gladstone, William 19, 90
Goldfinger, Ernö 183
 *Design for Trellick Tower, Edenham Street,
 Kensington and Chelsea, London* 183, *183*
Goodchild, J. E. 176
Gosse, Edmund 91
Gowers, Sir Ernest 122–23, **123**
Grant, Francis 18
Great Exhibition, London (1851) 90, 94
'Great Room', Pall Mall 14–15, *14*, **28**, 29, **29**
Green, Anthony 145, *145*
Grosvenor Gallery, London 94, 109

Hackney 162
Hadid, Zaha 25
 *Aerial View, Cardiff Bay Opera House, Cardiff, Wales,
 Competition 1994–1996* 183, **184**, 185
Hamilton, Emma 45
hang, paintings 24–25, 29
Hanging Committee 19–20, 38, 102, 111, 117, 124
 architectural drawings 182
 innovations 151, 157
 members 45, 104, 119, 171
 procedures 167
 rejections 132
 see also Selection Committee

Hatoum, Mona 157, *158*
 Grater Divide *158*
Havell, William 63
 Valley of Nant Ffrancon, North Wales 66–67, *67*
Hazlitt, William 20
Hearne, Thomas 63
Henley, William Ernest 91
Herkomer, Sir Hubert von 107
 Duke of Wellington 116
Hermes, Gertrude 119, 142, 144–45, *144–45*
Hill, John
 Exhibition Room, Somerset House 17
Hillier, Tristram 142
Hilton, William 83
Hirst, Damien 151
history painting 29–31, 34, 107, 113, 134
Hockney, David 20, 139, 143, 154–56, 161
 Bigger Trees near Warter 155, 156
 Double Study for 'A Closer Grand Canyon' **154**, 156
Holden, Charles 181, 182
Holland, Henry 171
Homer
 The Iliad 30
 The Odyssey 30
Horsley, John Callcott 104
House, Gordon 127
 1974 Summer Exhibition poster *127*
 1975 Summer Exhibition poster *127*
House of Commons 16–18
House of Lords 132
Household Words 85
Hoyland, John 127, 142
 Golden Traveller 20, *21*
 1997 Summer Exhibition poster *127*
Hudson, Mark 183
Hughes, Arthur 89
 Home from Sea 89, **89**
 A Mother's Grave 89
Hume, Gary 155
 Purple Pauline 146, 150–51, **150**
Hunt, Robert 20, 52, 55, 57, 71–72
Hunt, William Holman 80–84, 89
 The Awakening Conscience 86
 *A Converted British Family Sheltering a Christian
 Missionary from the Persecution of the Druids* 85, *85*
 *The Flight of Madeline and Porphyro During
 the Drunkenness Attending the Revelry
 (The Eve of St Agnes)* 80
 The Light of the World 86–88, **87**
 Rienzi Vowing to Obtain Justice… 80–84, *81*
Hutchison, Sidney 18
Huxley, Paul 142, 155, 156

IBM 143
Illustrated London News 22, *22*, 86, 99, *131*, 136, 142
Inchbold, John 89
Indian Mutiny (1857) 100
Iraq War (2003–11) 161–62

James, Henry 103, 116, **116**, 124
Japanese art 103, 111
John, Augustus 125
Jones, Allen 20
Jones, George 56
 Castor and Pollux 93

Kahn, Louis 187
Kauffman, Angelica 13, 30, 59, 117, 126
 Hector Taking Leave of Andromache 30, **30**, 39–40, 59
 The Return of Telemachus 30
Keats, John
 'Isabella; or the Pot of Basil' 83
 'Lamia' 114
Kelpra Press 127
Kiefer, Anselm 155, 156, 161
 Aperiat terra et germinet Salvatorem 152–53, 155, 156
Kitaj, R. B. 139, 148–49
 The Killer-Critic Assassinated by His Widower, Even
 148, **149**
 Sandra One: The Critic Kills 148, *148*
 Sandra Two 148
 Sandra Three 147–49, *147*, *150*
Kitchen, Paddy 139
Kitchen Sink School 136
Knight, Dame Laura 104, 117–19, 126
 Lamorna Birch and His Daughters 112, 117–19, **118**
 1937 Summer Exhibition poster *126*
Knight, Richard Payne 61

Lambert, Maurice
 Basildon Fountain (Mother and Child) 12
Lambie, Jim
 'Zobop' installation *8*, 159
landscape painting 34–35, 57, 61–75, 120–21
Landseer, Sir Edwin 83
 The Monarch of the Glen 93, *93*
 The Sanctuary 93
Landy, Michael 155
Langhorne, John
 The Country Justice 39
Large Weston Room 151, *168–69*
Lasdun, Denys 183
Lawrence, Sir Thomas 41, 45
 Arthur Wellesley, 1st Duke of Wellington 55, 56
 *Charles William Vane-Stewart, 3rd Marquess
 of Londonderry* 41, **41**
 Elizabeth Farren, Later Countess of Derby 40, 41
Le Brun, Christopher 25, 161
 Always Almost **161**
Le Corbusier 183, 187
Lecture Room 157–58, *158*, 159
Leigh, Mike 61
 Mr Turner (film) 60
Leighton, Frederic 19, 91, 107, 109, 120
 An Athlete Wrestling with a Python 109, *109*
 Clytie **108**, 109
 Sluggard 91, 109
Leonardo da Vinci 84
Leslie, Charles Robert 61, 83
Lewis, Wyndham
 Portrait of T. S. Eliot 123–25, **124**
Lhote, André 117
Library 42
Linley, Elizabeth and Mary 33, **33**
The Literary Chronicle and Weekly Review 72
Lloyd, Joanna 32, **32**, 34
Lloyd, Messrs 98–99
London Chronicle 13
London Gazette 55
London Planned (1942) 123
London Regional Civil Defence Control Room 123, **123**
London season 22, 107
London Underground 126, 127

Londonderry, Charles William Vane-Stewart,
 3rd Marquess of 41, **41**
Lorenzo Monaco
 San Benedetto Altarpiece 84
Loutherbourg, Philippe Jacques de 45
Louvre, Paris 15
Lowry, L. S. 136
Lucas, Sarah 151
 Bunny 150
 Willy 151, *151*
Lytton, Edward Bulwer
 Rienzi, the Last of the Roman Tribunes 83

MacColl, D. S. 103
McEwen, John 147
Maclise, Daniel 132–35
Magazine of Art 91, 105, 107
Mail on Sunday 166
Malton, Thomas the Younger
 Interior of St Paul's Cathedral 172, **172**
Manasseh, Leonard
 *Design for Radipole Lake Pumping Station,
 Weymouth, Dorset* 183, **183**
Manet, Edouard
 The Execution of Maximilian 148
Martini, Pietro Antonio
 The Exhibition of the Royal Academy; 1787 15, *16*
memorials 120
Meynell, Alice 103
Middlesex Hospital, London 121
Millais, Sir John Everett 80–86, 88–89
 Christ in the House of His Parents (The Carpenter's Shop)
 84–86, *84*
 Isabella 79, **79**, 80–85
 My First Sermon 100, **101**
 My Second Sermon 100, **101**
 The Woodman's Daughter 86
Minton, John 132–35
 The Death of Nelson (after Daniel Maclise) 132, **134**
Mr Turner (film) 60, 61
mixed-media assemblages 149
models, architectural 186–87
'Modern Art in the United States', Tate Gallery (1956) 131
modernism 182–83
Moore, Albert
 A Venus 103–4, *103*
Moore, George 103
Morland, George 48, 50
 Alehouse Politicians 50, *51*
 Morning, or The Benevolent Sportsman 44, 45, 48, **49**, 59
Morning Post 51, 115
Mornington, Sir Thomas 137, 144
Moser, Mary 25, 35–37, 117
 Medora and Angelica 36
 Summer 37
Mosnier, Jean-Laurent 59
Mulready, William 52–54, 55, 89
 The Convalescent 56–57, *56*
 The Fight Interrupted 53–54, **53**
 The Idle Boys 52–54, *52*
Munnings, Sir Alfred 131
 Does the Subject Matter? 131, **132**
Munro, Alexander
 Paolo and Francesca 90–91, **90**
Myerscough-Walker, Raymond
 *University of London, Bloomsbury. View from
 the Southwest at Night* 181–82, *181*

narrative painting 115–16, 134–35
Nash, John 142
Nash, Paul 120
 The Menin Road 122
National Gallery 15, 18, 84, 116–17
National Gallery of Victoria, Melbourne 107
'The Nation's War Paintings and Other Records' exhibition
 (1919) 122
Nelson, Admiral Horatio 132–34
Netherlands 51, 173
Nevinson, C. W. 120
New English Art Club 120
New Monthly Magazine 54, 72
New Sculpture 91, 109, 114
New Zealand 99
newspapers 20, 101, 140–42
Nightingale, Florence 105
Nimptsch, Uli 139
nudes 103–4

Observer 129–30
Odedina, Abe
 Deep Cut 162, *164–65*
Old Masters 32, 61, 158
O'Neil, Henry Nelson
 Eastward Ho! August 1857 99–100, *100*
 Home Again 100, *100*
O'Neill, George B.
 Public Opinion 95, *95*
Op art 138
Orpen, William 126

Pall Mall 'Great Room' 14–15, *14*, **28**, 29, **29**
Palmerston, Lord 180
pamphlets 20
Pantheon, Rome 187
Paris Salon 15, 91
Parker, Cornelia 157–58, *158*
 Stolen Thunder (Red Spot) **156**, 157
Parker, K. A. L. 123, **123**
Paton, Noel
 In Memoriam 100
Payne, William
 Private View of the Royal Academy 16, **17**, **78**
Pearce, Harry
 2012 Summer Exhibition poster *127*
Penny, Edward 30, 48
Pentagram *127*
Perry, Grayson 157
perspective drawings 180–82
Phillips Exeter Academy Library, New Hampshire 187
photographs 166–67
Piccadilly Circus 159
picturesque 61
Pearce, Harry
 2012 Summer Exhibition poster *127*
Piper, Myfanwy 135
plein-air paintings 120
'Poem by a Perfectly Furious Academician' 102–03
Pollock, Jackson 131
Pop art 136–37
porters 26, **27**, 167

portraiture 31–34, 122–23
posters *11*, *22*, *23*, 126–27, *126–27*, 188
Poynter, Edward John 117
 The Catapult 104
 Diadumenè 104
 Ten Lectures 104
Prater, Chris 127
Pre-Raphaelites 79–91
Price, Uvedale 61
Princep, Val 107
prints 99, 110–11, 142
Privy Council Offices 187
Procter, Dod 119, 182
 Morning 118
Pugin, Augustus
 Exhibition Room, Somerset House 15, *17*
Punch 24, *25*, *92*, 102, 105

Radipole Lake Pumping Station, Weymouth 183, **183**
Ramberg, Johann Heinrich
 The Exhibition of the Royal Academy; 1787 15, *16*
Ramos, Theo 127
A Rap at the R.A. – A Satire 167
Raphael 84
Rauschenberg, Robert 155
Red Cross 122
red dots 21, 99, 157
Repository of Arts 53–54
Reynolds, Sir Joshua 13, *25*, 31–33, 36, 38,
 41, 43, 45, 82–83, 126
 Colonel Acland and Lord Sydney: The Archers 32, *32*, 33
 Discourses 113
 Joanna Leigh, Mrs Richard Bennett Lloyd,
 Inscribing a Tree 32, *32*, 34
 Maria Marow Gideon and Her Brother, William **40**, 41
 Portrait of King George III 43, *43*
 Portrait of Queen Charlotte 43, *43*
Richardson, Sir Albert 182
Richardson, Mary 116–17
Riley, Bridget 151
Roberts, William
 TV 129, **130**, 136
Robinson, Frederick Cayley 121
 The Acts of Mercy 121
 Pastoral 121, **121**
Rodin, Auguste
 The Age of Bronze 91, **91**
Rogers, Richard 185
Roman Catholic Church 85
Rome 187
'Rosarius' (Rosa Brett) 89
Rosoman, Leonard 127
 1971 Summer Exhibition poster *11*, 127
Rossetti, Dante Gabriel 82, 90
 The Girlhood of Mary Virgin 79–81, *80*
Rossetti, William Michael 80, 82
 Notes of the Royal Academy Exhibition 103
Rowlandson, Thomas 22–24, 29
 Exhibition Room, Somerset House 15, *17*
 The Exhibition Stare-Case 24, **24**, 26
 Viewing at the Royal Academy 24, **24**
Royal Academicians 82

catalogues 59
displays of work by deceased 120
elections 132
Honorary Academicians 18, 59, 155
poster designs 126, 127
women Academicians 35–36, 104, 117–19
Royal Academy
 Academy Banquet 105, 119, 125, 131, *131*
 at Burlington House 18–19, 95
 Council 119, 122, 127
 finances *22*, 142–43
 importance of royal family to 42–43
 Instrument of Foundation 13, 171
 and modern art 124, 131–32
 Munnings's criticisms of 131
 1960s refurbishment 137–38
 Planning Committee 123
 Presidents 140
 at Somerset House 15, *17*, 42–43
 in Trafalgar Square 15–16, 18, 110, 175
 war damage 121–22
 see also Summer Exhibition
Royal Academy Illustrated 144, *144–45*
Royal Academy Schools 84
 Antique Academy 26. *63*
 architectural training 171, 172, 176, 180, 186
 Life Academy 26
 students 38, 82
Royal Charters 119
Royal College of Art 132, 138
Royal Commission (1864) 18
royal family 42–43
Ruskin, John 86, 89, 102
 Modern Painters 89
 Notes on Some Principal Pictures Exhibited
 in the Rooms of the Royal Academy 20, 101–3
Russell, John
 A Porter of the Royal Academy 26, **27**

Saatchi, Charles 150, 151
sales 21–22, 98–99, 130
Salon, Paris 15, 91
Sandby, Paul 63, 175
 Morning 64, *64*
Sandby, Thomas 48, 171, 176, 177
 A Bridge of Magnificence 174–75, *175*
 The Royal Academy Annual Exhibition of 1792:
 The Antique Academy 63, *63*
 The Royal Academy Annual Exhibition of 1792:
 The Great Room, West Wall 45, *46–47*, 59
Sandle, Michael
 Iraq Triptych 161–62, *162*
Sargent, John Singer
 Gassed 122
 Henry James 116, *116*, **116**, 124
Sass's Academy 82
Saville, Jenny 155
 Reverse 20, *20*
Scott, Sir George Gilbert
 Design for Government Offices, Whitehall,
 Westminster, London 180, *180*
Scragg, Tony 126
sculpture 130
 figurative sculpture 139–40
 New Sculpture 91, 109, 114
 Pre-Raphaelite 90–91
Searle, Ronald 24, 134

Private View: Ronald Searle at the Academy 25
Second World War 121–23, 130–31
Segonzac, André Dunoyer de 117
Selection Committee 19–20, 102, *102*
 members 104, 119, 144–45, *144–45*, 171
 rejections 106, 123–25, 132
 selection process 166–67, *166*
 and women artists 104, 117
Senate House 181–82, *181*
'Sending-in Day' 166
'Sensation' exhibition (1997) 150–53, 158
serialisation 99–101
Seurat, George
 Bathers at Asnières 159
Seven Years' War (1756–63) 31, 39, 55
Sewell, Brian 147
Sex Disqualification (Removal) Act (1919) 119
Shakespeare, William
 As You Like It 32
Shakespeare Gallery, London 40
Sharpe, Charles William 99
Sheridan, Richard Brinsley 34
Sherlock, Marjorie
 Liverpool Street Station 117, **117**
Shonibare, Yinka 155, 162, *164*, 165
 Bunch of Migrants 162, **163**
'Show Sundays' 107
Sickert, Walter 103, 117, 132–34, 143
Sims, Charles
 Clio and the Children 119–20, **119**
Smirke, Sydney 18, 19
 Design for Gallery III, Burlington House, Piccadilly 18, **18**
Smith, Bob and Roberta 157
Smith, Richard 151
Soane, Sir John 175, 176, **176–77**, 177, 180, 187
 Model of the Principal Front of a Design for
 Completing the Buildings at Whitehall 186, *187*
Society of Artists 13, 14, 38
Solomon, Solomon J. 117
Somerset House 42–43
 architectural drawings 171
 Great Room 15, *17*, 26, *36–37*, 36–38, 45, *46–47*, 171
 Library 42, 171
 Royal Academy moves to 15
Soukop, Willi 139
Spall, Timothy *60*
Spear, Ruskin 132
 Francis Bacon 143, **143**
Spence, Basil 131
 Design for the Cathedral Church
 of St Michael, Coventry 182, **182**
Spencer, Sir Stanley 129, 131–32
 Christ Preaching at Cookham Regatta 128, 129
 The Farm Gate 132, **133**
 The Lovers (The Dustman) 132
 St Francis and the Birds 131–32
Spielmann, M. H. 107
Stanfield, Clarkson 63
 Mount St Michael, Cornwall 75, *75*
Stanton Williams
 Intangible 187, **187**
Stephens, F. G. 80, 111
Stevenson, R. A. M. 103
Stone, Marcus 107
Stourhead, Wiltshire 76–77
Street, George Edmund 180–81
Stubbs, George 38

Bulls Fighting 38, **38**
Horses Fighting 38
suffragettes 116–17
Summer Exhibition
 aims 29–30
 first (1769) 13
 invites non-Academicians 151–53, 157
 at Pall Mall 'Great Room' 14–15, **28**, 29, **29**
 Press Views 101
 private views 19, *19*, 101, *128*
 rejected paintings 106, 123–25, 132
 at Somerset House 15, *17*
 sponsors 143
 submissions 113, 166–67
 in Trafalgar Square 15–16, 110
 Varnishing Day *92*, 61, 105
 visitors 16, 22–24, 29, 52, 95, 126, 135–36, 156–57
 see also Hanging Committee; Royal Academy;
 Selection Committee
Sunday Telegraph 147
The Sunday Times 147
Suprematism 185
Sutherland, Graham 182
Suzuki, Tomoaki 162–65, *165*
Swanwick, Betty 126
 1974 Summer Exhibition poster *127*
Swinburne, Algernon C.
 Notes of the Royal Academy Exhibition 103–4
Swynnerton, Annie 117
Sydney, Lord *31*, 32

Tate Gallery 119, 131, 132, 138, 148
television 136
Teniers, David the Younger 51
 Two Men Playing Cards in the Kitchen of an Inn 51, *51*
Terry, Ellen 19
Tillmans, Wolfgang
 Greifbar 1 **157**, 158
The Times 85, 86, 94, 104, 113, 131, 142–43, *142*
Titian 84
topographical watercolours 64
Trafalgar Square, Royal Academy in 15–16, 18,
 110, 171, 175, 180
Trellick Tower, London 183, *183*
Trollope, Anthony 19
Turner, Joseph Mallord William 61–63, 64–65,
 67–69, 70, 72–75, 76–77, 121, 127, 156, 161
 Calais Pier 68
 Calais Sands at Low Water: Poissards Collecting Bait
 73–75, **74**
 Dolbadern Castle 76, *76*
 Dort or Dordrecht: The Dort Packet-Boat
 from Rotterdam Becalmed 69, *69*
 The Field of Waterloo 57, *57*, 155
 Harbour of Dieppe. Changement de Domicile 73, *74*
 Helvoetsluys: The City of Utrecht, 64,
 Going to Sea 61, *62*, 75
 Malmesbury Abbey 63, *64*
 Norham Castle on the Tweed, Summer's Morn 64
 Rise of the River Stour at Stourhead 76–77, **77**
 St Michael's Mount, Cornwall 75, **75**
 Sheerness and the Isle of Sheppey 68, *68*
 The Tenth Plague of Egypt 67–68

Uglow, Euan
 Nude 138, **138**
United States of America 99

University of London 181–82

Vaizey, Marina 147
Varnishing Day 61, *92*, 105
Velázquez, Diego de Silva y
 Rokeby Venus 116–17
Victoria, Queen 22, 99, 105
video art 136

Wagner, Richard 83
War Artists' Advisory Committee (WAAC) 122, 123, **123**
War Relief Exhibition (1915) 122
Ward, John 22, *23*
Ward, William
 Alehouse Politicians 50, *51*
warfare 120–23, 130–31
watercolour paintings 63–64, 76–77, 142, 172
Waterhouse, John William 107–9
 Ulysses and the Sirens 107–9
Waterloo, Battle of (1815) 54, *55*–57, *57*
Wearing, Gillian 155
Webster, Thomas
 A Chimney Corner 93
Weight, Carel 132
 Turner Goes to Heaven 126–27, *188*
Wellington, Duke of 55, *55*, 56, 116
West, Benjamin 13, 30
 Agrippina Lands at Brundisium 14
 The Death of General Wolfe 30–31, *31*, 39
 Hector Taking Leave of Andromache 30
 The Institution of the Order of the Garter 45
Wheatley, Francis 49
Wheeler, Sir Charles
 Mother and Child 114, **114**
Whibley, Charles 103
Whistler, James Abbott McNeill 110–11
 Arrangement in Grey and Black No. 1:
 Portrait of the Painter's Mother 106, *106*
 Black Lion Wharf **110**, 111
 The Lime Burner 111, **111**
Whitehall Evening Post 65
Wilde, Oscar 19, 109
Wilkie, Sir David 50–52, 55, 83
 Chelsea Pensioners Reading the Waterloo Despatch (The
 Chelsea Pensioners Receiving the London Gazette
 Extraordinary...) **54**, 55–56, 98
 The Village Politicians 50–52, **50**
Wilkins, William 15, 171
Wilson, Richard 34
Winter Exhibition 95, 130
Withers, John 26
Wohl Central Hall 6–7, 159
Wolfe, General James 30–31, *31*, 40, 52, 55
women
 art critics 119
 lack of female Presidents 140
 'New Woman' 116
 problem pictures 115–16
 as Royal Academicians 35–36, 105, 117–19
 suffragettes 116–17
 women artists 104–7, 117–19
Wood, Mary 116
Woolf, Virginia 115–16
Woolner, Thomas 80
Worshipful Company of Fishmongers 135
Wright, Joseph of Derby 25, 38–40
 The Dead Soldier 39–40, **39**, 41, 57

'X' sticks 166–67

YBAs (Young British Artists) 150
Yenn, John 173–75
 Design for a Bath or a Mansion 173, **173**
 Design for the Temple of Diana, Blenheim Palace 170, 171
 Principal Front of a Green-house 174, 175
 Principal Front of a Town Mansion 173, **174**

Zimmern, Helen 103

RA BENEFACTORS

SUPPORTERS OF THE ROYAL ACADEMY

PRESIDENT'S CIRCLE
Blavatnik Family Foundation
Mervyn and Jeanne Davies
The Dorfman Foundation
The Clore Duffield Foundation
Heritage Lottery Fund
Mrs Gabrielle Jungels-Winkler
Sir John Madejski OBE DL
Ronald and Rita McAulay
The McLennan Family
Mead Family Foundation
Mr and Mrs Robert Miller
The Monument Trust
Simon and Virginia Robertson
The Rothschild Foundation
Dame Jillian Sackler DBE
The Garfield Weston Foundation
The Maurice Wohl
 Charitable Foundation
The Wolfson Foundation

SUPPORTERS
The 29th May 1961 Charitable Trust
The Aldama Foundation
Lord and Lady Aldington
Joan and Robin Alvarez
The Anson Charitable Trust
The Band Trust
Ambassador Matthew Barzun
 and Brooke Brown Barzun
Sir David and Lady Bell
Ms Linda Bennett
Aryeh and Elana Bourkoff, Liontree
The Deborah Loeb Brice Foundation
The Consuelo and Anthony Brooke
 Charitable Trust
Sir Francis and The Hon. Lady Brooke
Garvin and Steffanie Brown
Mr and Mrs John Burns
Peter and Sally Cadbury
The Cadogan Charity
Sir Richard and Mary Carew Pole,
 Carew Pole Charitable Trust
Mr A.E. Carter
Adrian Cheng
Sir Trevor and Lady Susan Chinn
Mr and Mrs Jonathan Clarke
Mr Andrés Clase
The John S. Cohen Foundation
Jeremy Coller Foundation
John and Gail Coombe
Ina De and James Spicer
The Roger De Haan Charitable Trust
Lady Alison Deighton
Sir Harry and Lady Djanogly
Dunard Fund
The John Ellerman Foundation
Mr Richard Elman
The Lord Farringdon Charitable Trust
The Fidelity UK Foundation Mr and
Mrs Stephen Fitzgerald
The Foyle Foundation
J. Paul Getty Jnr Charitable Trust
Mr Thomas Gibson
Antony Gormley and Vicken Parsons
HRH Princess Marie-Chantal of Greece
The late Sir Ronald Grierson
Sir Nicholas Grimshaw CBE PPRA
The Golden Bottle Trust
Horace W. Goldsmith Foundation
Nicholas and Judith Goodison's
 Charitable Settlement

Mr and Mrs Jim Grover
The Alexis and Anne-Marie Habib
 Foundation
Charles and Kaaren Hale
Mr and Mrs Peter Hare
Mr and Mrs Julian Heslop
Mr and Mrs Jeremy Hosking
Harry Hyman and family
The Inchcape Foundation
Japanese Committee of Honour
 of the Royal Academy of Arts
Alistair D.K. Johnston CMG FCA
The Kirby Laing Foundation
Nicolette and Frederick Kwok
Christopher Le Brun PRA
 and Charlotte Verity
The David Lean Foundation
The Lennox and Wyfold Foundation
Mr Nelson Leong
Lord Leverhulme's Charitable Trust
Christian Levett and Mougins
 Museum of Classical Art
Sir Sydney Lipworth QC
 and Lady Lipworth CBE
Miss Rosemary Lomax-Simpson
Mr William Loschert
The Loveday Charitable Trust
Molly Lowell and David Borthwick
Dr Lee MacCormick Edwards
 Charitable Foundation
Mr and Mrs Donald Main
Mr Javad and Mrs Narmina Marandi
J.P. Marland Charitable Trust
Philip and Valerie Marsden
The Lord Mayor's Appeal
The Paul Mellon Estate
The late Mr Minoru Mori HON KBE
 and Mrs Mori
Christina Ong
Mr Charles Outhwaite
Simon and Midge Palley
John Pattisson
P F Charitable Trust
Mr and Mrs Maurice Pinto
John Porter
Mrs Tineke Pugh
Sir Simon and Lady Robey OBE
The Royal Academy
 Development Trust
Sir Paul and Lady Ruddock
Mr Wafic Rida Saïd
The Basil Samuel Charitable Trust
Mrs Coral Samuel CBE
Edwina Sassoon
The Schroder Foundation
Mr Sean Scully RA
In memory of Brian and Mary Senior,
 Friends of the RA
Louisa Service OBE
Jake and Hélène Marie Shafran
David and Sophie Shalit
Mr Richard S. Sharp
William and Maureen Shenkman
The late Pauline Sitwell
Mr Brian Smith
Mr Christopher Smith
Mr and Mrs Roger Staton
Sir Hugh and Lady Stevenson
David and Deborah Stileman
The Swire Charitable Trust
The late Sir David Tang KBE
The Thompson Family Charitable Trust
Julian and Louisa Treger
Sir Siegmund Warburg's
 Voluntary Settlement

Martin and Anja Weiss
The Welton Foundation
Sian and Matthew Westerman
Mr W. Galen Weston
 and The Hon. Mrs Hilary Weston
Chris Wilkinson OBE RA
Mr Peter Williams
Viscount Ivor Windsor
Manuela and Iwan Wirth
Yagi Tsusho Ltd

RA PATRONS

CHAIR
Robert Suss

PLATINUM
Celia and Edward Atkin CBE
Mr and Mrs Christopher Bake
Mrs Deborah Brice
Mr and Mrs Frank Destribats
Mr Jim Grover
Charles and Kaaren Hale
Mr Yan Huo
Mrs Elizabeth Lenz
Mr and Mrs John R. Olsen
David and Sophie Shalit
Alex Beard and Emma Vernetti

GOLD
Molly Lowell Borthwick
Richard Bram and Monika Machon
Sir Francis Brooke Bt
Ms Lisa Carrodus
Dr Martin A. Clarke
Caroline Cole
Christopher and Alex Courage
Mrs Patricia Franks
Amy Griffin
Mrs Robin Hambro
Mrs Elizabeth Hosking
Mr Nicholas Maclean
Federico Marchetti
Mr Stephen Marquardt
Sir Keith and Lady Mills
Lady Rayne Lacey
Jean and Geoffrey Redman-Brown
The Lady Renwick of Clifton
Richard Sharp
Mr Richard Simmons CBE
Mr Kevin Sneader
 and Ms Amy Muntner
Jane Spack
David Stileman
Mr Robert John Yerbury

SILVER
Lady Agnew
Mrs Anna Albertini
Ms Ruth Anderson
Miss H.J.C. Anstruther
Mrs Jacqueline Appel
Mr Edward Baker and Dr Annie Yim
Mr Brian Balfour-Oatts
Mrs Jane Barker
Catherine Baxendale
Mrs Elissa Benchimol
Mrs J.K.M. Bentley, Liveinart
Mrs Francelle Bradford
Eleanor E. Brass
Mr and Mrs Richard Briggs OBE
Mrs Marcia Brocklebank
Mrs Charles Brown
Jeremy Brown
Mr and Mrs Zak Brown

Lord Browne of Madingley
Sir Andrew Cahn
Mr F.A.A. Carnwath CBE
Sir Roger and Lady Carr
Mrs Ann Chapman-Daniel
Sir Trevor and Lady Chinn
Mr Michael L. Cioffi
Mr and Mrs George Coelho
Sir Ronald and Lady Cohen
Mrs Jennifer Coombs
Ms Linda Cooper
Andrew M. Coppel CBE
 and June V. Coppel
Mark and Cathy Corbett
Mr and Mrs Ken Costa
Gwendoline, Countess of Dartmouth
Mr Daniel Davies
Peter and Andrea De Haan
The de Laszlo Foundation
Mrs Kate de Rothschild
Dr Anne Dornhorst
Mr and Mrs Jim Downing
Ms Noreen Doyle
Mrs Janet Dwek
Lord and Lady Egremont
Mrs Jocelyn Fox
Arup and Harshi Ganguly
Mrs Jill Garcia
Mrs Mina Gerowin Herrmann
Caroline and Alan Gillespie
Mr Mark Glatman
HRH Princess Marie-Chantal of Greece
Ms Jane Gregory
Mrs Sarah Harvey-Collicott
Sir John Hegarty
 and Miss Philippa Crane
Sir Michael and Lady Heller
Mrs Katrin Henkel
Lady Heseltine
Mrs Pat Heslop
Mary Hobart
Mr Philip Hudson
S. Isern-Feliu
Mrs Caroline Jackson
Sir Martin and Lady Jacomb
Mrs Raymonde Jay
Art JED Gallery
Mr Alistair D.K. Johnston CMG
 and Ms Christina M. Nijman
Fiona Johnstone
Mrs Ghislaine Kane
Dr Elisabeth Kehoe
Mrs Emma Keswick
Princess Jeet Khemka
Mr D.H. Killick
Mrs Aboudi Kosta
Mr and Mrs Herbert Kretzmer
Kathryn Langridge
Joan H. Lavender
Lady Lever of Manchester
Miss R. Lomax-Simpson
The Hon. Mrs Virginia Lovell
Mr and Mrs Henry Lumley
Gillian McIntosh
Andrew and Judith McKinna
Sir John Mactaggart
Madeline and Donald Main
Mr Paul Marshall
Mr Charles Martin
Mr and Mrs Richard C. Martin
The Anthony and Elizabeth Mellows
 Charitable Trust
Mr David Mirvish
Mr Daniel Mitchell
Ms Bona Montagu

Mr Eli Muraidekh
Mrs Alexandra Nash
Dr Ann Naylor
Ms Emma Norden
Mr Richard Orders
Mr Michael Palin
Mr and Mrs D.J. Peacock
Julian Phillimore
David Pike
Mr and Mrs Anthony Pitt-Rivers
Mr Basil Postan
John and Anne Raisman
Serena Reeve
Erica Roberts
Rothschild Foundation
Miss Elaine Rowley
Sir Paul and Lady Ruddock
The Lady Henrietta St George
Christina Countess of Shaftesbury
Mr Robert N. Shapiro
Alan and Marianna Simpson
Mr Stuart Southall
Anne Elizabeth Tasca
Lady Tennant
Mr Sacha Thacker
Anthony Thornton
Mr Anthony J. Todd
Mrs Carolyn Townsend
Miss M.L. Ulfane
John and Carol Wates
Anthony and Rachel Williams
Mrs Janet Winslow
Mrs Adriana Winters
David Zwirner

DONORS

Geoffrey Ainsworth
 and Jo Featherstone
William Brake Charitable Trust
Jean Cass MBE and Eric Cass MBE
Mr Richard Hoare
Mr Charles Holloway
Mr and Mrs James Kirkman
Jacqueline and Marc Leland
Cate Olson and Nash Robbins
John Pattisson
The Michael H. Sacher Charitable Trust
H.M. Sassoon Charitable Trust
Jake and Hélène Marie Shafran
*and those who wish
to remain anonymous*

ARCHITECTURE PATRONS GROUP

CHAIR
Mr Roger Zogolovitch

GOLD
Mr Michael Stiff
Mr Peter Williams

SILVER
Mr Richard Baldwin
Jacqueline and Jonathan Gestetner
Anne Holmes-Drewry
Alan Leibowitz and Barbara Weiss
Mr and Mrs Robin Lough
Mr Stephen Musgrave
Mr Paul Sandliands
*and those who wish
to remain anonymous*

BENJAMIN WEST GROUP PATRONS

CHAIR
Lady Barbara Judge CBE

PLATINUM
David Giampaolo
Gareth Hughes
Mr Christian Levett

GOLD
Ms Alessandra Morra
Kathryn Uhde
Mr Michael Webber

SILVER
Lady J. Lloyd Adamson
Mr Dimitry Afanasiev
Mrs Spindrift Al Swaidi
Poppy Allonby
Mr Andy Ash
Marco and Francesca Assetto
Mrs Leslie Bacon
Francesca Bellini Joseph
Ms Pauline Cacucciolo
Mrs Sophie Cahu
Brian and Melinda Carroll
Mrs Caroline Cartellieri Karlsen
Damian and Anastasia Chunilal
Andrew and Stefanie Clarke
Mr and Mrs Paul Collins
Vanessa Colomar de Enserro
Mrs Cathy Dishner
Mr and Mrs Jeff Eldredge
Suzanne Ferlic Johnson
Mrs Stroma Finston
Ronald and Helen Freeman
Mr Christopher Harrison
Lady Barbara Judge CBE
Miss Rebecca Kemsley
Mrs Stephanie Léouzon
Ms Ida Levine
Mr Guido Lombardo
Charles G. Lubar
Mrs Victoria Mills
Neil Osborn and Holly Smith
Lady Purves
Mrs Janice Sacher
Ms Elena Shchukina
Mr James B. Sherwood
Sir Hugh and Lady Sykes
Mr Ian Taylor
Mr Craig D. Weaver
Mrs Juliana Wheeler
Mr and Mrs John Winter
*and those who wish
to remain anonymous*

CONTEMPORARY CIRCLE PATRONS GROUP

CHAIR
Susan Elliott

GOLD
Sara Alireza
Joan and Robin Alvarez
Tom and Diane Berger
Mr Jeremy Coller
Patrick and Benedicte de Nonneville
Virginia Gabbertas
Mr Alexander Green
Jessica Lavooy
Mr Michael Marx

Simon and Sabi North
Mr and Mrs Simon Oliver
Yana and Stephen Peel
Robert and Simone Suss
Erica Wax
Manuela and Iwan Wirth

SILVER
Ghalia and Omar Al-Qattan
Mrs Charlotte Artus
Constance and Boris Baroudel
Ms Martina Batovic
Mr David Baty
Jeffrey Boone
Viscountess Bridgeman
Ms Debra Burt
Mr Steven Chambers
Jenny Christensson
Mrs Caroline Cullinan
Helen and Colin David
Mrs Georgina David
Ms Miel de Botton
Belinda de Gaudemar
Mrs Jennifer Duke
Rosemary Edgington
Mrs Samira El Hachioui
Mr Timothy Ellis
Mr Alexander Flint
Maria Almudena Garcia Cano
Mr Stephen Garrett
Dicle Evin Guntas
Mrs Susan Hayden
Mrs Michele Hillgarth
Zane Jackson,
 Director of Three Point Enterprises
Mrs Cathy Jeffrey
Shareen Khattar
Mr Gerald Kidd
Mrs Anna Kirrage
Mr Matthew Langton
Mrs Julie Lee
Florian and Henriette Lefort
Mr Jeff Lowe
Ms Kathryn Ludlow
Mary McNicholas
Olivier & Priscilla Malingue
Dr Carolina Minio Paluello
Mrs Sophie Mirman
Mr James Nicholls
Mr and Mrs Jeremy Nicholson
Mrs Tessa Nicholson
Roderick and Maria Peacock
Mr Malcolm Poynton
Mrs Tineke Pugh
Mrs Catherine Rees
Mrs Yosmarvi Rivas Rangel
Miss Harriet Ruffer
Edwina Sassoon
Ms Polina Semernikova
Mrs Veronica Simmons
Jeffery C. Sugarman
 and Alan D.H. Newham
Mr Matt Symonds
Mrs Arabella Tullo
Mr and Mrs Maurice Wolridge
Mr Mario Zonias
*and those who wish
to remain anonymous*

INTERNATIONAL PATRONS GROUP

Niloufar Bakhtiar-Bakhtiari
Steffanie Brown
Bonnie Chan Woo
Andres O. Clase

Valentina Drouin
Stephen Fitzgerald
Belma Gaudio
Joanna Kalmer
Stella Kesaeva
Nelson Leong
Aarti Lohia
Nick Loup
Scott Mead
Christina Ong
Hideyuki Osawa
Frances Reynolds
Thaddaeus Ropac
Sabine Sarikhani
Annie Vartivarian
Jessica Zirinis
*and those who wish
to remain anonymous*

RA SCHOOLS PATRONS GROUP

PLATINUM
Joseph and Marie Donnelly
Hugo Eddis
Andrew Hanges

GOLD
Sam and Rosie Berwick
Mr Charles Irving
Mrs Marcelle Joseph
Mrs Kit Kemp
Mr Christopher Kneale
Mr William Loschert
Mr Keir McGuinness
The Lord and Lady Myners
Janet and Andrew Newman
Carol Sellars
David and Alison Sola
Mrs Sarah Chenevix-Trench

SILVER
Lord and Lady Aldington
Mrs Elizabeth Alston
Lorna Anne Barker
Mr and Mrs Jonathan and Sarah Bayliss
Alex Haidas and Thalia Chryssikou
Rosalind Clayton
Mr Richard Clothier
Ms Cynthia Corbett
Mrs Dominic Dowley
Nigel and Christine Evans
Mrs Catherine Farquharson
Mr David Fawkes
Catherine Ferguson
Gaye and Kent Gardner
Mr Mark Garthwaite
Stephen and Margarita Grant
Mrs Michael Green
Mr and Mrs G. Halamish
Mr Lindsay Hamilton
Mrs Lesley Haynes
Professor and Mrs Ken Howard RA
Mark and Fiona Hutchinson
Mr and Mrs S. Kahan
Paul and Susie Kempe
Mrs Alkistis Koukouliou
Nicolette Kwok
Mrs Anna Lee
Mrs Julie Llewelyn
Mr and Mrs Mark Loveday
April Lu Boon Heng
Mr George Maher
Philip and Val Marsden
Itxaso Mediavilla-Murray

Morgan Stanley & Co International PLC
Pentland Group PLC
Sumitomo Mitsui Banking Corporation
 Europe Ltd

CORPORATE
Bird & Bird LLP
Bloomberg LP
The Boston Consulting Group
Capital Group
Charles River Associates
Christie's
Clifford Chance LLP
GAM London Ltd
Generation Investment
 Management LLP
Holdingham Group
iGuzzini
John Lewis Partnership
Lindsell Train
Macfarlanes
Marie Curie
Rathbone Brothers PLC
Ridgeway Partners
Rolex
The Royal Society of Chemistry
Sky
Slaughter and May
Ten Acre Mayfair (Native Land,
 Hotel Properties and Amcorp)
Trowers & Hamlins LLP
UBS Wealth Management
Value Retail
Weil

PREMIER
The Arts Club
BNY Mellon
Cazenove Capital
Charles Stanley
Chestertons
Deutsche Bank AG London
FTI Consulting LLP
HS1
Insight Investment Funds
 Management Ltd
JM Finn & Co.
JTI
KPMG LLP
LetterOne
Linklaters LLP
Newton Investment Management
Pinsent Masons LLP
Sanlam UK
Smith & Williamson
Sotheby's
Winsor & Newton

**CORPORATE SPONSORS AND
SUPPORTERS OF THE
ROYAL ACADEMY OF ARTS**
Arup
BNP Paribas
BNY Mellon, Anniversary Partner
 of the Royal Academy of Arts
Cazenove Capital Management
David Morris – The London Jeweller
Edwardian Hotels
Government of Flanders
Google Arts and Culture
HS1 Ltd
HTC VIVE
Insight Investment
Jack Wills
JM Finn

JTI
Kickstarter
LetterOne
Lisson Gallery
Lowell Libson Ltd
Maserati
Momart
Newton Investment Management
Phillips
Pictet Wealth Management
Sketch
Sky Arts
Switzerland Tourism
The White Company
Turkishceramics
Unilever
Wells Fargo
White & Case
David Zwirner, New York/London

**TRUSTS, FOUNDATIONS
AND INDIVIDUAL DONORS**
Charles and Regine Aldington
Art Mentor Foundation Lucerne
The Atlas Fund
Petr Aven
The Nicholas Bacon
 Charitable Trust
Albert van den Bergh
 Charitable Trust
Blavatnik Family Foundation
BNP Paribas Foundation
Boeing Foundation
Charlotte Bonham-Carter
 Charitable Trust
William Brake Charitable Trust
Brooke Brown Barzun
Jeanne and William Callanan
David Cannadine
Capital Group
Rosalind Clayton and Martin Higginson
Cockayne Grants for the Arts
The London Community Foundation
Mr and Mrs Damon de Laszlo
Gilbert & Eileen Edgar Foundation
Mary Ellis
The Eranda Foundation
The Exhibition Supporters' Circle
Stephen and Julie Fitzgerald
Flow Foundation
Joseph Strong Frazer Trust
Robin Hambro
Holbeck Charitable Trust
The Rootstein Hopkins Trust
Edwina Dunn and Clive Humby
Intrinsic Value Investors
Paul and Susie Kempe
Ömer Koç
The David Lean Foundation
The Mead Family Foundation
Leche Trust
Nelson Leong
Christian Levett
Rosemary Lomax Simpson
The Loveday Charitable Trust
Maccabaeans
Machin Foundation
Scott and Laura Malkin
McCorquodale Charitable Trust
Paul Mellon Centre for
 Studies in British Art
The Andrew W. Mellon Foundation
The Mercers' Company
The Merrell Foundation
Sir Keith Mills

The Henry Moore Foundation
The Peacock Charitable Trust
Stanley Picker Trust
The Polonsky Foundation
The Red Butterfly Foundation
Rippon Travel Award
Kate and Nash Robbins
Sir Stuart Rose
Rose Foundation
The Rothschild Foundation
Adrian Sassoon
Jake and Hélène Marie Shafran
The Archie Sherman Charitable Trust
Christina Smith
South Square Trust
Nina and Roger Stewart
 Charitable Trust
Peter Storrs Trust
Taylor Family Foundation
The Terra Foundation
 for American Art
Mr and Mrs Bart T. Tiernan
Celia Walker Art Foundation
Sian and Matthew Westerman
Mr Galen Weston and The Hon.
 Mrs Hilary Weston
Spencer Wills Trust
The Wingate Foundation
Iwan Wirth
Lord Leonard and Lady Estelle
 Wolfson Foundation
Worshipful Company
 of Chartered Architects